Actresses, Gender, and the Eighteenth-Century Stage

Playing Women

Helen E. M. Brooks

palgrave
macmillan

First published 2015 by
PALGRAVE MACMILLAN

Palgrave Macmillan in the UK is an imprint of Macmillan Publishers Limited, registered in England, company number 785998, of Houndmills, Basingstoke, Hampshire RG21 6XS.

Palgrave Macmillan in the US is a division of St Martin's Press LLC, 175 Fifth Avenue, New York, NY 10010.

Palgrave Macmillan is the global academic imprint of the above companies and has companies and representatives throughout the world.

Palgrave® and Macmillan® are registered trademarks in the United States, the United Kingdom, Europe and other countries.

ISBN 978–0–230–29833–0

This book is printed on paper suitable for recycling and made from fully managed and sustained forest sources. Logging, pulping and manufacturing processes are expected to conform to the environmental regulations of the country of origin.

A catalogue record for this book is available from the British Library.

Library of Congress Cataloging-in-Publication Data
Brooks, Helen, 1981–
Actresses, gender, and the eighteenth-century stage : playing women / Helen Brooks.
pages cm
ISBN 978–0–230–29833–0 (hardback)
1. Women in the theater—England—History—18th century.
2. Acting—History—18th century. I. Title.
PN2593.B76 2015
792.0942—dc23 2014030372

Typeset by MPS Limited, Chennai, India.

For Will and Dorothy

Contents

List of Illustrations

Acknowledgements

In the years I have been writing this book I have been the grateful recipient of support and encouragement from more people than it is possible to mention here. Particular thanks go to Jane Milling, who first sparked my interest in the long eighteenth century and whose enthusiasm and insight has been a constant inspiration; Janette Dillon, who supported me in the first years of my career with kindness and advice; and Nicola Shaughnessy whose mentoring over recent years has been invaluable. I am also in debt to the late and much missed Jane Moody whose words of wisdom continue to shape my work today. I am ever grateful to the numerous friends and colleagues who have provided advice, feedback, and criticism on this work in its various forms, particular thanks going to Gilli Bush-Bailey, Kate Newey, Elaine McGirr, Laura Engel, Jennie Batchelor, Peter Thomson, and Robert Shaughnessy; as well as Jo Martin, Peggy Yoon, and Angie Varakis-Martin whose friendship and advice has always been invaluable. I am also grateful to have found such supportive and efficient editors in Paula Kennedy and Peter Cary at Palgrave Macmillan.

Since the project's inception I have been the recipient of a number of grants which have enabled me to access archives both nationally and internationally. My gratitude goes to the Arts and Humanities Research Council, the British Academy, the Theatre Society, and the Standing Conference of Undergraduate Drama Departments, as well as to the many librarians and archivists who have assisted me throughout: in particular Marcus Risdell, Curator and Librarian at The Garrick Club; Gayle Richardson at the Huntington; Pam Clark and Jill Kelsey at the Royal Archives, Windsor; Dennis Sears at the University of Illinois at Urbana-Champaign; and the staff of the British Library, National Archives, Folger, and Bodleian. Gracious thanks are also given for the use of material from the Royal Archives at Windsor, by the kind permission of Her Majesty Queen Elizabeth II.

Lastly, my thanks go to all my friends, who have shown endless enthusiasm despite the many years I have been discussing 'the book' with them. Most importantly however, none of this would have been possible without the support, particularly over the last year, of my wonderful family: Dominique, Paul, Austin, and Owen Frith; Philip Meade and the late Dorothy Meade, who I only wish had lived to see

the book in print; and the 'Lowries', Eleanor, Arthur, Jess and Nick. To my parents David and Mary Brooks, whose love and encouragement has been a constant in my life, thank you for always being there for me. And finally, to my beautiful daughter Dorothy, who has inspired me in so many ways, and to Will, whose astute insight has resolved many a conundrum, and who, throughout all that life has thrown at us, has always kept me laughing – thank you.

Introduction

Every summer Buckingham Palace opens its gates to the public, welcoming the thousands of visitors who stream through the State Rooms to marvel at the gilded ceilings, sparkling chandeliers, and exquisite furniture. From the Throne Room to the White Drawing Room visitors are dazzled by treasures from the Royal Collection, and nowhere more so than in the forty-seven metre Picture Gallery with its portraits of kings and queens, religious compositions by Old Masters, and expansive landscapes. Amongst these however, visitors will also find a life-size marble statue of an eighteenth-century actress (Figure 0.1). Simply entitled 'Mrs Jordan', this figure by the celebrated Regency sculptor Sir Francis Chantrey, depicts one of the most famous performers of her day, Dorothy, or Dora as she preferred to be known, Jordan.[1] For thirty years, between 1785 and 1815, Jordan dominated the boards of Drury Lane with her performances in comedies and farces, while her extensive touring across the country brought her both fame and fortune. Hailed as Thalia, the Comic Muse, her success in this vein was unrivalled. Yet it is not in her professional role that the statue depicts Jordan. Dressed in a classical robe, gazing lovingly down at the sleeping infant cradled in her arms, while a young, curly-haired boy stands contentedly by her side, resting his head on her lap, Chantrey presents Jordan not as an actress but as a mother. It is a powerful image. Unaware of our intrusive gaze, Jordan's attention is focused solely on her son; she is entirely absorbed in this intimate moment. With strands of hair falling over one exposed shoulder where her clasp has been loosened, probably to breastfeed, she holds the edge of her robe gently as though about to refasten it without waking the peaceful baby. Meanwhile, behind her relaxed bare feet the abandoned symbols of her work, a comic mask and pan-pipes, lie half-hidden in the folds of her dress.

1

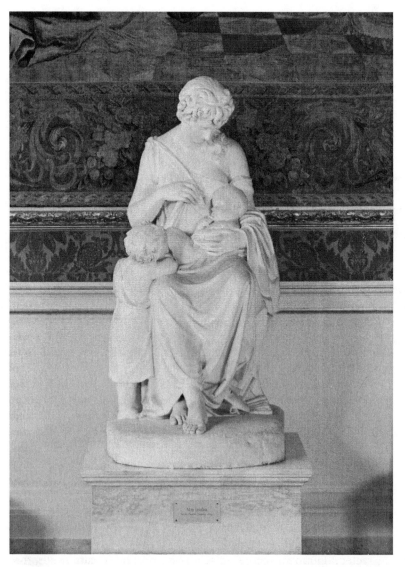

Figure 0.1 'Mrs Jordan', by Sir Francis Chantrey, 1834 (The Royal Collection)

Intended as a memorial to his partner of twenty-one years and the mother of his ten children, it is hardly surprising that when King William IV (formerly the Duke of Clarence) commissioned this statue in early 1831, only shortly after his accession and fifteen years after

Jordan's death, it was in the role in which he knew her best, as a mother, that he wanted to remember her.[2] And certainly the hundreds of letters Jordan wrote to William and her children testify to the maternal love and devotion which is captured in the statue. Yet, as we see in Chapters 1 and 5, the depicted insignificance of Jordan's professional work, symbolically discarded at her feet and overshadowed by the powerful image of maternity, speaks more to the period's notions of idealised motherhood as a woman's primary role than to the place of theatrical work in Dora Jordan's life.

Jordan was not the only actress to be portrayed in this way. From the last decades of the eighteenth century, public discourse around actresses focused increasingly on their subscription to idealised, bourgeois femininity, as demonstrated through their embodiment of the domestic roles of wives, daughters, and most importantly, as we see in the statue of Jordan, mothers. Margaret Farren, who spent her whole life touring in the provinces and is best known as the mother of the more famous Elizabeth Farren, was not unique when she was described in 1797 as having fulfilled, 'the duties of a Mother with great tenderness'.[3] Similarly the poetic panegyric on her daughter, who had debuted in London in 1777 and after years of success retired to marry Lord Derby in 1797, repeated a familiar trope when it declared that, 'completely amiable in private life / she lives the pattern for a perfect wife'.[4] Jane Pope, on the other hand, was praised for her her filial role. 'To the qualities of one of the best actresses of her time', we are told, joined 'the superior characters of a *dutiful* daughter, and a *virtuous* woman'.[5] Pope, who had been a member of the Drury Lane company from October 1759 and remained there, other than one season, for half a century, was known for playing a diversity of comic characters. Yet in 1786, 'her present appellation, the 'Heiress of the public favor'', and the audience's 'general satisfaction', wrote the author of the *Green Room Mirror*, stemmed equally 'from her private virtues, and public merit'.[6] Private virtues', as the same author asserted in discussing the actress Mrs Brown, who had made her debut at Covent Garden on 28 January that year, were those 'requisites absolutely necessary to establish the patronage of a public character'.[7] Elizabeth Bannister, who had made her theatrical debut in 1778 and was celebrated in particular for her beautiful singing voice, was described in similar terms: her reputation and polite patronage being considered the result of a 'comparison of her private character [. . .] blended with her public merit'.[8] And the success of Charlotte Goodall who, despite being a recognisable figure on the London stage in 1792, had, according to Joseph Haslewood, not been considered 'a very

eminent Actress' in Bath and Bristol in early 1780s, was attributed not only to the 'elegance of her figure, [and] the vivacity of her countenance' but also to 'the amiableness of her private character'.[9] Even the lower-tier actress, Katherine Sherry, whose theatrical career was cut short after only ten years, when she died in 1782, was immortalised on her tombstone in St Paul's, Covent Garden with both, 'a short encomium on her abilities as an actress, and her virtues as a private character'.[10] Irrespective of her place in the theatrical hierarchy it seemed, by the turn of the century an actress' professional success was as, if not more reliant upon her domestic and private merits as it was upon her professional skills. By 1827, seven years before Chantrey completed his statue of Dora Jordan, the symbiotic relationship of public success and private virtue was so well established that the *Encyclopaedia Edinensis's* entry on the actress commented that:

> At that period [reign of Charles II], female performers were regarded as persons of infamous character; but, in the present day, the same remark is here equally applicable as to actors; for the degree of respect in which they are held corresponds with the propriety of their moral conduct.[11]

By the early nineteenth century, it seems, there had been a radical reversal of the way in which actresses were both valued and perceived. From being a profession in which, for much of the last 150 years, participants had been tarnished as being, in Kristina Straub's influential phrase, 'sexual suspects', now, these sources suggest, individual actresses could, and were, breaking free from their profession's historic associations with the other, and oldest, public profession for women: prostitution.[12]

This grand narrative, which marks the turn of the nineteenth century as the first major moment of change in the image of the actress, continues to influence scholarship today. It can be seen in the elevation of Sarah Siddons as the first actress to overcome her profession's 'shame' through, what Gill Perry has described as, her 'public image as a respectable and happily married wife and mother'; in the continuing fascination with the transgressive nature of actresses' lives; and in the repeated categorising of these women using what Felicity Nussbaum has described as the 'proper lady/prostitute' opposition.[13] Whether scholars accept the shift in discursive representations of actresses at the turn of the century at face value, or consider it a defensive strategy to recuperate those women whose public professionalism jarred with the ideal of femininity as domestic and passive, the focus remains on actresses'

successes, or more frequently, failures to embody a particular model of late eighteenth-century femininity. The idea, as Straub has argued, that actresses were caught in crosscurrents which defined their sexuality as public by profession yet private by gender, making them the 'site of an incompletely successful struggle to contain feminine sexuality within the dominant cultural confines of domesticity' is well established.[14] Actresses could never, as Laura Engel has recently summarised, 'be regarded as paragons of eighteenth-century femininity because they participated in a profession defined by display and impropriety'.[15]

This book began life out of my concern about the limitations presented by this approach to eighteenth-century actresses; my concern that by locating actresses in an anomalous relationship to mainstream society and womanhood we risk obscuring their important place as professionals, economic agents, theatrical innovators, and perhaps most importantly, figures within women's history. This is not to deny the important and influential work which has been done on sexuality, and which has, over the last twenty-five years, opened up valuable new perspectives on gender and the theatre. It *is* to argue that we need to study sexuality alongside other aspects of actresses' lives, and against a more nuanced background than that of bourgeois domesticity, if we are to understand the complex interactions of gender, sex, and performance in these women's work. The fact that actresses, not only at the end but throughout the century, have been judged against a model of idealised, domestic femininity has been problematic for two reasons. Firstly, by placing the emphasis on early and mid-eighteenth century actresses' subscription to a gender ideology which was, for them, only emerging, rather than established, it limits recognition of the ways in which these earlier actresses responded to the models of femininity circulating within *their* cultures. It is a limitation which arises, in part, from the failure of much gender history to deal with change, which, as Karen Harvey notes, is itself a consequence of gender history's roots in cultural history, a field which she identifies as being, 'strongest in its analysis of the synchronic rather than the diachronic'.[16] Secondly, with the focus on late-century actresses' anomalous relationships to domestic ideology little attention has been given to the ways in which these women spoke to the material experience of this ideology. As Lawrence Klein reminds us, rather than focusing on why individuals did not conform to high theory, and classing them as transgressive, we should always ask, 'what is the "theory" of the actual practice?': a question which resonates throughout the following chapters.[17]

This book responds directly to over-reliance on bourgeois femininity as the cultural framework through which we understand the

eighteenth-century actress. Drawing on recent work in social and cultural history, in order to understand the distinctiveness and complexity of the gendered contexts in which individual actresses were living and working at different points across the century, it argues that there was a far more sophisticated relationship between actresses and contemporary models of femininity than has previously been recognised. Rather than being at odds with, or exceeding the bounds of, acceptable femininity, I argue that throughout the century individual actresses offered performances which reflected, responded to, adapted and challenged the varying and rapidly changing models of femininity which saturated the societies they lived in. By considering the multiple female identities engaged with and performed by eighteenth-century actresses, both on and off the stage, in dramatic fiction and in life, and at a time when ideas about gender were shifting radically, I therefore demonstrate just some of the ways in which leading actresses responded to, and reciprocally shaped, understandings of what it meant to be a woman. Rather than positioning the actress as a marginalised or counter-cultural figure, I argue instead for her significance as the site of important cultural negotiations over radically shifting gender roles.

As social historians have been documenting for over twenty years, the eighteenth century was a period in which constructs of femininity and masculinity were constantly in conflict. It was, as Tim Hitchcock has noted in a phrase which aptly evokes the century's radical reconstruction, even reversal, of human sexuality and gender roles, a period of 'sexual revolution'.[18] And the cause was a fundamental, albeit neither smooth nor comprehensive, alteration in understandings of human physiology. As detailed by Thomas Laqueur in his seminal 1990 book, *Making Sex*, and subsequently developed and critiqued by others, this reordering saw the dominant model of a hierarchical or 'one-sex' body, in which sexual difference was a matter of degree and the humoural composition of the individual body, being gradually overthrown in favour of a compatible or 'two-sex' model, in which men and women were distinguished as anatomically and categorically different.[19] From sex being a secondary, or sociological phenomenon, as compared to gender which was 'real', Laqueur argues, in the two-sex model sex became an ontological category.[20] For the first time the physical body – flesh, nerves, and bones – became the cause of sexual difference. The impact of this revision on attitudes towards sexual behaviour, and gender roles and expectations, has been well documented by social historians over the last twenty years: having been used to contextualise the desexualisation of women, the bifurcation of sexual desire into heterosexual and

homosexual binaries, the growth of gendered separate spheres, and the birth of the 'naturally' chaste and domestic woman.[21] Yet its influence on theatrical performance remains largely unexamined; despite the fact that theatre is, as Erika Fischer-Lichte has pointed out, a 'genre of cultural performance concerned with the creation, self-fashioning and transformation of identity'.[22]

One of the key questions which the book seeks to examine therefore is the way in which this radical reconstruction of what it meant to be a woman shaped female performance across the eighteenth century. Yet although I demonstrate how actresses negotiated, promoted, and resisted changing models of femininity, it is important to recognise that they did not simply respond to pre-determined gender constructs. Gender, as Fabio Cleto notes, is created through repeated and publicly visible behaviours: 'the effect rather than the cause, of repeated and stylised acts of performance'.[23] And with the theatre being, in Fischer-Lichte's words, a 'liminal space which gives the spectator the opportunity of testing new identities and acting them out' it was therefore the nexus at which gender identities were not only engaged with, but also constructed, tested, negotiated and culturally disseminated.[24] As Judith Butler has noted, discussing Simone de Beauvoir's famous statement that, 'one is not born, but rather becomes, a woman [. . .] it is civilisation as a whole that produces this creature':

> It follows that *woman* itself is a term in process, a becoming, a constructing that cannot rightfully be said to originate or to end. As an ongoing discursive practice, it is open to intervention and resignification.[25]

By publicly 'playing women' in their multiple incarnations the 'playing women' of the eighteenth-century theatre were therefore central to the ongoing, but never complete, formation of female identity and roles. My emphasis on play in the title is important moreover as it was through their performative playing that these women provided, to draw on a definition from play theory, 'opportunities for people to experiment with and create new ways of being, seeing and relating'.[26] In embodying particular models of female identity, both on stage through the interaction of dramatic character and theatrical persona, and off-stage through their construction of 'self' in the public eye (in particular towards the end of the century, as we see in Chapters 4 and 5), actresses functioned as public sites in which diverse constructions of female identity could be examined, tested, and reflected back to wider society.

To understand the ways in which actresses engaged with changing models of identity however, we need to look beyond the dramatic texts and fictional characters they presented and examine their performances as embodied events in specific historic moments. Studies such as Lisa Freeman's *Character's Theater*, Cynthia Lowenthal's *Performing Identities*, and Jean Marsden's *Fatal Desire* have offered valuable insights into the relationship between female gender identity and long eighteenth-century drama.[27] However the importance of *how* actresses performed and not just *what* they performed has been largely overlooked. Drawing on Diane Taylor's influential study *The Archive and the Repertoire,* which argues that we need to take performance 'seriously as a system of learning, storing, and transmitting knowledge', this book therefore considers both the evidence on offer through the archive of the dramatic text *and* the meaning transmitted through the performance, or to use Diane Taylor's term, the 'repertoire'.[28] And as Chapters 2 and 3 highlight with their respective foci on she-tragedy and cross-dressing, it was often in the gaps and tensions between the written text and the embodied performance, as much as in the similitude, that the richest meaning was created.

With its focus on actresses' performances this book also seeks to remedy the overwhelming absence of the actress from histories of acting and to consider the distinctive meaning on offer through the female performing body. It has, of course, long been recognised that styles and methodologies of performance reflect the ways in which social bodies are understood and interact. Even as early as 1744 an anonymous tract reflected that:

> As acting is to represent mankind,
> actors new method in each age must find;
> as fashions vary, or as humours change
> attempt this year what they might last think
> strange.[29]

Over the last thirty years, eighteenth-century acting has been examined from a number of perspectives: Alan Hughes detailed the relationship between rhetorical expressions of the passions and Baroque art in his 1987 trilogy of essays, Paul Goring considered acting as part of a wider social project to train the body, and most influentially, Joseph Roach's *Player's Passions* provided an expansive analysis of acting styles in relation to physiognomic understandings of the body.[30] By drawing on eighteenth-century acting theory however, a genre which was overwhelmingly written by men and which largely assumed a universal,

therefore male, body, such studies largely absorbed the actress into the generic term 'actor' and overlooked the distinctive signifiers on offer through the interaction of acting styles and the female body. The result has been a narrative of male progression and innovation which elevates figures such as Thomas Betterton, David Garrick, Charles Macklin, James Quin, and John Philip Kemble, whilst eliding the equally important contribution of women such as Anne Oldfield, Peg Woffington, Dora Jordan, and Sarah Siddons: the four women whose contributions to theatre history are examined in Chapters 2 to 5.

The gendered imbalance in the source materials available to historians, evident across these androcentric histories of acting, is a significant difficulty throughout the eighteenth-century, but particularly so in the early years. For Robert D. Hume, it limits the kinds of arguments which can be made. Arguing that 'historical reconstruction depends on "evidence" and in the absence of satisfactory evidence, the method cannot work properly and should not be used', Hume points out that the difficulty, or often impossibility, of finding evidence before the nineteenth century radically limits the kinds of arguments which can be made.[31] Thomas Postlewait however, outlines a methodological approach which enable us to look beyond this problem. Critiquing Robert D. Hume's archaeo-historic position, Postlewait argues that we need an approach which allows us to narrate what E. P. Thompson described as 'history from below': the histories not only of women, but also of racial and ethnic groups, and all those effaced from the dominant narrative of history.[32] This methodology, which Postlewait describes as speculative, is one which I have drawn on throughout this book.[33] Drawing on evidence from performance studies, art history, literature, economics, and the history of medicine, I bring together sources which often find themselves studied separately because of disciplinary boundaries. And in drawing on methodologies from both social and cultural history – where in Catherine Belsey's words 'social history gives priority to describing practices, while cultural history records meanings' – I consider these sources as both representative of material practices and as signifying the social values that actresses and their publics subscribed to.[34]

By focusing on practice and experience alongside theory and prescriptive discourse I also resist what Karen Harvey has described as the 'deep and broad narrative of women's history' which, she argues, 'suggests a vision not simply of changing roles or ideals, but of increased rigidity in the nature of those ideals'.[35] Although with its broadly chronological arc the book charts an overarching shift in actresses'

engagements with shifting models of femininity in the context of wider social changes – in particular the shift to a two-sex body and the, not unconnected, Romantic alignment of an authentic interior 'self' with external presentation – it does not conclude that this change was restrictive. Certainly there was an increasingly complex alignment of actresses' public, professional and private identities towards the end of the century (as detailed in Chapters 4 and 5), and a concurrent curtailing of the mutability and multiplicity of gender which is evident in the early years (explored in Chapters 2 and 3). However whilst feminine roles and behaviours might have become more proscribed in theory, in practice women's behaviours and activities reflected the complex range of factors shaping their lives, of which bourgeois ideals were but one part. And it was this dynamic mix of gendered ideals and realities that actresses like Dora Jordan and Sarah Siddons spoke to in the latter decades of the century. Just like their early and mid-century predecessors, Anne Oldfield, Mary Porter, and Peg Woffington, these late-century actresses continued to respond to, reflect, and challenge women's experiences of gender as both an idealised discourse and a lived experience. Rather than offering a narrative of steady progression or decline therefore, the book focuses on specific moments across the century to reveal the way in which women who were working at different times were nevertheless engaged in the same practice of negotiating and shaping the gender constructs which suffused the culture they lived in. Whilst *ideas* about gender changed, thereby prompting, even demanding, new embodiments of femininity on stage and in society, actresses themselves were no more or less restricted in their response to these ideas than they were at the start of the century.

Throughout the book, by building my argument around these specific moments of gender negotiation by particular actresses, rather than arguing for sweeping or comprehensive change, I also deliberately leave a space open for discussion of alternative narratives. It is important to remember that, throughout the long eighteenth century, the gradual shift from the one- to two-sex body was complex and unstable, as well as both pre- and post-dating the period: as Nancy Tuana notes the hierarchical model continued to circulate, at least in part, as late as the 1930s.[36] Whilst the examples of female performance selected for this book work together to present a narrative in which actresses' changing performances of gender parallel the wider changes in understandings of sex and gender therefore, I am more than aware that other examples can be selected to offer an alternative history. Just as masculinity and femininity remained in flux throughout the century, actresses as a group reflected what Karen Harvey has described as the, 'plurality of

female bodies [which] complicates the argument that one type of early modern female body was replaced by one type of modern female body at some point during the eighteenth century'.[37] And whilst the examples I have chosen present one perspective on actresses' relationships to contemporary gender models, future scholarship will, I hope, contribute new interpretations, whether by drawing on different contextual frameworks or by looking at different actresses. The work, for example, of women like Frances Abington, Susannah Cibber, and George Anne Bellamy, amongst other 'star' actresses who are largely absent from the present study, would certainly provide fertile grounds for further exploration of actresses' negotiations of gender roles and expectations.

It is not only such 'stars' however, who should be noted for their exclusion from the present study. Minor actresses, regional performers, and women who never made it to the top of the profession have, unfortunately, been overlooked by the majority of studies in the field: a practice which, as Gilli Bush-Bailey warns, leads to isolationism and the separating of women in theatre both from one another and from themselves.[38] It is a criticism from which this book cannot be entirely exempt. And whilst throughout I attempt to highlight the parallels between the gender play of star and lower tier actresses, I am aware that much remains to be done in terms of examining the ways in which actresses, at all levels of the hierarchy, responded to and engaged with the diverse models of femininity on offer throughout the century. Having said this, the practical difficulty presented by the relative scarcity of source material for many of these women, and the necessity of being selective when considering the expanse of theatre history under discussion, are not the only reasons for focusing predominantly on star actresses in the present study. There are also methodological grounds. Arguing for a positive correlation between individual actresses' professional successes and the extent to which these women spoke to contemporary debates over, and experiences of femininity, the case studies offered here focus, by necessity, on the most successful and celebrated actresses of their day: those women whose timely response to particular models of femininity was a central facet of their achievements.

This link between professional success and gender-play is an important one. The women examined here, it must be remembered, were real people, working in a commercial environment in order to earn a living. As well as theorising *how* their performances spoke to contemporary constructs of gender therefore, I also ask *why* they engaged in this dialogue. Financial gain, I conclude, was the primary motivation. Recognising that an actress's primary role was as an active participant in a profit-making enterprise, I tease out the intersection between

professional, economic success, and specific actresses' engagements with varied gender identities. These women, I argue, appropriated, shaped, and re-performed gender identities for a specific reason: to create publicly valuable images which would, when traded in the theatrical marketplace, enhance their economic returns. Focusing on the monetary motivation at the heart of actresses' cultural work, this book therefore draws together often distinct work on theatre economics, as spearheaded by Judith Milhous and Robert Hume, with that on gender, image, and identity. At the same time, it consciously interweaves approaches from women's history and gender studies, two fields which have been defined by Louise M. Newman as respectively dealing with 'why specific groups of women share certain experiences' and analysing 'how gender operates through specific cultural forms'.[39] As such, and by emphasising the actress's status as an economic agent, I stake a claim for the long-neglected position of actresses within the wider narrative of women's history of the period.

It is with this focus on the actress as a working woman that the book begins. Whilst Chapters 2 through 5 analyse actresses' performances of specific gender identities at key moments across the century, Chapter 1 takes a distinctive approach: both providing an overview of the whole century – thereby introducing many of the women who reappear across subsequent chapters – and focusing on the theatre as a business rather than a cultural form. Examining the earnings of actresses across the century, and in comparison with wages in other lines of work available to both women *and* men, I identify the theatre as an unique industry which gave ambitious women the opportunity not only to earn large amounts of money, but also to break free from the gendered wage gap which was evident both in wider society and at the lower tiers of the profession. By constructing highly valuable, exclusive commodities which spoke, in diverse ways, to their culture's ideas about gender, women like Anne Oldfield, Peg Woffington, Dora Jordan, and Sarah Siddons were able to earn far beyond the limits of their gender. And whilst the performative ways in which they did this are the focus of the four subsequent chapters, in Chapter 1 I examine the practical ways in which these women, and their peers, constructed their theatrical commodities: focusing in particular on the importance of roles as 'raw goods', and on the struggles to maintain control over the process not only of creation but also of selling. The actresses who the following chapters focus on were, I argue, female entrepreneurs: women who used their initiative and ambition to achieve phenomenal wealth, not in spite their gender but through its sophisticated application.

It is to this application of gender in the early years of the century that Chapter 2 turns, focussing on the ways in which female rhetorical performance complicated the gendered construction of women as lacking reason and restraint. The main focus of the chapter is a detailed performance analysis of Nicholas Rowe's she-tragedy, *Jane Shore*: a play which rocketed to popularity in 1714 through the performances of Anne Oldfield and Mary Porter. Providing a vehicle for these two actresses to demonstrate their rhetorical skills – a performance mode which demanded 'masculine' control and judgement over the body – *Jane Shore* was play which, in performance, challenged notions of female irrationality, even whilst the dramatic text being performed propounded them. The chapter concludes by examining responses to this demonstration of women's capacity to equal and even exceed their male peers, revealing how audiences both celebrated the masculine power of the female performing body at the same time as they felt threatened by these women's encroachment into masculine domains.

Chapter 3 picks up on this exploration of actresses' engagements with both masculine and feminine identities through examining how female cross-dressing spoke to shifting models of gender identity in the middle decades of the century. Unlike much work in the field, which tends to distort our understanding of theatrical cross-dressing by amalgamating distinct cross-dressing practices into one homologous activity, here I draw a sharp distinction between the meanings on offer through travesty performances (actresses playing male characters on stage), and breeches roles (female characters cross-dressing within the fiction of the play). Focusing predominantly on the work of Peg Woffington, an actress who was celebrated for her performances in both types of roles, I reveal how travesty and breeches performances each had a distinctive relationship with contemporary constructs of gender in the middle years of the century: travesty's playful approach to gender speaking 'back' to, and celebrating, a one-sex understanding of the body in which sexual identity was mutable; breeches roles, relying as they did on the transparent femininity beneath the male disguise, reflecting the growing perception of the body as fundamentally gendered. It is because of this distinction, I argue, that breeches roles continued in popularity as the century progressed and the two-sex body gained increasing dominance, whilst attitudes towards, and the intelligibility of, travesty performances underwent a concomitant alteration. Whilst recognising that actresses like Dora Jordan continued to perform travesty roles to the end of the century, the style and meaning of these performances, I argue, was far removed from the androgynous gender-play offered by Woffington a generation earlier.

In the last two chapters of the book I turn to the final decades of the century, examining the ways in which actresses responded to the new model of interiorised, domestic femininity which accompanied changing understandings of the sexed body. Identifying a shift in critical discourse around actresses' performances, with commentators increasingly celebrating the actress's expression of her 'self' rather than her transformation into an 'other', in Chapter 4 I argue that actresses at the end of the century increasingly sought to align their off-stage personas with their performances of dramatic characters. Sarah Siddons has, of course, long been recognised for her conflation of public and private. As Shearer West has noted, Siddons's public and private roles:

> Collapsed and blurred together in a period during which a monolithic view of woman's character and abilities was being challenged more frequently and consistently [. . .] her private life, as much as her stage roles, was a kind of performance, enacted with the knowledge that she was constantly being observed, admired, or envied.[40]

Yet Siddons was not alone in responding to her cultural milieu through this 'performance of self'. Dora Jordan, her peer and to a great extent her rival, also sought to mask the divide between the dramatic roles she played on-stage and her own identity off-stage: a fact long overlooked because of the tendency to treat these women as being polar opposites, both on the basis of their distinctive personal lives and because of their respective positions as the tragic and comic muses. Responding to the growth of bourgeois femininity, and the increasing concerns over the coherence of women's external presentation and their internal 'true' identities, both actresses developed what I describe as 'techniques of sincerity', cultivating by doing so, a perception that their performances were effortless expressions of their authentic selves and true emotions. And whilst such self-fashioning was on one level self-defeating, subverting the construct of bourgeois authenticity through the very act of performing it, on the other this 'performed authenticity' spoke directly to the performativity which was at the heart of the new middle classes' identity. Throughout Chapter 4 my interest is in Jordan and Siddons's performative techniques and the use of these to construct an impression of coherence and authenticity: an impression which often required these women to perform their theatrical personas off-stage as much as on. I conclude the book however, by looking at the reverse: the on-stage performance of personal, real-life roles. Throughout her career Sarah Siddons drew on her real-life maternal role and experiences, responding

directly to the late-century preoccupation with motherhood as the essence of a woman's identity. As I argue in Chapter 5 however, her use of her maternal role was more complex than is often recognised. Whilst Siddons certainly attempted to style herself as the epitome of idealised femininity, it was an attempt flawed by her evident status as a working, economically-productive woman: the image of the working actress as 'ideal' mother being an antithetical one in a context in which domestic and economic labour were divided into two incommensurable, gendered, camps. Whilst she might have unsettled the construct of the ideal mother however, Siddons reflected the experiences of a diversity of middling women for whom the negotiation of public and private working practices – of ideal and reality – was an ongoing challenge. Just as her 'performed authenticity' reflected the performativity hidden within middling-class identity, so Siddons's performances of idealised maternity spoke to the hidden working practices of many of her contemporaries. More than this however, she also provided a practical strategy for dealing with the problematic position working mothers found themselves in. Using her maternal identity not to negate her ambition, as has previously been argued, but rather to justify it, Siddons demonstrated how women could use the discourse of maternal duty to legitimise their economic productivity and place in the labour market.[41]

It is an argument which returns us to the theme with which I begin the book in Chapter 1: the importance of understanding that actresses were not simply performers, but were also businesswomen who had to work hard to ensure the profitability of their enterprise. As Jordan and Siddons's letters reveal, earning money was extremely important, just as it had been for many of their predecessors. Yet whilst earlier in the century, actresses' economic practices had been separate from their performances of gender – or to put it another way their identities and activities as traders had been independent of the commodity which they embodied – now with the new century dawning, a model of femininity emerged which enabled women like Siddons and Jordan to align both these aspects of their professional identities. Although intended to segregate economic labour along gendered lines, in fact the discourse of bourgeois motherhood gave these women the opportunity to align their performance of gender with a justification of their identity as working women. By the end of the century therefore, not only were their professional and personal personas becoming ever more closely entwined but actresses' identities as both theatrical traders and embodied commodities were being bound up in a way which was transforming what it meant to be an actress.

1

Playing for Money: 'This is certainly a large sum but I can assure you I have worked very hard for it'

On Tuesday 30 January 1810, and whilst on tour in York, Dora Jordan, the most celebrated comic actress of her day, took up her pen to write home to her long-term partner, William, Duke of Clarence – second in line to the throne and later to be King William IV. 'I played last night here to a very elegant house' she informed him, 'for York it was a great thing. Some families have taken up their quarters here for the time I stay; the applause great, and attention very flattering.'[1] Yet, as her next words reveal, this public appreciation was not, primarily, what Jordan was interested in. This, 'I perhaps do not set a sufficient value on' she continued, 'like a spoil'd child it is their money I want [. . .] it is a pity that like other professions I cannot have assistants. How much money I should make!'[2] It was a sentiment she echoed a number of times across her letters: in June 1809 she wrote from Dublin: 'nothing can be more flattering, than the reception I meet with every night but there is a vulgar song very expressive of my feelings in these occasions, without your cash your kissing won't do'.[3] A year later, in June 1810, she wrote in the same vein from Edinburgh: 'I should be content with less applause and more money'.[4] Celebrity, public acclaim, fame, recognition, and social status were not, as Jordan reveals in her extensive correspondence to William, what primarily motivated her throughout her thirty-year professional life: constantly striving to increase her financial returns, Jordan was focused not on the creation of 'art', or the cultivation of fame, but on making money. She was, above and beyond anything else, a businesswoman. And she was not alone in approaching the theatre in these terms. As David Garrick poetically put it, in a prologue spoken by William Powell at the opening of the new Bristol theatre on 30 May 1766:

That all the world's a stage, you can't deny;
And what's our stage? – a shop – I'll tell you why.
You are the customers, the tradesmen we;
[. . .]
To feast your minds, and sooth each worldly care,
We largely traffic in Dramatic Ware;
Then swells our shop, a warehouse to your eyes;
And we from small retailers, merchants rise![5]

In the following chapters I examine the varying gender roles that actresses engaged with across the century, revealing the ways in which they responded to, adapted, and shaped changing models of female identity: the ways in which they 'played women'. Yet whilst, as we will see, these women's performances of gender evolved in response to wider social and cultural shifts, consistent throughout the century were their identities as traders of a theatrical commodity: their identities as economic agents. In fact, as I explore in this chapter, it was this economic identity and profit motive which sat at the heart of, and drove, the gender play which the subsequent chapters examine.

A unique profession

It is hardly surprising that economically-ambitious women turned to the stage to make their money in the eighteenth century: at a time when women's earning power was constrained by their gender the theatre was unique in the economic opportunities it offered. Even at the lower and middle tiers acting often provided a level of income which was higher than in most other female occupations, such as domestic service or millinery. In the early years of the century, for example, whilst a skilled housekeeper might earn up to £15 per annum, when Anne Oldfield began her career in 1699 she received 15 shillings a week, an amount which averages at just over £22 a year using Milhous and Hume's helpful formula of one season being equivalent to 30 weeks or 180 days.[6] A few years later, in 1703–4 Mary Porter, who had debuted in 1698 and was now a solid middling rank actor, was earning the comfortable salary of £35–40.[7] Three years later, in 1706, this had risen to around £60; by 1709 she was earning £80; and at the end of her career in the 1720s she was receiving the significant salary of £266 1s per season with a clear benefit.[8]

Oldfield's rise however, was even more spectacular and reveals the extent to which a top-tier actress's income could exceed not only the vast majority of working women's, but also many men's, wages. Having

negotiated a contract in August 1706, which gave her 13s, 4d for every day the company performed (totalling £120 for the full season), three years later, in a thirteen-year contract signed on 21 April 1709 with Owen Swiney at the Haymarket, Oldfield was given £200 per annum, paid in nine equal monthly payments throughout the year.[9] At a time when the the average female wage was 5 shillings a week (or £13 p/a), with only a few specialist female workers achieving between 10 or 12 shillings a week (£26–£31 p/a); the cost of keeping a family was around £40; and the lower income threshold for a 'middling class' family was around £100, Oldfield's salary was considerable.[10] Twenty years later, in the 1728–9 season, her income was to rise even higher, bringing her a total profit of £878 (£378 with an additional £500 for one benefit performance).[11] Through a career which spanned almost thirty years, Oldfield earned amounts which surpassed not only the income of the vast majority of working women, but also of many professional men. When she died on 23 October 1730, her will, which included a number of large bequests discussed at the end of the chapter, was a testament not only to her wealth but also to her careful financial management.[12]

Oldfield was not alone however in achieving such high wages; in the years following her death, a new generation of actresses, who would push their salaries even higher, took to the stage. Susannah Cibber was just one of these women. Making her debut at Drury Lane in March 1734, she received a salary of £100 for her first season – an amount which the manager, Charles Fleetwood, estimated was doubled by her benefit – whilst in her second and third seasons her base salary was increased to £200, with her benefits returning around £150.[13] By comparison, in 1734 a lady's maid might expect to receive only £10; a housekeeper, £34.[14] Around five years later, when Peg Woffington made her debut at Covent Garden in November 1740, she was contracted at 5 guineas a week (£157 p/a); only two years on, in 1742–3, and now at Drury Lane, she made £250 plus £180 from benefits, bringing her total earnings to £430.[15] The versatile Hannah Pritchard (although receiving an additional clothes allowance of £50) made the same amount that season, despite having seven years more experience than Woffington (her exact debut is unknown but is thought to be around 1733).[16] Kitty Clive however, who had begun appearing regularly at Drury Lane in the 1728–9 season, and was by now a well-established actress, celebrated for her vocal and comic talents alike, made £525 plus £220 in 1742–3, taking her total earnings for the season to £745.[17]

Wages continued to rise as the century reached its mid-point. When Peg Woffington returned from Dublin in 1754, she signed a contract

with John Rich at Covent Garden which gave her £800 per season, and a year later Susannah Cibber, who had been contracted on an annual salary irrespective of how many times she performed, earned £700 for 13 nights' playing.[18] These levels of income are worth considering in light of Joseph Massie's 1759 estimation that a trained and educated lawyer earned £200 per annum, and the fact that this was also the allowance given to James Boswell by his father in London in 1760.[19] In fact, using Massie's estimation, these actresses' earning power was higher than even the 1000 wealthiest merchants whom he estimated as making £600 a year.[20]

These levels of income brought Susannah Cibber, Kitty Clive, Hannah Pritchard and Peg Woffington comfortably within the boundaries of the rising middling-classes. However even lower-tier actresses received wages which compared favourably to women's wages in other occupations. In 1734 the Duke of Newcastle's housekeeper, Anne Elliot, received £30 p/a, whereas, less than ten years later in 1742–3, the lowest-paid performer in John Rich's company was receiving 1s 8d per day.[21] This salary, which on the basis of an 180-day season could total a potential £32, is comparable to highly paid, or specialist female work in other fields; even if she were only paid for a proportion of the season, such an actress would still make more money than many of her peers.

In the second half of the century the theatre continued to offer women the opportunity to earn far in excess of their peers. The singer and actress, Ann Cargill, who made her debut as a child performer at Covent Garden in November 1771, advanced within seven years from her starting salary of £31 10s to making £273 6s 8d in 1778–9 for 178 nights' playing.[22] On 5 May 1775, the experienced comic actress Frances Abington, who had first appeared at Drury Lane in 1756 on a salary of 30 shillings a week (a potential £45 p/a), signed a contract with David Garrick giving her £12 per week (£360 p/a) and continuing her allowance of £60 p/a for clothes.[23] A year later, when Richard Brinsley Sheridan took over Drury Lane, Abington negotiated the same salary but doubled her clothing allowance and was give £200 in lieu of benefit.[24] By 1782 she was receiving £600 per annum at Covent Garden, the same salary as the governess of George III's children.[25]

Whilst Abington was very successful however, in the last two decades of the century two actresses were to transcend the earnings of all their predecessors. Dora Jordan and Sarah Siddons, the comic and tragic muses respectively, took to the boards of Drury Lane within three years of each other: Siddons in 1782, initially earning 10 guineas a week (a potential £300 p/a), although this was soon increased to £12 (£360 p/a)

and then £20 per week (£600 p/a); Jordan in 1785, earning £4 a week which was doubled less than two months later (bringing a potential £240 p/a).[26] Four years later, in the 1789–1790 season Jordan finally succeeded in matching Sarah Siddons' contract of £30 a week, with her own agreement to appear three nights a week at £10 per performance.[27] It was an amount which, for only forty performances – the birth of her daughter, Lucy Ford, delaying her first appearance to February 1790 – brought her basic earnings to £400. In addition, her one-night benefit performance brought a further £241.[28] This level of remuncartion placed both Jordan and Siddons well within the top band of the middling classes: as Davidoff and Hall have suggested, an annual income of around £200–300 would comfortably secure a place within the middle classes in 1802, with the lower annual limit for tax being £50 and top rates starting at £200.[29] In the last fifteen years of her career however Jordan superseded even these income levels. In 1809 she estimated that she would achieve a total income of between £4000 to £5000 for the year; an amount which, considered in light of Patrick Colquhoun's calculations of average family income between 1801–3, put her on equal terms with the country's 26 bishops, who earned £4000 p/a each, and was only superceded by the 287 peers who earned £8000 p/a.[30] Subsequently however Jordan's summer season in Dublin was disappointing and she complained that she was unlikely to make more that £1200 for the engagement, having hoped to make above £2000.[31] Nevertheless in total, over the course of her career Jordan estimated that she earned £100,000.[32]

The uniqueness of the theatre was not solely in the far greater income it offered compared to other lines of work. It was also the only field of employment where women could receive comparable or greater wages than their male peers, for doing the same, or comparable, work. Whilst women were a significant presence in the eighteenth-century urban economy, they invariably earned less than their male peers in the same, or similar, lines of work.[33] Both because women's income was perceived to be supplementary to a family's main earnings, and because women's reproductive status weakened their position within the labour market, they were, as Joan Chandler has highlighted, largely relegated to a reserve army of labour and paid at lower rates.[34] To an extent this was also the case in the theatre; yet whilst the salaries of middle and lower rank actresses were conscribed by their gender, as an analysis of both the 1703 list of annual salaries put together by John Vanbrugh for his proposed new company (Figure 1.1) and the Covent Garden account books of 1736–1736 (transcribed by Judith Milhous and Robert Hume in

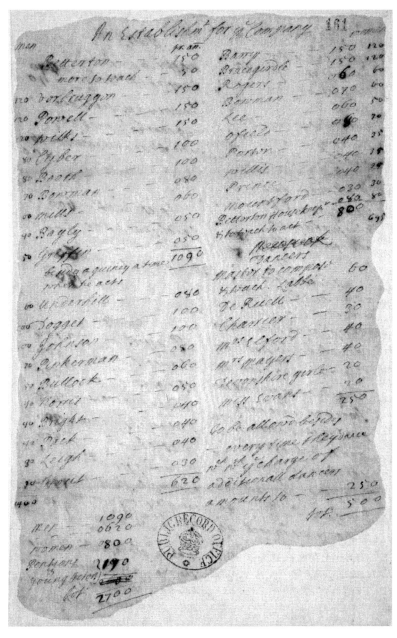

Figure 1.1 John Vanbrugh, 'An Establishment for ye company', 1703 (The National Archives) LC7/3 (161)

1990) reveals, in the top-tier actresses were also able to break free from this gendered wage discrimination.

With its hierarchical listing of proposed annual salaries for the start of the century, Vanbrugh's 1703 plan enables us to directly compare the intended wages of all the male and female members of the proposed company and draw conclusions as to the impact of gender on theatrical wages in a way which is often difficult to achieve with other sources. As Edward A. Langhans points out, differences in articles of agreement, such as benefit arrangements, whether performers were paid whether they acted or not, the length of contracts, and wardrobe provisions, make it difficult to compare the financial status of different performers.[35] Since Vanbrugh's plan is a proposal however, rather than a record, it circumvents this problem and, in a context in which, as Cheryl Wanko argues, value was increasingly being manifested as money, it therefore provides a helpful measure of the comparative value Vanbrugh ascribed to each of the performers.[36]

There are a number of significant points to make about the plan. Firstly, as well as there being twice as many men as women (twenty men to ten women), men, on average, received £11 more than women in the company: £83 as opposed to £72, or in other words a 13 per cent wage gap. When the top tier of actors and actresses – those earning the highest wage of £150 – is removed however, a starker wage difference becomes evident. Now the eight women's wages total just £420, with the 16 men's totalling £1060. For those performers below the top tier therefore, the gender wage gap was 21 per cent: a figure almost exactly reflected by Anne Oldfield's £80 salary which was 20 per cent lower than Thomas Doggett and Benjamin Johnson who each received £100.[37]

Clearly such figures preclude an argument for wage equality and highlight the long-held perception that the majority of actresses were underpaid and undervalued in comparison to their male colleagues. Yet the assumption that this translated into a widespread and everyday experience of disempowerment, lack of agency, or dissatisfaction, is complicated by consideration of women's working experiences in the twenty-first century. After all, not only do the performing arts continue to exhibit marked differences in the wages of men and women but, more broadly and beyond the arts sector, in 2013 the Equality and Human Rights Commission reported that the mean-based, full-time gender pay gap was 14.8 per cent for hourly, and 24.5 per cent for annual earnings (a disparity in part resulting from men tending to work longer hours and receiving more overtime).[38] To understand the effect of gendered wage discrimination on actresses' working lives in the eighteenth

century, we need only consider how the same discriminatory practices impact on women's working lives and experiences today: a comparison which might prompt us to re-evaluate the sometimes problematic, assumption that systemic inequality in remuneration translates into *individuals* being consistently disenfranchised or dissaffected.

Whilst women in the body of a theatre company were certainly discriminated against however, Vanbrugh's plan also reveals that this was not the case for all actresses, with the theatre enabling some women to exceed the limits imposed on their gender. Both Elizabeth Barry and Anne Bracegirdle, for example, were remunerated at the same level as their male peers, Robert Wilks, George Powell, and John Verbruggen, with only Thomas Betterton receiving an additional £50 for his services as actor-manager. And the same comparability is evidenced in the 1734–35 Covent Garden account books where Christina Horton, who after twenty years at Drury Lane had joined Covent Garden on 30 September that season, was the highest paid performer below John Rich, whose salary for acting is impossible to establish as his emoluments also reflected his managerial responsibilities.[39] Contracted at £250 for the season, Horton easily surpassed the wages of [Samuel?] Stephens at £200, and John Hippisley, popular for portraying fools and scoundrels, at £180.

This shift to recognising and rewarding top-tier actresses irrespective of their gender, was repeated throughout the century. In 1747–8 Susannah Cibber entered into a contract with the managers of Drury Lane which gave her £315 a year, a salary second only to Garrick's, whose 500 guineas also reflected his managerial responsibilities.[40] Almost forty years later Dora Jordan won the highest salary within Tate Wilkinson's touring Yorkshire company, earning £1. 11s. 6d. per week following her first appearance in *The Fair Penitent*.[41] Towards the end of her career Jordan continued to achieve the top wages, settling at Covent Garden, in the season of 1812–1813, for an unprecedented £50 a night for an agreed 30-night season.[42] It was a salary which gave her a phenomenal £1500 for the equivalent of one month's work. As she wrote to her son George, 'there never was such terms given for so many nights'.[43] Even her long-time rival Sarah Siddons who had retired on 29 June 1812 had never achieved such terms.

It is clear that there was a marked shift in how actresses' work was valued between the middle and upper tiers of the theatre hierarchy. Whereas women in the lower and middle ranks were remunerated on the basis of their theatrical offering *and* their gender, the earning power of women like Barry, Bracegirdle, Porter, Cibber, Woffington, Jordan,

Siddons, and others, was solely conscribed by the value of their theatrical offering in commercial exchange. Recognition of the theatre as perhaps the only industry in which women had the potential to equal and even exceed the earning power of their male peers is not, of course, new. Felicity Nussbaum and Edward Langhans have highlighted the ways in which actresses could compete economically with actors at the top tiers of the industry.[44] Yet left unexamined is what happened between the middle and upper tiers of the theatrical hierarchy to make this shift to wage equality possible.

The answer is that these women at the top levels of the theatrical hierarchy, and receiving the highest remuneration, had created what Arjun Appadurai calls a 'singular' commodity. Appadurai argues that there are two types of commodities (commodities, he defines as anything which is exchangeable in a market), singular and homogenous, and he uses these terms to:

> discriminate between commodities whose candidacy for the commodity state is precisely a matter of their class characteristics (a perfectly standardized steel bar, indistinguishable in practical terms from any other steel bar) and those whose candidacy is precisely their uniqueness within some class (a Manet rather than a Picasso; one Manet rather than another).[45]

While we must be wary of pushing the analogy too far, thinking of actresses in these terms can be helpful in understanding how top-tier actresses were able to achieve such high wages irrespective of their gender. Actresses in the lower and middle tiers were homogenous commodities and, although they were not entirely indistinguishable in the manner of Appadurai's steel bar, they had qualities which were largely interchangeable. It was a situation Colley Cibber recognised when he reflected on his position as a young actor. In his detailed account of the actors' rebellion from Christopher Rich's management of the United Company in 1694–95, Cibber evocatively describes his youthful self as having been, 'like cattle in a market, to be sold to the first bidder' and concludes that the Patentees only 'condescended to purchase' him since they were 'seeming in the greater Distress for Actors'.[46] It was, he notes, 'without any farther Merit, than that of being a scarce Commodity' that he was 'advanc'd to thirty Shillings a Week'.[47] Depicting himself as a homogenous commodity, Cibber makes it clear that the value which managers would pay for such interchangeable offerings was determined primarily by the market's level of saturation.

A singular commodity however, was independent of such market factors. As Michael Quinn has pointed out in his study of celebrity (a theme which although not explicitly examined in my own study is implicit throughout):

> Celebrity threatens to subvert [. . .] the arrangement of relative values [. . .] by introducing the actors as a singular quantity rather than a supply. The celebrity, as an absolutely reducible and apparently authentic being, can demand a high price for individuality.[48]

It was a disruption recognised in the eighteenth century. As Adam Smith reflected, 'the exorbitant rewards of players, opera-singers, opera-dancers, &c. are founded upon [. . .] the rarity and beauty of the talents'.[49] A rare theatrical commodity – a singular commodity in other words – was valued in the market in its own right, according to how much it would bring a manager, and more importantly, independently of the performer's gender.

An incident at Drury Lane at the end of the century reveals the irrelevance of a top-tier actress' gender to her power in the theatrical marketplace. In April 1796 both Dora Jordan and John Philip Kemble determined upon *Hamlet* for their benefits and, being unable to agree on who should be allowed to perform the play, they were forced to turn to Kemble's co-manager, Thomas Brinsley Sheridan, to arbitrate. Kemble might reasonably have expected the support of Sheridan. He was, however, disappointed. Recognising Jordan's greater audience appeal but unable to turn against his business partner, Sheridan determined to resolve the dilemma by banning either performer from performing the play. Consequentially Jordan took to the boards in *Romeo and Juliet*, whilst Kemble performed *Coriolanus* on 18 April before pointedly resigning and leaving for Ireland on 15 May.[50] After the widespread contempt and ridicule which accompanied Kemble's staging of the 'lost' Shakespearean history play, *Vortigern*, on 2 April 1796, Sheridan's refusal to let him play *Hamlet* was the last straw. Yet, as a letter by 'MISO PUFF', printed in Jordan's 1832 biography noted in relation to the 'procrasinated warfare' that existed between Kemble and Jordan:

> Kemble can never stand in the first rank of favourites till he evinces greater abilities, and less self-conceit. Before that period arrives, he will certainly meet with mortifications whenever he contends with a performer of Mrs Jordan's merit, who is singularly capable of supporting the interest of a theatre, as he has himself most injudiciously

proved by placing her perpetually in situations where all around her were drawbacks, instead of assistants. If any dispute between actors be brought before the public, their motto must of course be: '*Spectemur agendo*' – 'Let our performances be the test'.[51]

Jordan was not alone in being valued higher than a male peer on the basis of her audience appeal. Fifty years earlier, in 1744, Susannah Cibber's refusal to perform on the same stage as her estranged husband, Theophilus, resulted in his attempts to get an engagement being roundly ignored: the manager's decision being based on the fact, as 'Mr Neither-Side' noted in *The Impartial Examen*, that 'Mrs Cibber being something more *Novelle* than her husband, would bring [. . .] the most money'.[52]

Of course gender was not entirely irrelevant to these women's high wages; the creation of their singular commodities was achieved through their careful and sophisticated performances of gender identities. It was, as the following chapters explore, through 'playing women' in their various forms, that women like Oldfield, Porter, Woffington, Jordan, and Siddons achieved professional success and were able to create theatrical commodities, the value of which transcended their gender as traders of that product. Paradoxically, it was through embracing femininity in their performances, and creating a fundamentally gendered commodity, that these women were able to achieve remunerative rewards which were independent of their own gender.

Valuable parts

As the vehicles through which actresses engaged with, and portrayed, models of femininity, dramatic roles were central to the successful creation of a unique theatrical commodity. Moreover, since it was theatrical practice throughout the century for a performer to 'own' their roles, a convention which gave a performer a monopoly over that role for as long as they were with the company, success relied on actresses not only securing what they considered the best roles, but also, and particularly by the end of the century as we see in Chapter 4, it also relied on them taking on roles which complemented each other, in order to create and maintain a specific, consistent, image.

The value of a role to an actress is nowhere better seen than in Tate Wilkinson's description of the competition between the young Dora Jordan and Henrietta Smith, when both worked in his touring company in Yorkshire in the early 1780s.[53] After joining Wilkinson's company in 1779, Smith had established herself as a favourite of audiences and the

principle first actress of the company. A few years later however, in July 1782, Dora Jordan joined the company and was immediately a great success, with Wilkinson giving her 'the first terms' (2:141). It was unfortunate timing for Smith, who was pregnant and looking ahead to her confinement and lying-in. Even a short absence from the stage could result in the loss of roles and, with Wilkinson being a great supporter of his new actress, Smith grew concerned that she would lose her roles to Jordan once she was indisposed. By September, Wilkinson records, her concern was so great that she assured him that, 'she would wield her pike, and be on duty for three months longer' (2:171). Unfortunately however, only a few days later she fell ill and was forced, as Wilkinson termed it 'to lay down her arms and be stript of all her accoutrements' (2:171–2). The consequence was exactly what Smith had feared: her place being 'supplied for some time by Mrs Jordan, who was as happy as the other was unhappy; for she figured away in Emmeline, Lady Racket, Lady Bell, Lady Teazle, Lady Alton, Indiana, &c. the termed property of Mrs Smith' (2:172). Not unsurprisingly Smith was anxious to reclaim her roles and limit the damage to her theatrical status. She therefore determined to return to the stage as soon as possible and after only a short period of lying in – Wilkinson tells us that she was confined on 2 October – she began walking in a damp garden in order to get her strength up to make the eighteen-mile journey from Doncaster to Sheffield which was to take place on 13 October (2:172). 'So eager was she to be on the boards' Wilkinson notes, and so anxious was she that Jordan would not perform in her place, 'that act she would, and act she did', despite making herself lame through her exertions and limping and hopping throughout the performance (2:173). Unfortunately the consequence was that Smith was unable to perform again until 18 December. It was probably during this period (although it is unclear, as Wilkinson mixes his dates up) that Smith began working to turn audience opinion against her usurper, cultivating what Wilkinson describes as a 'scandal club' (2:149) and spreading rumours about Jordan's morality using, as grounds, the unmarried actress's own absence from the stage to give birth to her first child at some point between early November and 26 December.[54] Describing Jordan in 'colours not fit for description' (2:149), Smith's clique were temporarily successful in its aims and, as a result of its insinuations, Jordan's reception cooled notably, albeit only for a short period.

In most narratives this incident has been viewed simply as an example of 'cat fighting', jealousy, and bickering.[55] Yet it reveals the significant value which roles held for a performer, and the lengths they would

go to in order to hold onto this theatrical 'property': a term used by George Anne Bellamy who describes roles as being 'considered as much the *property* of performers, as their weekly salary'.[56] Henrietta Smith was not simply jealous of this new, younger actress who threatened to take her place; she was a commercial trader whose position in the market and stock-in-trade was being threatened and who, in order to survive, needed to devalue her competitor.

Henrietta Smith was not the only actress who fought hard to retain her roles: throughout the century there are examples of women at all levels of the theatrical hierarchy fighting to retain the parts they felt they were entitled to, and which were a central part of the commodity they were working to create. One of the most famous examples, and one which explicitly shows both the importance of roles, and the strategic way in which actresses managed their commodities, is that of the 'Polly War'. In November 1736, Theophilus Cibber, actor-manager of Drury Lane, attempted to take the role of Polly in *The Beggar's Opera* from its 'owner' Kitty Clive, to give to his wife of two years, Susannah Cibber, in the hope that her success in the role would recoup some of his debts. Clive however, reacted forcefully, refusing to give up her role. And when Theophilus attempted to use the public against her by turning to the papers, she responded with a carefully-worded open letter. 'If Mr Fleetwood [Theophilus' co-manager at Drury Lane] thinks fit to new-cast the Beggar's Opera, to give Polly from me to Mrs Cibber, and force me into that of Lucy, or make us alternately play them', wrote Clive, 'I cannot, without incurring the Penalty of my Articles, refuse to *acquiesce*'.[57] It was a sophisticated strategy. Emphasising that she was unable to go against management without suffering financially, Clive presented herself as a victim of the already unpopular Theophilus. Her strategy reaped dividends, and on 31 December 1736 Fleetwood staged *The Beggar's Opera* with Clive as Polly and Hannah Pritchard as Lucy. By engaging in a carefully calculated public fight, and by cultivating public support, Kitty Clive ultimately retained ownership of her role. And it was an achievement which highlighted both her professional agency and the greater value of her commodity for Fleetwood.

Nine months later, a similar event reveals that even if Theophilus had not learned from the Polly War, his wife, Susannah, had. Having been a passive figure during the Polly War, now when Theophilus tried to give her Ophelia, which was Clive's role, Susannah enacted the only power she had and, despite being fined five pounds, she refused to act. Whilst Susannah's marriage to a theatre manager had severely limited her professional autonomy and agency over her commodity, she was

still in the unique position, as all performers were, of embodying her commodity, and as such was able to withdraw it from circulation.[58] On some occasions, as she clearly recognised in 1737, refusing to perform a role was as important as taking one on. She was not the only actress to refuse a role in order to protect her theatrical commodity: in the 1790s Dora Jordan rowed with Sheridan over her refusal to play parts which she felt did not reflect her status within, and value to the company, while David Garrick, who as an actor-manager was responsible for selecting plays, even rejected whole plays if he felt that the female lead was stronger than the male and would overshadow his performance.[59] The 'true secret of Garrick's *coldness* to *Douglas*, *Cleone* and the *Orphan of China*', as James Boaden records, 'was that in them the female interest predominated – Mrs Cibber would have overwhelmed him'.[60] As a result, when new pieces were presented to him, Garrick:

> looked rather anxiously to the comparative *value* of the male and female characters; and as it was by no means favourable to a tragedy to be performed without Mr Garrick, so he might deem it equally below the public expectation and his own consequence, for him to accept a character inferior even to *one* other in the play.[61]

Roles were the primary means by which performers were able to create a valuable theatrical offering: the raw goods on which they built their singular commodity. And as Garrick clearly realised, maintaining the high value of his commodity and his status at the very top of the theatrical hierarchy relied on his always owning the most valuable of these goods.

For actresses who were already established within the industry, one of the best means of getting such valuable roles was to develop a mutually-beneficial relationship with a writer who would create the roles specifically for them. Not only did this enable an actress to bypass any competition over a role but it also gave her a role tailored specifically to her. The gains however, were not only on the actress's part. Writing for celebrated actresses also provided playwrights with a greater chance of success and a sought-after third night on which they would receive all the profits. For many, these mutually-beneficial relationships began with a prologue or epilogue. Following Anne Oldfield's performance of Aurelia in Susanna Centlivre's first play, *The Perjur'd Husband* (1700), the playwright wrote a number of further roles specifically for the actress.[62] Dora Jordan was similarly supported by Elizabeth Inchbald, who wrote the role of Lady Contest in *The Wedding Day* (first performed, November 1794) specifically for the actress. Some actresses even wrote plays and

roles for themselves: taking into their own hands every aspect of their commodity's construction. Kitty Clive was probably the most success-ful in this strategy. In her 1750 comedy, *The Rehearsal* (published 1753), Clive not only created a multilayered and highly successful new role for herself but, by appropriating the familiar rehearsal play format, she also made herself the central focus of the play.[63] Playing Mrs Hazard, a lady whose first play is about to be performed at Drury Lane by, amongst others, 'Kitty Clive', Clive dominates the play, not only in her physical presence and performance as Mrs Hazard, but also through the 'fic-tional' Clive's tangible absence throughout the play: an absence which allows her to become the subject of light-hearted satire and ridicule. Mocked for refusing Hazard's instruction, for rejecting the role selected for her, and finally for failing to turn up for rehearsals (she goes instead to see some ladies about her benefit) these jibes superficially seem to undermine Clive, portraying her as arrogant and supercilious. Yet they actually worked to the opposite effect. When Hazard protests that Clive is, 'so conceited, and insolent, that she won't let me teach it her' (15), and complains that Clive refused to take the part of the mad woman unless she could see the whole piece and select the role which she could act best (15–16), it is not the actress who is the butt of the joke but rather the conceited amateur who thinks she knows more than the pro-fessional. In this short but sophisticated comedy, Clive used self-satire not only to enhance her theatrical value and cultivate her celebrity status, but also to counter familiar criticisms and to highlight to the audience the importance of an actress' ability to control both which roles she played, and how.

Considered as the product of an astute and ambitious actress, *The Rehearsal* provides an insight into the constraints women like Clive worked under, and in particular the extent to which an actress' abil-ity to control her commodity through her choice of roles was always limited by the manager she worked for. When Hazard is informed that 'Clive' will refuse to play unless she can select her own role, as she has, 'been a great Sufferer already, by the Manager's not doing Justice to my Genius' (16) Hazard's response is direct. 'Do you think I wou'd venture to expostulate with her?' she asks Witling, 'No, I desir'd Mr *Garrick* wou'd take her in hand; so he order'd her the Part of the Mad-woman directly' (16). Ultimately, a manager always controlled the distribution of roles. And whilst, as we have seen, actresses could refuse to play a part, such action impacted as much on their own earnings, as it did on the manager. To truly control the roles they played, actresses had to find ways of wresting managerial control over their theatrical commodity.

Managing success

On a number of occasions during the eighteenth century, top-tier actresses attempted to break into theatre management and thereby achieve professional and economic autonomy. Other than Elizabeth Barry and Anne Bracegirdle however, who along with Thomas Betterton, managed the Lincoln's Inn Fields company in 1695, they were overwhelmingly unsuccessful.[64] When Anne Oldfield sought to join Thomas Dogget, Colley Cibber, and Robert Wilks in managing Drury Lane in 1711, her involvement was vetoed by Dogget. And over thirty years later, Susannah Cibber was similarly unsuccessful when she attempted to become Garrick's co-manager at Drury Lane. Whilst women managed strolling theatre companies in the regions, and fair booths in the capital, when it came to management of London's patent theatres, being a woman remained a liability. 'Our affairs could never be upon a secure foundation', argued Dogget on vetoing Oldfield's management of Drury Lane, 'if there was more than one sex admitted to the management of them': his comment speaking as much to a wider concern over women's lack of commerciality, as to the risk that Oldfield's sex might influence her ability to do the job, or cause disagreement amongst the male managers.[65] For Garrick however, there was a very clear reason why Susannah Cibber would make an unsuitable manager. 'How can she be a joint patentee?' he wrote to his adviser, Somerset Draper, 'her husband will interfere, or somebody must act for her, which would be equally disagreeable'.[66] With a woman's legal and commercial agency being restricted by her status, or potential status, as a *feme covert*, joining with an actress in management was a risky move.

Oldfield and Cibber's attempts were not entirely fruitless however. Soon after their respective rejections, both women negotiated contracts which gave them some of the professional benefits and financial rewards which had motivated their managerial ambitions. Oldfield was given carte blanche over the terms of her employment, and was not hesitant to take advantage of the offer, promptly negotiating an agreement almost identical to that of a manager: an annual salary of £200, which was later advanced to 300 guineas, and a clear benefit, which often brought twice her annual salary.[67] In negotiating her contract with Garrick, after he became manager of Drury Lane in April 1747, Susannah Cibber won equally impressive terms. On top of negotiating an annual salary of £350, second only to Garrick, and ensuring that the cost of her dresser, stage wardrobe, lace and jewels (all of which were a great expense for a female performer) would be paid for by the company, she got the right to the first benefit after Garrick, free of charges.

Since they operated at a loss for the theatre (with all takings going to the performer and none to the theatre), the clear benefits which Oldfield and Cibber negotiated were incredibly rare and as such were only given to the most valuable performers. Standard practice was for performers to take the net profit after paying a house charge for the use of the theatre, although in some cases a 'guaranteed' benefit was agreed, ensuring that if the net profit (after the house charge) failed to reach an agreed level the managers would make it up to that amount. In 1748 Susannah Cibber's clear benefit risked being so incendiary that she actually had to keep it a secret from the rest of the company: the prompter recording a fake charge of £60 so that, 'the principle treasurer should not know to the contrary, because it was told him that Mrs Cibber paid for her benefit, and if he had imagin'd otherwise, he perhaps would have insisted upon the same terms for his wife [Hannah Pritchard]'.[68]

Cibber's contract with Garrick at Drury Lane however, also had an additional and unique clause written into it. More than simply demanding the financial rewards that management would have brought her, Cibber demanded the right to read all new plays and claim any female role she wanted. It gave her exactly what many top-tier actresses sought: the opportunity to have almost full control over which roles she would perform. And the fact that she won this right reveals the determination with which she approached her business. Garrick's comment on hearing of her death in January 1766 gives us some sense of the hard-nosed and canny negotiations that Cibber engaged in to achieve this level of commercial autonomy. 'She was the greatest female plague belonging to my house', he said:

> I could easily parry the artless thrusts, and despite the coarse language of some of my other heroines; but whatever was Cibber's object, a new part or a new dress, she was always sure to carry her point by the acuteness of her invective, and the steadiness of her perseverance.[69]

For most actresses, of course, the only time when they could experience the level of quasi-mangerial control over roles achieved by Cibber was on their benefit night. As Boaden commented in his biography of Jordan, an actress's benefit play was not only an opportunity to put 'the town in possession of her own opinion of herself', but also to extend her claims, to 'invade the line of a rival', or to 'correct the, perhaps, obstinate prejudice of a manager'.[70] On this one night, by choosing which role to perform irrespective of 'ownership', by selecting who

would perform alongside her, and by marketing the performance and selling the tickets (often from their homes as well as the box office), actresses gained full control over the creation and sale of their theatrical commodity.

The financial returns of a benefit could be significant. Until the middle of the century this one night could potentially double a performer's annual income and, as such, as Milhous and Hume note, it was a major source of income at both the higher and lower ranges of the theatrical hierarchy.[71] Even at the end of the century a benefit could bring a significant boost to a performer's annual wage. In her first London season, after working in both Bristol and Edinburgh, the mid-tier actress Elizabeth Hartley made a profit of £180 2s 6d on 22 March 1773.[72] Dora Jordan's first benefit, at Drury Lane in 1786, was rumoured to have brought her £500, £300 of which supposedly came as a gift inside a purse presented by members of Brooks's, the Whig club in St James, and to which Richard Brinsley Sheridan, Charles James Fox and the Prince of Wales had all contributed.[73] Sarah Siddons's first London benefit however, given shortly after she debuted at Drury Lane in 1782, brought an even greater return, totalling £830.[74] And as the *Public Advertiser* noted on 31 March 1783, her second benefit that season (which we can presume was her annual benefit) was 'a pretty good Counterpart to her Benefit the first – 650l. – of which Lady Spencer gave 90 Guineas for her Side Box – and Lady Aylesbury a Bank note of 50l. for an Upper Box!'[75]

Positioning was key to the profitability of a benefit. With affluent Londoners departing for the country in late spring, and the benefit season (mid-March to late May) being increasingly saturated as it wore on, an early benefit was invariably more profitable. Anne Oldfield was just one actress who recognised the importance of a well-timed benefit. On 21 April 1709 she signed a contract with Owen Swiney which included a clause stating that, she 'shall have a play given out and acted for her benefit in the month of February in every year during the said term of thirteen years'.[76] And in 1720 she went so far as to get an order from the Lord Chamberlain instructing management that 'no benefit might be allowed for the future to any actor before Mrs Oldfield and Mrs Porter's benefit night'.[77]

For much of the century the benefit night was the only occasion on which actresses could take full control of the sale of her theatrical wares, however as the country and the theatre industry both developed in the latter years of the century, new markets opened up, and with them new opportunities for professional autonomy. At the end of the century the development of a transport network was rapidly shrinking

the British Isles and linking together the already well-established tour-
ing circuits and growing number of Theatre Royals, which spread from
Exeter in South-West England to Edinburgh in Scotland. Actresses like
Sarah Siddons and Dora Jordan, who had both begun their careers on
these touring circuits, were quick to recognise the potential of these
secondary markets as a source of income during the summer months,
when the London theatres were dark and both were frequently to be
found performing in the regions: from Margate and Canterbury in the
south east, to Exeter in the south west, up to York and Edinburgh in
the north, and across the Irish sea to Dublin, they traversed the British
Isles at the turn of the century. 'I fly from one employment to another'
Jordan wrote to William on 19 April 1809, in one of the many letters
she wrote home whilst on tour 'and endeavour to create business till
I am really stupid'.[78]

Jordan's description of herself as 'making business' is particularly rel-
evant; working in the regions actresses had control over their business
to a far greater extent than when they worked in London. Being able
to negotiate where and what they would perform, when, and for how
much, going on tour gave them extensive control over the management
and sale of their theatrical commodities and this, in conjunction with
the fact that, as Arjun Appadurai argues, commodities which travel
greater distances, are often subject to an intensification of demand,
meant that they often made a greater profit whilst on tour than for their
performances in London.[79] This intensification of demand is more than
evident in Jordan's letters. When performing in Dublin in 1809 she
reported having to wear a veil to hide her face, whilst three years later
she wrote from Exeter, 'the audience here are quite *crazy* about me – and
with regard to emoluments I shall do very *well*'.[80] The financial returns
of such enhanced demand were certainly significant. In the summer of
1777, the experienced actress Ann Barry who had made her debut in
York in 1752 and subsequently worked Crow Street, the King's Theatre,
the Haymarket, and Drury Lane, cleared upwards of £1100 during her
regular summer season in Dublin, on top of her salary of £370 for per-
forming at Covent Garden.[81] Sarah Siddons made a similar amount,
earning just over £1000, when she sailed across the Irish sea to perform
in Dublin after her first season in London in 1782, whilst when Dora
Jordan travelled north to perform at Edinburgh and Glasgow after her
own first season at Drury Lane, she earned £50 a week, as well as being
offered £20 a night for three extra nights at one theatre.[82] The ability to
set their own terms at each theatre they visited meant that actresses like
Jordan and Siddons could negotiate exceptional rates, often far greater

than those available to them in London. As such they could make more money in less time. As Jordan wrote to William on 30 April 1809, 'I have it in my power to make more money in four months, than I should in as many years, were I to again engage in London'.[83]

The professional autonomy available through touring was certainly profitable. However it was also extremely hard work and Jordan's letters reveal the constant negotiations with managers and the strategising which ensured her profitability. Writing home from Worcester in February 1811 she reported with satisfaction that she had 'heard again by express from Watson', the manager of a circuit of more than 40 theatres across the south-west and the Midlands, including Cheltenham, Coventry and Birmingham, and complained:

> This man is forty thousand pounds [. . .] and still anxious to make a few pounds, but he declares it is to oblige the inhabitants, and yet he haggled with me for £50, but I held out and he was obliged to give it [. . .] I shall have made £1007. This is certainly a large sum but I can assure you I have worked very hard for it.[84]

As Jordan reveals, ensuring a net profit at the end of the day demanded careful negotiations and haggling for the highest rates. However it also demanded careful financial management. The costs of touring could be significant, and travel, accommodation, and living were all a constant drain on funds. Over three weeks in Edinburgh in 1810 Jordan paid a total of £75 on living and lodgings alone, which worked out as 17 per cent of her gross profit of £440.[85] 'The journey and living has been very expensive' Jordan reflected in writing to William from Bath on 1 May 1809 'but we cannot have all profit'.[86]

Having to balance expenses against projected income was made all the harder by the fact that actresses were often unaware of how much an engagement would bring until they had begun performing. Rather than working for a set wage many actresses played on shares: a profit-sharing agreement between a performer and the theatre's manager. It was a deal which had the potential to bring a greater return – in Manchester in January 1810, Jordan's arrangement brought her £70 for one night out of a house receipt of £200 – but which was also much riskier.[87] With managers, on occasion, misleading her as to the size and profitability of their houses in order to reduce their own costs, Jordan certainly found that playing on shares could be frustrating, as she revealed in a letter to William from a disappointingly empty Edinburgh in June 1810. 'This disagreeable and unprofitable engagement is, thank

God, drawing to a conclusion', she wrote, lamenting that the lack of audiences had made the difference of £400 to her. And being asked to play on shares, she continued:

> Was a proof that he knew he [Henry Siddons, the manager of the theatre and Sarah Siddons's son] was deceiving me. It is now too late to rectify it, and fruitless to complain, but it is really hard, as I have scarcely strength or spirits to go through it even had it proved what I was taught to expect.[88]

The result of the manager's deception, she concluded a week later, was that she 'would not have made more than £500 and Mr Siddons £1000'.[89] In fact, she found out on 23 June that she had only made £440.[90] It was not always the case that managers were deliberately duplicitous. On another occasion, in Dublin 1809, it was the manager's incompetence which impacted on Jordan's earnings. 'Poor Atkinson' the manager of the Crow Street Theatre, 'is full of blunders', she wrote home 'the house when as full as possible, will not hold 500, he said 600'.[91] Two days later she added 'I find that 200 is what is thought here a wonderful stock night [. . .] this is certainly a disappointment, as far as money is concerned'.[92] As such instances reveal, whilst actresses could manage their business far better than when contracted in London, working hard to ensure low costs and the highest percentage profit did not always guarantee a strong return and control over their earnings was not entirely in their own hands; unscrupulous or inept managers were a constant frustration.

Whilst agreements with regional managers might not always be as profitable as actresses would have liked, the opportunity to make large amounts of money through quasi-managerial activities was just one of the benefits which the growing regional market for London performers brought. It also broke up the monopoly of the London theatres; gave performers a competitive market edge in negotiations with the London theatres; and perhaps most importantly, provided a viable alternative when such bargaining broke down. For many years however, until well into the second half of the century when the first provincial Theatre Royals began to be licensed (Bath and Norwich in 1768, York in 1769, and Bristol in 1778), the only mainstream alternative to working at Drury Lane and Covent Garden (excepting the Haymarket's summer season) was to turn to Ireland. Frances Abington was just one performer who made this move, taking herself to Dublin in October 1759, following a disagreement with Drury Lane's management, and performing at

Smock Alley and subsequently Crow Street where she was a great suc-
cess. Peg Woffington and Jane Pope also looked to Ireland when unable
to agree terms in London. In June 1775, when Garrick refused to agree
to her demand for £10 a week (instead of her current £8) Jane Pope, who
had been an established member of the Drury Lane company since 1759,
determined to 'perform only with those that pay the best' and (after a
failed attempt to negotiate with Covent Garden) left for Ireland.[93] It
was a risky strategy however, as she found when her attempt to return
to Drury Lane on her old terms in September was refused on the basis
that her former parts had been shared out amongst the company. Peg
Woffington also moved to Ireland when the London theatres failed to
match her expectations. Spending three years working in Dublin, after
she became dissatisfied with Covent Garden in 1751, she received the
pick of roles denied her in London, as well as an annual wage of £400
for her first season, and £800 for the next. And for Woffington, unlike
Pope who returned to London in October 1776 on her old salary of £8
per week, the market also worked in reverse. Unable to convince Smock
Alley's manager, Benjamin Victor, to renew her contract at the same rate
in 1754, Woffington was able to maintain her £800 salary by returning
to Covent Garden.

The Dublin theatres were certainly a viable alternative for many
performers turning away from London, but for those women who
were unable or unwilling to uproot themselves, and often their fami-
lies, to live in Ireland whether on a short or longer term basis, there
were few options available in negotiations with management. Often
their only bargaining power, in fact, was to remove their commodity
from circulation, as Susannah Cibber did when James Lacy, manager
of Drury Lane, attempted to deal with the theatre's financial troubles
by cutting performers' wages in 1745–6. Cibber's frustration with her
lack of bargaining power is tangible in the letters she wrote to David
Garrick at the time, as well in her semi-facetious suggestion to him that
they join together in 'setting up a strolling company' in order to show
Lacy that 'we could get our bread without him'.[94] In the middle years
of the century the lack of a mainstream and, prior to the patents given
to provincial theatres in the 1760s, legitimate regional theatre circuit,
limited Cibber's options. In her comments to Garrick however, she
anticipated exactly what such theatres would bring: a viable alternative
to use in negotiations with intractable London managers. Finding her-
self in a similar position to Cibber half a century earlier, in 1812 Dora
Jordan therefore had a very different outlook. Whilst in negotiations
with Drury Lane's management over the terms upon which she would

appear at the newly re-opened theatre Jordan wrote to her son, George, that she certainly hoped to 'be in London the end of this month', adding however that she was glad to hear that 'the houses at Drury Lane have not been great [. . .] and sincerely hope they will continue so till I have made my bargain'.[95] As she pointed out at the start of the letter however, contracting to Drury Lane was not the only option available to her. 'If I do not play soon at Drury' she explained to her son 'I shall go from London to Portsmouth where I have had a great <u>offer</u>.' As one newspaper reported condescendingly, 'the lady finds she can employ herself better in a provincial ramble, than even at a brilliant theatre in the metropolis'.[96] Although performing in what were often small regional theatres (Jordan wrote in April 1809 that the Bristol theatre could not have held more than 160 people) might not compare to performing in the newly redeveloped, leading theatre of the country, it was often at least as, if not more, profitable, and as her letters reveal it was this, rather than prestige, that Jordan sought.[97] As she wrote to George in 1813, Drury Lane were 'so shabby in their offers [. . .] that as I can make more in the country I am resolved to reject them'.[98] Providing an alternative source of income, regional playhouses gave London actresses like Jordan excellent grounds for negotiations, as well as an alternative source of income should London theatres fail to fulfil their demands.

Throughout her career, Jordan was largely successful in her wage negotiations. With determination and a pragmatic approach, she used every tactic available to her, from playing theatres off against each other – as she did when, unhappy with the Kemble 'coterie' at Drury Lane in 1788–89 she used an offer of carte blanche from Covent Garden to force Sheridan, 'alarmed at the idea of losing one of the main props of his house', to agree to her demands of £30 a week, – to refusing to play, as she frequently did when her pay was slow to materialise.[99] However there are also plenty of examples of actresses failing to come to agreements with managers: most often as a result of the mismatch between their commodity's value and the terms they demanded. When Susannah Cibber, with only a few years' experience of acting, demanded the highest wage in the Drury Lane company, she was, understandably, refused outright. As Charles Fleetwood explained in 1738, her absence from the theatre that season was, 'because we could not agree upon the terms. I would not come up to her terms' which were for 'as good a salary as any woman in the house; and the first benefit', despite the fact that he had 'got more money by Mrs Clive'.[100] Whilst in this case Cibber's demands were probably her husband's rather than her own, it reveals the risk of failing to match wage demands to an accurate

estimate of commercial value. And Susannah Cibber was not the only actress to find herself temporarily out of work as a result of overestimating her commodity's value in the market. In 1744 *The Impartial Examen* noted that Kitty Clive's current absence from the stage was because she ceased to 'be a novelty' and had 'set a greater Value on herself than she ought', demanding a salary which 'no manager was able to give'.[101] Whilst a similar point was made by Benjamin Victor in refusing to renew Woffington's £800 contract at Smock Alley in 1754: such a 'great salary cannot be given' he explained, 'even to her, the fourth season! because novelty is the very spirit and life of all public entertainments – and to succeed the scene must be changed'.[102] Just under fifty years later, in the 1782–83 season, Frances Abington's attempts to increase her wage to £1000 were also refused: 'neither manager, as James Boaden noted, considering 'her attraction at this time at all equivalent to the engagement she demanded'.[103]

Greedy consumers

Actresses were not always successful in their ambitious wage demands, however the fact that they sought them is significant in itself. In a context in which money was moving from being the medium of exchange between commodities to becoming, in itself, a sought after and traded commodity, actresses were in many ways, greedy consumers. Tate Wilkinson's light-hearted address to Jordan in his memoirs exemplifies this. 'But now, dear Mrs Jordan', he declares jovially, 'you do like the cash, and I believe and hope you take care of it; that you love to receive it I know, and so does every other manager; you *have* made us all know that: you will excuse my being jocular.'[104] Jordan was not alone, however, in her 'love' for cash, as Wilkinson puts it. In May 1786, describing Ann[e] Crawford (formerly Barry) an actress who, having made a name for herself in London over the last twenty years, was now touring the regional theatres, the manager noted, 'She loves money, and would, I am assured, have obtained a great deal more but for her plaguing herself as well as other people, and fretting and fuming at every trifle.'[105] Yet it was not only money for its own sake which these women sought. Rather, as Jordan wrote to William in October 1811, it was 'for the good and agreeable things it [money] can procure' that she worked so hard.[106] Providing for her family was clearly one of these 'good things', and from the earliest days of her theatrical life Jordan's financial independence enabled her to provide both for the current, and for the future, stability of her ever-increasing progeny. On accepting William's 'proposal' to

become his partner, Jordan transferred all her funds, as well as promising half her future income, to her sister and Richard Ford (the father of her two youngest children) for the future provision of her three children. Years later, on her daughter Fanny's twenty-first birthday she gave her and her two half-sisters by Richard Ford a home in cosmopolitan Golden Square. Yet it was not only the big purchases, but also the small ones which mattered: such as Jordan's sending 'portable soup', 'flannel and Leather for waistcoats', and 'a pair of curtains ready made up' to her son, George, whilst in the navy in 1808–9.[107] Enabling Jordan to send money back to her family, as she did in many of her letters, as well as giving her the means to provide for both the smallest and greatest needs of her children, her earnings had a value beyond the materialistic. And whilst Jordan was virtually penniless when she died – the activities of an unscrupulous son-in-law having sent her spiralling into debt in the last years of her life – the £1000 she had put into life assurance annually ensured that her children were well provided for.

Jordan was not the only actress who used her earnings to provide for her family. As well as supporting her two sons throughout her lifetime Anne Oldfield distributed the majority of her wealth to them in her will, not only leaving her house in fashionable Grosvenor Street – bought for £2000 in 1719 – to her son, Charles Churchill, but also providing her other son, Arthur Mainwaring, with the interest on £5000 until he reached 30, at which time he received the principle.[108] Similarly, Sarah Siddons used her significant wealth to support the needs of her children (and less successful husband), also justifying her economic labour on this basis, as examined in Chapter 5. And whilst Jane Pope had not accrued the wealth of Oldfield or Siddons, when she died on 30 July 1818 she left her sister Susanna £178 in annuities and £2763 at 5 per cent.[109] Providing for their families, both during their lifetimes and beyond, was, for many actresses, a motivating factor behind their professional and economic ambition. Yet at the same time their earnings – which were often far beyond the amount needed to comfortably support a middle-class family – were not entirely motivated by familial duty.

Whilst the spending of top-tier actresses is largely unrecoverable, many, as we have already seen, invested substantial amounts in residential properties: on 1 June 1708, eleven years before she bought her Grosvenor Street house, Oldfield signed a lease for a parcel of land near Covent Garden, where she built her first home; in 1755 Hannah Pritchard purchased a house on the banks of the Thames, subsequently leaving it to her three daughters in her will; and, at the end of the

century, Frances Abington bought the lease on a house at Hammersmith-hope [*sic*] near the Thames, which she later sold to Sophia Baddeley.[110] As well as often being family homes however, these properties also functioned on a number of other levels. In a context in which solid property was seen as being a literal investment in the English nation, and luxurious spending was being argued, by both Bernard Mandeville and David Hume, to have a vital role to play in increasing the nation's wealth and economic strength, investments like these contributed, both physically and metaphorically, to the growth of a commercial nation.[111] More directly however, these purchases enabled top-tier actresses to make their disposable income, and economic status, visible within wider society. Just like their seventeenth-century male predecessors, who James Forse argues located themselves in relation to the aristocracy by investing in land and property, now eighteenth-century actresses located themselves economically, if not always socially, within the new and growing middling classes through investing in fashionable London property.[112] In fact, if, as Dickson has argued, the middle-class philoso-phy was that wealth, in itself, was good and could be earned by talent and hard work, and that individuals seeking their own good would cre-ate wealth and prosperity for their country as a whole, actresses could be argued to be the quintessence of this new class.[113]

In a social context in which female earning power was largely restricted by gender, throughout the eighteenth-century women turned to the stage as one of the only fields in which they could, through their own independent labour, make not just a living, but potentially a fortune. The theatre provided women with the opportunity to exceed the earning power of many of their contemporaries, both men and women. Through their own hard work and astute business-sense, these women became the century's new entrepreneurs: individuals who, to use Lawrence Klein's definition, used integral resources such as initiative, industry, and sense, and who, being motivated by the powerful incentive of material gain, strove to make their own fortune.[114] The most successful of these 'the-atrical entrepreneurs' however, achieved their fortune not despite being women, but because of it. Transforming their gender from a liability to an asset, the actresses examined in the following chapters, engaged with con-temporary models of femininity to offer a unique and timely commen-tary on their sex, and in doing so established themselves as some of the most culturally visible, and independently wealthy women of their time.

2
Playing the Passions: 'All their Force and Judgment in perfection'

'How fierce a Fiend is Passion!' exclaims Hastings in Act II of Nicholas Rowe's 1714 she-tragedy *Jane Shore*,'with what Wildness, / What Tyrrany untam'd it reigns in Woman!'.[1] This 'Unhappy Sex!' as he calls them, have so little control that they give 'way to every Appetite alike':

> Each Gust of Inclination, uncontroul'd,
> Sweeps through their Souls, and sets 'em in an uproar;
> Each motion of their Heart rises to Fury,
> And Love in their weak Bosoms is a Rage
> As terrible as Hate, and as destructive.
> So the Wind roars o'er the wide senceless Ocean,
> And heaves the Billows of the boiling Deep;
> Alike from *North*, from *South*, from *East*, and *West*;
> With equal Force the Tempest blows by turns
> From every Corner of the Seaman's Compass

(13)

The juxtaposition of ungovernable female passion, jealousy, and desire, with male reason and rationality is a central dynamic throughout *Jane Shore*, most obviously through the pairing of Alicia and Hastings. It is Alicia's jealousy, after all, believing her lover, Hastings, to have been unfaithful with her best friend Jane Shore, which instigates the tragedy of the play. 'Ruin seize thee' Alicia rages at Hastings in Act II in a vitriolic attack which prompts his contemplation on female passions quoted above, 'and swift Perdition overtake thy Treachery' (12). Threatening that her 'feeble Hand' will 'find the Means to reach thee, / Howe'er sublime in Pow'r, and Greatness plac'd' and 'hurl thee Headlong from thy topmost Height' (12), Alicia foreshadows the play's subsequent events

in which, led by her irrational jealousy, she seeks vengeance and ulti-
mately causes not only Hastings's execution, but Jane's banishment and
death, as well as her own madness. In direct contrast to Alicia however,
Hastings is portrayed as rational, level-headed and insouciant. Simply
ignore 'that Devil, which undo's [sic] your Sex, / That cursed Curiosity'
(11), he advises the jealous Alicia. 'Needless Secrets' if neglected:

> Shall never hurt your Quiet, but once known,
> Shall sit upon your Heart, pinch it with Pain,
> And banish the sweet Sleep for ever from you.
>
> (11–12)

And whilst Alicia's jealousy might seem understandable, and Hastings's
attempts to seduce and rape Jane (with only Jane's disguised and pre-
sumed dead husband preventing him) deeply disturbing, it is ultimately
he who is given the soliloquy at the end of the scene, and the intimacy
and dialogue with the audience that this convention provides. As the
drama continues to unfold moreover, it becomes ever more apparent
that it is Hastings, not Alicia, who the audience is expected to emphasise
with. Whilst Alicia is left 'like a common Wretch, to Shame and Infamy'
(11), Hastings, on the other hand, is depicted as the ideal Englishman,
who prizes his country 'Beyond or Love's or Friendship's sacred Band'
and is willing to 'die with Pleasure for my Country's Good' (25).

On reading the play the contrast between the raging, passionate Alicia
and the calm, controlled Hastings, makes it hard to avoid the conclusion
that women's passions are an unpredictable and dangerous force. Yet the
performance of these characters by actresses in the live environment of
the early eighteenth-century theatre complicates this gendered under-
standing of the passions: at the same time as contemporary attitudes
towards women's passions are reinforced through the dramatic fiction,
they are simultaneously brought into question by the control and judge-
ment of actresses over their performing bodies. With its particular focus
on the female passions, *Jane Shore* therefore provides an ideal framework
through which to examine the way in which early eighteenth-cen-
tury actresses' performances engaged with, and challenged, prevailing
stereotypes about women's irrationality.

Irrational women

The seventeenth and early-eighteenth century was a period of flux in
scientific and philosophical thinking: ancient understandings which

had held sway for over a millennia were being overridden by, as well as absorbed into, new thinking on the body and its operation. Established Greek theories by Aristotle, Plato, and Galen were discarded, and new theories were developed by modern philosophers such as René Descartes and physicians including Marin Cureau de La Chambre and Julien Offray de la Mettrie. Yet, as Roy Porter reminds us, whilst these new approaches pronounced their modernity with the outright rejection of Aristotelianism and Galenism, in many ways they often recycled the same ideas under a new guise.[2] And nowhere is this more apparent than in the discourse around rationality and the passions.

In the Greek model, women's limited ability to control their passions (a term which could refer to emotions in the general sense, but was more often understood to refer to the raw, violent, or uncorrected emotions which were outside of the control of the 'sufferer') was understood to result from their lack of heat: the fundamental principle which perfected all animals. Not only, Galen theorised, did this deficiency prevent women's genitals (which he understood as inverted peni and scrota) from turning out from their bodies, but it also hindered women's brains from developing fully.[3]

These classical notions of the body held sway of hundreds of years. Yet even in the seventeenth century, new scientific discourses looking for new evidence to support the notion of women's irrationality often drew implicitly, if not deliberately, on the Greek model. One of the central concepts of seventeenth-century philosophy, that it was women's softer brains which caused them to be more impressionable than men, was clearly indebted to the Aristotelian idea of women's underdeveloped brains.[4] Similarly the classical relationship between women's lack of heat and their ungovernable passions could be found in the work of the French Court physician and physiognomist Marin Cureau de La Chambre, who concluded that men's heat was a principle of strength, courage, and confidence, whilst women's coldness caused their weakness, lowness of spirit, and fearfulness, from which emanated distrust, anger jealousy, weakness, fear, artifice, craft, and revengefulness.[5] Echoing the classical notion of women's inability to control the passions through reason, in his *Discourse upon the Passions in two parts* (trans 1661) La Chambre argued that women, who find 'themselves more exposed to injuries':

> are easily born away with a desire of vengeance because their weakness makes them apprehend every thing, and the subtile heat which they have is so quickly inflamed, that they have not time enough to

consider whether they are truly injured, and whether they ought to revenge themselves.[6]

It is the application of 'Reason which moves us to oppose the Passions', La Chambre explained, 'whence it is that young people and Women whose spirits by reason of their constitution are less strong, are troubled to resist their Passions'.[7] Drawing on the developmental parallel between children and women made by Greek philosophers, he therefore surmised that whilst the 'judicious and magnanimous man seldom grows angry', women's spirits which were easily agitated made them impulsive and passionate.[8] The role of women's weaker constitutions was echoed by physician George Cheyne when he reflected that men were 'stronger, but coarser, [in] both bodies and Faculties', comparing this with women's 'weaker, but more delicat [sic] and pliable Bodies and Spirits'.[9]

Even philosophers such as Descartes, whose splitting of the soul from the body was a radical reversal of the Greek notion of the holistic body and spirit, drew on Aristotle's association of the mind with the rational, and the body with the passionate, when he argued that non-intellectual passion, sense and imagination all came from the body. And whilst Descartes did not gender this division, it was soon drawn into the debate on women's passions: the split of reason/passion and mind/body being easily aligned with the well-established view of women as influenced by the body and emotion.[10]

Descartes was not alone in having his theories appropriated to justify women's irrationality. Issac Newton's *Opticks* (1704), a text which G. J. Barker-Benfield argues reverberated throughout the eighteenth century with its conception of the place of nerves in transferring the power of the will from the brain to the muscles, made no distinction between male and female nerves.[11] However it was not long before women's weaker, feminised nerves were posited as the reason for their comparative delicacy: an idea which would later be taken up in the discourse around sensibility. For Julien Offray de La Mettrie, author of *L'homme machine* (1748), there was however a clear difference between the male and female nervous system, with the delicacy of the female nervous system explaining women's temperament of 'tenderness, affection and lively feelings' since such emotions were 'based on passion rather than on reason'.[12] In theorising that there was a material difference between men's and women's nerves, with women's more liquid brains and nerves resulting in their delicate temperaments and propensity to disturbances of the passions and men's more solid brains and nerves giving them

more vigorous minds, La Mettrie, Kathleen Wellman argues, borrowed directly from the Greek notion of women's greater 'wet' humour.[13]

Overall, throughout the seventeenth and early-eighteenth century, with old and new scientific thinking interweaving, the explanation for women's irrational, passionate, and emotional qualities continued to be found in understandings of female physiognomy. Being weaker and more delicate, women were much more likely to be controlled by, rather than controlling, their bodies and its desires: passive subjects rather than active, empowered agents. It is a struggle which is vividly realised in Act II of *Jane Shore* where Alicia, transformed by her jealousy and anger, wishes she could:

> [. . .] be Mistress of my heaving Heart,
> Stifle this rising Rage, and learn from thee [Hastings]
> To dress my Face in easie dull Indifference.
>
> (10)

Echoing humoural understandings of the body, here Alicia's rage is depicted as physically rising from the depths of her body and overwhelming her heart which, in the Aristotelian model, as Noga Arikha notes, was the seat of intellect and sense.[14] And by contrasting this image of passionate femininity with Hastings' rational ability to control his physical expression and emotional responses, Rowe dramatises the common perception that women were deficient in reason and rationality: a deficiency which has fatal consequences through the rest of the play.

In his 1673 conduct book *The Ladies* [sic] *Calling*, Richard Allestree warned readers of the dangers of women's passions. A will which is 'resign'd to Reason and just Autority [sic] is a felicity all rational natures should aspire to', he advised readers:

> so especially the feminine sex, whose passions being naturally the more impetuous, ought to be the more strictly guarded and kept under the severe discipline of Reason; for where 'tis otherwise, where a Woman has no Guide but her Will, and her Will is nothing but her Humour, the event is sure to be fatal to herself, and often to others also.[15]

Posing a danger not only to herself but also to those around her, and thereby to society, the passionate woman was a very real threat. It is a danger exemplified in *Jane Shore*. Jane's downfall, which takes place prior to the start of the play, is explicitly stated to be the consequence of her uncontrolled passions, which led her to commit adultery with King

Edward IV. She is, as she says herself, 'Sense and Nature's easy Fool' (9), having given in to Edward's 'fatal love' (7). Now at the start of the play however, with Edward dead, Gloucester installed as Lord Protector, and the two princes in the Tower of London, Jane is suffering the consequences of her ungovernable passions. Stripped of her land and without a protector she is filled with grief and anguish at her actions. And whilst over the course of the play the audience watch Jane reprieve herself through her virtue (a trait which was understood as being the result of reason and judgement), this is paralleled by the fall of Alicia who in her jealousy embodies the dangers of being, as Christian writer John Norris put it in 1710, 'bribed and corrupted' by passion.[16]

Alicia is not an intrinsically bad character, rather she is a woman overwhelmed by, and suffering as a result of, her passions. Whilst prior to first meeting Hastings she had been full of 'the Peace of Innocence, and Pride of Virtue' (11) now, overtaken by her love, she is prone, as Hastings exclaims, to 'endless Quarrels, Discontents and Jealousies':

> These never-ceasing Wailings and Complainings,
> These furious Starts, these Whirlwinds of the Soul,
> Which every other Moment rise to Madness.
>
> (11)

Throughout the play Alicia is the embodiment of what Chris Shilling describes as the early eighteenth-century stereotype of the uncivilised body as giving 'immediate physical expression to emotions' and satisfying 'bodily desire without restraint or regard for the welfare of others'.[17] She loves Hastings, as she says, 'Beyond my Peace, my Reason, Fame and Life' (43) and overwrought by her jealousy of Hastings' desire for Jane, turns her back on the friend she had earlier called her 'other self' (8) and promised to hold 'nearer to my Soul, / than ev'ry other Joy the World can give' (8). Seeking revenge, Alicia therefore determines to inflame Gloucester's fear of Hastings's disloyalty by swapping Jane's petition to the Lord Protector for a letter identifying Jane as the reason for this disloyalty. Jealousy, 'worst Invader of our tender Bosoms' (19) as Alicia describes it, has overwhelmed and transformed her nature. Her very eyes, as she reveals, are 'chang'd' (19) so much by this overriding passion that they now 'Loath that known Face [Jane's], and sicken to behold' the woman who was 'Once my Heart's dearest Blessing' (19). Fuelled, as she declares, by 'Love and Vengeance' (20) Alicia fails to consider the potential outcomes of her treachery and puts Hastings in a position where he is forced to reveal his ultimate loyalty to the

imprisoned prince as the rightful king and is consequently sentenced to death.

In the final scene between Gloucester and Alicia we get the strongest picture of how the passions ravage an uncontrolled female body. Forcing her way through the guards escorting Hastings to the gallows, Alicia, as Hastings describes her, is the very embodiment of 'frantick grief', and 'conflicting Passions' (41), with her broken, contradictory, and rapid speech revealing the irrationality of her thought. 'Thy Reason is grown wild', Hastings exclaims in disbelief on hearing Alicia's distraught revelation that she had caused his death, 'Could thy weak Hand / Bring on this mighty Ruin?' (41). The response Alicia gives is a stark warning against the dangers of female passions. 'Thy cruel Scorn had stung me to the Heart / And set my burning Bosom all in Flames' (41) she tells Hastings, revealing the power of jealousy in her weak female body. Hastings's response typifies contemporary attitudes to this passion. 'Blindfold it runs to undistinguish'd Mischief' (42) he curses, emphasising the mindless nature of the passions. 'Fiercer than Famine, War, or spotted Pestilence; / Baneful as Death, and Horrible as Hell' (42), when loosed in the female body jealousy is the most dangerous of the passions.

Alicia's ungoverned passions see not only the undoing of Hastings however, but also of herself: ultimately resulting in her madness. As Hastings warns her when she rages against Gloucester in Act IV:

> this rage that tears thy Bosom,
> Like a poor Bird that flutters in its Cage,
> Thou beat'st thy self to Death.

> (44)

Whilst Alicia's death does not come within the bounds of the play, our final image of her, mad and raving in Act V, leaves us in no doubt over her ultimate fate. Living in misery where 'Grim Spectres sweep along the horrid Gloom, / And nought is heard but Wailing's and Lamentings' (51), Alicia is plagued by delusions: experiencing what was, at the time, understood to be a common consequence of unmanaged passions. As Baltasar Gracián warned in 1705, 'Passions are the Elementary Humours of the mind. So soon as those begin to abound, the Mind becomes Sick'.[18] This sick mind is all too evident in Alicia's final scene. 'See the nooding [*sic*] Ruin falls to crush me! / 'Tis fall'n! 'Tis here! I feel it on my Brain!' (51), she cries to Jane, with a reference which made clear the final and full submersion of her reason (located in the brain) and self under the force of the passions. Her brain is finally 'turn'd' (51), Jane

tells us sadly as she watches Alicia run off after the imagined vision of Hasting's 'horrid headless Trunk' (51).

Jane Shore is a play in which contemporary stereotypes over the gendering of the passions are hard to avoid. They infuse not only how the characters act but also the language of the play itself. References to witchcraft throughout, for example, a practice which Nancy Tuana notes was closely connected to women's lack of rational faculties and greater passions, are a constant reminder of the dangers of the passionate woman.[19] Blaming his shrunken arm on 'the Sorcery of *Edward's* Wife' (31) and 'the potent Spells' of 'that Harlot *Shore*, / And other like confederate Midnight Haggs' (31) Gloucester is not alone in depicting women as witches: Alicia describes Jane as a 'Beautious Witch' (50) as well as crying out to the dead Hastings 'I conjure thee, hear me!' (42). Speckled with such references throughout, the play revels in the fatal dangers of uncontained female passions. And in embodying the stereotype of inferior and dangerous femininity recycled across philosophy and literature for centuries, *Jane Shore's* two female protagonists reinforce and reiterate the need for male authority, control, and rule, both domestically and nationally. Yet, this advocacy of patriarchal dominance was not necessarily as clear cut as the text would suggest; the play in performance offered a very different model of femininity.

Rational actresses

First performed at Drury Lane on 2 February 1714, with Anne Oldfield in the title role and Mary Porter as Alicia, *Jane Shore* was a hit from its first night, running for fourteen consecutive nights (at a time when five nights would be considered a great success) and being revived repeatedly throughout the year. It was a play written very much as a vehicle for its leading ladies. The two female protagonists dominate throughout both thematically and also in terms of stage time. Even when out of sight they remain the focus of discussion and debate: a constant presence throughout the drama. From their entrance shortly after the start of Act I, one or both characters remains on stage for the majority of the play, with only short scenes being given to the male characters alone. As Judith Milhous reminds us, Nicholas Rowe 'had worked with most of the actors before, knew which members of the company he needed to please, and tailored the script accordingly'.[20] Pleasing Oldfield and Porter however did not simply mean giving them plenty of stage time (although this was almost certainly a consideration) but also giving them strong characters to play: characters which enabled them to

demonstrate their skills as tragic actors. And it was through their exhibition of these expertise that both women challenged the model of weak and irrational femininity which dominated contemporary thinking, and which was foregrounded in the fiction they performed.

To understand how Oldfield and Porter's performances resisted the established image of irrational femininity however, we first need to recognise the centrality of reason and rationality to the rhetorical mode of acting in which they performed. Celebrating judgment, rhetorical acting was a style which emphasised the rational actor's control over the emotional expression of the body: the release, and yet at the same time control and balance, of volatile passions in order to ensure a truthful and moving theatrical expression. As in classical oratory, on which the rhetorical style was based, the actor needed both to feel, and at the same time control the passions if 'he' was to move an audience: 'Cicero expressly teacheth', as the Renaissance writer Thomas Wright pointed out to his readers, 'that it is almost impossible for an orator to stirre up a passion in his auditors, except he be first affected with the same passion himselfe'.[21] As Joseph Roach argues in his influential study, *The Player's Passions*, the actor's skill was therefore not in freeing his actions, but rather in confining them and controlling their 'direction, purpose and shape' so that he might 'attain restraint, [and] control over these copious and powerful energies [and . . .] acquire inhibitions'.[22] It is a description which resonates throughout early eighteenth-century descriptions of acting. As Antony Aston reflected of the famous Restoration actor, Thomas Betterton, his strength was in the fact that his 'Actions were few, but just' and he 'kept his Passion under, and shew'd it most'.[23] Expressing the passions in this way, with carefully regulated precision and restraint, demanded management and judgement, as many acting manuals informed readers. The 'truth of action', wrote John Hill, 'consists principally in three things: the changes in countenance, attitude, and gesture, are the means of it; and all depend upon their being conducted with judgment'.[24] Celebrating and centering on the individual's psycho-physical ability to regulate the movement of the passions within their body, rhetorical acting was a fundamentally masculine skill.

The essentially masculine characteristic of rhetorical acting was, however, as much connected to the cultural practice and gendered traditions of oratory as it was to ideas of physiology. Public oratory, which became a major movement at the start of the eighteenth century, was exclusively understood and constructed as a masculine practice. Oratorical theory focused solely on the male body and the cultivation of an appropriate,

controlled, and rational physicality and expression, and training in rhetorical expression was central to the male education system. Within the exclusive environs of academia, Aristotle's *The Art of Rhetoric* was studied by male students, whilst in wider society a large number of writings on the eloquence of the body ('a certaine visible eloquence, or an eloquence of the bodie' was Thomas Wright's definition of rhetoric) were published in the early years of the eighteenth century, and aimed exclusively at a male readership.[25] Women on the other hand were prohibited from public oratory until the nineteenth century and it is only relatively recently that a female tradition of rhetoric has begun to be recovered.[26]

Actresses certainly deserve a place within this recovery of a history of female rhetoric: in the early eighteenth century they were the only women who publicly demonstrated rhetorical skill. More importantly however, they were also celebrated for it. Elizabeth Barry and Anne Bracegirdle were both praised for both properly managing their expression, and for feeling the correct sentiments. Their 'Action is always just' wrote one commentator in 1742, echoing a similar description of Elizabeth Barry in 1710, 'and produc'd naturally by the Sentiments of the Part they act, everywhere observing those Rules prescribed to the Poets by Horace'.[27] As Colley Cibber noted in his own tribute to Elizabeth Barry, 'no Violence of Passion could be too much for her'.[28] Anne Oldfield was praised in terms which similarly drew on the classical skill of keeping the passions 'under' and calm. She had, as the anonymous author of a poem to her memory reflected, 'Sense – which temper'd every thing she said; / [and] Judgment, which ev'ry little Fault could spy', as well as knowing 'how each various Motion to controul, / Sooth every Passion, and subdue the Soul'.[29] Her rational judgement, suggests this author, was always in control of her passions, a point echoed by the author of *An Essay on the Theatres* (1744) who eulogised her for, 'her elegance of judgement [which] made all new'.[30] Theophilus Cibber made a similar claim when he commented four years later that both Oldfield and Mary Porter, achieved the 'Height of Reputation, with all their Force and Judgement in Perfection'.[31]

Whilst the successful rhetorical *actor* embodied the idealised construction of contemporary, civilised man, these successful rhetorical *actresses* offered a more complex representation of their gender. Figured as rational agents with control over their bodies, these women seemed to embody the very antithesis of contemporary stereotypes of femininity as irrational and uncontrolled. It was their skills as rational actors however, which were central to she-tragedies like *Jane Shore* and, more importantly, to their popularity with audiences. Examined as embodied performances

rather than as texts, it becomes clear that the scenes in which Jane and Alicia are most subsumed by their passions were paradoxically also the scenes in which Oldfield and Porter were best able to demonstrate their skillful control over the passions. Whilst the characters might embody women's passivity in the face of their passions, their function theatrically was as vehicles for two actresses to demonstrate the opposite.

Alicia's raving against Hastings in Act I exemplifies the contrast between the actress's and the characters' passions. 'Are you wise!', exclaims Hastings seeing Alicia transformed by rage, 'Have you the use of Reason? Do you wake? / What means this raving! This transporting Passion?' (11). Alicia, as his lines reveal, is overtaken and consumed by her passion. Yet, Mary Porter certainly was not. After all, as Gildon wrote in 1710, the actor 'ought never be so extravagantly immoderate, as to transport the Speaker out of himself', since this would 'overtop the Modesty of, that is, to go beyond Nature'.[32] Throughout this scene, and the later 'farewell' between Alicia and Hastings in Act IV, Alicia's passions are of the most extreme kind. She appears in the latter scene, as Hastings tells us, full of 'conflicting Passions', to cause him 'new Terrors, new distractions' and turn him wild with her 'distemper'd Rage' (41). From anger to jealousy, love, terror, sorrow, despair and hatred, Porter was called on to feel and experience the most violent of raw passions and yet maintain control of her physical expression and embodiment. It was this juxtaposition which demonstrated her virtuosity: to experience and portray such extreme, transporting passions, without being overtaken by them was the height of theatrical skill.

It was not only that Porter was required to experience and express these extreme passions however. She was also required to effect sudden and instantaneous transitions between them. Like flicking a switch on and off, the greatest of early-century actors could spontaneously shift between passions in a way which revealed their absolute command over their body and its operations. And in writing *Jane Shore* Nicholas Rowe provided plenty of these transitions for both Oldfield and Porter. Oldfield is given the first of these moments. Only moments after stepping on stage in Act I, Jane is reminded of her dead husband. The broken structure of her line reveals the sudden shifts required of Oldfield:

> Alas! At *Antwerp*! – Oh forgive my Tears! (weeping)
> They fall for my Offences – and must fall
> Long Long 'ere they shall wash my Stains away.
> You knew perhaps – oh Grief! oh Shame! – My Husband.

(5)

Having been initially pleased, when Antwerp is mentioned, Jane is instantaneously provoked to tears; seconds later, to guilt, grief, and shame in quick succession. It is her final scene in Act V however, which reveals the extent to which the play provided a dramatic vehicle for her rhetorical skill. Prior to her appearance on stage, the first four pages of the act are devoted entirely to a protracted description of Jane's current state. Jane's husband, who has been in disguise as Dumont throughout the play, sets the scene for her entrance with a vivid description of her patiently walking barefoot, her hair hanging loose on her shoulders and her footsteps 'mark'd with Blood' (45). She is, he says, both 'sad and shelterless' (48), a description echoed by his friend, Bellmour who calls her a 'poor abandon'd Creature' (48). The overarching picture is one of suffering and misery and when Jane appears it is affirmed. However, a close analysis reveals a scene carefully sculpted to provide Oldfield with the opportunity to demonstrate her exceptional rhetorical skills. Dominating from her entrance, and not least because she is alone on stage, Oldfield portrays a woman who is resigned to enduring her fate. After only five words however, Jane is instantaneously overwhelmed by her past transgressions which press, 'like a Weight of Waters down' (48). Feeling helpless in the face of a righteousness God she switches to despair, yet just as quickly switches back and resolves to wait patiently for death. Within only ten lines Oldfield has had to shift between at least four discernible and distinct passions and the act continues in the same vein. Only a few lines later, overtaken by feelings of desolation and abandonment, and filled with despair, Jane faints, as her 'Spirits fail at once' (49). Yet in a pattern of juxtapositions which is repeated throughout the act, just as all appears lost, new hope is offered. It is a dramatic technique which requires Oldfield not only to switch between passions but between markedly distinct types of passions. When she chances upon Alicia's door, for example, Jane is filled with joy at the expectation that she will receive 'a little Succour from her Goodness' (49). Yet her hopes are immediately dashed when she is turned away by the servant. 'Why should I wander / Stray further on', Jane asks abandoning herself to misery, 'for I can die ev'n here!' (49). Echoing the pattern a few moments earlier, just as all seems lost, the mad Alicia appears and injects a moment of hope into the scene. Once more this is quickly crushed however, and Jane moves from begging desperately for food and water, to reminiscing over her former friendship, pleading for pity and mercy, and finally, when she sees the extent of her friend's delusions, selflessly praying to heaven to show mercy to her friend. With Alicia exiting, all possible respite now appears gone and Jane's health quickly deteriorates.

'My head runs round' she cries, 'my Eyes begin to fail / And dancing Shadows swim before my sight/ I can do no more' (51), vividly suggesting the extremes of expression demanded of Oldfield. Lying down on the ground (rather than collapsing which would have indicated a loss of bodily control) Jane seeks rest. However, in a now familiar pattern, having resolved herself to death a new impediment to this closure is introduced. The introduction of Dumont/Shore and Bellmore provides opportunity for a wealth of new and contrasting passions: consumed by fear that Bellmore will be arrested for treason for helping her, she is then filled with joy on hearing of Dumont's arrival, crying 'then Heav'n has heard my Prayer, his very Name / Renews the Springs of Life and chears my Soul' (52). Yet when he arrives, now undisguised, and she recognises him as being her own husband whom she had thought dead, this joy turns swiftly to shock and horror. Swooning, although swiftly reviving with a blush upon her 'Ashy Cheek' (53), Jane's heart is 'thrill'd with Horror' (53) and she refuses to look on him, afraid and distressed. Guilt and shame swiftly follow and Shore's questioning of his wife provides a vivid description of the points Oldfield was expressing:

> Why does thou turn away? – Why tremble thus?
> Why thus indulge thy Fears? And in Despair,
> Abandon thy distracted Soul to Horror?
> Cast every black and guilty Thought behind thee,
> And let 'em never vex thy Quiet more.
>
> (53)

Finally Jane accepts her husband's forgiveness, crying that she wishes to 'fall down beneath thy feet / And weep my Gratitude for ever there' (54). As Shore takes her arm to lead her away however, Jane's gratitude and brief moment of happiness are overtaken with sorrow at her past actions, and the physical result is seen in her description of her decline:

> My feeble Jaws forget their common Office,
> My tasteless Tongue cleaves to the clammy Roof,
> And now a gen'ral Loathing grows upon me
> Oh, I am sick at Heart!
>
> (55)

With 'Murd'rous Sorrow' (55) sapping her blood, Jane falters and Bellmour is called to support her. On the verge of death however, once more Rowe refuses narrative closure, introducing guards who proceed

to seize Shore and Bellmour for aiding Jane. Seeing her husband being carried away, Jane cries out in a paroxysm of agony, tortured by the fear that he will die because he helped her. Breaking free to be with his wife in her dying moments, however, once more, Shore's dialogue provides a vivid image of Oldfield's rhetorical expression of the passions:

> Why dost thou fix thy dying Eyes upon me
> With such an earnest, such a piteous Look,
> As if thy Heart were full of some sad Meaning
> Thou couldn'st not speak!
>
> (56)

'Forgive me! – but forgive me!' (56) is Jane's response, and, on Shore's assurance that he has, she finds a moment of peace before, grieving that she can leave her husband 'Nothing but one sad Sigh', she cries 'Mercy Heav'n!' and finally expires (56).

Dominated entirely by its heroine's emotional state, this final scene of the play is a roller-coaster of passions: horror, shame, fear, pity, pleading, agony, hope, joy and more, suffuse the climax. Yet whilst the fictional world depicts Jane as a passive suffering victim, weak and filled with uncontrollable and varied passions, as a performance a very different image of femininity is offered. Tight-packed with a diverse range of passions, coming in quick, often almost immediate succession, Oldfield was given a vehicle through which to demonstrate her virtuosity in a style of acting which celebrated the controlled expression of the passions. Paradoxically therefore the centrality of female suffering and emotional distress in the fiction was the means through which Oldfield was enabled, in performance, to demonstrate her exceptional psycho-physical skill and control: skills which were conventionally and physiologically understood as masculine. Recognising the meaning on offer through the embodied performance, it becomes clear that whilst the fiction of the she-tragedy, in Jean Marsden's terms 'reiterates gender as a stable series of binary oppositions: male/female, subject/object, and actor/acted upon, oppositions that supported rather than threatened existing social structures', the embodied performance simultaneously resisted such binaries.[33]

Containing the challenge

The rational self-control and psycho-physical regulation which actresses demonstrated in their performances presented a direct challenge to

constructions of women as irrational and passionate. However within a context in which the boundaries of sex and gender were fluid and based on overlap rather than opposition, such moments could also be understood as examples of exceptionality rather than as threats to an established order. The binary framework and the two-sex body which is the basis for our understanding of sex and gender today was, as scholars including Thomas Laqueur, Londa Scheibinger and Karen Harvey have demonstrated, not yet firmly established in the early eighteenth century.[34] And with the one-sex body continuing to dominate people's understandings of their bodies and identities, men and women, rather than being physiologically opposite, were understood to share the same essential body, simply demonstrating greater or lesser levels of perfection: to be at different points on a hierarchy or continuum of perfection.[35] Whilst women as a whole might be inferior due to their peculiar mix of humours and their lack of the vital heat which would perfect their bodies into the masculine form, because there was no there was no fundamental difference between men and women, an *individual* woman, as Anthony Fletcher points out, could have the potential to surpass and 'receive praise for showing more strength than many ordinary men'.[36] As Margaret Sommerville reminds us, 'the axiom that women were weaker did not entail that every woman was necessarily less strong, less intelligent, and less balanced than any male'.[37]

It is in this context that the performances of actresses who were celebrated for their masculine rhetorical skill must be understood. Such performances did not radically disrupt social structures or challenge the general construction of women as inferior and irrational, so much as demonstrate these women's individual exceptionality and ability to break free from their gender's limitations. At the same time however, with significant numbers of actresses being celebrated for their rhetorical skill, Oldfield and Porter were clearly not unique: in the one-sex model women had the capacity to advance up the hierarchy and equal men in masculine arenas such as reason and rationality and it was a capacity which actresses, as a group, embraced and embodied. And whilst audiences clearly enjoyed this demonstration of masculine skill, the embodied challenge presented to patriarchal prerogative also provoked a defensive response across contemporary discourse.

There are two main trends evident within these responses. The first is the discourse of male-centred professional learning which explained, and therefore recuperated the threat of these women's abilities on the grounds that they had learnt their rhetorical skill and rational control from their male peers. Grounded as it was in traditions and practices of

rhetoric, early eighteenth-century acting was a mode which relied on the performer being trained to correctly express the passions by senior figures in the profession. Actors were praised, as Robert Wilks was in 1733, for entering, *'thoroughly* into the Parts, which he studied after those *who had gone before him'*.[38] The process of learning this skill, however, was long and thorough: indeed, as the 1741 *History of the English Stage* asserted, 'perfectly to attain' excellence as a performer 'requires a studious Application of a Man's whole Life'.[39]

It is within this context of skills transmission that actresses' rhetorical abilities were recuperated within gender roles. Figuring actresses as lacking the skill or ability to perform on stage without the intervention of key male figures, the narrative drew explicitly on the long-established role of men as providing the rational influence over women's uncontrolled passions. The most famous example of this recuperative strategy is the story of how the late seventeenth-century actress, Elizabeth Barry, came to the stage. When first appearing on stage in 1675, so the story goes, Barry was incapable of acting. Although, as the author of the 1741 *History of the English Stage* noted (a publication which embellished the story and established it as 'fact'), her voice and good air had led William Davenant to take her on, she was then discovered to have a 'bad Ear' and 'they found it so difficult to teach her, [that] they thought it would be impossible to make her fit for the meanest Part'.[40] Barry was apparently given three attempts. However she ultimately had 'so little Success, that several Persons of Wit and Quality being at the Play, and observing how ill she performed, positively gave their Opinion she never would be capable of any Part of Acting'.[41] John Wilmot, Earl of Rochester, however, supposedly thought otherwise and laid a wager that he could make her the finest player on the stage within six months. Making her perform parts repeatedly and teaching her how to change herself, 'as it were, into the Person, not merely by the proper Stress or Sounding of the Voice, but feeling really, and being in the humour, the Person she represented, was supposed to be in', Rochester was credited with training Barry in rhetorical control and gave her the skills to manage her passions.[42] When she reappeared on stage, months later, she was transformed. As Colley Cibber wrote in describing her performances, she had 'a presence of elevated Dignity, her Mien and motion superb, and gracefully majestick; her Voice full, clear, and strong, so that no Violence of Passion could be too much for her'.[43] Yet it was only through her male tutor's instruction, the story functions to remind readers, that Barry learnt to control the volatile passions which were essential to the actor's art.

The story of Barry's transformation into a skilled actress through timely male intervention is not unique. Across diverse accounts, whilst actresses were consistently presented as having some natural skill or temperament which made them suited to the profession, these natural feminine excesses had to be refined through the skilled intervention of a knowledgeable male figure. Kitty Clive, for example, who debuted on the stage in 1728, was recognised for having 'a facetious Turn of humour, and infinite Spirits, with a Voice and Manner in singing Songs of Pleasantry peculiar to herself'.[44] However it was not until the intervention of Colley Cibber, 'whose infallible Judgement soon found out her Excellencies', that these natural skills were refined to the point where she could succeed upon the stage.[45] In a similar vein, when Ann Dancer first appeared on the York stage William Cooke records that 'her tones were so *shrill* and *discordant*' that even an experienced judge like Charles Macklin thought she would never succeed as an actress: it was only 'under the tuition of the *silver-toned Barry*' he adds, that she became an affective tragedienne.[46] Like Dancer, Susannah Cibber, an actress celebrated for her rhetorical skills, was also portrayed as requiring the intervention of knowledgable men, including her father-in-law Colley Cibber and playwright Aaron Hill, to become an actress.[47] Whilst Susannah clearly had the natural qualities required to become a performer, these were nevertheless seen as requiring refinement by knowledgeable male practitioners before she could succeed on the stage.

The only notable exception to this discourse of male tutelage is Anne Oldfield. According to Colley Cibber, Oldfield was very slow in making an impression after her debut in 1699, so much so, that when having to rehearse with her for *Sir Courtly Nice* he concluded 'that any assistance I could give her, would be to little, or no purpose'.[48] When it came to the performance however, Oldfield amazed Cibber with an unexpectedly powerful performance, and, as he noted, 'what made her Performance more valuable, was, that I knew it all proceeded from her own understanding, untaught, and unassisted by any one more experience'd actor'.[49]

Whilst Oldfield might not have been trained by an actor however, she certainly learnt from other women. As her *Authentick Memoirs* notes, recognising the importance of imitation in the transmission of theatrical skills, it was by 'copying after those inimitable Actresses, Mrs Barry, and Mrs Bracegirdle, [that] she soon improved'.[50] Public discourse might seek to explain actresses' abilities to equal men in the field of rhetorical expression through the narrative of male-centred training but, as a number of examples reveal, in practice women resisted such discursive

containment through their active transmission of rhetorical skills amongst themselves. Throughout the eighteenth century, experienced actresses like Mary Betterton, Mary Porter and Kitty Clive passed on their skills and experience, both directly and indirectly, to newcomers into their profession.[51] Mary Betterton, for example, as well as being a leading actress in her own right and wife to the famous actor Thomas Betterton, tutored a generation of actresses at the turn of the eighteenth century and was listed in Vanbrugh's 1703 plan for a new theatre company at an £80 salary for housekeeping and teaching (Figure 1.1). It was a role for which she was later memorialised by Colley Cibber, who wrote in his *Apology* that 'when she quitted the Stage several good actresses were the better for her instruction'.[52] Both Anne Bracegirdle and the largely unknown actress Elizabeth Watson who joined the Betterton household in around 1686, were amongst these actresses, whilst outside the profession Mary Betterton is likely to have coached Princess Anne on more than one occasion: tutoring the princess for her appearance in Nathaniel Lee's *Mithridates* in 1681, as well as probably coaching her and her sister for the court masque *Calisto* in 1674–5. One of her more famous pupils, Mary Porter, continued her mentor's practice by taking on the training of younger actresses herself.[53] As Samuel Johnson reflected, not entirely complimentarily, towards the end of the century, Mary Porter 'taught her pupils no violent graces; for she was a woman of very gentle and ladylike manners, though without much extent of knowledge, or activity of understanding'.[54] In the middle and later years of the century established actresses like Kitty Clive and Dora Jordan continued to support their peers with both formal and informal tutoring: the talents of Jane Pope being described as 'cultivated under the tuition of the celebrated Mrs Clive'; and Dora Jordan training the young actress Molini in 1797–8, as well as providing informal advice to the actors she worked with on tour, noting in a letter to William in February 1811 that, 'you would be surprised to see with what eagerness all the performers treasure up any little instruction I give them at the rehearsals; many of them make memorandums of them in their pocket books'.[55] Playing a key role in the transferal of theatrical skills to a new generation of performers, these women, like their predecessors earlier in the century, continued a long tradition of female professional tutelage: a tradition which, certainly in the early years of the century, resisted the containment of actresses' skill within a narrative of masculine control.

Whilst the discourse of male training sought to limit actresses' threat to the patriarchal social structure through locating their psycho-physical, masculine control within a tradition of male training, a parallel

discourse however, sought not to explain but to counter the masculine qualities these women exhibited: by depicting rhetorically-skilled actresses as being the embodiment of contemporary notions of femininity. Throughout the early years of the eighteenth century women were widely considered to be more lustful and desiring than men: propensities which, in the classical model, were the result of women's greater proportion of moist humours which made them subservient to the passions in general, and to amorous passions in particular. As Nicolas Venette noted in 1720:

> Women are by far more lascivious and more amorous than Men. And if Fear and Honour did not retain them, there would be but few (in the natural violence of their Passion) but what would yield and do what we are used to do for them, to keep or to gain us.[56]

Lacking restraint, Venette suggests, women will yield to their lascivious inclinations, draw men in and 'keep' them: their uncontrolled passions giving them the capability to arouse men's senses and lust, overwhelm them, and make them passive victims of female sexual potency. It is an image which Rowe draws on a number of times in *Jane Shore*. As Alicia asks Jane near the start of the play, what could a woman wish for more than:

> To behold a Monarch,
> Lovely, Renown'd, a conqueror, and Young,
> Bound in our Chains, and sighing at our Feet?
>
> (6)

Considered as a moment of performance audiences might well have considered such references as referring as much to the actresses as to the fictional characters they played. Nell Gwynne's relationship with Charles II was still a recent memory, having ended just under thirty years earlier with his death in 1685 and similar relationships between a small number of actresses and the nobility were well known, including Anne Oldfield who in 1714 began a long-term relationship with an illegitimate nephew of the first duke of Marlborough, Charles Churchill. 'Many are the Instance of *real* Monarchs, and Persons of the *first* Distinction', as William Oldys pointedly commented in his 1741 biography of Oldfield, 'who have felt the Power of Beauty from the Stage, and fallen willing Victims to a Theatrical *Venus*'.[57]

Throughout the early years of the century the image of actresses as siren-like, alluring figures who seduced helpless male spectators

suffused contemporary discourse, countering the challenge to patriarchal prerogative embodied through their rhetorical performances. The Restoration actress Charlotte Butler, Colley Cibber wrote in 1740, had had 'a manner of blending her assuasive Softness, even with the Gay, the Lively and the Alluring', whilst her contemporary Anne Bracegirdle, 'threw out such a Glow of Health and Cheerfulness, that, on the Stage, few Spectators that were not past it, could behold her without Desire'.[58] The description of Lavinia Fenton's impact on a young mercer's apprentice however, is one of the most explicit examples of this motif. Describing how Fenton, famous for her portrayal as the first Polly in the *The Beggar's Opera* (1728), enticed and disempowered the men who beheld her on stage, her anonymous biographer wrote that:

> Seeing her one Night at the Play-house, the poor smitten Spark was so captivated at first Sight of her, that he could scarce forbear making Love to her before the Face of the whole Audience; his Colour went and came, he sigh'd, trembled, and in short, felt all those Emotions which Men in Love are subject to.[59]

This portrayal of Fenton's would-be lover as the passive victim of her sexual powers is not dissimilar from Hasting's own description of his suffering in *Jane Shore*. 'Thy Softness steals upon my yielding Senses' he tells Jane 'Till my Soul faints, and sickens with Desire' (14). It was a sensation which many men in the audience might well have empathised with whilst watching Barton Booth (playing Hastings) address Anne Oldfield in 1714. Descriptions of Oldfield's charms are consistent in their attention to her irresistible charms: 'her beauty was full of attraction but more of Allurement', wrote her biographer Oldys, whilst the author of Oldfield's *Authentick Memoirs* declared that 'any Man of Flesh and Blood would have sacrificed a King's Ransom to change Places with either the *Beau* or the *Footman*; so irresistible was she in every CHARACTER she personated'.[60] Other commentaries drew on the popular image of woman as enchantress, an image which, as we have already seen, originated in the long-held idea that witchcraft was a consequence of women being at the mercy of their sexual desires.[61] 'So enchanting was her lovely Frame' eulogised the author of *A Poem to the Memory of Mrs Oldfield*, that 'she spoilt, against her Will, the Poet's aim', whilst in a private letter to William Cranstoun on 3 April 1725, the poet James Thomson, who had recently arrived in London, commented that she 'twines her body and leers with her eyes most bewitchingly'.[62] It was Richard Savage who took the idea the furthest however when he praised

Oldfield for being able to lure the dead back to life with the powerful charm of her voice:

> Cou'd the pale Heroes your bright Influence know,
> Or catch the silver Accents as they flow,
> Drawn from dark Rest by your enchanting Strain,
> Each Shade were lur'd to Life and Love again.[63]

Just like Jane Shore who is repeatedly depicted as a witch throughout the play, here Oldfield is an enchantress, her power over men speaking to her inability to control her amorous passions and working to counter the image of her as rational and skilful agent over her body and emotions.

Throughout the early years of the century these discourses attempted to explain and contain the threat posed by women like Oldfield who, through their rhetorical performances, encroached on a masculine field and challenged masculine privilege. However, at the same time, audiences flocked to plays in which these skills were demonstrated, and theatrical commentators praised actresses' rational self-control. There was so simple solution to this contradiction. Across theatrical discourse, in plays and in tracts, images of actresses as strong, controlled, and 'masculine', constantly jostled with those of them as siren-like, alluring feminine figures, irresistible to the men in the audience. And in attempting to contain women's rhetorical skills through sexualising them, the attraction and power of the rhetorical female was paradoxically emphasised. At one and the same time audiences were both attracted and threatened by the masculine power of the female performing body, and it was a confused response which is nowhere better demonstrated than in the multiple and apparently contradictory responses which both celebrate and seek to contain its power.

3

Playing Men: 'Half the men in the house take me for one of their own sex'

Coming off stage one evening, after performing the role of Sir Harry Wildair in George Farquhar's *The Constant Couple*, Peg Woffington sat down in the Green Room and exclaimed 'In my Conscience! I believe Half the Men in the House take me for one of their own Sex.'[1] On hearing this comment James Quin, Kitty Clive, or another unnamed actress, depending on the version of the anecdote being told, is said to have replied, 'it may be so; but, in my Conscience! The other Half can convince them to the contrary.'[2] This apocryphal anecdote is well-known, having been recycled across theatrical histories since the eighteenth-century. Yet whatever its origins it is the popularity, rather than the veracity of the anecdote, which is of interest. In its repetition through the centuries this witty interchange speaks less to Woffington's implied promiscuity and more to an historic and continuing fascination with the gender-play at work in her performance. As we saw in the previous chapter, in the early-eighteenth century actresses like Anne Oldfield and Mary Porter were celebrated for their virtuosity in demonstrating the masculine trait of self-control in performance. Now in the middle years of the century Peg Woffington rose to fame through a performance of masculinity itself. Sir Harry, which she first performed in London on 21 November 1740, was probably only the fourth role Woffington had attempted in London after making her debut on 6 November 1740 at Covent Garden.[3] Nevertheless she was an immediate sensation and, as well as continuing to play the part twenty times that season, it remained one of her most prized roles throughout her career. Although Sir Harry had been a popular part since it was first portrayed by Farquhar's friend, Robert Wilks, in an unprecedented fifty-three night run at the turn of the century, Woffington's interpretation gave it new life.[4]

[Whilst Sir Harry was, by far, Woffington's most popular cross-dressed role however, it was not her only one. As well as playing other male roles *en travesti* – in particular, Lothario in *The Fair Penitent* and the popular travesty role, Macheath, in *The Beggar's Opera* – she also excelled in a range of breeches roles (characters who disguise themselves as men within the dramatic fiction) including Hypolita in *She Would and She Would Not*, Viola in *Twelfth Night*, Rosalind in *As You Like it*, Sylvia in *The Recruiting Officer*, and Portia in *The Merchant of Venice*. As such Woffington provides an excellent starting point for an examination of the way in which actresses' cross-dressed performances engaged with changing notions of gender in the middle years of the eighteenth century.]

[Predicated upon the interplay of masculine and feminine identities, bodies, and behaviours, cross-dressed roles (which encompass both travesty – by which I mean the portrayal of a male role by an actress – and breeches parts) spoke directly, although in distinctive ways, to shifting understandings of sex and gender in the middle years of the eighteenth century. Whilst for centuries it had been gender (masculine and feminine behaviours) rather than the biological-sexed body which had determined an individual's male- or female-ness – 'to be a man or a woman' within the one-sex world, as Thomas Laqueur argues, had been, 'to hold a social rank, a place in society, to assume a cultural role, not to *be* organically one or the other of two incommensurable sexes'– now, increasingly, men and women's sexual identities were becoming aligned to their physical bodies.[5] The inextricable mesh of interrelations between socially-constructed gender and biologically-determined sex were slowly being separated out from each other and whilst scholars are keen to point out that this shift did not happen either at once, everywhere at the same time, or even indefinitely, perhaps at no point more so than in the middle years of the eighteenth century, these two models of the sexed body collided and jostled against each, complicating any attempt to define how contemporaries might have understood sex, gender, or their relationship to each other.[6]]

[It is within this cultural context that this chapter places actresses' cross-dressed performances. Considering the wider cultural milieu allows us to unpack the distinctive ways in which travesty and breeches performances articulated, refracted, and challenged both the residual construct of the one-sex body and the emergent model of hierarchical sexual identity. And as we will see, whilst travesty celebrated and foregrounded the mutability of sexual identity which, as we touched on briefly in the last chapter, was on offer through the one-sex model,

breeches performances, which focused more often on the 'truth' of the character's sexual identity beneath the disguise, resisted this gender play and looked ahead to the idea of gender as biologically determined.

Celebrating androgyny

Studies on travesty have often struggled with the extent to which actresses succeeded in convincing the audience with their performance of masculinity, arguing that the actress's sexed body was aways foregrounded in the audience's mind and limited the potential of her performance of masculinity to deceive.[7] Yet the potential for a woman to embody an entirely convincing portrayal of masculinity would not have been strange to eighteenth-century audiences. 'Passing women' – women who lived, worked, or married, 'as men', either temporarily (most often to elope, attend carnivals, travel or riot) or long term – had been present within English culture for some time. And as Rudolf Dekker and Lotte van de Pol point out, they were a familiar feature of mid-eighteenth century society at all levels: chronicles, diaries, travel narratives, collections of anecdotes, popular scientific treatises and daily newspapers and magazines all reflecting literate middle- and upper-class attitudes towards female cross-dressing, and folk ballads which recounted tales of female soldiers and sailors speaking directly to a working-class female audience.[8] The 'female warrior', however was not only an imaginative archetype.[9] It was also a role which real women could embody. Christian Davies and Hannah Snell were just two women who achieved fame when they published their stories of military service as men in 1740 and 1750 respectively.[10] Hannah Snell (Figure 3.1) even extended her performance of masculinity into the theatre, appearing at Goodman's Fields between June and September 1750, where she sang, undertook manual operations and demonstrated military exercises. The actress Charlotte Charke, daughter of Colley Cibber, was another woman who 'passed' in the mid-eighteenth century. Cross-dressing not only on-stage but also off, Charke lived and worked for some time as 'Mr Brown' with her intimate friend and possibly lover, an actress who she referred to only as 'Mrs Brown'. As such examples reveal therefore, far from being an infrequent occurrence, female-to-male cross-dressing was a familiar practice in the early to mid eighteenth-century: part of what Terry Castle has described as the 'culture of travesty' and, 'the Protean life of the city' finding 'expression in a persistent popular urge toward disguise and metamorphosis'.[11] As such practices reveal moreover, mid eighteenth-century society was one in which men and women

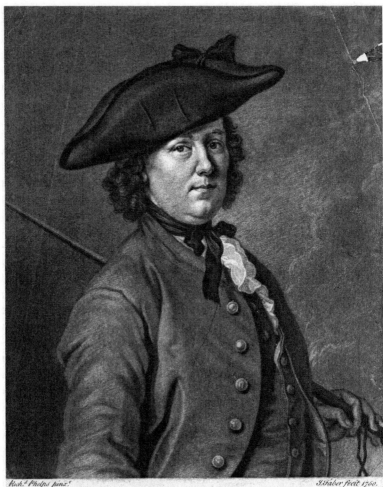

Figure 3.1 'Hannah Snell' by John Faber Jr. after Richard Phelps, 1750 (National Portrait Gallery)

were free, at least within certain limits, superficially, and temporarily, to adopt both male and female attributes.

Considered in this cultural context it is certainly possible therefore that actresses could have 'passed' as men on stage. Indeed reports on, and images of Woffington's performances as Sir Harry (Figure 3.2) suggest that she was highly successful in this respect. As the author of James Quin's memoirs recorded:

> There was no woman that ever yet had appeared upon the stage who could represent with such ease and elegance the character of a man. Everyone who remembers her must recollect that she performed Sir Harry Wildair [. . .] far superior to any actor of her time [. . .] She had besides dispossessed herself of that awkward stiffness and effeminacy which so common attend the fair sex in breeches.[12]

However complete Woffington's physical and behavioural embodiment of masculinity was of course, the audience's foreknowledge and the theatrical context mitigated against their being entirely 'taken in' as they might have been by a social cross-dresser. Yet to assume that they perceived the performance through this knowledge is, as theatre scholar Stephen Bottoms reminds us, to oversimplify the complexity of watching travesty performance. Describing watching modern-day drag-king, Danny King, he reflects, 'Some subconscious part of my brain was telling me that this was, in fact, a man even though my conscious mind knew that Danny was also Diane.'[13] Experiencing a conflict between the knowledge that he was watching a woman performing and the perception of the performance and character as masculine, Bottoms reminds us of the cognitive dissonance created by travesty performances. Yet to consider either Diane Torr's or Peg Woffington's performances as failing as a result of their inability to escape the theatrical frame and 'pass' as they might in society, is to misunderstand how travesty works: success is based not on completely fooling the audience, but on the complex interplay of gender and identity within the performance. It is the dissonance which Bottoms highlights, the ambiguity and interplay between these gender identities, which is at the heart of the enjoyment of travesty performance. Just as the popular 'warrior women' ballads and the stories of women like Hannah Snell and Christian Davies all relied on their readers' knowledge of their subjects' multiple identities, theatrical travesty thrived on the juxtaposition, rather than the effacement, of the female actress with the male character.

I play the part of Sir Harry
Wildair to Night yr humble Servt
Margaret Woffington

From the Original by HOGARTH in the possession of AUGUSTIN DALY, Esq

Figure 3.2 'Peg Woffington as Sir Harry Wildair', in *The Constant Couple*, print from a painting by William Hogarth [n.d] (University of Illinois at Urbana-Champaign)

There is however a key distinction between written accounts and the-atrical presentations of women's 'passing'. Unlike the former, theatrical travesty had the ability to simultaneously layer the gender identities on offer through the interplay not only through the different elements of an evening's entertainment – with actresses often following travesty roles in a main piece with a female character in an afterpiece – but also through the juxtaposition of dramatic text and embodied performance. And in *The Constant Couple* we have an excellent example of the effect of this multiple layering.[14]

The plot of *The Constant Couple* follows Sir Harry Wildair, an 'Airy Gentleman affecting humorous Gaiety, and Freedom, in his Behaviour' (12) and two other young men, the hypocrite Vizard and disbanded Colonel Standard, who each lay bets upon the relative qualities of their mistresses, unaware that they are all talking about the same woman: Lurewell. Throughout the play the three men compete for Lurewell's affections; she responds by playing Standard and Wildair against each other by suggesting her amorous dedication to each; and in a sub-plot Vizard sends Wildair to his cousin Angelica and her mother Lady Darling, deceiving him into thinking that their establishment is a brothel. After a number of classic comic conventions – closet scenes, escape by exchanging clothes with a servant, mistaken arrests, and an aborted duel – the play culminates with reformation through marriage: Standard and Lurewell, now discovered to be long-lost first lovers, are married to each other, whilst the rakish Wildair, finally discovering that Angelica is not in fact the whore he thinks she is, is faced with the choice of marrying her or facing a confrontation of honour with Vizard. 'Here I am brought to a very pretty Dilemma' he exclaims, 'I must com-mit Murder, or commit Matrimony [. . .] But, Damn it, – Cowards dare fight, I'll marry, that's the most daring Action of the two, so my dear Cousin *Angelica*, have at you' (84).

Although originally written for a male actor, Sir Harry is a role which lends itself to the layering of gender identities, not least through the similarities highlighted between Harry and his mistress, Lurewell. As Sir Harry tells Standard, 'we're Finger and Thumb, Sir [. . .] we are as like one another as a Couple of Guineas' (34). It is soon thrown back at him by Standard who replies to Harry's exclamation, 'why should I be angry that a Woman is a Woman? Since Inconstancy and Falsehood are grounded in their Natures, how can they help it?', with the sharp com-ment, 'Then they must be grounded in your Nature; for you and she are Finger and Thumb, sir' (35). Read as fiction such comments simply highlight the similar interests and attitudes of both characters: as Sir

Harry says, 'she [Lurewell] dances with me, sings with me, plays with me, swears with me, lies with me' (34). Yet spoken by a cross-dressed actress such lines take on another layer of meaning, foregrounding the blurring of gender boundaries. Performed by a woman Woffington's Sir Harry, after all, had many more similarities to Lurewell than Wilks' Sir Harry would have had. And the fact that Woffington also played Lurewell on a number of occasions would, for many spectators, have further obscured the distinctions between the roles, with Lurewell and Sir Harry both being inextricably bound up within the persona of Woffington the actress.[15]

With audiences' responses to Woffington's Sir Harry being shaped by their knowledge of the actress herself, as well as of the other female roles she played, her performance is best understood as an example of what George Piggford has described as the 'female androgyn': women who 'do not simply dress as men' but who 'who dress, perform, write, appear as gendered identities that might be placed in a range between masculine and feminine'.[16] Contemporary comments, such as those by the author of the *The Life of Mr James Quin*, certainly suggest that audiences identified Woffington's performance in these androgynous terms. 'She was the perfect contrast of the much celebrated Knayston [sic], who, in King Charles's time, so successfully appeared in all the female characters', wrote the author, 'that it was a most nice point to decide between the gentlemen and ladies, whether she was the finest woman or the prettiest fellow'.[17] For audiences, this author suggests, it was the mutability and instability of gender identity presented by Woffington's performance which was so enjoyable. Rather than transgressing sex/gender boundaries in the way that a transvestite might, the female androgyn, as Piggford argues, employs 'a camp sensibility – a code of appearance and behaviour that mocks and ironizes gender norms – in order to undermine the gender assumptions of their specific culture'.[18] And it was this that audiences so enjoyed in Woffington's performances. Drawing on the audience's foreknowledge of her biological sex and of her other female roles, whilst concurrently embodying masculinity, Woffington cultivated a camp sensibility which playfully brought into tension and queered cultural notions of masculinity and femininity.

Of course since camp, as Richard Dyer argues, is 'a way of prising the form of something away from its content', rather than a quality actually inherent in something, these queer moments are absent from the dramatic text.[19] Portraits of cross-dressing however, give us a glimpse of these moments of embodied gender disruption, revealing how women could make a claim on the symbolic power which was

invested in male clothing simply by appropriating it (see Figures 3.2 and 3.3). In performance moreover, and freed from female codes of dress such as long skirts and petticoats, which functioned, as Joanne Entwistle has highlighted, to discipline and manage the body in both social and spatial contexts, actresses had access to a new physicality and one which signalled strength, freedom of expression, and masculine privilege.[20]

In claiming this new level of physical and social freedom simply by dressing and behaving as male, actresses also drew attention to masculinity's status as something achievable – displayed, worn, and ultimately performed through gesture, clothing, posture, and vocal presentation – rather than innate: after all, as Esther Newton argues, 'if sex-role behaviour can be achieved by the "wrong" sex, it logically follows that it is in reality also achieved, not inherited, by the "right" sex'.[21] The distinction between men and women, travesty performances suggested, was socially rather than naturally constructed: an idea echoed in James William Dodd's 1777 portrait of Ann Spranger Barry, where the image of Barry as Sir Harry Wildair in the foreground is contrasted with a conventional feminine portrait on the wall behind (Figure 3.3).

Within a context in which the one-sex body still maintained a presence within social understandings of identity however, such notions were not anomalous. In the mid-eighteenth century, for many, differences between the sexes were of degree rather than kind, and femininity and masculinity were the epiphenomenon – indicators of sexual identity – rather than products of a sexual body. As social traits, masculinity and masculine traits could therefore be claimed by someone whose body was biologically female as much as by someone whose body was biologically male, and female bodies had the potential to exceed social and cultural expectations of their behaviour as feminine. As Hannah More's famous 1778 epilogue to *Percy* declared:

> I'll prove, ye fair, that let us have our swing,
> We can, as well as men, do any thing; . . .
> Mount the high horse we can, and make long speeches;
> Nay, and with dignity, some wear the breeches;
> And why not wear 'em?[22]

In both war and politics, this 'ode to gender transgression', as Dror Wahrman has described it, makes a pointed claim for women's equal skills and abilities.[23] Years earlier however, and in subtler terms, Woffington's portrayal of Sir Harry had made similar claims.

Figure 3.3 'Ann Spranger Barry (née Street) as Sir Harry Wildair in *The Constant Couple*' by James William Dodd, 1777 (University of Illinois Theatrical Print Collection)

Throughout *The Constant Couple* Woffington's travesty performance consistently subverted gendered stereotypes, destabilising masculine authority and making a female claim for male prerogative by, to paraphrase Kristina Straub, simply 'putting on' masculinity.[24] Yet it was not the actress's camp sensibility alone which queered gender boundaries, it was also the juxtaposition of this with dramatic content. As we saw in Chapter 2, in the first decades of the century Oldfield and Porter's rhetorical performances undermined the stereotypes of female irrationality presented within the characters they played. And now in the middle years of the century, in voicing female stereotypes as Sir Harry, for example the idea that women are inconstant and false, Woffington raised a theatrical eyebrow at such simple clichés. Even where the text did not comment directly on the status of women however, there were still opportunities to subvert gender constructs. In Act II for example, where Sir Harry beats the dishonourable Smuggler to the floor and throws snuff in his eyes (42–4), it is male autonomy and authority over other bodies which is disrupted by Woffington's travesty. And in a similar way, when singing Sir Harry's libertine 'ode' to pleasure and freedom it is a claim for *female* freedom which Woffington articulates. 'I make the most of Life, no Hour mispend' s/he sings at the end of Act II:

> Pleasure's the Means, and Pleasure is my End.
> No Spleen, no Trouble shall my Time destroy.
> Life's but a Span; I'll ev'ry Inch enjoy. (44)

In voicing this familiar image of white, male libertine privilege, Woffington troubles the social lines between male and female behaviour, and asserts her social and even – if she played on the innuendo of 'inch' – sexual independence. With a long history behind the notion that cross-dressed women had excessive sexual appetites, there might well have been some theatrical mileage in moments like this.[25]

The connection between cross-dressed actresses and sexuality is, of course, a well-honed one and a wealth of scholars have argued that the essential function of the cross-dressed actress was to titilate a predominantly male audience with the physical exposure of her body.[26] Yet this partnering of female sexual innuendo with masculine dress and behaviour often worked instead to undercut such uncomplicated heterosexual eroticism. The androgynous epilogues of Hester Santlow provide a useful example. Santlow was an early-eighteenth century actress and dancer who was known not only for breeches and travesty parts – including the page Dowglass in John Banks's *The Albion Queens*

and Fidelia in Wycherley's *The Plain Dealer* – but also for performing epilogues in which, as Elizabeth Miller Lewis notes, she included a mix of conventional signs of dress and gender, such as a combination of feminine dress with the masculine accoutrements of hat and bat, to establish a performative persona that was neither fully feminine nor completely masculine.[27] Embodying the female androgyn, Santlow then presented epilogues which were explicitly erotic. In the epilogue to *Don Quixote* for example, she demanded applause for 'our Quixot' threatening that if anyone deny it 'let him come out and die', and warning:

> Weak as I am, that wretch had better tarry;
> For I can make such thrusts – as no man here can parry.[28]

Clearly playing on the double meaning of 'thrust' the sexual overtone is evident. Her epilogue to *Valentinian* also seems to echo this emphasis on the male gaze. As she wittily demanded:

> Look in my face, you sparks, who croud the pit,
> For while you watch my legs, you lose my wit.
> Ask yon bright beaus, who the side-boxes fill,
> Have women's feet, or eyes, most power to kill?[29]

Drawing attention to the young men in the pit staring at her legs – a joke of course as much on their position which placed her legs, not face, in line of sight, as on their preoccupation with her body – and playing both groups of men off against each other, Santlow foregrounded the eroticism of her performance for the men in the audience. Yet she was far from being simply a commodified spectacle to be gazed upon. Rather than affirming heterosexual desire, these flirtatious comments from an attractive woman, dressed as a man and drawing on masculine behaviours, *used* heterosexual attraction to unsettle the basis both of gender identification and heterosexual eroticism. In the epilogue to *Valentinian* this was enhanced further by the fact that Santlow had just played the most androgynous of figures, the eunuch, in the play. Just like Woffington years later, Santlow interwove innuendo with both masculine and feminine signifiers to blur the distinctions between male and female, and hetero- and homoerotic. And in a context in which the demarcation of gender, sex, and sexuality along oppositional bounds was yet to be established, it was this playful approach to both gender and sexuality, not the objectification of these women for a male spectatorship, which appealed to contemporary audiences.

The unsettling of heteroerotic sexuality evident across a number of prologues and epilogues was furthered by the fact that many also addressed the desiring gaze of women, rather than the men in the audience.[30] Advertisements for cross-dressed performances often marked them as being at the request of 'the ladies' and, as a prologue from Mrs Bellamy (mother of the more famous George Anne Bellamy) reveals, prologues and epilogues often indicate a performed flirtatiousness towards the female members of the audience.[31] 'Dear Ladies, may I persish, but I'm proud', Bellamy declared in Dublin:

> To find you all recover'd, and so loud. [. . .]
> I found a female habit would not do,
> And therefore try'd a Pair of Breeches too:
> A spruce young Blade, well made, with such Ad-
> dress,
> Among you Belles may speak with some Success –
> And I, who am a Woman – to my Cost,
> Know, by myself, what please the Ladies most.[32]

Donning breeches, as she says, to please the ladies, Bellamy's prologue foregrounds her as an erotic object, but notably not for the men in the audience. Whilst there is certainly the potential to perform the speech without sexual innuendo, it is hard to avoid the playful flirtation of this 'spruce young Blade', who proclaims 'himself' 'well made' and who in such 'address' (playing on the potential of the word when spoken aloud, to sound like 'a dress'), knows 'what please[es] the Ladies most'. In a context in which women's heterosexual role as man's commensurate and oppositional Other was yet to achieve the dominance it would with the establishment of the two-sex body later in the century, such moments speak to an openness by women to expressing their attraction to other women.[33] Rather than directly challenging heteronormative roles therefore, the homoerotic flirtations within performances like these were the product of a social context in which both gender and sexual desire were fluid and could be enjoyed by both women and men in the audience.

Other examples speak to a more explicitly erotic response by female spectators, suggesting that the appeal of travesty for some women *was* in the space it gave them to explore same-sex desires.[34] 'In Breeches next, so well you play'd the Cheat' declared a poem dedicated to Woffington:

> When first in Petticoats you trod the Stage,
> Our Sex with Love you fir'd, your own with Rage!

In Breeches next, so well you play'd the Cheat,
The pretty Fellow, and the Rake compleat –
Each sex, were then, with different Passions mov'd,
The Men grew envious, and the Women loved.[35]

So successful is Woffington in her performance of masculinity, the poem reveals, that heteronormative audience responses have been reversed: the men envy her masculinity, and the women gaze on with desire. The author of 'The Vision' is another woman who describes the same-sex attraction fostered by Woffington's performance. This poem describes a dream in which Woffington, surrounded by Greek gods, performed extracts from her various roles, including Lothario in *The Fair Penitent*:

All adroit, each taper Thigh enclos'd
In manly Vestments, with *Parisian* step;
Light as the bounding Doe she tripp'd along,
The gay LOTHARIO, in his Age of Joy.
Venus surpriz'd, thus whisper'd 'Let me die,
If dear ADONIS wore a lovelier Form.'
Then clasp'd the Youth-dres'd Damsel to her Breast,
And sighing, murmur'd, *O that for my Sake*
Thou wert this Instant what thou represents.[36]

With this vision of Venus clasping the blushing actress, the homoerotic potential of Woffington's travesty performance is foregrounded. And whilst Venus' wish for Woffington to be what she appears suggests regret at the impossibility of a heterosexual coupling, the poem does not entirely close down the potential of a homosexual one. The focus on Lothario in this poem moreover is not accidental since, as Castle suggests, early lesbians often symbolically assumed the persona of the male libertine.[37]

Offering us an image of the female desiring gaze 'The Vision' reminds us of the multivalent attractions of travesty performances for both male and female spectators. For many the attraction of the androgyn was in the glimpse it gave of what Terry Castle has described as, a 'state unmarred by sexual differentiation and the limitation it implies'.[38] For others the attraction was in the playful blurring and queering of gender and sexuality. And in a context in which adopting male dress and demeanour was, as Beth Friedman-Romell notes, a key means of self-identification for women-loving women, the appeal of the travesty performer for some was in the space it made available for the exploration of female same-sex desire.[39] For many perhaps it was a mixture of all three.

'In all but love we approve them': performative impotence

The varied attractions of travesty performance in the middle years of the eighteenth century are hard to ignore. However, contemporaries were not ubiquitous in their praise of such performances. And for some it was the same-sex eroticism which was the source of this aversion. As a commentator in the *World* noted in February 1754, in an article criticising young men's behaviour:

> When they talk to common women as they pass them in the Mall, they seem as much out of character as Mrs Woffington in Sir Harry Wildair, making love to Angelica. In short, every part of their conduct, though perhaps well intended, is extremely unnatural.[40]

Such comments were not unique. As John Hill similarly wrote in 1755:

> We see women sometimes act the parts of men, and in all but love we approve them. Mrs Woffington pleases in Sir Harry Wildair in every part, except where she makes love; but there no one of the audience ever saw her without disgust; it is insipid, or it is worse; it conveys no ideas at all, or very hateful ones; and either the insensibility, or the disgust we conceive quite break in upon the delusion.[41]

For both authors it was specifically the scenes in which Sir Harry 'makes love' which caused discomfort. Unlike the rest of the play, in which the gendered performance of identity was foregrounded, in love-making scenes where heterosexual intercourse was the focus of the drama's action, the audience's attention was drawn to the physical, sexed body. At these moments the biological gap between the actress' dramatic body and her real body became unavoidable and therefore problematic. What is rarely recognised however, is that the problem, for Hill at least, was not specifically the image of same-sex coupling but rather the scene's dramatic inauthenticity. As Hill reveals, in the often overlooked second part of the quote, 'we have men at this time on the stage from whom love comes as unnaturally as from a dressed woman; and we never fail to be as much disgusted by it' (202). For Hill the character's imagined 'body' and the performer's had to be aligned for such moments to be affective and the sex of the performer was only one of the qualifications required to perform love scenes. 'Only certain persons of those who are qualified for the stage are fit to act love parts', he wrote, this depending as much upon age as sex since the woman should be in the 'bloom of youth' and

the man is in the 'prime of life' (203). 'Nothing does but nature' (202) Hill asserted, adding that, 'the delusions must be kept up [and] nature only can do this' (203) because the audience need to 'feel, while we look upon the representation and [. . .] have from it something of reality' (202). Whilst the audience could accept the dramatic representation through the rest of the performance, the combined knowledge of the actress's biological body, as well as the androgynous, rather than heterosexual masculine performance Woffington offered, made love-making scenes at best unintelligible, and at worst disgusting: no more so however than if Sir Harry had been played by an old man. Sexually unbelievable, or as scholars such Laurence Senelick and Felicity Nussbaum, have suggested, sexually impotent, the pairing of an attractive woman with an androgynous lover failed to move audiences in the way required by the dramaturgy.[42]

Despite Hill's disgust at the scenes of love-making in *The Constant Couple* however, such moments were few and far between, and mitigated both by Wildair's ultimate failure in his amorous desires – neither Lurewell nor Angelica, the two objects of his attentions, are successfully 'won' during the play, and Wildair only promises to marry at the end out of necessity – and by the comic framework with its jokes. After all, as Mary Douglas reminds us, the function of joking is to subvert dominant structures of ideas, attack hierarchies and devalue social classifications, an effect which is achieved by the confrontation of one pattern with something else: in this case the confrontation of the dramatic fiction with the audience's knowledge of the actress.[43] Whilst the dramatic realism of the love-making scenes itself might have been unintelligible therefore, the comic frame of the play worked to support and enable the subversive playfulness of the layered identities on offer allowing, to borrow from Eric Weitz, 'closely held systems of personal/social/cultural framing [to] give way to new and unlikely connections' and reminding us that there is 'more than one way to make sense'.[44]

Whilst in *The Constant Couple* the comic framework held in tension these moments in which the character's and actress's bodies became dramatically incompatible, when Woffington played Lothario in the she-tragedy *The Fair Penitent* on 24 March 1757, there was no such supportive mechanism available. Unlike comedies, which thrived on the layering of multiple levels of dramatic and metatheatrical meaning, for *The Fair Penitent* to succeed in evoking the tragic emotions of sorrow, fear, and anxiety, audiences needed to invest in the characters before them. 'The nearer it approaches the reality, and the further it removes us from all idea of fiction, the more perfect is its power', wrote Edmund Burke on the power of tragedy in 1757, highlighting the specific importance of the

imitation of reality.[45] And with Woffington's performance of Lothario *en travesti* being unable to 'approach reality' in this way, many – although not as the author of 'The Vision' reminds us, all – considered it a failure.[46]

The Fair Penitent tells the story of Calista, the eponymous penitent who has been promised in marriage to Altamont. Lothario however, has already seduced and abandoned Calista as an act of revenge against Altamont who is his sworn enemy.[47] Soon after her marriage, which Calista despairingly resigns herself to, Horatio, Altamont's brother-in-law, discovers a letter written by Calista to Lothario in which she asks for one last meeting before killing herself. On being confronted with the letter by Horatio, Calista rips it up. However then being discovered in tears by her husband, she reacts swiftly to cover her deception, threatening to take herself to a religious cloister and refusing to sleep with him whilst his 'divided Heart / Doats on a Villain that has wrong'd' her (49). Attempting to reveal the truth to Altamont, an act which results in a bloodless duel, Horatio is subsequently banished with his wife Lavinia (Altamont's sister). However, shortly after, Altamont comes across Calista and Lothario in a garden and, realising the truth of Horatio's accursation, kills Lothario in a duel. Realising what has happened, Calista's father, Scioltio, comes close to killing her, only relenting to banish her to a dark cell. In the final act Calista, alone with the body of Lothario in a gloomy mausoleum, is visited first by her father, who gives her a knife to kill herself with, and shortly after by Altamont who offers to die with her. The play culminates with a double stabbing: Scioltio by a gang of Lothario's men and Calista by her own hand on hearing the news of her father's attack. Returning to die with her, Scioltio finally forgives his daughter with his last breath before she too dies.

In playing Lothario Woffington took on a very different type of character to Sir Harry. Arrogant – 'I am Lothario' he proclaims 'As great a Name as this proud City boasts of' (36) – angry, vicious and cruel, whilst he appears to share the same libertine desires for pleasure and freedom as Sir Harry, his tone is markedly different. Undermining what Elaine McGirr has described as 'the rhetoric of "innocent enjoyment" employed by rakes in the 1660s and 1670s', Lothario proudly asserts his refusal to conform to social expectations or niceties.[48] The difference between Sir Harry's 'ode to pleasure', as I earlier described it, and Lothario's statement of his desires is significant. 'By the Joys' he declares in Act II:

> Which my Soul yet has uncountroll'd pursu'd'
> I would not turn aside from my least Pleasure,
> Tho' all thy Force were arm'd to bar my Way;

> But like the Birds, great Nature's happy Commoners,
> That haunt in Woods, in Meads, and flow'ry Gardens,
> Rifle the Sweets, and taste the choicest Fruits,
> Yet scorn to ask the Lordly Owner's Leave.

<div align="right">(39)</div>

Whilst the type of sexualised language he uses is similar to Sir Harry's, Lothario is motivated not by pleasure but by vengeance, seducing Calista purely to have revenge on Altamont. Unlike Sir Harry's expansive, ebullient and most importantly unfulfilled (within the dramatic world of the play) sexual desires, Lothario's sexuality is powerful, aggressive, and dominates the play. The very real sexual act, which Lothario recounts in rich and explicit detail on his first appearance on stage, foregrounds his sexed and sexual body vividly in the audience's mind:

> Once in a lone and secret Hour of Night,
> When ev'ry Eye was clos'd, and the Pale Moon
> And Stars alone, shone conscious of the Theft,
> Hot with the Tuscan Grape, and high in Blood,
> Hap'ly I stole unheeded to her Chamber
> [. . .]
> Oh! 'Twas great!
> I found the fond, believing, love-sick Maid,
> Loose, unattir'd, warm, tender, full of Wishes;
> Fierceness and Pride, the Guardians of her Honour,
> Were charm'd to rest, and Love alone was waking.
> Within her rising Bosom all was calm,
> As peaceful Seas that know no Storms, and only
> Are gently lifted up and down by Tides.
> I snatch'd the glorious, golden Opportunity,
> And with prevailing, youthful Ardor prest her,
> 'Till with short Sighs, and murmuring Reluctance,
> The yielding Fair One gave me perfect Happiness.
> Ev'n all the live-long Night we pass'd in Bliss,
> In ecstasies too fierce to last for ever;
> At length the Morn and cold Indifference came;
> When fully sated with the luscious Banquet,
> I hastily took my leave.

<div align="right">(20)</div>

It is not hard to see how Woffington's performance of this sexually-explicit speech would have failed to effect the dramatic realism required and why critics, such as the author of her 1760 memoirs, referred to its impotence: the performance of 'that gay, perfidious Libertine' was, as the anonymous author reflected 'an absurd, an inconsistent and an impotent attempt'.[49] Even more so than in Sir Harry's love-making scenes, here knowledge of Woffington's female body and her androgynous presence obviated that immersion in the dramatic realism which Burke identified as central to the power of tragedy. And with Lothario's virile sexuality, emphasised in this moment in particular, forming the narrative thrust of the play – motivating Calista in her desire for Lothario and her planned suicide after marrying Altamont; Altamont in banishing Horatio and killing Lothario; and Scioltio in his banishment of Calista and wish for her death – the tragic power of the play relied on Woffington's alignment with the role: an alignment which, at least for the author of her memoirs, was notably absent. 'Any Sentence, which came from the Mouth of the *supposed Lothario*', wrote her biographer, 'lost its Force, by being played by a Woman':

> it was impossible for the Mind to be so far possessed with Delusion, as to forget the Reality, that it was a Woman that played the Character; and consequently, that the Sentiments, the Conduct and the Actions of the personated *Lothario*, seemed to be a mere Attempt to represent Things which formerly *had been*, instead of convincing the Spectators that the Scenes they saw before them were *then* real [. . .] she was absolutely unfit for the Character, and played it with all the Impotence of mere Endeavour.[50]

Unable to reconcile the disjoint between Lothario and Woffington's sexed bodies, and thereby the break between the dramatic fiction and the stage reality, the play failed to move many of its audiences, with the *Dramatic Register* noting that, 'the interest, which the heart naturally takes in the business of this play, was weakened by our being conscious that a woman was playing the part', although adding that, 'Mrs Woffington takes off her hat, draws her sword, fights and dies with such an elegant gallantry, that she is the prettiest fellow on the stage.'[51] Whereas in comic travesty the knowledge that this was a woman playing a man might enhance the subversiveness already on offer through

the comic frame, in tragedy it appears, it merely detracted from the dramatic power of the play.

'We applaud the performer, but always in the knowledge that the object before us is a *woman assuming the character of a man*': breeches roles

Breeches roles, like comic travesty, relied on the audience's knowledge that the performer they saw on stage was a woman. Where they differed from travesty however, was in the function of this knowledge. For whilst travesty's gender play served to queer heteronormative boundaries of sex and gender, in breeches roles these boundaries were both demarcated and reinforced. As such, whilst travesty reflected the one-sex body's mutable identity with its playful approach to the body, performance, and homoeroticism, it was with the emerging model of the two-sex body that the breeches role resonated with its foregrounding of the character's (and actress's) biological sex over her performance of masculinity.

Breeches protagonists vary in the extent to which they success-fully pass within the fictional world of the play: some, like Silvia in Farquar's *The Recruiting Officer,* fool everyone, while others, like Peggy in Garrick's *The Country Girl,* fail to an equal degree.[52] However what-ever their skills in passing, to work theatrically the audience always has to be aware of these characters' 'true' identities, as we see in *The Recruiting Officer.*

One of the most popular plays of the eighteenth century, Farquhar's comedy tells the story of the heroine, Sylvia who, having been sent away from Shrewsbury by her father, disguises herself as 'Jack Wilful' in order to return and test her intended husband, Captain Plume. Centering on the heroine's experiences, the play was a popular one with actresses, and Sylvia was played both by Anne Oldfield and later, by Peg Woffington for her London debut on 6 November 1740. Essential to the success of the play in performance however, is the audience's knowledge of Wilful's true identity as Sylvia; only through this dramatic irony does Sylvia's parody of military, rakish masculinity, and her com-mentary on masculine stereotypes become intelligible. As she observes to the audience at the start of Act IV:

> Had I but a Commission in my Pocket, I fancy my Breeches wou'd become me as well as any ranting Fellow of 'em all; for I take a bold Step, a rakish Toss, a smart Cock, and an Impudent Air, to be the principal Ingredients in the Composition of a Captain. (54)

Being a captain, Sylvia suggests, takes little more than a few key, stereo-typical gestures, a point echoed later in the play when she, as Wilful, is charged with debauching Rose and declares:

> I'm call'd a Captain, Sir, by all the Coffee-men, Drawers, Whores, and Groom-Porters in *London*; for I wear a red Coat, a Sword, a Hat *bien troufée*, a martial Twist in my Cravat, a fierce Knot in my Periwig, a Cane upon my Button, Picquet in my Head, and Dice in my Pocket. (76)

Claiming the name Captain Pinch, she adds, 'I cock my Hat with a pinch; I take Snuff with a Pinch, pay my Whores with a Pinch: In short, I can do any Thing at a Pinch, but fight and fill my Belly' (76). With such com-ments Sylvia seems to suggest that masculinity can be easily 'put on' in same way as in the travesty role; certainly Francis Gentleman's reflection in 1770, that 'there was not a more agreeable one on the stage, equally *degageé* [*sic*] in the female and male semblance' than Woffington as Sylvia, would seem to support this.[53] Yet whilst Woffington might be easy in both male and female dress, Gentleman's further comment that, 'she ravished in both rendering even absurdities pleasing by the elegance of her appearance and vivacity of her expression', suggests that the attraction was actually in her femininity.[54] Unlike the androgynous masculinity which Woffington's travesty roles offered, as Sylvia/Wilful her appeal was in her essentially feminine presence. As Charles Macklin noted, where a woman 'personates a man pro tempore, as is the case in several of our stock comedies [. . .] the closer the imitation is made, the more we applaud the performer, but always in the knowledge that the object before us is a woman assuming the character of a man'.[55] Commenting on masculinity but without fully embodying it, there was always a gap between the parodic performance of masculinity and the 'authentic' femininity of both Sylvia and Woffington. This gap, and the audience's awareness of Sylvia's 'true' feminine interi-ority is also essential to containing the apparently homoerotic moments that her disguise makes available. From Sylvia's first appearance as Wilful, Plume, his rival recruiting officer Brazen, and the sergeant Kite, all find themselves attracted to the young rake, with the former two competing over who can enlist him. 'I'll prefer you, I'll make you a corporal this Minute' (50) declares Brazen' prompting Plume to better the offer:

> *Plume.* Corporal! I'll make you my Companion, you shall eat with me.
> *Braz.* You shall drink with me.
> *Plume.* You shall lie with me, you young Rogue. (*kisses*)
>
> (50)

Although it was common practice for soldiers to 'lie' together, the tone of Plume's invitation and the fact, as Randolph Trumbach has documented, that homosexual seduction in the eighteenth century often started with the offer of a drink and then led to the sharing of a bed, makes the subtext clear.[56] And it is not the only moment of homoeroticism in the play. Attempting to kiss Sylvia/Wilful, Kite explains, 'We Officers do [kiss each other]: 'tis our way; we live together like Man and Wife, always either kissing or fighting' (52), while later, in a tender, intimate scene in Act IV, Plume's attraction is all too apparent when he informs Sylvia/Wilful that any serious fault on his part will result in his discharge rather than disciplining because, 'something tells me, I shall not be able to punish you' (58). 'I find something so agreeable about you, that engages me to court your Company', Plume exclaims, 'and I can't tell how it is, but I shou'd be uneasy to see you under the Command of any body else [. . .] 'Sdeath! There's something in this Fellow that charms me' (58). Whilst such comments seem to indicate an openness to male same-sex attraction however, in fact the reverse is the case: the audience laugh at the men's confusion in the full knowledge that, and *because*, the source of this attraction is Sylvia's real identity as a woman. As such, any anxiety over possible threats to heteronormative structures is deflected as soon as it is made available.

For her own part, Sylvia/Wilful also forecloses any homoerotic potential. Although 'bedding' a local girl, Rose, and finding herself on trial in front of her father, a local justice, for debauchery, Sylvia's motivation in this is as much to protect her virginity from slander and maintain her marriageability, as it is to keep up the act of being a young rake. As her father says with relief on discovering she had slept not with Plume but with Rose, 'all's safe' (90). There is never any indication moreover, that Sylvia is attracted to Rose. Rather, throughout the play all her attentions are directed solely at Plume, with her feelings openly on display when she responds to his comment that he could never punish, only discharge her, by declaring that, the 'greatest Dangers in your Profession [. . .] wou'd be less terrible to me, than to stay behind you' (58). With Plume unaware of Sylvia's real identity, yet drawn into this intimate exchange, the scene is one of the most amusing in the play. Yet it only works if the characters are viewed through a heteronormative frame. Rather than being open to multiple models of sexual desire such moments function to resolve homosexual panic: a process which Judith Butler argues serves to provide a 'ritualistic release for a heterosexual economy', fortifying by doing so, 'the heterosexual regime in its self-perpetuating task'.[57] Playing roles like Sylvia, although Woffington's negotiation of gender

roles might have seemed superficially comparable to her travesty performances, in fact she served to police, rather than challenge the boundaries of heteronormative culture.

The extent to which breeches roles conformed to, rather than challenging emerging ideas about gender and sexuality is evident in their continued, and largely unedited presence through the middle and later years of the eighteenth century. Whilst plays such as Thomas Shadwell's *The Humours of the Army* (1713) were altered to suit the new cultural milieu – most notably in this case with the male-to-female cross-dressing removed – the breeches elements frequently remained almost entirely intact.[58] *The Humours of the Army* sees Belvidera (or Charlot in the 1763 adaptation, *The Female Officer*) follow her lover to war as a young soldier after a bitter argument.[59] Unable to find him she vows revenge on all the men she comes across, a promise she soon makes good on, being so abusive to a solider on parade (in fact her unrecognised lover, Wilmot) that he tries to shoot her and is sentenced to death. As in *The Recruiting Officer*, there is plenty of male parody throughout. But there are also some significant differences. Where Sylvia is overwhelmingly successful in passing as a man, in *The Female Officer* Charlot's male persona is less secure, indicated not least by her lack of a male name: she is only 'the female officer'. In addition, not only does the heavily accented Major Cadwallader refer to Charlot as 'her' (24), but when Charlot is described by Hearty in effeminate terms as, 'a pretty pert young Fellow' (39) Wildish responds with the unknowingly insightful comment, 'I fancy 'tis a Wench of his, that he has fobb'd upon the General for an Officer' (39): a point to which Hearty does not disagree, only adding, 'He has a very Womanish Face' (39). Unlike Sylvia, Charlot lacks masculine authority, a fact reinforced by repeated references to the female officer's youth. Described as 'boy', 'babe' and 'child' throughout, her 'smooth countenance' (23), as Surly describes it, works repeatedly against her despite her attempt to 'put on all the Saucy Airs of a real Man' (23). Charlot's performance of masculinity, such references highlight, is both incomplete, inexperienced and lacking in social authority and it is no surprise therefore, that at the end of the play her fundamentally feminine body gives her away. Testifying against Wilmot in his court martial in Act V, and hearing the story of how her ill-treatment has led him to this point, Charlot finally realises who Wilmot is when he cries out 'O cruel barbarous *Charlotte*' (57). Shocked by the revelation, Charlot then immediately loses control over her body and her attempt to perform masculinity collapses. Swooning, the most feminine and sensitive of responses, and subsequently fitting, her body

reveals its inescapable femininity. 'Tis indeed a Woman', as Major Buck comments, 'and a very soft bewitching one' (57). Stressing what Jean E. Howard describes as, 'those feelings held to constitute a "true" female subjectivity', moments like this make it hard, as she argues, to 'avoid concluding that many cross-dressing comedies have as their social function the recuperation of threats to the sex-gender system'.[60] Yet whilst Charlot's performance of masculinity was suspect throughout and ultimately collapsed, revealing her true femininity, three years later a play would be performed in which the breeches heroine would be unable to embody even the most basic aspects of masculinity.

In *The Country Girl*, the 1766 adaptation of William Wycherley's *The Country Wife* (1675), David Garrick created a heroine whose inability to perform masculinity was evident before she had even donned the breeches. In the play, Peggy, the country girl of the title, is brought to London by her guardian, an old rake called Moody, who has convinced her that they are as a good as married in order to keep his hold on her before he actually marries her in London. Belville and Peggy however, are secretly in love and Peggy's maid convinces Moody to allow Peggy to go to the park, having already arranged for Belville to meet Peggy there. Being jealous of any attention Peggy elicits however, Moody insists she dresses in men's clothes and appears in public as his godson. It is a plan which is quickly ruined by Peggy's overwhelming inability to perform a convincing version of masculinity. 'Suppose, Bud' she asks Moody naively when he informs her that she is to dress as a man, 'I must keep on my petticoats, for fear of shewing my legs?' (29). Peggy's difficulty in masking her identity continues through the following scene in the park, and whilst the comedy relies on some of the characters being taken in, the failed disguise is clearly indicated when Sparkish comments that 'he' must be 'Some relation of Peggy's, I suppose, for he is something like her in face and gawkyness' (34). Belville meanwhile recognises her immediately. 'By all my hopes', he cries out excitedly and with not a little sexual frisson, 'Peggy in man's clothes – I am all over agitation' (34), and telling her once they are alone, that, 'No disguise could conceal you from my heart' (41).

Peggy's failure to perform masculinity encompasses not only her appearance however, but also her behaviour. Throughout, as Moody says, 'she carries it so sillily' (38), a description realised on stage when Peggy attempts to imitate Harcout and Belville's gentlemanly courtesies, and is unable to move beyond unintentional parody:

Harcourt [addressing Peggy in disguise]: Pray, young gentleman, present my humble service to her [meaning Peggy, who Harcourt thinks is in bed]

Peg: Thank you heartily, Sir (*bowing*)
Moody: 'Sdeath, she will discover herself yet in spite of me (*aside*)
Belv: And mine too, Sir
Peg: That I will indeed (*bowing*)
Harc: Pray give her this kiss for me (*kisses Peggy*)
Moody: O heavens! What do I suffer?
Belv: And this for me
Peg: Thank you, Sir (*courtesies*)
Moody: O the idiot – now 'tis out.

(39)

Not only, as Moody's response indicates, is Peggy's bowing clearly exaggerated, but when kissed by Belville she entirely forgets to play the man and curtsies. Unlike other breeches heroines, and in a sharp contrast to the confident, assertive, and sexually dominant performances of masculinity presented through travesty, Peggy is unable to offer even a passable impression of masculinity: her female body being firmly stamped as Other to the male body she attempts to imitate. Foregrounding the 'true' femininity of its heroine, *The Country Girl* therefore points to the increasing cultural conditioning of the gendered body as 'natural', reinforcing the alignment of gender and sex into two incommensurate bodies, and resisting the mutability of gender. By reasserting constructs of heterosexual desire and an essential femininity moreover, *The Country Girl*, like other breeches plays, inhabited and created an explicitly heterosexual, normative space.

'Did the lady really look like a man, the coarse *androgynus* would be hooted from the stage': cross-dressing at the end of the century

Towards the latter decades of the century the growing dominance of the oppositional model of sexual identity saw an increasing gap opening up between attitudes towards breeches and travesty roles. Whilst the former, with their emphasis on the essential differences between men and women continued to be enjoyed, the latter, speaking to gender fluidity and queering norms of sexuality and gender, became increasingly problematic.[61] The distinction is apparent in Benjamin Victor's advice to actresses in 1770. 'The wearing breeches' Victor advises:

merely to pass for a man, as is the case in many comedies, is as far as the metamorphosis ought to go [. . .] it should not be in the least extended, – when it is, you overstep the modesty of nature; and

when that is done, whatever may be the applause within doors, you will be injured by remarks and criticisms without . . . each change becomes unnatural; and whenever a man appears effeminate, or a woman masculine, they will, in spite of temporary applause, be great losers in the end.[62]

Whilst the breeches role posed no concern for Victor, the masculine woman in travesty roles transgressed the 'natural' alignment of sex and gender within the two-sex model and was deeply troubling. 'There is nothing required so much beyond the delicacy of your sex, to arrive at the point of perfection', he continued, 'that if you hit it, you may be condemned as a woman, and if you do not, you are injured as an actress.'[63] To succeed as a travesty actress, Victor suggests, is to lose the essential delicacy which increasingly defined women within the two-sex paradigm. He was not alone in thinking this. Almost forty years later Leigh Hunt similarly reflected that:

if she succeeds in her study of male representation she will never entirely get rid of her manhood with its attire; she is like the *Iphis* of OVID and changes her sex unalterably. There is required, in fact, a breadth of manners and demeanour in a woman's imitation of men, which no female, who had not got over a certain feminine reserve of limb, could ever maintain or endure; and when the imitation becomes frequent and the limbs bent to their purpose, it is impossible to return to that delicacy of behaviour, which exists merely as it is incapable of forgetting itself.[64]

Whilst interestingly, neither commentator denies the possibility that the actress *could* become masculine, to do so was to ruin herself: feminine delicacy was a 'natural' state which once lost, was lost forever and once she had represented masculinity, the travesty actress could never return to this unmarred state.

By the turn of the nineteenth century, as such responses reveal, the travesty performer's androgynous appearance and behaviour was no longer perceived in playful terms; now it was a direct challenge to social norms. In this new world where male and female bodies were largely defined in opposition and identified on the basis of the minutiae of their physiognomy – not only in the genitals but in every aspect of the body, from the bones, hair, and mouth, to the voice, blood vessels, and brain – external presentation of those bodies had to be aligned with, and reflect the inner truth of, the sexed and heteronormative body.

As Londa Scheibinger has detailed, defining 'women's social worth in her physical nature' in this way, had a clear political tone, providing as it did 'a sure and easy solution to the "woman problem"': the growing calls for women's rights and equalities.[65] The camp androgyny of the travesty performance however spoke to a world in which sex, as a product of gender, was culturally ascribed and in which women could break free from the normative bounds of their gender roles. Continuing to 'put on' the external signifiers of sexual identity, and refusing to be contained within the bounds of heteronormative desire, travesty therefore resisted the legibility of the body whilst concurrently countering the increasing onus on men and women to limit their behaviour to a gendered, heterosexual norm, and to find the other and now 'opposite' sex attractive. As such, in the latter years of the century the travesty performer was a prominent point of resistance to the socio-political project of constructing femininity and masculinity in oppositional terms. And the result of this conflict with the increasingly dominant cultural context was a marked decline in the appreciation of travesty towards the end of the century. Roles like Sir Harry Wildair, which less than fifty years earlier had prompted panegyrical responses now repelled many critics. 'Since the time of Mrs Woffington several females have been eager to expose themselves in male characters', reflected the *The European Magazine* after Dora Jordan's performance as Sir Harry on 2 May 1788 and, 'on such deviations from propriety, we think it sufficient to observe, that they are offensive and disgusting; and where talents, as in the present case, are united, deserve every censure that can be bestowed upon them'.[66] In fact, rather than being censured the role was performed a total of twenty-eight times between May 1788 and October 1790, suggesting that many spectators continued to enjoy of the subversive meaning of travesty performances. However its subsequent decline in popularity, being performed only once in the following two and a half years, and by a male actor, marks what Dror Wharman has identified as the decline in performances gesturing towards gender instability in the last two decades of the century.[67]

The distaste felt by many spectators towards travesty at the end of the century, and its concurrent decline however, were not simply a response to its *conflict* with the new model of sexual identity. They were also the consequence of its increasing cultural unintelligibility. Previously, and informed by a sensitivity to the one-sex body, spectators had revelled in actresses' camp androgynies and blurring of gender signifiers; now within a binary system of sexual difference the cultural framework which enabled spectators to make meaning from this interweaving of

gender identities was missing. The result was an increasing absence of what Eve Kosofsky Sedgwick has called 'camp recognition': the cultural understanding required to decode the excesses of camp androgyny in performance.[68] With the relationship between masculine and feminine, and between character and performer changing, travesty soon became reinterpreted in the only way possible: as an attempt to *imitate* masculinity which, because of the fundamental differences between masculinity and femininity, would always fail. As William Cooke wrote in his 1806 memoir of Charles Macklin, 'there is such a *reverse* in all the habits and modes of the two sexes, acquired from the cradle upwards that it is next to an impossibility for the one to resemble the other so as totally to escape detection'.[69] Misreading actresses' androgynous appearance and behaviour as unsuccessful attempts to perform authentic masculinity – attempts which were fundamentally flawed because of these women's essential femininity and the fundamental differences between the sexes – travesty was, within this context, always doomed to failure.

By the end of the century, this lack of 'camp recognition' and the decline in travesty was so extensive that when Dora Jordan played Sir Edward Bloomly in *Cheap Living* in 1797 the prologue went so far as to offer a disclaimer, explaining, as Dror Wahrman notes, how the performance would work, and asking the audience to suspend their disbelief:[70]

> To prevent disappointment, but not to forestall,
> To one little hint your attention we call:
> For this 'tis but right we should tell of his plan –
> You must fancy a female is really a man;
> Not merely conceal'd in the manly array,
> But a man, bona-fide, throughout the whole play;
> This we own, as it else might your feelings perplex,
> Since she charms you so much in her own proper sex.[71]

Whilst the prologue is certainly open to being performed in a knowing way, nodding to the audience's knowledge of travesty as much as offering as a sincere warning, the fact that it could play on the supposed ignorance and confusion of the audience highlights the shift in the popularity and reception of travesty since the middle of the century.

Despite the prologue's tentative framing of Jordan's performance of Sir Edward however, it was generally well received. Although the character itself was considered 'unnatural' by the *Morning Chronicle*, with the play as a whole exhibiting 'ridiculous caricatura [. . . and] whimsical situation[s]', Sir Edward was, as both this paper and *Lloyd's Evening Post*

agreed, 'admirably performed by Mrs Jordan, who seemed resolved to
aid the Author by the best display of her talents'.[72] In a review which
points to one of the reasons for the seemingly anomalous acceptance of
this travesty performance the *London Packet* concurred, reflecting that,
'the character of the *Boy-Baronet*, played by Mrs Jordan is well drawn,
and may be considered as new to the stage'.[73] Despite the prologue's
reference to Jordan performing a man, as this review reveals, in fact Sir
Edward was a boy. Playing a soft, incomplete and inexperienced version
of masculinity – 'a youth only sixteen years of age, who throughout the
play affects the manners of a man' – the role lacked the social status
which adulthood would bring, and Jordan's performance was stripped
of any social or political challenge.[74] With women's social and physi-
cal status placing them on a par with boys, Jordan's embodiment of
the effeminate quality of prepubescent masculinity signified in a very
different way to roles like Sir Harry. As a comment from the *True Briton*
reveals, Jordan's 'true' femininity was evident throughout her perfor-
mance: she 'obtained and deserved the warmest applause', the paper
commented, having 'never appeared to more advantage'.[75]

Whilst the role of Sir Edward lent itself to a feminine performance
however, it was not the only travesty role which gave prominence to
the femininity of its performer. As James Boaden was at pains to point
out in his biography of Jordan, when she played William in Frances
Brooke's *Rosina*, 'did the lady really look like a man, the coarse *androgy-
nus* would be hooted from the stage'.[76] Similarly when discussing her
performance of Sir Harry, he emphasised that Jordan, 'beautiful in her
figure, stood confessed a perfect and decided woman; and courted,
intrigued, and quarrelled, and cudgelled, in whimsical imitation of the
ruder man'.[77] As he added, reflecting on Woffington's claim to have
been taken for a man as Sir Harry, and using the term travesty to mean
parody or caricature, 'I am convinced that no creature there supposed
it for a moment: it was the *travesty*, seen throughout, that really consti-
tuted the charm of your performance, and rendered it not only gay, but
innocent.'[78] Boaden was not alone in emphasising actresses' femininity.
The 1821 entry for the singer and actress Miss Balke in *Representative
Actors*, noted that she had 'some lower tones of a depth and richness
which rarely belong to a female voice, and which yet are entirely femi-
nine', adding that her performance of Macheath in *The Beggar's Opera*
was, 'the prettiest make-believe imaginable – not the character, which
would be intolerable; but a lady's free sketch of it, in which the outline
is preserved, but all attempts at likeness in the more revolting parts is
gracefully resigned'.[79] Travesty as a form might not have disappeared

entirely, such comments reveal, but it only survived by adapting itself to the new cultural climate. This whimsical, innocent, gay imitation of masculinity was as different from earlier forms of travesty performances as breeches performances were. Parodying masculinity from a position of inherent femininity, not only did it leave gender boundaries untroubled, but in many ways it actually mirrored the fundamental qualities and function of breeches roles in asserting an essential femininity. Whilst travesty therefore continued in a new, adapted form at the turn of the century, in affect and meaning, such performances were far removed from Woffington's mid-century queering of gender roles as Sir Harry and Lothario.

4

Playing Herself: 'It was not as an actress but as herself, that she charmed every one'

On 27 September 1785, a notice in the *Morning Herald* announced that the tragicomedy *Philaster* was shortly to be revived by the manager of Drury Lane, Richard Brinsley Sheridan.[1] Yet whilst intended as a vehicle for the debut of three new performers to the London stage, Mr Lawrence, Miss Collins, and Mrs Jordan, plans soon changed. Whilst it had been, 'the intention of the Drury-lane [*sic*] managers to have brought out Mr *Lawrence* and two young female performers together', the *Morning Post* reported on 6 October, adding that the play had been rehearsed the previous Monday, 'it seems that design is now altered, and they are to make their entries separately'.[2] Jordan, it turned out, was now fixed to make her debut in a revival of a play not seen for eleven years on the London stage: David Garrick's *The Country Girl*.[3] It was widely agreed to be a well-chosen vehicle for this new actress, being, as the *Morning Post* pointed out, 'peculiarly calculated to exhibit Mrs Jordan in that cast of character, in which, if we may trust our information, she particularly excels – a girlish and hoydenish vivacity'.[4] Yet whether it was Sheridan or Jordan's choice is not clear. Whilst the manager had determined on and rehearsed *Philaster* – with Jordan being cast in the role of Euphrasia, the passive heroine who disguises herself as the servant Bellario in order to be close to the object of her affections, the weak and ineffectual protagonist Philaster – there was little opportunity here for Jordan to make her mark. Six months earlier however, when touring with Tate Wilkinson in Yorkshire, Jordan had seen Mrs Brown, an experienced regional actress, perform a role which would be the ideal vehicle for her debut: Peggy, the simple, naive, carefree and playful young protagonist of *The Country Girl*.[5] It seems likely therefore that Jordan demanded to make her debut in a role she had already identified. And on 18 October the twenty-three year old actress stepped out onto the boards of Drury

Lane as Peggy for the first of what would be many performances in the role, over a long and very successful career.

Breeches roles, as I argued in the previous chapter, worked by foregrounding the 'authentic' feminine interiority of their heroines, often, as we see with Peggy, through their defective performances of masculinity. And it was this fundamental inability to escape her natural femininity – her true interiority – which made Peggy the ideal role for Dora Jordan's London debut. Responding to a new cultural moment which sought to align internal and external presentation and, as Barbara Maria Stafford has argued, 'pierce to the bottom of all blurred visual signals', Jordan began her London career with a performance which sought to emphasis her own authentic interiority by bringing character and actress together in one unambiguous and coherent identity.[6] Through both the choice of this specific role, and her mode of presentation, Jordan encouraged audiences to associate her with the essence of this 'country girl', who, like Jordan herself in 1785, was a young woman only recently arrived in London. It was a commonality made even more evident by Peggy's humorous comparisons between the country and London. 'Our playhouse in the country is worth a thousand of't; would I were there again!' (17) she exclaims in Act II, for example, reminding audiences of Jordan's own experience working on the York circuit over the last three years. As James Boaden noted when looking back over Jordan's career over forty years later, the actress's 'sphere of observation had for the most part been in the country, and the Country Girl, therefore became her own', with the 'seeming coincidence in the ages of the actress and the character she played' further adding to the effect.[7]

The alignment between actress and role was not achieved solely through the text however. Jordan also made deliberate performance choices which added to the effect; most notably, as portraits of the actress in the role reveal, choosing to wearing her curly brown hair naturally and without powder (Figure 4.1). Writing to her sister-in-law, Elizabeth Sheridan, after watching Jordan perform Peggy, it was a choice which stood out for Mary Tickell, not least because she could hardly see Jordan's face, 'owing to the amazing bunch of hair she had pulled over her forehead'.[8] Rejecting the fashion for powder and wearing her hair in its natural state, Jordan not only made memorable impression, but she deliberately signposted the naturalness of her performance, rejecting, as Gill Perry has argued, the artificiality of theatrical conventions.[9]

Peggy however, was only the first step in what would become a life-long performance of her self through the theatrical frame. Over thirty years and across her repertoire, Jordan worked hard to frame

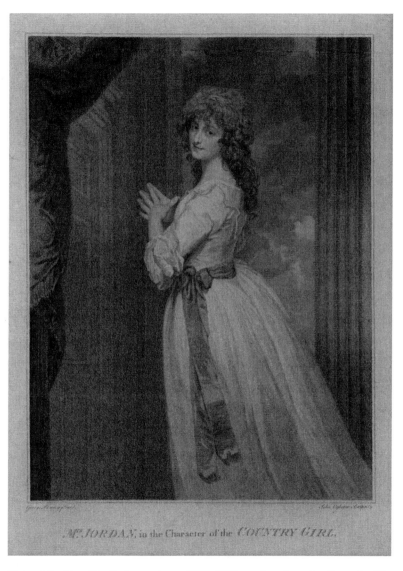

Figure 4.1 'Dorothy Jordan, actress, 1762–1816, as the character Peggy in *The Country Girl*', copy after George Romney by John Ogborne, 1788 (The Art Archive / Garrick Club)

her theatrical performances as expressions of her own 'true' self. She was not alone in doing so. Sarah Siddons, Jordan's contemporary and tragic counterpart mirrored Jordan both in the cultivation of an effect of sincerity – sincerity being defined by Jacob Golomb as the congruence of 'one's behaviour and one's innermost essence' – and in the techniques used to elicit it.[10] Whilst only a few decades earlier Peg Woffington had been celebrated for her embodiment of multiplicity and mutability, now in the final years of the century Jordan and Siddons achieved even greater levels of fame through offering audiences access to their apparently 'real selves' through their dramatic performances.[11] In doing so both these women transformed the way in which women's theatrical performance was understood, re-aligning it within the framework of bourgeois notions of femininity and cultivating in the process a relationship between the personal and the performed which still persists to this day.

From exterior to interior

This radical shift from a mode of performance which split dramatic content from its form and presentation, and reveled in the ambiguity and multiplicity of identity did not, of course, come out of nowhere; nor were actresses like Jordan and Siddons the only cultural figures to explore the notion of a real, inner self at the turn of the century. What Felicity Nussbaum has described as the 'impetus to "write one's self" [and] produce a consumable interiority' had been growing for some fifty years, with the growing market for 'confessions', scandalous memoirs, and autobiographical writings, responding to, and cultivating an increasing fascination with authenticity: the idea, as intellectual historian Charles Guignon writes, that 'lying within each individual, there is a deep, "true self" – the "Real Me" – in distinction from all that is not really me'.[12] Jean-Jacques Rousseau's claim to a singular and self-defining inner life in *The Confessions* had been one of the departure points for a shift away from a plastic notion of personality, opening as it did with the claim that, 'I know my own heart [. . .] I am made unlike anyone I have ever met. I will even venture to say that I am like none in the whole world.'[13] And it was a theme with which Romantic writers were constantly preoccupied, with both novels and poems placing new emphasis on inner psychological depths and requiring individual and original characters rather than types. Re-evaluating the nature of self, these writers affirmed self-possession and authenticity: celebrating the individual who strives to truly know themselves and then transfer

this knowledge outwards into the world. Whilst the notion of selfhood predates the late eighteenth century therefore, it was only in the last decades of the century that the split between inner and outer, was established, enabling individuals to think of their internal selves as 'true' and providing a context in which being 'true to oneself' could be a worthy endeavour in its own right.[14]

The new fascination with interiority was not, however, only a feature of the cultural sphere: a desire to see the body as being a clear and uncomplicated signifier of internal emotions and truth was also evident across the sciences, with new emphasis being placed on what William Godwin described as the 'indissoluble' link 'which binds together the inward and the outward man'.[15] Even for Romantics like Godwin, for whom the self was formed through interaction with the world rather than preceding it, the relationship between interior and exterior remained foundational.[16] And he was not alone in this view: the idea, as articulated by physiognomist Samuel Stanhope Smith, that 'joy and grief, solitude and compassion, objects of attention, habits, manners, whatever occupies the mind, tends to impress upon the countenance its peculiar traits', shaped the way in which many late eighteenth-century individuals thought about their identity and its presentation in the social world.[17] The growing dominance of a hierarchical understanding of sexual identity also played a key role in this fascination with interiority. With its focus on the minutiae of the body as indicators of an essential sexual identity, the two-sex paradigm established the body as the physical projection of, not only an authentic interior self, but a fundamentally *gendered* self. It was in this context, in which external presentation was understood as projecting a true feminine self, that comments such as those by the *Morning Herald* on Sarah Siddons's sister, Mrs Curtis, could be made. Commenting after her public lecture in 1783 that, 'if we may judge from the manners and deportment of Mrs Curtis, she is the last person of whom any thing indelicate can be conceived', for this author the body was a transparent surface onto which a faithful image of Mrs Curtis's interiority, and moral character, was projected.[18]

It is to this cultural fascination with the notion of an authentic inner life and coherent identity projected through the body and into the world, that Jordan and Siddons responded with their 'performances of self' at the turn of the nineteenth century. Through careful attention to performance styles, roles, off-stage image, and how they depicted their work, both women cultivated a perception that their performances were expressions, through the characters, of their own authentic emotions and selves; as Siddons told Tom Moore in 1828, reflecting on her

reasons for retiring from the stage, 'she always found in it a vent for her private sorrows, which enabled her to bear them better' and often 'got credit for the truth and feeling of her acting when she was doing nothing more than relieving her own heart of its grief'.[19] Joshua Reynold's comments on Jordan echo Siddons' description of acting as an expression of her authentic self. Jordan 'vastly exceeded everything that he had seen', Reynolds is reported as saying, 'and really *was* what others only affected to be'.[20] It was a sentiment James Boaden repeated. She was, 'the genuine thing itself', he reflected in 1831:

> That she *imitated* at all, never obtruded itself for a moment upon her audience. There was a heartiness in her enjoyment, a *sincerity* in her laugh, that sunk the actress in the woman; she seemed only to exhibit herself, and her own wild fancies.[21]

It was a significant reversal of the way in which earlier actresses had been expected to perform. Since the mid-century innovations of actors like David Garrick, and acting theorists including John Hill and Aaron Hill, performers had been counselled to surrender themselves to the role, effacing their own identities so that they could transform themselves into another person. Colley Cibber's description of Susannah Mountfort's transformation during her performance in Thomas D'Urfey's play *The Western Lass*, exemplifies this style. Mountfort, he tells us, who 'was Mistress of more variety of Humour' than any other actress he had known, 'transform'd her whole Being, Body, Shape, Voice, Language, Look and Features, into almost another Animal'.[22] Similarly Hannah Pritchard was praised by John Hill for carrying 'with her nothing that is peculiar to herself into the character'.[23] And as the author of the 1744 *Essay on the Theatres: or, the Art of Acting* reminded readers:

> All actors are to seem what they are not;
> Which to perform, themselves must be forgot:
> Their mind must lost in character be shown,
> Nor once betray a passion of their own.[24]

Requiring the performer to efface 'all note, or image of himself', this mode of performance was entirely consistent both with the notion of selfhood as self-loss or release to something greater, and with the perception of identity as mutable.[25]

Now however, in the early nineteenth century, Jordan was celebrated for achieving the opposite effect: praised not for sinking herself into the

character, but rather for foregrounding herself through it. As William Hazlitt reflected in 1821:

> It was not as an actress, but as herself, that she charmed everyone. Nature had formed her in her most prodigal humour; and when nature is in the humour to make a woman all that is delightful she does it most effectually [. . .] Her face, her tones, her manner, were irresistible; her smile had the effect of sunshine, and her laugh did one good to hear it; her voice was eloquence itself: it seemed as if her heart were always at her mouth. She was all gaiety, openness, and good-nature. She rioted in her fine animal spirits, and gave more pleasure than any other actress, because she had the greatest spirits of enjoyment in herself.[26]

By the end of the century the earlier mode of performance in which the actor transformed themselves into another had become increasingly at odds with prevailing discourse, reflecting as it did an earlier cultural understanding of identity as plastic and fluid, and Jordan's performances were a direct response to this shift. As Rousseau's comments on the theatre reveal, the performer's ability to embody multiple, hybrid identities, what Patricia Michaelson has described as 'pliancy of personality', ran counter the construction of an authentic, and knowable inner identity and self, expressed through the body.[27] 'What is the actor's talent?' he asked:

> The art of deception, to take on another character instead of his own, to appear other than he is, to be passionate in cold blood, to speak other than how he really thinks and to do it as naturally as if he really thinks in that way and finally to forget his own situation so much that he transforms himself into another . . . what then is this spirit which the actor draws into himself? A mixture of baseness, falseness . . . which enables him to play all kinds of role except the most noble which is what he abandons, the role of human being.[28]

With their ability to detach their external representation from their 'true' self, the 'immersive' performer presented a direct challenge to the ongoing project of aligning interiority with external, social presentation. As Trilling argues moreover, it was a challenge with potentially widespread consequences, the 'contamination' of the actor being understood to spread to the spectator who contracted, 'by infection the characteristic disease of the actor, the attenuation of selfhood that results from impersonation'.[29]

Tapping into the period's insecurities over the falsity of appearances this mode of acting was particularly problematic for actresses. Women's abilities to falsify their external appearance and social interaction were a constant source of anxiety for contemporaries: being all too aware, as they were, that the female body not only had the ability to reveal its true interiority, but could also conceal and fake. As John Bennett therefore pointedly advised in his *Letters to a Young Lady*, young women needed to cultivate an '*unstudied* openness' since, 'young people are, generally, the most amiable, that are most undisguised'.[30] It is hardly surprising that the actress was frequently drawn on to represent these concerns about femininity. As Hannah More declared in her *Strictures on the Modern System of Female Education*, the life of modern young ladies 'too much resembles that of an actress; the morning is all rehearsal, and the evening is all performance'.[31] With its trade in false appearances and dissembling, the theatre seemed to embody all that troubled the causal relationship between the internal and external self.[32] And the 'immersive' actress with her well-honed ability to imitate and counterfeit was the very antithesis of the virtuous bourgeois woman whose social self was a direct representation of her authentic self.

It was in response to this conflict between acting and bourgeois feminine interiority therefore, that both Dora Jordan and Sarah Siddons constructed their 'performances of self' at the turn of the century. Presenting themselves not as dissembling or transforming themselves into another character – Jordan, Boaden noted was an actress who was 'offended by affectation and false action' – both women framed their performances as expressions of their own emotions, and authentic selves, through the medium of the character.[33] Siddons, as Joseph Haslewood noted, was 'an original; she copies no one living or dead but acts from Nature and herself', prefiguring this with the clarification that nature arises, 'immediately from the sentiments and feelings, and is not seen to prepare itself before it begins'.[34] Whilst the actress who could successfully efface her own self for the dramatic character and transform herself into, 'shapes as various as her Sex's are' certainly continued to speak to many spectators – particularly if we accept, as Geoff Eley argues, that the public sphere was made up of competing, rather than homogenous cultural ideas – Jordan and Siddons's concern with cultivating an effect of sincerity through the expression of their coherent personalities and the portrayal of their authentic selves, reveals a canny response to the prevailing cultural discourse and one which would position them both at the apex of their profession.[35]

Constructing artless performance

Jordan and Siddons's 'performances of self' at the end of the century gave every impression of being the result of a radical change in acting techniques; in fact however, they were simply the result of a change in the way that these women represented their theatrical work. Rather than rejecting 'art' entirely, in the new cultural climate in which they found themselves Jordan and Siddons instead had to mask the artistic work they undertook in a way unnecessary for earlier actors. Indeed, if Siddons rejected art entirely, as Mary Robinson reflected, she would hardly touch the audience in the way she did. 'Acting', as Robinson wrote to John Taylor in October 1794, 'must be the perfection of *art*; nature, rude and spontaneous, would but ill describe the passions so as to produce effect in scenes of fictitious sorrow'.[36] Siddons's success, Robinson suggested, was based on her '*inspiration* [. . .] that *soul* beaming through every veil of fiction, and making art more lovely than even nature in all its fairest adornments'.[37] Echoing John Hill's 1755 description of the actor as needing 'all the sensibility' of someone who on reading a passage is so moved that he is 'unable to give utterance to the words', his whole frame being disturbed and tears interrupting his delivery, yet who also has 'all the command of himself that is necessary to regulate its emotions', Siddons's fellow actress clearly recognised that whilst the Tragic Muse might appear to reject art, in fact she drew on well-established theatrical techniques.[38]

One of these techniques was Siddons's attention to classical sculpture. Commenting on one occasion, that the 'first thing that suggested to her the mode of expressing *intensity* of feeling was the position of some of the Egyptian statues, with the arms close down by the sides & the hands clenched' Siddons reveals herself to be the beneficiary of a tradition of acting which dates back through Garrick to Betterton.[39] As Gildon records in his *Life of Betterton*, studying history painting was essential for the actor who wanted to learn how to mould his face 'to appear quite another Face', while Garrick's *Essay on Acting* (1744) similarly recommends that the actor pay detailed attention to the minutiae of gesture and embodied physicality.[40] Even Aaron Hill's work was based on imitation to an extent. Applying the 'look to the idea', or in other words embodying the correct physicality for the idea being portrayed, Hill highlighted in his *Essay on the Art of Acting*, could produce the same effect as starting with the imagination.[41] Proposing that the body would naturally follow in expressing an idea imaginatively captured in the mind, Hill's method, as Paul Goring has argued, internalised the

act of imitation in order to offer an external sign which was genuine.[42] Whilst Siddons might use the same performance techniques drawn on and recommended by generations of actors before her, there was one key difference. Where these men were open in their use and discussion of these techniques, even to the extent of publishing on the subject, Siddons, like Jordan, had to work hard to mask the application of these techniques in their own work. The fact that Tom Moore, who records Siddons' comment on the Egyptian statues in his diary, is forced to re-evaluate his notion of Siddons as a result of hearing this revelation, highlights how well she achieved this. As Moore writes, he now had to allow 'a more intellectual feeling as to her art that I have ever given Mrs Siddons credit for'.[43] For Moore, the disclosure that considered study and reflection had been important for Siddons ran counter to the image of untaught skill so carefully constructed both by her and her commentators.

Rather than developing a new mode of acting then, both Jordan and Siddons developed what I will term 'techniques of sincerity': approaches which worked to mask the fundamental theatricality of what were, in fact, well-planned performances, and which framed their hard work as spontaneous, unrehearsed, original and effortless. They were techniques which functioned to distance the actual performance approaches employed from the audiences' perception of the performance and its creation. Yet despite this gap between perception and actuality, contemporary reviews, as well as Jordan's and Siddons's own reflections, can offer glimpses of these techniques of sincerity, revealing just how these performances of self were achieved.

Careful attention to the physical expression of emotions, and the replication of this on stage, as we have already seen with Siddons's use of the Egyptian statues, was one of these approaches, but it was not restricted to the extreme emotions of tragedy: across Jordan's comic performances we also see evidence of mimesis, although in her case, of realistic, everyday, familiar behaviours. In Leigh Hunt's description of Jordan's performance as Peggy in *The Country Girl*, for example, we get a glimpse of how the imitation of familiar details, even in small moments, created an impression of naturalness and authenticity. 'The very sound', he writes:

> of the little familiar word *bud* from her lips (the abbreviation of hus-
> band), as she packed it closer, as it were, in the utterance, and pouted
> it up with fondness in the man's face, taking him at the same time by
> the chin, was a whole concentrated world of the power of loving.[44]

Painting a vivid picture of a moment of performance, perhaps from Peggy's first appearance in Act II when, assuring her guardian Moody that she loves him best of any, she promises 'You are my own dear Bud, and I know you; I hate strangers' (19), Hunt demonstrates how Jordan's intonation and specific, commonplace gestures framed her performed emotions as sincere. It is a style evident in yet another, and this time slightly more comprehensive description, this time of Jordan's laughter which Hunt described as the 'happiest and most natural on the stage'.[45] 'If she is to laugh in the middle of a speech' he recorded in 1807:

> it does not separate itself so abruptly from her words as with most of our performers; she does not force herself into those yawning and side-aching peals, which are laboured on every trifling occasion, when the actor seems to be affecting joy with a tooth-ach [*sic*] upon him or to have worked himself into convulsions like a Pythian priestess; her laughter intermingles itself with her words, as fresh ideas afford her fresh merriment; she does not so much indulge as she seems unable to help it; it increases, it lessens with her fancy, and when you expect it no longer according to the usual habit of the stage, it sparkles forth at little intervals, as recollection revives it, like flame from half smothered embers.[46]

In this wonderfully expansive description Hunt reveals Jordan's minute attention to realistic detail and the effect of naturalness and spontaneity it fostered. Not only did Jordan reject the conventions of stage laughter evident in other actors' work but, in breaking up the text with her laughter, varying its intensity, and reviving it after appearing to have finished laughing, she imitated a recognisable, realistic pattern. As a result, as Hunt says, she gave every appearance of being unable to control herself. Despite detailing, and somewhat paradoxically, appearing to recognise the technique which Jordan used to create a natural effect, Hunt therefore concluded that, 'this is the laughter of the feelings; and it is this predominance of the heart in all she says and does that renders her the most delightful actress'.[47] Drawing on what appeared to be her own innate humour and joyfulness, Jordan's laugh seemed to bubble up out of her, appearing at once both sincere and original. It is a moment which typifies Charles Lamb's reflection on her performances: that there was 'no rhetoric in her passion; or it was nature's own rhetoric [. . .] it seemed altogether without rule or law'.[48] Eschewing familiar theatrical gestures, and thereby distancing herself from any implication of imitation, whether of previous performers, or styles, Jordan created

her own style out of the familiar and everyday, appearing, as a result, to perform from her self.)

The apparent spontaneity of Jordan's laughter in *The Country Girl* also points to another technique of sincerity: the denial of training and preparation. She seemed, as James Boaden highlighted simply to 'utter the impromptus of the moment', a sentiment echoed by Sir Jonah Barrington who noted, reflecting back on seeing an early appearance by the actress in Dublin, that:

> she was *perfect* even on her first appearance: she had no art, in fact, to study; Nature was her sole instructress. Youthful, joyous, animated, and droll, her laugh bubbled up from her heart, and her tears welled out ingenuously from the deep spring of feeling.[49]

This was not, of course, entirely true: Tate Wilkinson, for example, records the theatre critic Cornelius Swan teaching her to act in Yorkshire and sitting at her bedside when she was ill, instructing her in the character of Zara.[50] At the same time however, Jordan was not the first performer to be talked about in this way: as the eponymous heroine of Burney's *Evelina* (1778) commented on seeing Garrick perform, 'I could hardly believe he had studied a written part, for every word seemed spoken from the impulse of the moment'.[51] Yet whilst the emphasis on performative impulsivity was evident prior to the 1780s, Jordan was one of the first to draw on this discourse herself in order to frame her theatrical performances. Like the Romantic poets who were concurrently foregrounding immediacy across their work and developing what Jerome J. McGann has described as 'a set of stylistic conventions' which gave 'the illusion of "spontaneous overflow"' and a sense of sincerity to their verses, Jordan worked to create a spectre of spontaneity and an illusion of artlessness in her theatrical performances.[52]

Of course 'natural' talent and spontaneity had long been an ingredient in performance. The difference however, was that previously they had been considered partners to 'art' and preparation. For the Roman rhetor Quintilian, whose theory informed rhetorical acting styles, 'nature' or spontaneity had to be carefully balanced with premeditation ('care, art, polish'); in 1731 Anne Oldfield had been eulogised for being, 'with ev'ry Art and Talent form'd to please'; and in the middle of the century Thomas Wilkes had professed that it was 'study and practice that must improve that genius to such an accuracy and perfection as will stand the examination of the most judicious critic and impartial judge'.[53] And whilst there had been exceptions to this partnering of

art and nature – the seventeenth-century actor Jack Verbruggen being posthumously praised for being 'wild and untaught', a 'rough diamond [which] shone more bright than all the artful, polish'd Brilliants that ever sparkled on our stage', and his wife Susannah Verbruggen being, 'all Art, and her Acting acquir'd but dress'd so nice, it look'd like nature' – as a rule, actors had been understood to require training and preparation to hone their natural talents.[54]

At the end of the century however, emphasising the absolute rejection of any form of study, practice or 'art', Jordan presented her acting as the spontaneous expression of unrefined, unmodified 'nature'. As she was reported to have told a friend, she had negated all but the most basic necessity of art: that of learning her lines. As she informed Sir Jonah Barrington in 1809:

> Had I formally studied my positions, weighed my words, and measured my sentences I should have been artificial, and they might have hissed me; so, when I had got the words well by heart, I told nature I was then at *her* service to do whatever she thought proper with my feet, legs, hands, arms, and features. To her I left the whole matter; I became, in fact, merely her puppet, and never interfered further myself in the business. I heard the audience laugh at me, and I laughed at myself; they laughed again, so did I; and they gave me credit for matters I knew very little about, and for which Dame Nature, not I, should have received their approbation.[55]

It was an approach which she was purported to have repeated in a conversation with the journalist Helen Maria Williams in the last weeks of her life: 'My scenic endowments appear to me to have been attended with so little study', she supposedly commented:

> and even the points eliciting most applause, were such ebullitions of the moment, that I must regret, as I before stated, they did not merit the commendations heaped upon them by a generous and open-hearted public.[56]

Like Jordan, Sarah Siddons also portrayed herself as lacking training or preparation: as performing spontaneously from the heart. Describing herself at the start of her London career, in her 'Three Reasons for Quitting the Bath Theatre', as 'an untaught Muse' and at the end, in her *Reminiscences*, as an 'untaught, unpractised Girl', Siddons's claim to lacking 'art' was threaded throughout her career.[57] As she responded at the height of her

fame, when interrogated for the 'grand secret of her acting with such wonderful effect' by a group of Bluestockings, hers was a mode of acting in which she simply 'did her best'. 'Mrs Montague was deputed deputy prolocutress on this important occasion', Siddons records:

> 'Pray, Madam,' said she, very seriously, 'give me leave to interrogate you, and to request you will tell us, without any duplicity or mental reservation, upon what principle you conduct your dramatic demeanour? Is your mode of acting, by which you obtain so much celebrity, the result of certain studied principles of art? Have you investigated, with profound research, the rules of elocution and gesture as laid down by the ancients and moderns? Have you reduced these rules to practice? Or do you suffer nature to predominate, and only speak the untutored language of the passions?' – 'Ladies,' replied the chief favourite of Melpomene, modestly yet unhesitatingly, 'indeed I know not how to answer so learned a speech. All I know of the matter is, that I always *play as well as I can.*'[58]

Not only did Siddons here refuse to be drawn on how she constructed her performances, but she feigned ignorance of the very conventions of contemporary performance, professing herself unable to respond to such a 'learned speech'. If, as Jacob Golomb argues, 'to be authentic is to invent one's *own* way and pattern of life', denying 'any rigid a priori essence' and rejecting 'any intrinsic value in compliance with a given set of standards', then by denying external influence and claiming simply to play as best as she could, Siddons positioned herself as an authentic subject.[59]

The claim to authenticity is also evident across descriptions of Jordan as, in Sir Jonah Barrington's words, the 'untutored child of nature', as well as being echoed in Joshua Reynolds' comments on seeing Jordan perform.[60] Studying 'children with the greatest care, when they imagined themselves unobserved', Boaden tells us, Reynolds, 'could permit to every part of the frame its unrestrained genuine motion' and was 'quite enchanted, therefore, with a being, who, like Jordan, ran upon the stage as a play-ground, and laughed from sincere wildness of delight'.[61] Like the best actors, who German Enlightenment actor Conrad Ekhof declared could imitate, 'that spontaneous gesture, observed in "nature", in the "ordinary man", the child, and the savage who have not been deformed by cultivation and social behaviour', Jordan's performances gave every appearance of being unshaped by social or spectatorial influences.[62]

With this emphasis on the authenticity of children, it is no coincidence that Jordan made her name playing a character defined by her child like qualities. Peggy is a girl (rather than the wife of William Wycherley's original version) who from a young age has been secreted away by her guardian, Moody, and kept apart from society in the country. She is therefore an essentially un-socialised character.[63] As well as apparently hardly being able to write (although she is certainly able to when the plot device of crossed letters requires it), she has, as Harcourt tells Belville, 'seen nobody to converse with, but the country people about 'em; so she can do nothing but dangle her arms, look gawky, turn her toes in, and talk broad Hampshire' (8). So ignorant is this 'simple' creature, as she is repeated called, that Moody has convinced her, on the basis of 'breaking a six-pence, or some nonsense or another, that they are to all intents married in heaven' (11) with only the signing of papers and a church service being required to complete their union'.

Lacking socialisation, Peggy remains innocently trusting, physically unconstrained, and simple in her speech, as revealed not least (and to what we can presume would have been great laughter), by her comment that at the theatre she 'lik'd hugeously the actors; they are the goodliest, properest men' (15). Revealing not only her uncultivated language, but also her ignorance of social norms – the joke working by dint of the traditional reputation of actors as anything but goodly, proper men, as well, of course, as through the metadramatic irony of an actress speaking such lines – Peggy proves herself naive, honest, and guileless. In many ways however, the play is the story of Peggy's socialisation, with this innocent country girl learning to deceive and dissemble in order to act on her attraction to Belville. As Moody himself professes, it was love which 'gave women their first craft, their art of deluding; out of nature's hands they came plain, open, silly, and fit for slaves' (48). Yet it is not only through her attraction to Belville that Peggy learns to dissemble and 'act', but also as a result of becoming aware of his gaze. Like Reynolds' children who are only authentic when they imagine themselves unobserved, on learning of Belville's attention Peggy soon learns to perform in response to the expectations and demands of her 'spectator'.

The impossibility of an individual maintaining their authenticity once they were aware of being observed was a challenge for actresses like Jordan and Siddons. Whilst this theatrical paradox – the need to stage the unstageable inner self – extends, Matthew Wikander argues, back to European early modern drama, it was a point of particular concern in the late eighteenth century, as Rousseau's *Letter to D'Alembert* reveals.[64]

Struggling with the idea that any exposed self in public is necessarily inauthentic, since the true self cannot be exposed, Rousseau's concern, as David Marshall argues in his analysis of the *Letter*, was not only with the deception and falsity of acting but also with the inescapable fact that 'people become actors [. . .] from the moment they are aware that they must represent themselves for others'.[65] The fundamental paradox for actresses like Jordan and Siddons was, therefore, that the authentic inner identity they claimed to express externally was invalidated by its projection on a public stage. Actresses were not however, alone in being placed in this problematic position: fictional heroines also found themselves subject to the dual impulses of revelation and concealment. And in their example we get a glimpse of the strategies used by actresses to negotiation this problem on the stage. As Christine Roulston argues, the literary heroine, 'must neither fear the revelation [. . .] nor show any awareness that they are being revealed [since] it is in the liminal space between revelation and innocence that the authentic female subject comes into being'.[66] Whilst earlier actresses had engaged directly with spectators, acknowledging them with curtsies, nods and even on occasion engaging them in conversation therefore, Jordan distanced herself from this interaction. As she informed Sir Jonah Barrington, 'the best rule for a performer is to forget, if possible, that the audience is listening [. . .] I scarcely ever saw a good performer who was always eying the audience'.[67] Both on display and yet purportedly unaware of the spectator's gaze, Jordan responded to the theatrical paradox of staging the unstagable authentic self by locating her performances within a liminal space. In a theatrical culture in which, until recently, audience members had sat on stage, and often interrupted performances, this was a radical shift in the relationship between audience and performer.[68] However developments in scenographic design and technique, and the increasing size of the theatres (with Drury Lane holding over 3600 by the end of the century), had already begun to create a distance between the audience and performer. As such, the physical and scenic environment enabled Jordan to construct a perception of her performances which would have been impossible earlier in the century. Creating the illusion that she had forgotten the audience and was performing for herself rather than for the gratification of her public – a reversal of the rhetorical stance which demanded the actor face the audience in order to transmit the passion to them – Jordan's performances mark what Lionel Trilling has described as the artist's shift from being 'a craftsman or performer, dependent upon the approval of the audience' to a being a figure whose 'reference is to himself only'.[69] Developing as as part of

the 'cult of genius' in the nineteenth-century, this idea that the artist was an entity in his or her own right, and that, as Charles Guignon puts it, 'all that really matters in art is that the creative genius authentically expresses him – or herself', was already well established in the performances of women like Jordan and Siddons at the turn of the century.[70]

Managing the authentic self

Throughout their careers, Jordan and Siddons's successes in affecting sincerity were reliant not only on their development of the theatrical techniques explored above, but also on their careful management and coherence both of their stock of roles and of their on- and off-stage personas. As Jacob Golomb notes, a key facet of authenticity is the appearance of a 'whole, congruent and harmonious personality in the existentialist quest for individuum, which rejects any symptom of dividuum within one's authentic self'.[71] For Jordan and Siddons' performances to be perceived as expressions of their true selves it was not enough therefore for them simply to appear natural, spontaneous, and original in performance; they also had to ensure a consistent image across both the different roles they played, and across their personal, professional, and dramatic appearances. Whatever the role, and whether they appeared in a play or at a social occasion, Siddons and Jordan had to be consistently and recognisably 'themselves'.

On stage this was achieved through the development of what I will term an 'authentic theatrical signature': a repeated style which is reproduced in variant forms throughout actresses' performances both on- and off-stage.[72] The evidence of this signature is extensive. As William Hazlitt reflected, 'Mrs Jordan was the same in all her characters, and inimitable in all of them, because there was no one else like her.'[73] And it was a point echoed by James Boaden when he responded to the criticism that Siddons had performed in the same manner across three different plays. 'This I consider to be the highest compliment that malice or folly ever paid' he declared, since:

> The styles of performance CANNOT be different, when the original manner was drawn from actual nature; because this would be a gross error in philosophy, where the effects should be different, the causes remaining exactly the same.[74]

Only through the consistent repetition of their style of performance could Jordan and Siddons ensure that their performances were perceived

as authentic expressions of self. After all, as Jeremiah Jones noted in 1798, whilst it is easy to counterfeit a name, age, country or opinions, it is 'almost impossible with any exactness to imitate another's style [since] every man has his peculiar air in moving, speaking [. . .] and many other things by which he is distinguishable from others'.[75] To convince audiences of their originality and sincerity, Jordan and Siddons therefore had to repeat these behavioural traits across their many roles.

Ensuring consistency of style across different roles also however, determined the types of roles which both women could take on. Whereas in the early years of the century Anne Oldfield had been celebrated for being, 'an exact Copy of the Woman of Fashion, and the modish Coquette [. . .] a roguish wheedling artful Miss [. . . and] the buxom wanton Wife', as well as for excelling in tragedy, Jordan and Siddons had to be far more strategic in the cultivation of their stock of roles.[76] For Jordan this often meant playing lighthearted, romping hoydens and girls. This did not solely restrict her to comedy however. Indeed nothing, wrote Leigh Hunt of her performances in *Hamlet*, could be 'more natural or pathetic than the complacent tones and busy goodnature of Mrs JORDAN in the derangement of *Ophelia*; her little bewildered songs in particular, like all her songs indeed, pierce to our feelings with a most original simplicity'.[77] Although Ophelia might be a tragic heroine, as Hunt was keen to point out to readers, it was a role which worked well with Jordan's authentic theatrical signature. 'A great distinction' as he wrote:

> must be made between characters originally and essentially tragic, and those which become so by some external means that do not change their disposition; between characters in short which are tragic on account of what they have done or felt, and those which become so by what is done to them: in the former case a general solemnity and sorrow is necessary in the performer, in the latter the character may still preserve it's [*sic*] sprightliness in its utmost tragedy as *Ophelia* does in her madness, so that the tragic effect of such a character does not consist in the performer's powers of tragedy but in the contrast which it's misfortunes make with its' [*sic*] behaviour.[78]

Rather than being tragic because she figures in a tragedy, Ophelia, as Hunt points out, is an essentially 'sprightly' character – a term not infrequently applied to Jordan herself, with Boaden describing her as having, 'an action full of sprightliness and grace' – whose nature

continues to shine through despite her misfortunes.[79] The tragic effect so well achieved by Jordan came not, Hunt therefore points out, from the actress's virtuosity in the tragic form, but rather from her skills in playing innocent, joyful girls. It was the contrast between Ophelia's nature and her tragic situation which was so appealing.

Of course just as certain characters from tragedy were compatible with Jordan's authentic theatrical signature, there were characters from comedies who were not: as Jordan discovered to her cost when trying to expand her range by taking the retiring Elizabeth Farren's roles in April 1797. With these characters being, as Boaden commented, 'produced by fashion rather than herself', they were incompatible with Jordan's signature, and were consequentially poorly received.[80] She also failed when she attempted Imogen in *Cymbeline* in November 1785. Jordan 'had not the natural dignity of the wife of Posthumous' records Boaden, 'she could not burst upon the insolent Jachimo in the terrors of offended virtue', nor could she 'wear the lightnings of scorn in her countenance'.[81] Whilst Jordan was highly successful in constructing an authentic theatrical signature, on occasion, as such examples reveal, she also sought to expand her range beyond the character types which were fundamental to her success. Perhaps in these roles she saw the potential to develop her style further and incorporate a wider range of roles, or perhaps she simply wanted to break free from the theatrical limitations she had constructed and try out different types of roles. Whichever it was, an audience trained to accept her performances as expressions of her authentic self could not countenance the apparent gap between self and performance which these 'experiments' revealed. And the same was true when Siddons ventured into light-hearted roles. Her attempt to perform Rosalind, as Anna Seward reflected, did not suit 'the dignity of the Siddoniad form and countenance', lacking the 'playful scintillations of colloquial wit, which most strongly mark that character'.[82] Similarly, when Sir Gilbert Elliot reflected on the performance of *Julia* in 1787, Siddons's excellence in the tragic mainpiece was sharply contrasted with her failure in the comic epilogue which exposed, 'her want of all comic power and familiar easy levity'.[83] It was, as he wrote, 'like the ass playing the lap-dog; and though we did not wish to reject her gambols with a cudgel, like the man in the fable, yet we all longed for the real lapdog, Mrs Jordan, in her place'. Siddons, like Jordan, clearly found that success at establishing an authentic theatrical signature came with limitations.

As we see in private letters and the recollections of intimate acquaintances however, Jordan and Siddons's respective leanings to perform in

tragedy and comedy reflected their off-stage, personal lives far more than many contemporaries realised. Whilst Siddons certainly had her fair share of personal tragedy, suffering with illness, miscarriage, marital discord, and the deaths of her daughters Maria, in 1798, and Sally, in 1803, close acquaintances also testify to the fact that she was a lively, droll character. 'Mrs Siddons, could be infinitely comic when she pleased', Hester Piozzi was reported as saying on one occasion, 'and was among her intimates; though anything but a comedian on the boards'.[84] Anne Jackson, the wife of the actor Matthew Jackson echoed this comment, recording in her husband's biography that Siddons was, 'addicted to drollery':

> She was very fond, in private society, of adding, like the *Old Scotch Lady*, 'her little mite to the conviviality of the evening,' by singing, with a tristful countenance, the burlesque song called 'Billy Taylor', and I will venture the assertion, from many evidences, that both Mrs Siddons and Mr John Kemble had a bias, I may say a great leaning, towards comedy.[85]

Just as Siddons enjoyed comedy and amusement in the private company of close friends and acquaintances however, Jordan's letters reveal her constant struggles in the face of sorrow and distress. In the early years of her career Jordan's concern to provide for her ever expanding family was frequently accompanied with the distress and loneliness she felt at being away from her family when on tour; in the latter years her concern over her elder boys' entering into military service, her separation from William in 1811, and her unscrupulous son-in-law's theft of her money which eventually sent her fleeing to France to escape creditors, dominated her thoughts. Melancholia, depression, and worry, these letters reveal, were often simmering beneath Jordan's public, professional image as joyful and lighthearted. When George, her eldest son with William, was posted overseas in the navy at the age of fourteen, Jordan's maternal angst was a constant wear on her, and at no point more so than when waiting to hear from him after he led a squadron at Toulouse in April 1814. As she wrote to him, 'it is impossible to remove my fears – and til I hear again, my bitterest enemy [. . .] would pity my feelings'.[86] The spring of 1814 was a difficult time for Jordan in a number of respects: in addition to her concern over George, her second daughter by Richard Ford, Lucy, almost died in childbirth. Confined and blessed twice, there had seemed to be little hope of recovery and Lucy, as Jordan wrote to George, awaited 'her doom with the resignation of an angel'. For Jordan the suspense of waiting was 'almost too

much to bear' and she was 'in the greatest misery & distress expecting to see one of the most amiable young creatures in the world breath her last'.[87] Whilst publicly she might be seen as a figure of 'unbounded hilarity' who, as the *Morning Post* put it in reviewing her performance in Bath in February 1814, expressed such 'vigour of action and cheerfulness of air' that she seemed to 'tell the audience that her gaiety is not only natural, but invicincible', the reality of Jordan's personal life was more complex.[88] Only a month earlier, whilst on her way to perform at Bath in fact, she had revealed to George that rather than being the outpouring of her self on stage, acting served as a means to forget her woes: 'I begin to feel' she wrote to him on 6 January, 'that acting keeps me alive – in fact it keeps me from <u>thinking</u>'.[89]

With their personal lives resisting the coherence needed to present their performances as authentic expressions of self, in public situations both Jordan and Siddons worked hard to mask those aspects of their personalities which failed to fit their respective images as the comic and tragic muses. For Siddons this meant maintaining a persona of dignity and solemnity across her social appearances. Sir Gilbert Elliot recounted the impression she cultivated, after 'supp[ing] at Windham's' with the actress in 1787. 'Mrs Siddons is very beautiful in a room', he wrote:

> But of the strong powerful sort of beauty that reminds one of a handsome Jewess. She does not speak much, and that modestly enough, but in a slow, set, and studied sort of phrase and accent very like the most familiar passages of her acting, but still in a degree theatrical.[90]

Five years earlier Frances Burney had made a similar observation. Writing in December 1782 about one of Mary Monckton's famously informal dinners, Siddons, Burney reflected, 'behaved with great propriety, very calm, modest, quiet, and unaffected . . . [and with] a steadiness in her manner and deportment by no means engaging'.[91] Although this off-stage performance might have palled on people like Burney, by acting in social settings using the same authentic theatrical signature as spectators would see on stage, Siddons elided the gap between her social and dramatic expression, encouraging audiences to read the former both through, and in, the latter.

These social performances were not, however, without effort. In fact Siddons's own recollection of having dinner at Mary Monckton's depicts it as a very trying occasion. Faced with a large crowd who had come to observe the new Tragic Muse, instead of the small party she had expected, she was, she tells us, tormented with 'ridiculous

interrogations' by the 'Blues', and subsequently 'often declined the honour of such invitations'.[92] A comment by Horace Walpole affirms that this was the case. 'Mrs Siddons continues to be the mode, and to be modest and sensible' he wrote in 1782, however 'she declines great dinners, and says her business and cares of her family take up her whole time'.[93] It was certainly a valid excuse and one Siddons herself used, pointing out in her memoirs that 'professional avocations alone, independently of domestic arrangements, were of course incompatible with habitual observances of Parties and Concerts'.[94] Yet whilst the demands of regular performances, touring, and young families would certainly have given Siddons little time to take part in London's social circuit, her reticence also reflects the effort involved in performing on this social stage.

For Jordan, performing in social situations the 'youthful, joyous, animated, and droll' persona she had cultivated on stage was not quite as challenging, and at dinner parties, as one of her biographers noted, her 'affability of manners and sweetness of deportment were the general themes of admiration'.[95] Even so however, this constant self-presentation was clearly demanding and her letters are peppered with descriptions of her attempts to avoid company, not only because she wanted to avoid the attentions of her admirers but also because of the constant demand to perform as 'herself'. In Margate in September 1802, for example, she wrote home that she had refused the 'great honor' of a dinner invitation from Lady Wittingham, which 'I suppose surprised the party not a little'. 'The people', she added:

> say it is very unkind of Mrs Jordan not to be seen <u>any where</u> but at the theatre – I go out early with poor Floyd and my sister and walk by the sea, and this I find sufficient amusement.[96]

In fact, as she informed William, 'because I go out so little the door of the house is beset with people half the day, which is very unpleasant' and sometimes, in an effort to avoid these crowds sometimes she even had to make her 'escape at the back door'.[97] Jordan's evasion of company is a regular feature in her letters: in October 1808 she wrote from Bushy that, 'I see no one and am glad of it – the frivolous conversation of visitors I can easily dispense with', whilst on tour in Bath the following year she wrote home a number of times saying that she has gone for walks when the rest of the town was quiet.[98] Motivated not just by a weariness with the demands of an emergent celebrity culture, Jordan, like Siddons, seems to have recognised that the fewer appearances she

made as 'herself', the less likely it was that her public, social self would be found out for the constructed performance it really was. With society's gaze destroying authenticity – as Guignon reminds us, 'at some level, to be authentic is already to be asocial' – avoiding social situations helped both women maintain the image of authenticity which was so central to their successful performances of self.[99]

Masking their performativity and aligning their on- and off-stages personas to cultivate an understanding of their dramatic work which fitted within, and reflected, post-enlightenment ideals of selfhood, both Siddons and Jordan worked hard at the turn of the century to cultivate an effect of sincerity. Yet in responding to the shifting cultural landscape in this way, paradoxically they undertook the most comprehensive and artful performances since the arrival of the actress in 1660. And in cultivating this impression of a coherent, stable, and authentic subjectivity through the exclusion and suppression of contradictory elements, they also revealed the tenuousness of the sincere, authentic subject itself, exposing it as an unavoidable product of artifice.

Rather than undermining the bourgeois notion of sincerity however, Jordan and Siddons's performances embodied the continual self-management and regulation which were at its heart. All too aware of its potential to both display and conceal, eighteenth-century culture required the body, and in particular the female body with its greater capacity to insincerity and dissembling, to be carefully regulated: a self-monitoring which Patricia Michaelson notes protected the virtuous bourgeois lady against impropriety.[100] Constantly on guard, and managing their emotions in response to expectations and social perceptions, the bourgeois individual, as Ruth Grant has argued, therefore became, 'alienated and inauthentic, never himself, never in public life what he would privately wish to be':

> Subjected to the pressures of modern life in commercial, liberal societies, he must create a phoney self to satisfy his anxious concern to be pleasing, to be acceptable, or respectable in the eyes of others.[101]

Constructed authenticity is, as Grant reveals, unavoidable for the bourgeois individual, indeed it is a necessity of it. And as such the in/sincere performances of self which Jordan and Siddons offered both on stage and in life rather than challenging bourgeois ideals, embodied the contradiction at their heart.

As well as acting out the paradox of authenticity however, these performances also went further, collapsing the binary of in/authentic

and in/sincere and searching out a way of being at once both truthful and constructed. As such they mirrored, perhaps even set the template for the engagement with notions of selfhood taking place across the cultural sphere. In discussing female poets of the 1790s and the ways in which they used dramatic versions of their private selves to fashion public personas, Judith Pascoe points out that rather than simply threatening to substitute 'theatricality for sincerity and multiplicity for authenticity', these women's poetry melded such apparently contrary ideas, cultivating what she terms a 'theatrical sincerity and a multiple authenticity'.[102] Similarly, in her discussion of the dramatic works of Eliza Haywood, Elizabeth Inchbald, and Maria Edgeworth, Emily Hodgson Anderson notes how theatricality does not necessarily go hand-in-hand with a superficial and protean sense of self: in consciously performing their feelings, and even anticipating how and when they will express certain emotions, these women's dramatic characters she argues, 'illustrate that feelings could be both staged and sincere, at once personal and performed'.[103] Blurring the lines between sincerity and performance, and constructing an authentic self through careful regulation, perhaps therefore Jordan and Siddons' success came as much from their embodiment of the complex dynamics at the heart of bourgeois ideals, as it did from their simple reflection of bourgeois ideals of the authentic self.

5
Playing Mothers: 'Stand forth ye elves, and plead your mother's cause'

In July 1775 David Garrick wrote to his friend, the Reverend Henry Bate, editor of the *Morning Post*, asking him to make a stop in Cheltenham on his way to Worcester. The reason, Garrick informed Bate, was that he wanted a report on a promising young actress. This provincial performer, Garrick had been informed, wanted to 'try her Fortune' at Drury Lane and the manager needed Bate to ascertain both whether she seemed 'worthy of being transplanted' and 'upon what conditions she would make yᵉ Tryal'.[1] Bate did as requested, and having watched the twenty-year old actress playing Rosalind in *As You Like It* he produced a detailed report for Garrick, detailing each of her qualities. Her face, he informed the manager, 'is one of the most strikingly beautiful for stage effect', yet this was 'nothing to her action, and general stage deportment which are remarkably pleasing & characteristic'.[2] Unfortunately however, these qualities jarred with the shape of her body which, Bate noted, although likely to 'be remarkably fine' would only be revealed as such 'when she is happily delivered of a big-belly, which entirely mars for the present her whole shape'.[3] The actress, it turned out, was visibly pregnant. And for Bate, the temporarily misshapen body of the mother-to-be was at odds with the aesthetic qualities he expected in an actress. Pregnancy in its physically manifestation, for this critic at least, detracted from her performative appeal. For Garrick however it was the practicalities of the actress' pregnancy which were the primary concern: 'your account of the *big belly* alarms me!' he wrote back to Bate in an agitated tone, 'when shall we be in shapes again? how long does the lady count? when will she be able to appear?'[4]

This image of the actress's pregnancy conflicting with her professional role, whether aesthetically or pragmatically, is of particular note because of its subject. Within a decade of this comment being made the actress

117

in question, Sarah Siddons, would be the most celebrated performer in the country and it was a success achieved, to a great degree, through a careful re-positioning of the relationship between her professional and her maternal identity: the very aspect embodied in her fecund body in 1775. From 1782, when Siddons left the Theatre Royal, Bath to make her second debut at Drury Lane (her first attempt under Garrick in the 1775–1776 season having been a failure) she began to weave together her personal experiences and emotions as a mother, her public identity as an actress, and her dramatic representations of motherhood on stage. Going a step beyond the performances of self we explored in the previous chapter she therefore encouraged audiences to see her dramatic performances of tragic mothers as the specific expression of her authentic maternal self. More than this however, by responding to what was, by the penultimate decade of the century, the quintessence of bourgeois femininity, Siddons also spoke to what Linda Colley has called the 'cult of prolific maternity', tapping into the contemporary zeitgeist.[5] With images of motherhood permeating the cultural sphere – in the production of sentimental and melodramatic images of suffering mothers; in the proliferating conduct literature advising women on their maternal duties; and in the new attention being paid to maternal breastfeeding – Siddons' performed motherhood, as the expression of her own authentic motherhood, positioned her as a cultural touchpoint for a society obsessed with the maternal.[6] Yet her success came not only from her embodiment of dominant maternal discourse; complicating the idealised image of bourgeois maternity through her inescapable status as both an economically-active and professionally-ambitious mother, Siddons also spoke to what was, for many contemporaries, the reality of the maternal role: the need to balance economic labour with being a 'good' mother.

Performing mothers

On 10 October 1782 Siddons made her second debut at Drury Lane, six years after she had left the theatre having failed to impress either the management or the London audiences.[7] Now however there was a new manager, Richard Brinsley Sheridan, and Siddons had a chance to start afresh. The role chosen for the occasion could not have been more different from the strong heroine of Shakespeare's *Merchant of Venice*, the part she had first appeared in seven years earlier. Isabella, the eponymous heroine of David Garrick's *Isabella; or The Fatal Marriage* is, above all else, a mother.[8] And on that stage so was Siddons, because

performing alongside her, in the role of Isabella's fictional son was her own eight-year-old boy, Henry. Making her debut alongside her eldest child was a canny move. From the moment she stepped out from the wings of the stage Siddons was the living image of both real and fictional motherhood. And it was a duality, as Robyn Asleson has argued, which led audiences to 'confuse the sentiments that the actress feigned on the stage with her actual feelings as a mother'.[9] In fact, audiences had been prepped to confuse the real and fictional even before Siddons appeared on the stage. As the *Morning Post* wrote on the morning of 10 October:

> Mrs Siddons, of Drury Lane theatre, has a lovely little boy, about eight years old – Yesterday, in the rehearsal of the fatal marriage [*sic*], the boy, observing his mother in the agonies of the dying scene, took the fiction for reality, and burst into a flood of tears; a circumstance which struck the feelings of the company in a singular manner.[10]

Whilst readers, like the rest of the company, might have smiled indulgently at the naiveté of the young boy, the central conceit, that Siddons' own son was unable to distinguish between his mother's authentic and performed emotions, was a powerful one and served, in conjunction with Henry's presence on stage, to encourage audiences to interpret Siddons's performance as the expression of her real, maternal emotions. It was a strategy which was overwhelmingly successful. Audiences flocked to see the new star; the play was performed eight more times, as well as being revived another twenty-two times that season; and the image of mother and son was replicated across a plethora of prints, miniatures, drawings and paintings of the play (Figure 5.1). Producers of poetic and literary tracts also jumped on the bandwagon. The author of *The Theatrical Portrait, A Poem on the Celebrated Mrs Siddons*, memorialized her performance as 'The hapless Mourner of a Husband lost' in vivid terms:

> Her tender Infant all her Care employs
> Life of her Life, and Soul of all her Joys!
> She sees in him his Father's Image rise,
> And all her Soul is in her ravish'd Eyes.[11]

Drawing directly on Isabella's words in Act I, where she declares 'My bury'd husband rises in the face / of my dear boy' (7), the emphasis in the poem, as in all the visual and textual commentaries, was upon the

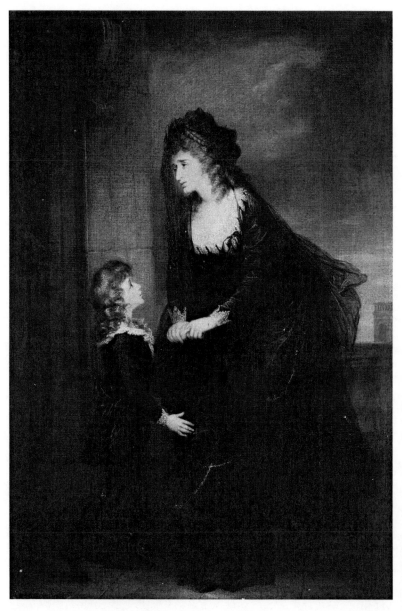

Figure 5.1 'Mrs Siddons & Henry Siddons in Isabella or the Fatal Marriage by David Garrick' by William Hamilton, ca. 1785 (The Art Archive / Garrick Club)

image of motherhood Siddons embodied.[12] 'She came upon the stage with her son', recorded James Boaden:

> her head declined slightly, her eye resting upon her son. The first impression having been deeply made by her exterior, the audience was soon struck by the melancholy sweetness with which the following exquisite passage came upon the ear [. . .] and her fair admirers were in tears as she questioned her son.[13]

In fact the scene between mother and son is hardly a passage, being just thirteen lines long in total. It begins when Isabella, turning to her son and seeing her husband's features reflected in his face asks, 'canst thou forgive me, child?' (7) and continues with the boy asking:

> Why, have you done a fault? You cry as if
> you had. Indeed now, I've done nothing to offend you:
> but if you kiss me, And look so very sad upon me,
> I shall cry too.

> (7)

'My little angel' Isabella replies, 'no, you must not cry; / Sorrow will overtake thy steps too soon: / I should not hasten it' (7). Despite the brevity of the conversation audiences were gripped by the image of maternal love created by this real-life mother and son. As the *Whitehall Evening Post* reflected, there was:

> Something so affecting in her manner [. . .] she wore her sorrows with so much persuasive sincerity, that she made the audience her advocates; and it must be confessed, she never quitted the hold she had so early taken of their feelings, till she had created an universal and melting sympathy all around.[14]

As this critic reveals, Siddons took every opportunity to emphasise Isabella's maternal devotion through a nuanced gestural performance. For the author of *The Beauties of Mrs Siddons* there were two moments in particular which stood out. Isabella's meeting with the creditors where Siddons's, 'soule seemed absorbed in the melancholy delight of viewing her little boy'; and the scene where Isabella consents to marry Villeroy in order to save her son whilst 'fondly kissing her little boy', an act through which she seemed 'to endeavour to extract some inducement from her maternal love for an action so irksome to her mind'.[15]

As Boaden was to note similarly, 'the *glance* at the child to determine the sacrifice' revealed her motivation to her audience.[16] For him however the moment which stood out was where Isabella is threatened with separation from her son. Bursting 'forth with the peculiar *wildness* of a mother's impatience', he wrote, she was irresistible to the whole house.[17]

Siddons' debut as Isabella marked the start of what would become a career-long interweaving of her own apparently authentic maternal emotions and experiences with her staged performances of tragic mothers.[18] Over the following thirty years, Siddons created performances which, as *The Times* noted in 1788 of her performance in *The Regent*, 'strike to the feelings of maternal affection, and produce a sympathy of tenderness not frequently to be felt from stage effect'.[19] Encouraging her audiences to interpret these dramatic performances as being expressions of, or drawn from, her own authentic feelings as an ideal, tender, 'good' mother, Siddons conflated the dramatic/non-dramatic, personal/professional, positioning herself as the embodiment of idealised motherhood and domestic virtuosity at a time when both were considered the epitome of bourgeois femininity.

To a great extent however, Siddons's suggestion that she drew on her maternal emotions on stage was a performance in itself. Whilst her emotions might well have provided a stimulus when first performing a role, the repetition of many of these parts season after season certainly mitigates against the idea that she consistently drew on the same heightened emotions in her dramatic portrayals. A comment in 1795, only thirteen years after first playing Isabella in London, certainly suggests as much. 'Any thing is better than Saying Isabella etc. over and over again till one is so tired', Siddons complained to Lady Perceval on 24 November, 'How I do wish that Somebody would write two or three good Tragedies Some wet afternoon!'[20] At other times however Siddons appreciated the process of performance not as an opportunity to express, but rather as a distraction from, her own maternal experiences and emotions. As she reflected in 1815 after the death of her son Henry, it was for its value in taking her away from herself that she missed her theatrical work. 'I am now without a profession', she wrote, 'which forced me out of myself in my former afflictions'.[21] Rather than being an opportunity to give herself up to her suffering and express it on stage, theatrical employment was often an effective, if temporary, diversion and as Siddons said herself, was 'the best recipe [. . .] for bad spirits'.[22]

The complex relationship between Siddons's own maternal experiences and her stage performances is however, also evident at those

times when her own tragedies as a mother resonated with those of the dramatic heroines she played. For whilst the stage provided a valuable outlet for her 'real' feelings at such times, conversely and in a reversal of the stage-artifice, home-sincerity binary, in her real-life maternal role she often found herself performing false emotions. As she wrote to her friend, Penelope Pennington, in August 1798, 'my soul is well-tun'd for scenes of woe':

> and it is sometimes a great relief from the struggles I am continually making to wear a face of cheerfulness at home, that I can at least upon the stage give a full vent to the heart, which, in spite of my best endeavours, swells with its weight almost to bursting; and then I pour it all out upon my innocent auditors.[23]

As such comments reveal, 'real' bourgeois motherhood was also a performance and one which was often put on not only within society at large, but also within the home.

The summer of 1798 was certainly a very difficult period for Siddons. Whilst she was away on a gruelling tour (she covered Gloucester, Worcester, Hereford, Cheltenham, Brighton and Birmingham between July and early August) her youngest daughter, eighteen-year-old Maria, was confined with consumption and being cared for by Siddons's friend, Penelope Pennington. Siddons was fully aware of the likely outcome of Maria's illness, writing to Pennington on 9 August, 'I do not flatter myself that she will be long continued to me'.[24] This however was not Siddons's only trouble. She was also embroiled in dealing with the renewed passion of the artist Thomas Lawrence for her elder daughter, Sally, who accompanied her on the tour. At these difficult times there may well have been some truth in the claim that Siddons used the stage to vent her maternal anguish through the dramatic mothers she portrayed. And certainly it was a narrative which she actively promoted. As she told Tom Moore in 1828, after the deaths of Maria and Sally she often received 'credit for the truth and feeling of her acting when she was doing nothing more than relieving her own heart of its grief'.[25]

This idea, as Siddons once told Hester Piozzi, that she felt she had never 'acted so well as once when her heart was heavy concerning the loss of a child', was however deeply troubling both to some of Siddons's contemporaries and to the actress herself.[26] In 1801, three years after the death of Maria, Siddons received a letter which, according to Hester Piozzi, accused the actress of being accustomed to 'attend with unfeeling apathy, Death Bed Scenes, in order to render the impression on

her audience more strikingly shocking and affecting'.[27] At the heart of the attack, Piozzi recorded, was the allegation that 'she had taken her last Lesson from that of her Daughter – which she was supposed to represent with the nicest Accuracy'.[28] Yet whilst the effect was 'painful in the extreme', with Siddons reportedly in floods of tears and inconsolable, more notable was the fact that the accusation was one which Siddons herself had struggled with. As Piozzi confided to their mututal friend Penelope Pennington, 'it is the Idea that has been present in her Mind ever since the Death of Maria and that she has always been fighting against – How cruel to lacerate such a Heart and to open such half healed Wounds!!!'[29] Yet it was not only the unpalatable idea that Maria's death, and her own maternal grief, had become simply another source of inspiration – like the Egyptian sculptures she carefully studied – that unsettled Siddons. Drawing on her maternal grief to achieve professional and economic success, she was also at risk of undermining the very image she had built her career upon. For whilst on the one hand Siddons's maternal grief made her performances of tragic mothers all the more affective, promising audiences an apparently authentic experience of sentimentalised motherhood, at the same time her public use, even exploitation, of this most private and profound experience for professional gain was in direct conflict with the image of idealised motherhood she had cultivated since she first stepped onto the boards of Drury Lane.

Ideal and reality: balancing work and motherhood

Towards the latter years of her career Siddons's use of her experiences for professional ends risked bringing into question the authenticity of her maternal emotions themselves. However this was not the first time that her apparently straightforward image as a 'good' mother had been complicated. From the earliest days of her career at the same time as she was working to establish her public image as the ideal, devoted, sentimental mother, Siddons's very presence on stage had openly challenged many of the facets of the bourgeois model of femininity. Not only did her visibility as a working, economically-productive mother complicate the idealised image of motherhood she embodied; frequently her body itself, heavily pregnant as it often was, posed a direct challenge to society's expectations of mothers-to-be.

With its vital role in producing a strong and stable society in the face of concerns over population decline, colonial endeavours, and the

ongoing war efforts, in the second half of the eighteenth century preg-
nancy came increasingly under the spotlight and new attention was
paid to how expectant mothers might ensure the health and strength
of their offspring.[30] It was not only the physical, but also the emotional
and mental disposition of the mother however, which was considered
to have an important influence on the unborn child, with writers keen
to dictate what expectant women should and should not do in all
aspects of their lives. Warnings about the dangers of idleness, indolence,
and 'excessive effeminacy' were matched by those against anything
more than gentle activity.[31] 'Immoderate exercise in dancing, riding, or
even walking' and 'masculine and fatiguing employments' such as trav-
elling in carriages on uneven roads were all considered to cause serious
harm or miscarriage, whilst the 'fatiguing dissipations' of the bon ton
also posed serious risks.[32] Crowded assemblies, as midwife Martha Mears
warned in 1797, 'especially at night, when the number of candles that
are burning, and the breath of the persons collected together, concur
to exhaust and corrupt the air' could collapse women's lungs, weaken
their pulse, and make them more susceptible to disease.[33] Equally dan-
gerous, philanthropist Priscilla Wakefield pointed out, were late nights,
'tumultuous pleasures, violent passions, and an irregular life', which
should all be 'resolutely avoided' since they would otherwise result in
'puny offspring, inadequate to the noble energies of patriotism and vir-
tue'.[34] Of course such advice was not purely didactic: with the increased
susceptibility of women to disease and infection during pregnancy, and
the potential risks of strenuous physical activity, much of this mater-
nal conduct literature was highly practical, and as any glance through
modern pregnancy advice books will reveal, was not entirely dissimilar
to advice today.

Echoes of modern advice about stress can also be found in the various
warnings to women to guard against excessive emotional and mental
strain during pregnancy. Believing that an expectant mother's feelings
and experiences could shape the mind, constitution and disposition of
her unborn child, as well as impacting on the mother's health and the
viability of the pregnancy itself, women were warned against strong
emotions and 'mental perturbations'.[35] And whilst anger was perhaps
the most dangerous – 'no hereditary, no constitutional disease can
be so injurious to the child in the womb as the mother's ungoverned
anger' warned Martha Mears – fear, terror, and grief were also blamed
for haemorrhages, convulsions and consumption.[36] To do her maternal
duty, pregnant woman were therefore counselled both to avoid 'every

object of a disagreeable nature', and to refuse to listen to 'dismal or frightful stories'.[37]

It is not difficult to see how working actresses, and in particular affective tragediennes like Sarah Siddons, found themselves in conflict with this ideal maternal conduct. Working for long hours and late into the evening in crowded, candle-lit spaces; travelling considerable distances by coach whilst touring; and being called on to feel and express the very passions pregnant women were warned against, these women's working bodies were a visual reminder of the extent to which their behaviour conflicted with the ideal expectant mother: a physical representation of their abnegation of maternal and patriotic duty for commercial gain. The charge of putting money ahead of duty was certainly one levelled at actresses, and whilst lower-tier actresses were somewhat protected by the perception that they were victims of mercenary managers – 'Surely the Managers should now let her rest, and allow a substitute to represent her characters till she has got up from lying-in!' wrote the *Morning Chronicle* on the heavily-pregnant Isabella Mattocks' performance in September 1773 – higher tier actresses like Siddons were at risk of appearing to put their financial gain ahead of maternal duty.[38] As Hester Piozzi worried, when a five-month pregnant Sarah Siddons performed Lady Macbeth at Drury Lane in 1794, 'She is big with Child, & will I fear for that reason scarce be well received: for People have a notion she is covetous and this unnecessary Exertion to gain Money will confirm it.'[39]

Whilst working practices limited the extent to which women like Siddons could embody the ideal behaviour of an expectant mother however, they also impacted on an actress's ability to fulfil the cultural expectations of motherhood after birth. Not only did working at rehearsals in the mornings and at performances in the evening prevent actresses from being constantly attentive to, and supervising their children in the way maternal discourse demanded; it also limited their ability to embrace the new dictates on breastfeeding. Although it had long been encouraged, in the latter years of the eighteenth century, as Toni Bowers highlights, breastfeeding became re-figured as the primary signifier of maternal virtue, with women who gave their children to wet nurses being vilified as 'unworthy of the sacred name of mother'.[40] The demands of long working hours however, would have made any attempt to maintain the four-to-five recommended breastfeeds a day for six months, a struggle at best, with many actresses probably resorting to dry-feeding, at least in part.[41] The memoirs of strolling actress, Ann Catherine Holbrook offer a rare insight into how some actresses may have felt about the impact of their work on their ability to breastfeed.

'An actress can never make her children comfortable', wrote Holbrook bitterly:

> ill, or well, even while sucking at the breast, the poor infants, when the Theatre calls, must be left to the care of some sour old woman [. . .] The mother returning with harassed frame and agitated mind, from the various passions she has been pourtraying [*sic*], instead of imparting healthful nourishment to her child, fills it with bile and fever.[42]

In this bitter denunciation in which Holbrook accuses her fellow actresses of abandoning their children, whether ill, well, or indeed half way through feeding, to another's care, the theatre always takes precedence. Yet even when actresses returned home and were able to breastfeed their children, Holbrook suggests that they did more harm than good. With the emotional strains experienced during performance corrupting their milk, even when attempting to fulfil their most natural duty, as mothers, actresses were doomed to fail.

Holbrook was not alone in highlighting the conflict between the demands of good motherhood and the working life of an actress. Writing in 1791 on the contemporary rage for private theatricals, Richard Cumberland made a similar, if less vehement, argument about the actress-mother's predicament. There was, he reflected, a particular:

> disadvantage, which the public performer is subject to and the private exempt from: The Andromache of the stage may have an infant Hector at home, whom she more tenderly feels for than the Hector of the scene; he may be sick, he may be supperless; there may be none to nurse him, when his mother is out of sight, and the maternal interest in the divided heart of the actress may preponderate over the heroine's.[43]

For Cumberland, the duality of the actress-mother results in her failure in both roles. Abandoning her child to fulfil her professional obligations, the mother abnegates her maternal duty even though, as Cumberland makes clear, her love for the real child is undoubtedly greater than for her fictional one. In fact it is this love for her real child which causes the actress to simultaneously fail in her professional duty. Her 'divided heart', as Cumberland suggests, being distracted with concern over her own child results in a performance which is ultimately lacking. In re-naming the child after his father ('an infant Hector' rather

than Astyanax as he is in the source play) Cumberland also endows the patriotic and noble qualities embodied by the great Trojan warrior, Hector, to the infant, implying by doing so the danger of such maternal failings to the nation's strength. What solution can there be except to abolish this duality, Cumberland seems ultimately to ask, when the duties of mother and actress are so at odds?[44]

For contemporary readers, Cumberland's use of Andromache as the exemplar of the actress-mother's dual failure may well have had specific resonance. Not only was Andromache one of the most idealised dramatic depictions of motherhood but in the 1790s it was also a role overwhelmingly associated with Siddons. And the conflict between maternal and professional duty depicted by Cumberland was certainly one which Siddons struggled with throughout her career, not least when she was on tour. I am counting 'the minutes till I return to my poor children' she wrote to her friend Elizabeth Barrington from Ireland in 1794, adding that the girls' 'tender reproaches for my long stay (silly girls for whom do I stay?) are sometimes too much for me'.[45] In this one short phrase, gently critical of her 'silly girls', Siddons reveals the pressure she faced from her children: not to perform the role of ideal mother necessarily but rather simply to spend more time with them, and less on tour. Siddons was not alone in feeling the conflicting pulls of work and family. Dora Jordan's many letters home to William whilst on tour reveal her constant distress at being far away from her young family. 'No applause or success can for a moment compensate for the loss of your society and the happiness of being with the dear babes', she wrote to William in 1801, a sentiment she echoed just under ten years later when she wrote from Edinburgh that 'all places are alike to a mind so ill at ease as mine *must* be when so far removed from my family'.[46] Despite the money she could make on tour, she reflected in one letter in December 1810 that she had made 'but a small profit, taking the fatigue, anxiety, the BANISHMENT and all into consideration'.[47] Jordan's letters are replete with her unhappiness at being away from her family for such extended periods. Away in Margate in 1802 when her son Adolphus was only seven months old, she wrote home, 'I dreamt of Molpuss all night, dear little fellow. I have sworn I felt him in bed several times', adding in a subsequent letter, 'I fear Frederick', who was just coming up to his third birthday, 'will soon forget me'.[48] Jordan's sense at failing to fulfill her maternal role is also evident: 'Why did I quit you' she writes in 1809 from Dublin during a particularly unhappy period, 'in endeavouring to perform one duty I have I feel neglected one still more splendid'.[49] The difficulty of reconciling responsibilities at

home – as mother and 'wife' – and at work – to their public – was clearly an ongoing challenge for hard-working actresses.

Yet whilst such comments reveal an anxiety caused by the conflict between work and motherhood which went beyond the ideological, just as important to note were the frequent letters which freely intermingled the discussion of maternal and professional activities without any misgivings. Siddons' private letters to Elizabeth Barrington, for example, loosely interweave discussion of maternal care with comments on the theatre, with her thoughts on inoculation being immediately followed, on one occasion in 1794, by the confession that she is nervous over playing *Macbeth* at the soon to be re-opened, Drury Lane.[50] In a similar way, Jordan's letters back to Clarence reveal the constant interweaving of her maternal and professional roles. 'The desire of seeing me here is so great that the pit [is] entirely turned into boxes' she wrote home in 1801:

> and as I get half the house I think I shall in the two nights bring home something that was worth staying for. My benefit last night £90; the Duchess very handsomely sent 12 guineas. I have recd my dear Sophy['s] first dear letter. Tell her I have bought her a very pretty work box and my dear George a writing case, and Henry a new fashioned lanthorn. Give my love and blessing to all. God bless you all. Excuse this wretched scrawl but I write in a great hurry.[51]

Writing in a rush from her dressing room as she prepared to go on stage, Jordan's desire to communicate with her family back home, about her professional, economic success; about her delight in receiving her daughter's first letter; and about the treats she had picked up whilst on her travels, is an important reminder that the experience of being both actress and mother was not always a disjointed one.

For all the negative representations of actress-mothers moreover, there were also moments in which public discourse reflected this more complex, lived experience of the actress-mother. The family division of labour offered in James Gillray's 1797 'La Promenade en Famille – a sketch from life' (Figure 5.2) is one such example. In this gently satirical print of Dora Jordan, the Duke of Clarence and their young family moving from Richmond to their new home in Bushy, the viewer is presented with what a 1995 exhibition catalogue describes as a domesticated Duke and an affectionate image of the family.[52] Whilst a sweating Clarence is hard at work pulling the little carriage containing the three Fitzclarence children, one of whom holds his father's reigns and a

130

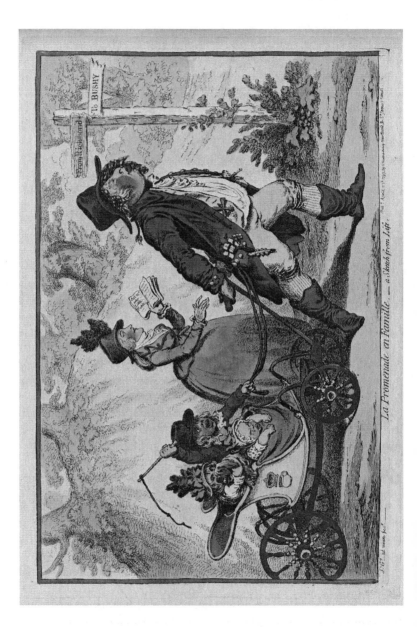

whip, Jordan strolls alongside looking very relaxed and with one hand held out absentmindedly towards the carriage's handle, engrossed in the script for one of her best known roles, 'Little Pickle' in *The Spoil'd Child*. Although there is certainly a satirical bent to the representation of Clarence here, the nature of this sketch as a reflection on Jordan's interweaving of her roles as both mother and actress is unavoidable. Even more direct however, is a similar, if far more sentimental story about Siddons. Going to see Siddons as Belvidera in *Venice Preserv'd* in 1786 and being strongly affected by the actress's ability to make 'men and women weep', the German novelist Sophie von La Roche recorded a small incident in her diary, noting it as evidence of how, 'despite this work and study, this woman is a good mother and housekeeper'.[53] Describing how a group of admirers who had come to visit Siddons, came upon her 'at her sick child's cot, rocking it with her foot and holding another at her breast, her new role in hand, which she was learning', La Roche tells us that the group were so 'affected by this tale' that they wanted to publish an 'engraved portrait of this estimable lady in this position, without any alterations'.[54] The portrait itself was never realised. However the fact that Siddons's admirers were touched rather than disturbed by this explicit juggling of roles, offers an alternative response to Cumberland's criticism of the 'divided heart of the actress', and reminds us, as La Roche does herself, that the schism of working actress and 'good' mother was not quite as clear cut as conduct literature might suggest.

The diversity of images and responses to the actress-mother, both by contemporaries and by actresses themselves, reveals how this duality was seen in distinct and often contradictory ways by different individuals and at different times. As scholars are increasingly emphasising, motherhood was not a monolithic identity but a contested term which was continually being reinvented.[55] And nowhere is this more evident than in representations of actress-mothers. For some, actresses embodied a failure to conform to bourgeois ideals of motherhood which could often only be resolved in popular discourse by representing the contentment of retired actresses in, as one commentator said of Elizabeth Banister, 'filling [. . .] the more amiable characters of a domestic wife and a tender Mother'.[56] However, for others being an actress did not automatically proscribe a woman from being a good mother. From top-tier performers like Siddons and Jordan, to mid-tier actresses like Mary Ann Davenport who was described as, 'through life's stages, in the varied characters of wife, mother, and a member of a respectable profession [. . .] possess[ing] the proud consciousness of having "done her duty"', a diversity of actresses were depicted as successfully fulfilling

the duties of the ideal bourgeois mother whilst continuing to work.[57] Being absorbed into the dominant model of maternal femininity, but without their professional activities being erased, being a 'good' mother, these images implied, was not incompatible with being a successful actress. The provincial strolling actress Margaret Farren (mother of the more famous actress Elizabeth Farren), could therefore be described as providing 'for the infancy of these Children with decency' *and* fulfilling 'the duties of a Mother with great tenderness', whilst successful actress and businesswoman, Hannah Pritchard, could be posthumously praised for having 'a large family of children, whom she brought up with the greatest care and attention'.[58] It was through such descriptions, which allowed actresses to be good mothers without quitting the profession, that the schism between actress and good mother was resisted.

Such images reveal how actresses as cultural icons, and in particular Siddons with her public embodiment of bourgeois maternity, not only complicated the ideal of the 'good' mother, but also spoke to what was, for many late-eighteenth-century middling women, the reality of the maternal experience: a reality in which economic work continued to be a necessity, if not always a choice. Although the ideological development of separate, gendered spheres of activity resulted in a shift in the public, social perception of women's work in the 1780s and 1790s, there was, as Susan Kingsley Kent has argued, little material shift either in the kinds of work women were undertaking, or in the percentage of women who were in work.[59] Instead, at the turn of the century women across the middling classes were increasingly having to negotiate a position in relation to polarities which, on the one hand demanded their prescription to idealised domestic roles, and on the other necessitated the continuation of their economic labour in order to provide financial support to their families. This paradox, Kent argues, forced women to conceal the reality of their working practices.[60] And it was this concealment which both resulted in and concurrently masked what Catherine Belsey reminds us is, the 'substantial gap between the endorsement of a value and its widespread implementation'.[61] In cultural discourse surrounding actresses as mothers however, this gap, and the economic activity which was being concealed beneath the ideal of the domestic mother, was exposed. Speaking to the compatibility of motherhood and economic labour, actresses like Siddons therefore both enacted and reflected the contemporaneous negotiation of economic work and domesticity being engaged in by women across the middling classes, even becoming a nexus at which contemporary negotiations over expectations of female working practices and domestic roles were played out.

Work as maternal duty

At the turn of the century Sarah Siddons was highly successful in both positioning herself within dominant maternal discourse, and in concurrently rejecting many of the values embodied by this discourse. Yet like the middling women who masked their economic labour, Siddons's ability to hold the line between ideal and practice was achieved through dissimulation. Unlike these women who could conceal their economic activity however, for Siddons, bridging the gap between her biologically-reproductive and economically-productive labour demanded a different strategy. With her work being unavoidably public, Siddons therefore sought not to hide it, but rather to mask her professional and economic ambitions under the guise of maternal duty: framing her work as a function of her maternal role. Subverting the political function of bourgeois maternity in dividing economic and domestic labour, and adapting the discourse to her own ends, Siddons's successful revision of the relationship between motherhood and work would, by the end of the century be appropriated many times over across the cultural sphere.

In her reminiscences, written at the age of seventy-five and at the end of a long and phenomenally successful career, Sarah Siddons reflected that she was, as a young actress, 'an ambitious candidate for fame'.[62] Late in life, and in a manuscript not intended for publication, but only for her biographer Thomas Campbell's reference, she could make this admission freely. Yet it is not a description that she would have welcomed earlier in life. By the end of the eighteenth century ambition, like economic labour, had been largely configured in newly gendered terms and located as the antithesis of 'natural' femininity. A lack of competitive desires and worldly ambitions, as Nancy Armstrong has argued, was a central feature of a new idealised female type: a type which was disseminated widely and across class distinctions as a result of the increasing intermingling readership of domestic economy texts and conduct books.[63] To an extent this notion of ambition as an exclusively masculine concern derived from, or at least was reinforced by, Jean-Jacques Rousseau's *Emile* (1762) which by 1770 had appeared in at least five different English language editions.[64] Warning the female reader that even if she possessed 'genuine talent, any pretension on her part would degrade it. Her dignity depends on remaining unknown; her glory lies in her husband's esteem, just as her pleasures lie in her family's happiness', Rousseau located ambition and femininity in antithetical terms.[65] And the woman who responded to her artistic aspirations and cultivated her talents in the face of this advice was seen to do so

not only at the expense of her domestic duties as mother and wife but also, and consequentially, at the expense of the polity.

This definition of female ambition as a trait which threatened both domestic and national stability resulted in a radical reversal of attitudes towards actresses at the end of the century. In the early decades of the eighteenth century the actress Lavinia Fenton had been encouraged, even eulogised, for striving 'with Emulation to exceed the Bounds of her narrow Fortune' and for shining 'conspicuous above her Contemporaries'.[66] Yet by the end of the century, Boaden tells us in opening his biography of Siddons, the few women who yielded to their ambitions, did so in exchange for their natural feminine attributes of modesty and reserve. 'Women are devoted as much by nature as custom to the domestic duties' he pointed out:

> Their merits are to be felt in their homes and in their offspring; if the former be well ordered, and the latter well bred, the charm of both may without hesitation be ascribed to the mistress and the mother. The wide range of male ambition, but rarely tempts the modest reserve of our females [. . .] She who yields to a powerful impulse, and indulges either her fancy or her wit, with difficulty escapes from the reproach of pedantry; and is suspected to resign, for literary distinction, much of her *proper* charm, that graceful modesty, which retires from praise itself too vehemently pronounced. She is, therefore, generally contented to abstain from many subjects perfectly suited to her power, and allows to the bolder sex the mental ascendancy.[67]

Whilst Boaden continues by implicitly excluding Siddons herself from this category of women, on the basis that by her day the 'growing purity of the stage [allowed that] a woman of virtue might there be found', his narrative masks the fact that it was not the 'purity of the stage' which allowed Siddons to take to the stage, but rather the shift she advanced through her re-writing of economic and professional ambition within the framework of maternal duty.[68]

In the summer of 1782 Sarah Siddons was about to make the bold and ambitious move of attempting a second debut at Drury Lane, only seven years after her disastrous first attempt, and despite not only the fact that she was well-established and successful at Bath, but also the fact that she had three children under the age of eight. At risk of being publicly identified as the economically and professionally ambitious woman which she was, with her farewell performance to Bath on 21

May, Siddons therefore made a canny move: choosing not simply to counter this image, but to embrace and justify it on the grounds of her maternal role.

The strategy she developed was bipartite. Firstly she chose her main-piece role carefully to ensure that it would set the scene and emotional context for what was, in effect, the main performance of the night: the farewell speech in which she had promised in the local papers that she would explain her 'three reasons' for leaving Bath. The role she therefore determined on was the heroine of Ambrose Philips's *The Distrest Mother* (first performed and published 1712), an adaptation of Racine's *Andromache* (first performed 1667).[69] Set after the fall of Troy, Andromache has been captured and is faced with marrying her captor Pyrrhus in order to save her son (who never appears in the play). Being faced with either betraying her dead husband, Hector, or failing her son, Astyanax, Andromache chooses to sacrifice herself for her child. She therefore marries Pyrrus with the secret intention of committing suicide: although ultimately she is saved from doing so by Pyrrhus's death at the conclusion of the play. However before this, in Act IV, in one of the most powerful moments of the play, Andromache turns to her confidant Cephisa and, after determining upon her plan, asks her to 'Let him [Astyanax] know / I died to save him: – And would die again' (65). In giving her life for her son, Andromache is the epitome of late-century ideals of maternal devotion and self-sacrifice: a character who, in one of the few studies of the play, has been described as 'a beautiful example of maternal affection [who . . .] succeeds because her character is without flaw'.[70] Indeed, as the play's preface itself notes, the specific reason behind a number of the alterations made in adapting the play was to heighten the 'beautiful incident' of Andromache's maternal distress through presenting her in 'the character of a tender mother, an affectionate wife, and a widow full of veneration for the memory of her deceased husband.[71] Refocusing the plot away from Hermione's passion and onto Andromache's virtue, extending Astyanax's lifespan, and increasing the number and intensity of her references to her son, as Jean Marsden has argued, Philips created 'a heroine expressive of her sorrows, who embodies a new domestic ideal of self-abnegating motherhood'.[72]

Of course *Andromache* was adapted by Philips seventy years before Siddons took on the role. However, with this ideal of self-abnegating motherhood taking on new political significance at the end of the century, it was the ideal choice for an actress who wanted to present herself as giving up her personal desires out of maternal duty.[73] In this respect,

however, Siddons's performance as Andromache was only the precursor to the main performance of the evening: having embodied an idealised model of motherhood through the fiction of the play, now as it ended, Siddons used her 'farewell speech' to align this fiction to her own real-life maternal role. To do so however it is likely that she cut the standard epilogue. Flippant and witty, the dialogue of the epilogue in which Andromache declares that she has 'play'd my game, and topp'd the widow's part', and asks the ladies 'which of you all would not on marriage venture / might she so soon upon her jointure enter?' fractured the idealised femininity represented in the play and prompted the audience to remember that this image of idealised motherhood was simply a performance.[74] Instead therefore, Siddons carefully scripted her own alternative which, instead of disrupting the ideal of self-sacrificial motherhood, both reinforced it and applied it directly to her experience, presenting her, as the 'distrest' mother she had performed moments earlier. Returning to the stage after the play, as 'herself', Siddons declared:

> The time draws near when I must bid adieu
> To this delightful spot – nay, ev'n to YOU;
> > [*To the Audience*]
> To *you*, whose fost'ring kindness rear'd my name,
> O'erlook'd my fault, but magnify'd my fame.[75]

Depicting the Bath audience as tender parents who had nurtured her to success, Siddons carefully paved the way for the central theme of her epilogue: maternal duty. In turning to the main focus of her speech however, she first produced her 'three reasons', embodied in the form of her three young children, Henry, Sally and Maria, aged eight, six, and just under three. With her young family sheltering at her side, and being herself over eight months pregnant – she would give birth to her fourth child, her third having died in infancy in 1781, just under two weeks later – the actress then turned back to face the packed auditorium and spoke what would become her most celebrated epilogue:

> These are the moles that heave me from your side.
> Where I was rooted – where I could have dy'd
> Stand forth, ye elves, and plead your mother's cause,
> Ye little magnets – whose strong infl'ence draws
> Me from a point where ev'ry gentle breeze
> Wafted my bark to happiness and ease;
> Sends me advent'rous on a larger main,

In hopes that you may profit by my gain.
Have I been hasty? Am I then to blame?
Answer, all ye who own a Parent's name.

(8–9)

The appeal of this powerfully-staged image and carefully-scripted per-
formance of her own maternal duty was, we are told, 'irresistible and
the mother and the actress were alike gratified'.[76] As one commentator
reflected, 'how much the whole house was affected, when, in the deliv-
ery of this address she produced her three reasons in three beautiful
children, may be more easily conceived than expressed'.[77]

Siddons' foregrounding of her real maternal role at this seminal
moment in her career instantly became a defining moment in the crea-
tion of her public, professional reputation. And it continues to fascinate
scholars today. As a general rule however, it has largely been seen as
Siddons's attempt to counter her ambition and the perverse female
sexuality it represented, by presenting herself in relation to notions
of normative female sexuality.[78] Superficially this is certainly the case.
Professing to have no professional ambition, Siddons dramatically
informed the audience, she 'was rooted' and 'cou'd have dy'd!' at Bath,
being at 'a point, where ev'ry gentle breeze / wafted my bark to happi-
ness and ease' (8). She was, she insisted, entirely content in her present
position, being, 'secure in my employer's aid / who meets my wishes ere
they scarce are made' (8). To move to London moreover, was a risky ven-
ture and one which, as she recognised in her speech, audiences would
find hard to understand:

Why do you quit (you'll say) such certain gain,
To trust caprice, and its vexatious train
What can compensate for the risks you run?
And what your reasons – Surely you have none.

(8)

Having clearly articulated her own lack of professional ambition, and
made it clear that she herself, being economically and professionally
stable, had no need, or more importantly no desire to make the move,
Siddons then problematised the situation. Producing her three children
and declaring that they must plead her cause since it was their 'strong
infl'ence' (9) which was drawing her to London and away from her own
happiness, Siddons presented herself in the mould of Andromache: the

mother who sacrifices herself for her children. Siddons's sacrifice was not only in her move to London however, but also, as she made clear, by being ambitious itself. Professionally and economically, Siddons made clear, she had no aspirations beyond her current contented state, yet as a mother she had to sacrifice her own desires and become ambitious so that her young family might 'profit by my gain' (9). Rather than being unambitious therefore, Siddons depicted herself as actually becoming ambitious for the sake of her children's future. Such ambition, she suggested further, was not unfeminine but rather was a fundamental duty of her maternal role. 'Have I been hasty?' as she asked her audience, 'Am I then to blame? / Answer, all ye who own a Parent's Name' (9). Repositioning ambition as a facet of idealised femininity and re-aligning the maternal and professional in a new symbiotic relationship, Siddons did not therefore negate these 'unfeminine' desires but rather revised their meaning through aligning them with the ultimate of female identities. As such, and through drawing a careful distinction between selfish personal ambition and self-less maternal ambition, she demonstrated the means by which other working women, both within and outside the theatre, might also be re-aligned within dominant bourgeois discourse. From the moment of Siddons's farewell the idea of the 'mother's reason' was taken up by other women. From writers like the novelist, translator and schoolteacher Elizabeth Helme who in her 1788 preface to *Clara and Emmeline; or, the Maternal Benediction*, wrote that 'a celebrated Actress produced three reasons for leaving her Bath friends; now I have *five* as powerful *reasons* to induce me to write' to the assorted actresses whose families became the rational for their professional ambitions, the idea of the 'mother's reasons' not only became part of the cultural imagination but became a performative role which could be taken on by almost any woman.[79] Even if she did not have children moreover, an actress's filial love for a needy parent might serve as an effective substitute, as evidenced by the story of Jane Barsanti's debut. Described by Letitia Hawkins as taking to the stage in order to support her father, Miss Barsanti's bourgeois sensibilities are laid out in a vivid scene:

> At dinner on the day of her debut, her father, perhaps anxious to a dangerous extreme of the public reception of one whom nature and most devoted filial piety rendered doubly dear to him, and on whose success probably that very evening he must in future depend for the comfort of his advancing age – was afflicted with a paralytic seizure, so severe as to occasion his dropping his knife or fork [. . .]

I need not attempt to describe the agony of his daughter. With great difficulty she sustained her parts in what constituted the evening's performance.[80]

Like Dora Jordan who as a young woman had been 'determined on attempting the stage in order to procure the means of subsistence for herself and her suffering mother' and Elizabeth Billington who made her debut in a benefit specifically for her mother, actresses's professional ambitions were soon being entirely sublimated under their domestic roles whether as mothers or as daughters.[81]

Yet whilst familial duty was used to justify the professional ambitions of a number of actresses at the turn of the century, it was Siddons who embraced its full potential. Following her farewells to Bath, and a month later – two weeks after giving birth – to Bristol, her pioneering revision of ambition as maternal duty quickly become a central feature of her public image. As the author of the *British Cyclopaedia* noted, moving to London in 1782 Siddons was 'animated by the best inspiration, – a mother's feelings for her family – [and] prepared herself for a life of such exertion as mocks the toil of mere manual labour', adding significantly that her income was clearly not for her personal gratification since, 'she launched into no unnecessary expenses, residing merely in respectable lodgings in the Strand'.[82] Throughout Siddons's subsequent career she was repeatedly depicted as the ideal self-abnegating mother who, as Boaden noted, was 'conscious of the most unremitting diligence in her exertions and often endanger[ed] her health, to secure, along with fame to herself, the present and future comforts of her family'.[83] Yet it was not only Siddons's biographers who reiterated this image of selfless motherhood. Throughout her letters the actress frequently portrayed herself as sacrificing her own desires for the benefit of her children – and husband. As she wrote in September 1793 after having been forced to go on holiday to Margate, a place which she described as being 'as full as an Egg' and where 'nothing could make it favourable to me but that my husband and daughters are delighted with the prospect before them':

> I wish they could go & enjoy themselves there & leave me the comfort & pleasure of remaining in my own country house & taking care of my baby but I am every day more & more convinced that half the world live for themselves and the other half to fulfill the wishes of the former, at least this I am sure of, that I have had no will of my own, since I remember and indeed (to be just) I fancy I should have little delight in so selfish an existence.[84]

Despite the undertone of dissatisfaction in the gendered inequality she perceives around her, and her clear frustration at having no 'will' to choose her holiday destination, Siddons is keen to emphasis her self-less nature. Only months later it was this same selflessness which she claimed prompted her to go on a long tour, leaving her children behind. Although preferring to stay at home, as she pointed out to Elizabeth Barrington, this extensive tour was not for her own benefit, but for that of her family. 'When I know I go to fulfill engagements which advantage those I leave at home' as she wrote to her friend 'my regrets are not so great'.[85]

Siddons's portrayal of her continuing hard work and pecuniary ambitions as being in the service of her family was clearly successful: a year earlier, in 1793, when she had departed once more for the Irish theatre, even her close correspondent Hester Piozzi commented that it would, 'answer to her husband and family, [for] she has fame and fortune enough without running further hazards'.[86] Yet a touching comment from Siddons when on tour in Ireland in 1794 warns against reading her self-presentation of her work in maternal terms solely as a strategy. 'I shall be a thousand pounds the richer by my Irish expedition' she wrote to Elizabeth Barrington in 1794, 'but those dear silly girls of mine who know no wants while I am with them, think not how soon they may lose me, and how necessary it is to make some provision for that inevitable day'.[87] Working to provide for her children not only during her lifetime but also after her death, Siddons's alignment of work and motherhood was more than a tactic designed to reconcile her within maternal discourse and mask her professional ambition: it was also how she saw her role as a working woman. Siddons was, after all, the family's primary earner. And as such, she saw the practical, financial support of her family as an important part of her maternal role. She was not alone in feeling this way. Despite missing her family intensely when away on tour, Dora Jordan also repeatedly returned to the provinces in order to support them, describing this in 1810 as, 'a duty I owe my family'.[88]

Financial necessity, and the idea that economic provision was an important aspect of being a mother, were both evidently realities for women like Siddons and Jordan, just as much as they were discursive strategies for justifying their professional and economic ambitions within dominant discourse. However a comment by Siddons late in life also warns us against totalising their labour in these terms. 'Oh dear!' Samuel Rogers recollects her saying after her retirement, 'this is the time I used to be thinking of going to the theatres; first came the pleasure of dressing for my part, and then the pleasure of acting it; but that is

all over now'.[89] Reminiscing with a sense of loss over the satisfaction she used to gain from her labours, Siddons reveals in this comment the extent to which her work was not simply a maternal duty, or even a source of financial reward, but also a source of pleasure in itself. Her 'three reasons' for working were not simply the three children she stood on stage with in 1782. Indeed beneath this image of the selfless mother which she cultivated so carefully over the course of her career, she was not only professionally and financially ambitious, but also, perhaps most importantly, a woman who enjoyed the work she had chosen to perform.

Notes

Introduction

1. Claire Tomalin notes that once Dorothy was of an age to choose she used the name Dora, signing herself as such, and having seals made with 'Dora', *Mrs Jordan's Profession: The Actress and the Prince* (New York: Alfred A. Knopf, 1995), p. 17. Taking the lead from Tomalin, I refer to Jordan as Dora, rather than Dorothy, throughout.

2. William IV had ten illegitimate children with Dora Jordan and only one legitimate child, Princess Elizabeth Georgiana Adelaide, who died aged 12 weeks in 1821. Tomalin discusses the commissioning of the statue in *Mrs. Jordan's Profession*, pp. 1–3.

3. Petronius Arbiter, *Memoirs of the Present Countess of Derby, (late Miss Farren)* (London: Symonds, 1797?), p. 9.

4. 'On Miss Farren's Admirable Performance of Beatrice in the Comedy of *Much Ado About Nothing'* in London, British Library, *A Collection Of Cuttings From Newspapers, And Magazines Relating To Celebrated Actors, Dramatists, Composers, Etc,* 2 vols ([unpub.], 1730?–1855?)

5. 'Memoirs of Jane Pope' in BL, *Collection of Cuttings*.

6. Anon., *The Green-Room Mirror, Chiefly Delineating Our Present Theatrical Performers* (London: for the author, 1786), p. 47.

7. *Green-Room Mirror*, p. 50. Although making her London debut in 1786, Mrs Brown had worked on the provincial circuits for over a decade and was an experienced actress. Her last season at Covent Garden was 1787–1788, after which she returned to working in the regions.

8. *Green-Room Mirror*, p. 44.

9. Joseph Haslewood, *The Secret History Of The Green Room: Containing Authentic And Entertaining Memoirs Of The Actors And Actresses In The Three Theatres Royal, The Second Edition*, 2 vols (London: for H. D. Symmonds, 1792), I, p. 69.

10. London, Garrick Club, *Dramatic Annals: Critiques on Plays and Performers*, vol I, 1741–1785. Collected by John Nixon, p. 134. Katherine Sherry made her stage debut at Drury Lane on 25 April 1772 as Lady Macbeth and subsequently took on a broad range of roles, as well as working at the Haymarket in the summer seasons from 1776 (except 1777), until she died at the age of forty in 1782.

11. *Encyclopaedia Edinensis: Or A Dictionary Of Arts, Sciences, And Literature*, ed. by James Millar (Edinburgh: J. Anderson, 1827), I, p. 47.

12. Kristina Straub, *Sexual Suspects: Eighteenth-Century Players and Sexual Ideology* (Princeton: Princeton University Press, 1992); William Prynn's phrase 'women actors – notorious whores' and his description of Greek and Roman actresses as, 'all notorious impudent, prostituted Strumpets' is often held as evidence of the pre-Restoration association of female performers with sexuality, see William Prynne, *Histrio-Mastix: The Players Scourge, Or, Actors Tragaedie* (London: E[dward] A[llde], Augustine Mathewes, Thomas Cotes]

and W[illiam] I[ones] for Michael Sparke, 1633), index and p. 214. For a discussion of the association between actresses and prostitution during the Restoration, and the consequences of its continual recycling, see, Kirsten Pullen, *Actresses And Whores: On Stage and in Society* (Cambridge: Cambridge University Press, 2005), pp. 22–54.

13. Gill Perry, 'Musing on Muses: Representing the Actress as "Artist" in British Art of the Late Eighteenth and Early Nineteenth Centuries', in *Women, Scholarship and Criticism: Gender and Knowledge c.1790–1900*, ed. by Joan Bellamy, Anne Laurence and Gillian Perry (Manchester: Manchester University Press, 2000), pp. 16–41, p. 16; Felicity Nussbaum, *Rival Queens: Actresses, Performance, and the Eighteenth-Century British Theater* (Philadelphia: University of Pennsylvania Press, 2010), p. 9. For examples of Siddons's elevation as the first actress to break free of the 'whore' image see, Judith Pascoe, *Romantic Theatricality: Gender, Poetry, and Spectatorship* (Ithaca: Cornell University Press, 1997), p. 15; Russ McDonald, *Look To The Lady: Sarah Siddons, Ellen Terry, and Judi Dench on the Shakespearean Stage* (Athens: University of Georgia Press, 2005), p. 11; and Gill Perry, 'Ambiguity and Desire: Metaphors of Sexuality in Late Eighteenth-Century Representations of the Actress', in *Notorious Muse: The Actress in British Art and Culture, 1776–1812*, ed. by Robyn Asleson (New Haven: Published for the Paul Mellon Centre for Studies in British Art [and] the Yale Center for British Art [by] Yale University Press, 2003), pp. 57–80 (pp. 57–8). For examinations of actresses and sexuality see, Katherine Eisaman Maus, 'Playhouse Flesh and Blood: Sexual Ideology and the Restoration Actress', *English Literary History*, 46.4 (1979), 595–617; and Straub, *Sexual Suspects*, especially pp. 90–4, 98. The lady/whore dichotomy is explored in Kimberly Crouch, 'The Public Life of Actresses: Prostitutes or Ladies?', in *Gender In Eighteenth-Century England: Roles, Representations, and Responsibilities*, ed. by Hannah Barker and Elaine Chalus (London: Longman, 1997), pp. 58–78. The idea that actresses were considered sexually transgressive can be found across numerous studies including, Cheryl Wanko, *Roles of Authority: Thespian Biography and Celebrity in Eighteenth-Century Britain* (Lubbock: Texas Tech University Press, 2003), p. 75; Laura Engel, *Fashioning Celebrity: Eighteenth-Century British Actresses and Strategies for Image Making* (Columbus: Ohio State University Press, 2011), p. 62; and Ellen Donkin, 'Mrs Siddons Looks Back in Anger: Feminist Historiography for Eighteenth-Century British Theatre', in *Critical Theory and Performance*, ed. by Janelle G. Reinelt and Joseph R. Roach (Ann Arbor: University of Michigan Press, 1992), pp. 276–90, p. 277.

14. Straub, *Sexual Suspects*, p. 90.

15. Engel, *Fashioning Celebrity: Eighteenth-Century British Actresses and Strategies for Image Making*, p. 9.

16. Karen Harvey, *Reading Sex in the Eighteenth Century: Bodies and Gender in English Erotic Culture* (Cambridge: Cambridge University Press, 2004), p. 7.

17. Lawrence E. Klein, 'Gender and the Public/Private Distinction in the Eighteenth Century: Some Questions about Evidence and Analytic Procedure', *Eighteenth-Century Studies*, 29.1 (1995), 97–109, p. 101.

18. Tim Hitchcock, *English Sexualities, 1700–1800* (Basingstoke: Macmillan, 1997), p. 2.

19. Thomas Laqueur, *Making Sex: Body and Gender from the Greeks to Freud* (Cambridge, MA: Harvard University Press, 1990).

20. Laqueur, *Making Sex,* p. 8.
21. See for example, Randolph Trumbach, 'Sex, Gender, and Sexual Identity in Modern Culture: Male Sodomy and Female Prostitution in Enlightenment London', *Journal of the History of Sexuality,* 2.2 (1991), 186–203; Michael McKeon, 'Historicizing Patriarchy: The Emergence of Gender Difference in England, 1660–1760', *Eighteenth-Century Studies,* 28.3 (1995), 295–322, especially pp. 300–16; and Nancy Armstrong, *Desire and Domestic Fiction: A Political History of the Novel* (Oxford: Oxford University Press, 1989), especially p. 4. In *English Sexualities* Tim Hitchcock details how the transition from the one- to two-sex body changed the nature of elite views on the role of men and women, placing new emphasis on the importance of male sperm and lust and denying the female orgasm and sexual desire, at the same time as it established a set of 'natural' heterosexual categories, see also *English Masculinities, 1660–1800,* ed. by Tim Hitchcock and Michèle Cohen, (London: Longman, 1999), especially pp. 6–9. Elizabeth Susan Wahl draws on Laqueur's model in examining changing conceptions of female intimacy in *Invisible Relations: Representations of Female Intimacy in the Age of Enlightenment* (Stanford: Stanford University Press, 1999). Robert B. Shoemaker offers an excellent analysis of changes to male and female roles over the 'long' eighteenth century in *Gender in English Society, 1650–1850: The Emergence of Separate Spheres?* (London: Longman, 1998). In his expansive study on gender between 1500 and 1800 Anthony Fletcher highlights how the new model of gender encompassed the whole self, with women's physiology being understood in the context of their reproductive, child-minding and domestic responsibilities, see *Gender, Sex, and Subordination in England, 1500–1800* (New Haven: Yale University Press, 1995), p. 291. For an excellent survey of scholarship on the subject see, Karen Harvey, 'The Century of Sex? Gender, Bodies, and Sexuality in the Long Eighteenth Century', *The Historical Journal,* 45.4 (2002), 899–916.
22. Erika Fischer-Lichte, *History of European Drama and Theatre* (London: Routledge, 2002), p. 4.
23. Fabio Cleto, 'Introduction: Queering the Camp', in *Camp: Queer Aesthetics and the Performing Subject: A Reader,* ed. by Fabio Cleto (Edinburgh: Edinburgh University Press, 1999), pp. 1–42 (p. 14).
24. Fischer-Lichte, *History of European Drama,* p. 4.
25. Simone de Beauvoir, *The Second Sex* (London: Vintage, 1997), p. 295; Judith Butler, *Gender Trouble: Feminism and the Subversion of Identity* (New York: Routledge, 2006), p. 45.
26. Carrie Lobman and Barbara E. O'Neill, 'Introduction: Play, Performance, Learning, and Development: Exploring the Relationship', in *Play and Performance,* ed. by Carrie Lobman, and Barbara E. O'Neill (Lanham, MD: University Press of America, 2011), pp. vii–xvii (p. x).
27. Lisa A. Freeman, *Character's Theater: Genre and Identity on the Eighteenth-Century English Stage* (Philadelphia: University of Pennsylvania Press, 2002); Cynthia Lowenthal, *Performing Identities on the Restoration Stage* (Carbondale: Southern Illinois University Press, 2003); and Jean I. Marsden, *Fatal Desire: Women, Sexuality, and the English Stage, 1660–1720* (Ithaca: Cornell University Press, 2006).

28. Diana Taylor, *The Archive and the Repertoire: Performing Cultural Memory in the Americas* (Durham, NC: Duke University Press, 2003), p. 16.

29. Anon., 'An Essay on the Theatres: or the Art of Acting. In Imitation of *Horace's Art of Poetry*', in *The Harleian Miscellany or, a Collection of Rare, Curious, and Entertaining Pamphlets and Tracts*, 8 vols (London: for T. Osborne, 1744), V, pp. 543–9 (p. 547).

30. Alan Hughes, 'Art and Eighteenth-Century Acting Style. Part I: Aesthetics', *Theatre Notebook*, 41.1 (1987), 24–31; Alan Hughes, 'Art and Eighteenth-Century Acting Style. Part II: Attitudes', *Theatre Notebook*, 41.2 (1987), 79–89; Alan Hughes, 'Art and Eighteenth-Century Acting Style. Part III: Passions', *Theatre Notebook*, 41.3 (1987), 128–39; Paul Goring, *The Rhetoric of Sensibility in Eighteenth-Century Culture* (Cambridge: Cambridge University Press, 2005); Joseph R. Roach, *The Player's Passion: Studies in the Science of Acting* (Ann Arbor: University of Michigan Press, 1993).

31. Robert D. Hume, *Reconstructing Contexts: The Aims and Principles of Archaeo-Historicism* (Oxford: Oxford University Press, 1999), p. x.

32. Thomas Postlewait, 'Writing History Today', *Theatre Survey*, 4.2 (2000), 83–106 (pp. 91–2); Although the term had been used before, E. P. Thompson was the first to define and theorise the idea of 'history from below' in E. P. Thompson, 'History from Below' (first published 7 April 1966, *Times Literary Supplement*), in *The Essential E. P. Thompson*, ed. by Dorothy Thompson (New York: The New Press, 2001), pp. 481–9.

33. Postlewait, 'Writing History Today,' p. 92.

34. Catherine Belsey, 'Reading Cultural History', In *Reading The Past: Literature and History*, ed. by Tamsin Spargo (Basingstoke: Palgrave – now Palgrave Macmillan, 2000), pp. 103–17 (p. 107).

35. Harvey, *Reading Sex*, pp. 5–6.

36. Nancy Tuana notes that in the 1930s Sigmund Freud claimed that portions of male sexual apparatus were present in women's bodies in an atrophied state, see Sigmund Freud, 'Femininity' in *Standard Edition of the Complete Psychological Works*, volume 21 (London: Hogarth Press, 1964) cited in Nancy Tuana, *The Less Noble Sex: Scientific, Religious, and Philosophical Conceptions of Woman's Nature* (Bloomington & Indianapolis: Indiana University Press, 1993), p. 25.

37. Harvey, *Reading Sex*, p. 8.

38. Gilli Bush-Bailey, *Treading the Bawds: Actresses and Playwrights on the Late-Stuart Stage* (Manchester: Manchester University Press, 2006), p. 16.

39. Louise M. Newman, 'Critical Theory and the History of Women: What's at Stake in Deconstructing Women's History', *Journal of Women's History*, 2.3 (1991), 58–68 (p. 59).

40. Shearer West, 'The Public and Private Roles of Sarah Siddons', in *a Passion For Performance: Sarah Siddons and Her Portraitists*, ed. by Robyn Asleson et al. (Los Angeles: J. Paul Getty Museum, 1999), pp. 1–39 (p. 3).

41. See for example, Celestine Woo, *Romantic Actors and Bardolatry: Performing Shakespeare from Garrick to Kean* (New York: Peter Lang, 2008), p. 89; and Jan McDonald, "Acting and the Austere Joys of Motherhood": Sarah Siddons Performs Maternity', in *Extraordinary Actors: Essays on Popular Performers: Studies in Honour of Peter Thomson*, ed. by Jane Milling and Martin Banham (Exeter: University of Exeter Press, 2004), pp. 57–70 (p. 58).

1 Playing for Money: 'This is certainly a large sum but I can assure you I have worked very hard for it'

1. Letter to William, Duke of Clarence, York, 30 January 1810 in *Mrs. Jordan and Her Family: Being the Unpublished Correspondence of Mrs. Jordan and the Duke of Clarence, Later William IV*, ed. by Arthur Aspinall, (London: Arthur Barker, 1951), p. 133.
2. Letter to William, Duke of Clarence, York, 30 January 1810 in *Mrs Jordan and Her Family*, pp. 133, 134.
3. Letter to William, Duke of Clarence, Dublin, 18 June 1809, San Marino, CA, Huntington Library, Dorothy Jordan Papers, DJ 249.
4. Letter to William, Duke of Clarence, Edinburgh, 14 June 1810 in *Mrs Jordan and Her Family*, p. 140.
5. David Garrick, *The Poetical Works of David Garrick, Esq*, 2 vols (London: for George Kearsley, 1785), I, pp. 213–14. Two years later, in 1778, this theatre would be given a royal patent and become the Theatre Royal, Bristol. William Powell had first performed at Drury Lane in October 1763 and at Jacob's Wells in Bristol in the summer of 1764.
6. Examples of eighteenth-century wages for both men and women are available at Clive Emsley, Tim Hitchcock, and Robert Shoemaker, 'London History – Currency, Coinage & the Cost of Living', *Old Bailey Proceedings Online*, www.oldbaileyonline.org, version 7.0 [accessed 4 June 2013]; for Anne Oldfield's salary see Jane Milling, 'Oldfield, Anne (1683–1730)', *Oxford Dictionary of National Biography* (2004; online edn, Jan 2008) http://www.oxforddnb.com/view/article/20677, [accessed 21 March 2014]; Judith Milhous and Robert D. Hume, 'John Rich's Covent Garden Account Books for 1735–36', *Theatre Survey*, 31.2 (1990), 200–41 (p. 226). For the following wage analyses, where only a nightly or weekly salary is available, in order to enable both internal and external comparability to the profession I have estimated the annual wage using Milhous and Hume's formula.
7. Jane Milling, 'Porter, Mary (*d*.1765)', *Oxford Dictionary of National Biography*, (2004; online edn, Jan 2008) http://www.oxforddnb.com/view/article/22575 [accessed 7 March 2014].
8. In 1706 Porter was contracted for 40s a week, Milling, *Porter*; for Porter's 1709 contract see Kew, The National Archives, 'Articles of Agreement on 24 May 1709 Between Owen Swiney and Mary Porter of St Paul's Covent Garden, Spinster', LC 7/3, Folio 117; *A Biographical Dictionary of Actors, Actresses, Musicians, Dancers, Managers & Other Stage Personnel in London, 1660–1800*, 16 Vols, ed. by Philip H. Highfill, Kalman A. Burnim and Edward A. Langhans, (Carbondale: Southern Illinois University Press, 1973), XII p. 94.
9. TNA, 'Agreement Between John Vanbrugh Esq and Mrs Ann Oldfield for Acting in Her Majesties [*sic*] Company of Comedians in the Hay Market, August 15 1706', LC 7/2, Folio 3. In 'Mrs Oldfield Complains, 4 March 1708/9', LC 7/3, Folio 101 Oldfield also notes that she had an agreement for four pounds a week whilst at the Haymarket; TNA, 'Articles of Agreement Indented, Made, Concluded, and Agreed Upon This 21st Day of April 1709 By and Between Owen Swiney of the Parish of St James Gent of the One Part, and Anne Oldfield of the Parish of St Pauls Covent Garden, Spinster, of the Other Part', LC 7/3, Folio 111.

10. Peter Earle, 'The Female Labour Market in London in the Late Seventeenth and Early Eighteenth Centuries', *The Economic History Review*, 42.3 (1989), 328–53 (pp. 342–3); Emsley, Hitchcock and Shoemaker, *Currency, Coinage*.

11. See Milling, *Oldfield*. Oldfield's salary for the year was 12 guineas a week, with one guinea being equivalent to 21 shillings, although this did vary depending on the quality of the coinage in use.

12. William Egerton [Edmund Curll], *Faithful Memoirs of the Life, Amours and Performances, of That Justly Celebrated, and Most Eminent Actress of Her Time, Mrs. Anne Oldfield* (London: [n. pub], 1731), pp. 5–6.

13. Anon., *The Tryal of a Cause for Criminal Conversation, Between Theophilus Cibber, Gent. Plaintiff, and William Sloper, Esq; Defendant* (London: T. Trott, 1739), pp. 9–10; Charles Fleetwood notes that in Susannah's second season her benefit 'must have been a good deal better than a hundred pound' and in her third it was worth £150 (10). Susannah Cibber's £200 salary is confirmed by her mother, Anne Arne, in TNA, 'From Anne Arne Complaint to the Right Honourable Philip Lord Hardwick Baron of Hardwick Lord High', C11.

14. J. Jean Hecht provides a detailed anaylsis of wages for a range of domestic roles using advertisments in newspapers, diaries and memoirs in, *The Domestic Servant Class in Eighteenth-Century England* (London: Routledge & Kegan Paul, 1956), p. 146.

15. Richard Allen Cave, 'Woffington, Margaret [Peg] (1720?–1760)', *Oxford Dictionary of National Biography*, (2004) http://www.oxforddnb.com/view/article/29820 [accessed 7 March 2014]; Milhous and Hume, 'Covent Garden Account Books,' p. 228.

16. *Biographical Dictionary,* XII p. 181; Milhous and Hume 'Covent Garden Account Books', p. 228.

17. Milhous and Hume, 'Covent Garden Account Books,' p. 228.

18. Cave, *Woffington*; *Biographical Dictionary,* III p. 278.

19. Douglas Hay and Nicholas Rogers, *Eighteenth-Century English Society: Shuttles and Swords* (Oxford: Oxford University Press, 1997), p. 20; Liza Picard notes Boswell's annual allowance in Liza Picard, *Dr. Johnson's London: Life in London, 1740–1770* (London: Phoenix, 2003), p. 298.

20. Hay and Rogers, *Eighteenth-Century English Society*, p. 20.

21. Gilly Lehmann, 'The Birth of a New Profession: the Housekeeper and her Status in the Seventeenth and Eighteenth Centuries', in *The Invisible Woman: Aspects of Women's Work in Eighteenth-Century Britain*, ed. by Isabelle Baudino, Jacques Carré and Cécile Révauger (Aldershot: Ashgate, 2005), pp. 9–25 (p. 21); Milhous and Hume, 'Covent Garden Account Books,' p. 226.

22. *Biographical Dictionary,* III, pp. 64–7.

23. *Biographical Dictionary,* I, pp. 13, 15.

24. *Biographical Dictionary,* I, p. 15.

25. Sophie Loussouarn notes that the salary for governesses in the second half of the century ranged from £30–£100 but that the governess of George III's children received £600 p/a, Sophie Loussouarn, 'Governesses of the Royal Family and the Nobility, 1750–1815', in *The Invisible Woman: Aspects of Women's Work in Eighteenth-Century Britain*, ed. by Isabelle Baudino, Jacques Carré and Cécile Révauger (Aldershot: Ashgate, 2005), pp. 47–55 (p. 55).

26. Roger Manvell notes that the agreed salary for Siddon's second Drury Lane debut was 10 guineas per week in, *Sarah Siddons* (London: Heinemann,

1970), p. 68. The *Morning Herald* reported on 31 March 1783 that although Siddons had originally been engaged 'for three years, at the rising salary of 10. 11l. and 12l. per week for each year' after only a month her salary had been raised to 12l. per week and she had been given an additional benefit which had cleared 830l. In addition, the newspaper commented, the managers had now given her the right to 'fix her own terms in the future, which are said to be mutually settled for the next season at the rate of *twenty pounds* per week'; For Jordan's wages see Brian Fothergill, *Mrs. Jordan: Portrait of an Actress* (London: Faber and Faber, 1965), p. 78.

27. Fothergill, *Portrait of an Actress*, p. 105.

28. Jordan's benefit was on 22 March 1790 and brought £352, 18s 6d with a charge of £111 6s 11d, *The London Stage, 1660–1800: A Calendar of Plays, Entertainments & Afterpieces, Together with Casts, Box-Receipts and Contemporary Comment. Compiled from the Playbills, Newspapers and Theatrical Diaries of the Period*, 5 Parts in 11 Volumes, ed. by William Van Lennep et al. (Carbondale: Southern Illinois University Press, 1960–1968), Part 5: 1776–1800, II, The Theatrical Seasons 1783–1792, p. 238.

29. Leonore Davidoff and Catherine Hall, *Family Fortunes: Men and Women of the English Middle Class 1780–1850* (London: Hutchinson, 1987), p. 23.

30. Letter to William, Duke of Clarence, Bath, 14 April 1809, Huntington, DJ 219; Patrick Colquhoun's calculations from his 1806 *A Treatise on Indigence exhibiting a General View of the National Resources for Productive Labour* (London: for J. Hatchard) are cited in Hay and Rogers, *Eighteenth-century English Society*, p. 21.

31. Letter to William, Duke of Clarence, Dublin, 24 June 1809, *Mrs Jordan and Her Family*, p. 99. In her letter of 18 June, Jordan had noted, 'if I make £1000 [I] fear it will be *the utmost*, which you know is not *one half* of what *I expected*' (96).

32. Letter from Dora Jordan to William, Duke of Clarence, Cheltenham, 1 October 1811, *Mrs Jordan and Her Family*, p. 205.

33. For studies on women's involvement in the urban economy see Hannah Barker and Karen Harvey, 'Women Entrepreneurs and Urban Expansion: Manchester 1760–1820', in *Women and Urban Life in Eighteenth-Century England: On The Town*, ed. by Rosemary Sweet and Penelope Lane (Aldershot: Ashgate, 2003), pp. 111–29; Christine Wiskin, 'Urban Businesswomen in Eighteenth-Century England', in *Women and Urban Life*, pp. 87–110; and Nicola Phillips, *Women in Business, 1700–1850* (Woodbridge: The Boydell Press, 2006).

34. Joan Chandler, *Women Without Husbands: An Exploration of the Margins of Marriage* (London: Macmillan, 1991), p. 46.

35. Edward A. Langhans, 'Tough Actresses to Follow', in *Curtain Calls: British and American Women and the Theater, 1660–1820*, ed. by Mary Anne Schofield and Cecilia Macheski (Athens: Ohio University Press, 1991), pp. 3–17 (p. 4).

36. Cheryl Wanko, *Roles of Authority: Thespian Biography and Celebrity in Eighteenth-Century Britain* (Lubbock: Texas Tech University Press, 2003), p. 163.

37. These figures do not include Betterton's additional fifty pounds for teaching or Mary Betterton's payment for teaching and housekeeping. In 1703 Anne Oldfield was around four years into her career, having been taken into the Drury Lane company in 1699.

38. Philippe Coulangeon, Hyacinthe Ravet and Ionela Roharik, 'Gender Differentiated Effect of Time in Performing Arts Professions: Musicians, Actors and Dancers in Contemporary France', *Poetics*, 33.5–6 (2005), 369–87 (p. 372); David Perfect, *Briefing Paper 6: Gender Pay Gaps, 2012* (Manchester: Equality and Human Rights Commission, 2013), p. 5.

39. Milhous and Hume, 'Covent Garden Account Books,' p. 231. Although largely forgotten today, Christina Horton was a successful actress in the 1730s who was praised by Aaron Hill in *The Prompter* in 1735 as being 'undoubtedly the finest figure on any stage at present', cited in *Biographical Dictionary*, VII p. 421.

40. *Biographical Dictionary*, III p. 275; Garrick's salary is detailed in his contract with James Lacy dated 9 April 1747, *The Letters of David Garrick*, 3 vols, ed. by David M. Little and George M. Kahrl (Cambridge, MA: Belknap Press of Harvard University Press, 1963), III p. 1347.

41. Tate Wilkinson records that Jordan received the 'first terms' after performing *The Fair Penitent*, see *The Wandering Patentee; or, a History of the Yorkshire Theatres, From 1770 to the Present Time*, 4 vols (York: for the author, by Wilson, Spence, and Mawman, 1795), II, p. 141. He also noted in his memoirs that she played at York at £1. 11s. 6d., *Memoirs of His Own Life*, 3 vols (York: Printed for the author by Wilson, Spence, and Mawman, 1790), p. 2:78. Joseph Haslewood offers different figures, noting that she was initially given 15s. per week, and that after playing Calista this was doubled to 1l. 10s., see, *The Secret History of the Green Room: Containing Authentic and Entertaining Memoirs of the Actors and Actresses in the Three Theatres Royal, the Second Edition*, 2 vols (London: for H. D. Symmonds, 1792), I, p. 127.

42. Letter to George Fitzclarence, Gosport, 8 December 1812, *Mrs Jordan and Her Family*, p. 244.

43. Letter to George Fitzclarence, Gosport, 8 December 1812, *Mrs Jordan and Her Family*, p. 244.

44. Felicity Nussbaum, 'Actresses and the Economics of Celebrity, 1700–1800', in *Theatre and Celebrity in Britain, 1660–2000*, ed. by Mary Luckhurst and Jane Moody (Basingstoke: Palgrave Macmillan, 2005), pp. 148–68 (p. 155); Langhans, 'Tough Actresses,' p. 3.

45. Arjun Appadurai, 'Introduction: Commodities and the Politics of Value', in *The Social Life of Things: Commodities in Cultural Perspective*, ed. by Arjun Appadurai (Cambridge: Cambridge University Press, 1988), pp. 3–63 (pp. 9, 16).

46. Colley Cibber, *An Apology for the Life of Mr. Colley Cibber: Comedian, and Late Patentee of the Theatre-Royal* (London: by John Watts for the author, 1740), p. 112.

47. Cibber, *Apology*, p. 112.

48. Michael L. Quinn, 'Celebrity and the Semiotics of Acting', *New Theatre Quarterly*, 6.22 (1990), 154–61 (p. 157).

49. Adam Smith, *An Inquiry Into the Nature and Causes of the Wealth of Nations*, 3 vols (Dublin: printed for Messrs. Whitestone, Chamberlaine, W. Watson, et al., 1776), I, p. 157. It should be noted that the other reason Smith gave for both male and female players' extortionate salaries was that it was recompense for their 'prosituting' themselves.

50. A report on the dispute is found in the *London Packet or New Lloyd's Evening Post*, 15–18 April 1796.

51. Anon., *The Great Illegitimates: Public and Private Life of That Celebrated Actress Miss Bland, Otherwise Mrs. Ford, or Mrs Jordan, Late Mistress of HRH the Duke of Clarence, Now King William IV* (London: J. Duncombe, 1832?), p. 75.

52. Anon., *An Impartial Examen of the Present Contests Between the Town and the Manager of the Theatre* (London: M. Cooper, 1744), pp. 8–9.

53. See Wilkinson, *Wandering Patentee*, II, pp. 171–3. Further references to this work are given after quotations in the text.

54. This was Frances, known as Fanny, Jordan's child by the Irish theatre manager Thomas Daly.

55. See for example, Claire Tomalin, *Mrs Jordan's Profession: The Actress and the Prince* (New York: Alfred A. Knopf, 1995), p. 32; and Fothergill, *Portrait of an Actress*, p. 58.

56. George Anne Bellamy, *An Apology for the Life of George Anne Bellamy, Late of Covent Garden Theatre, Written By Herself,* 5 vols. (London: for the author, 1785), I, p. 100.

57. *London Daily Post and General Advertiser*, 19 November 1736.

58. For a discussion of the relationship between Susannah's marriage and her professional agency see, Helen E. M. Brooks, 'Negotiating Marriage and Professional Autonomy in the Careers of Eighteenth-Century Actresses', *Eighteenth-Century Life*, 35.2 (2011), 39–75 (pp. 47–57).

59. See Tomalin, *Mrs Jordan's Profession,* p. 153.

60. James Boaden, *Memoirs of Mrs. Siddons: Interspersed With Anecdotes of Authors and Actors,* 2 vols (London: Henry Colburn, 1827), I, p. 156.

61. Boaden, *Memoirs of Mrs Siddons*, p. 1:156.

62. John O'Brien notes the association between Centlivre and Oldfield which developed after 1700 commenting that Centlivre seems to have considered playwriting a collaborative craft 'in which the author's task is in part to create opportunities for a star to shine' and noting that Violante in *The Wonder: A Woman Keeps a Secret* (1714) was written specifically for Oldfield, see *The Wonder – A Woman Keeps a Secret*, ed. by John O'Brien, (Peterborough, Ontario: Broadview Press, 2004), pp. 26–7. Oldfield also played Lady Reveller in *The Basset Table* (1705) and Camilla in *The Perplex'd Lovers* (1712).

63. Catherine Clive, *The Rehearsal: or, Bays in Petticoats. a Comedy in Two Acts. As it is Performed at the Theatre Royal in Drury-lane* (Dublin: J. Exshaw and M. Williamson, 1753).

64. Although Betterton has often been considered the 'leading' manager of the Lincoln's Inn Fields co-operative, Gilli Bush-Bailey suggests that Barry and Bracegirdle probably took on a more active role in the day-to-day management than the actor who, at sixty, was no longer at the height of his powers. See, Gilli Bush-Bailey, *Treading the Bawds: Actresses and Playwrights on the Late-Stuart Stage* (Manchester: Manchester University Press, 2006), p. 109.

65. Cibber, *Apology*, p. 236; in their discussion of women's exclusion from enterprise Davidoff and Hall note that women's business activities were often limited because they were seen as lacking commercial credibility. Being poor credit risks as a result of their legal disabilities, being dependent on male intervention and with their activities tied to their life cycle status as daughters, wives, widows, women, they note, were only semi-independent at best, see, *Family Fortunes*, p. 278. Dogget's attitude towards female managers might also reflect his negative experience under the triumvirate of Barry,

Bracegirdle and Betterton, see Joanne Lafler, *The Celebrated Mrs. Oldfield: the Life and Art of an Augustan Actress* (Carbondale: Southern Illinois University Press, 1989), p. 66.

66. Letter from David Garrick to Somerset Draper, Dublin [*ca.* 26 December] 1745, Garrick, *Letters*, I, p. 74.

67. See *Biographical Dictionary*, XI, p. 107.

68. Entry of 7 March 1748 in *London Stage*, Part IV: 1747–1776, I, p. 34.

69. David Erskine Baker, *Biographia Dramatica, or, a Companion to the Playhouse: Containing Historical and Critical Memoirs, and Original Anecdotes, of British and Irish Dramatic Writers*, 2 Vols (London: for Mess. Rivington, T. Payne and son, L. Davis, et al., 1782), I, p. 85.

70. James Boaden, *The Life of Mrs. Jordan, Including Original Private Correspondence, and Numerous Anecdotes of Her Contemporaries*, 2 vols (London: Edward Bull, 1831), I, pp. 179–80.

71. Milhous and Hume, 'Covent Garden Account Books,' p. 229.

72. *Biographical Dictionary*, VII, pp. 159.

73. Boaden notes the 'handsome present' Boaden, *Life of Mrs Jordan*, I, p. 84. Tomalin notes however that no record of this gift exists in the Brooks club's archives, Tomalin, *Mrs Jordan's Profession*, pp. 338, fn.13.

74. *Morning Herald*, 31 March 1783.

75. *Public Advertiser*, 31 March 1783.

76. TNA, LC 7/3, Fol. 111. As well as being early in the season this was also a clear benefit.

77. TNA, LC 5/157 f.284.

78. Letter from Dora Jordan to William, Duke of Clarence, Bath [19 April 1809], Huntington, DJ 222.

79. Appadurai, 'Commodities and the Politics of Value,' p. 56.

80. Jordan wrote to William, Duke of Clarence on 18 June 1809 saying, 'I dress at my lodging and go to the house in a chair, and the first time of course drew the curtains. The wretches that followed the chair told Thomas if I did that next time they would throw stones into the chair, I now arrange, by putting a large loose gown over my dress, and a muslin veil, and leave the curtains [undone], with this they are quite satisfied', Huntington, DJ 249; Exeter 1812, *Mrs Jordan and Her Family*, p. 239.

81. *Biographical Dictionary*, I, pp. 343–4.

82. Roger Manvell notes that Siddons amassed around £1000 from her performances in Dublin and Cork in 1783 Manvell, *Sarah Siddons*, p. 89; Letter to William, Duke of Clarence [after March 1795], Royal Archives, Windsor, GEO/ADD40/55.

83. Bath, 30 April 1809, Huntington, DJ 232.

84. Worcester, 23 February 1811, *Mrs Jordan and Her Family*, p. 188.

85. Letter from Dora Jordan to William, Duke of Clarence, Glasgow, 23 June 1810, *Mrs Jordan and Her Family*, p. 146.

86. Huntington, DJ 233.

87. Letter from Dora Jordan to William, Duke of Clarence, Manchester, 2 January 1810, *Mrs Jordan and Her Family*, p. 123.

88. 16 June 1810, *Mrs Jordan and Her Family*, pp. 140–1.

89. Letter from Dora Jordan to William, Duke of Clarence, Edinburgh, 21 June 1810, *Mrs Jordan and Her Family*, p. 144.

90. Letter from Dora Jordan to William, Duke of Clarence, Glasgow, 23 June 1810, *Mrs Jordan and Her Family*, p. 146.
91. Letter from Dora Jordan to William, Duke of Clarence [Dublin, 15 June 1809], Huntington, DJ 246.
92. Letter from Dora Jordan to William, Duke of Clarence [Dublin, 17 June 1809], Huntington, DJ 248.
93. *Biographical Dictionary*, XII, p. 81.
94. David Garrick, *The Private Correspondence of David Garrick, With the Most Celebrated Persons of His Time, Second Edition*, 2 vols (London: for H. Colburn by R. Bentley, 1835), I, p. 34.
95. Exeter [September 1812], RA, GEO/ADD40/195.
96. Cited in Linda Kelly, *The Kemble Era: John Philip Kemble, Sarah Siddons and the London Stage* (New York: Random House, 1980), p. 186.
97. Letter from Dora Jordan to William, Duke of Clarence, Bath, 11 [April 1809], Huntington, DJ 216.
98. [1813?] Wm 1812, RA, GEO/ADD40/222.
99. Anon., *Great Illegitimates*, p. 27. In an undated letter to William, Jordan reported that she had forced the manager's hand by, refusing to play 'till past four oclock [*sic*] – when they sent me £21 with a solemn assurance of the same sum this morning', RA, GEO/ADD40/66.
100. *Tryal of a Cause*, p. 11.
101. *Impartial Examen*, pp. 10–11.
102. Benjamin Victor, *Original Letters, Dramatic Pieces, and Poems*, 3 Vols. (London: for T. Becket, 1776), I. p. 233.
103. Boaden, *Memoirs of Mrs Siddons*, I, p. 280.
104. Wilkinson, *Wandering Patentee*, II, p. 136.
105. Wilkinson, *Wandering Patentee*, II, p. 261.
106. Letter from Dora Jordan to William, Duke of Clarence, Cheltenham, 1 October 1811, *Mrs Jordan and Her Family*, p. 205.
107. Letters from Dora Jordan to George Fitzclarence [December 1808], RA, GEO/ADD40/135; March 1809, RA, GEO/ADD40/140.
108. *Biographical Dictionary*, XI, p. 110.
109. *Biographical Dictionary*, XII p. 82.
110. Lafler, *Celebrated Mrs. Oldfield*, p. 144; *Biographical Dictionary*, XII, p. 187, and I, p. 15.
111. See Bernard Mandeville, *The Fable of the Bees: or, Private Vices, Publick Benefits* (London: J. Roberts, 1714) and David Hume, 'Of Commerce', in *Political Discourses*, (Edinburgh: R. Fleming, 1752), both of which argued that luxurious spending had a key role to play in increasing the nation's wealth and economic strength.
112. James H. Forse, *Art Imitates Business: Commercial and Political Influences in Elizabethan Theatre* (Bowling Green, OH: Bowling Green State University Popular Press, 1993), pp. 10–11.
113. P. G. M. Dickson, *The Financial Revolution in England: A Study in the Development of Public Credit, 1688–1756* (London: Macmillan, 1967), p. 6.
114. Lawrence E. Klein, 'Property and Politeness in the Early Eighteenth-Century Whig Moralists. the Case of the *Spectator*', in *Early Modern Conceptions of Property*, ed. by John Brewer and Susan Staves (London: Routledge, 1995), pp. 221–33 (pp. 221–2).

2 Playing the Passions: 'All their Force and Judgment in perfection'

1. Nicholas Rowe, *The Tragedy of Jane Shore. Written in Imitation of Shakespear's Style* (Dublin: reprinted for S. Powell, P. Cambel, and G. Grierson, 1714). Further references to the play are given after quotations in the text.
2. Roy Porter, *Flesh in the Age of Reason* (London: Allen Lane, 2003), p. 54.
3. Merry E. Wiesner-Hanks notes the importance attributed to heat, detailing its impact on early-modern bodies in *Early Modern Europe, 1450–1789* (Cambridge: Cambridge University Press, 2013), pp. 55. Heat, she notes, also explained male baldness (heat burning the hair up), men's broader shoulders (being expanded by heat), and women's menstruation (men not needing to menstruate since the heat burned the unneeded blood up internally). See also Sharon Rose Yang, *Goddesses, Mages, and Wise Women: The Female Pastoral Guide in Sixteenth and Seventeenth-Century English Drama* (Cranbury, NJ: Associated University Presses, 2011), p. 72.
4. Susan James notes that bodily differences between the sexes were considered to be systematically reflected in their passions, with women being understood to be more impressionable than men as a result of their softer brains, as well as resembling children in their inconstancy of feelings and being susceptible to different passions, *Passion and Action: The Emotions in Seventeenth-Century Philosophy* (Oxford: Oxford University Press, 1999), p. 8.
5. Marin Cureau de La Chambre, *The Art How to Know Men Originally Written By the Sieur De La Chambre. Rendered Into English By John Davies* (London: by T. R for Thomas Dring, 1665), pp. 26–7.
6. Marin Cureau de La Chambre, *A Discourse Upon the Passions in Two Parts* (London: by Tho. Newcomb for Hen. Herringman, 1661), p. 289.
7. La Chambre, *Discourse Upon the Passions*, p. 187.
8. La Chambre, *Discourse Upon the Passions*, p. 259.
9. George Cheyne, *The Natural Method of Cureing the Diseases of the Body, and the Disorders of the Mind Depending on the Body* (London: for Geo. Strahan, and John and Paul Knapton, 1742), p. 281.
10. For a survey of scholarship on the gendering of Cartesian dualism see, Rebecca M. Wilkin, *Women, Imagination and the Search for Truth in Early Modern France* (Aldershot: Ashgate, 2008), pp. 183–4. Nancy Tuana notes that although Descartes did not perceive his new image of reason as excluding women, the definition of the rational person was at odds with the traditional view of women as being influenced by the body and emotions, *Woman and the History of Philosophy* (New York: Paragon House Publishers, 1992), p. 39.
11. G. J. Barker-Benfield, *The Culture of Sensibility: Sex and Society in Eighteenth-Century Britain* (Chicago: University of Chicago Press, 1992), p. 5.
12. Cited in Allison Muri, *The Enlightenment Cyborg: A History of Communications and Control in the Human Machine, 1660–1830* (Toronto: University of Toronto Press, 2007), p. 181.
13. Kathleen Wellman, *La Mettrie: Medicine, Philosophy, and Enlightenment* (Durham, NC: Duke University Press, 1992), p. 190.
14. Noga Arikha, *Passions and Tempers: A History of the Humours* (New York: HarperCollins, 2007), p. 22.

15. Richard Allestree, *The Ladies [sic] Calling in Two Parts* (Oxford: Printed at the Theater, 1673), p. 39.

16. John Norris, *A Treatise Concerning Christian Prudence: or the Principles of Practical Wisdom* (London: for Samuel Manship, 1710), p. 318.

17. Shilling contrasts this to the civilised body which has the ability 'to rationalize and exert a high degree of control over its emotions, to monitor its actions and those of others, and to internalize finely demarcated rules regarding appropriate behaviour', *The Body and Social Theory*, 3rd edn (London: Sage, 2013), p. 162.

18. Baltasar Gracián, *The Art of Prudence: or, a Companion for a Man of Sense* (London: for Daniel Brown, J. Walthoe, T. Benskin, and Tho. Brown, 1705), p. 52.

19. For discussion on the relationship between witchcraft and the passions see Nancy Tuana, *The Less Noble Sex: Scientific, Religious, and Philosophical Conceptions of Woman's Nature* (Bloomington & Indianapolis: Indiana University Press, 1993), pp. 59–60.

20. Judith Milhous, 'The First Production of Rowe's *Jane Shore*', *Theatre Journal*, 38.3 (1986), 309–21 (pp. 310–11).

21. Thomas Wright, *The Passions of the Minde in Generall. Corrected, Enlarged, and With Sundry New Discourses Augmented* (London: for Walter Burre [and Thomas Thorpe], 1604), p. 172.

22. Joseph R. Roach, *The Player's Passion: Studies in the Science of Acting* (Ann Arbor: University of Michigan Press, 1993), p. 52.

23. Antony Aston, *A Brief Supplement to Colley Cibber, Esq; His Lives of the Famous Actors and Actresses* ([London]: for the author, 1747?), pp. 4–5.

24. John Hill, *The Actor: or, a Treatise on the Art of Playing* (London: for R. Griffiths, 1755), p. 230.

25. Wright, *The Passions of the Minde*, p. 176; for discussion of the eighteenth-century elocutionary movement see Paul Goring, *The Rhetoric of Sensibility in Eighteenth-Century Culture* (Cambridge: Cambridge University Press, 2005), pp. 9–12.

26. For a useful survey of this emerging scholarship see Lynée Lewis Gaillet and Elizabeth Tasker, 'Recovering, Revisioning, and Regendering the History of 18th- and 19th-Century Rhetorical Theory and Practice', in *The Sage Handbook of Rhetorical Studies*, ed. by Andrea A. Lunsford (Thousand Oaks, CA: Sage, 2009), pp. 67–84.

27. Anon. *The History of the Stage in which is Included, the Theatrical Characters of the Most Celebrated Actors Who Have Adorn'd the Theatre* (London: for J. Miller, 1742), p. 92. Charles Gildon used the same words in describing Elizabeth Barry, see *The Life of Mr. Thomas Betterton, the Late Eminent Tragedian. Wherein the Action and Utterance of the Stage, Bar, and Pulpit, Are Distinctly Consider'd* (London: for Robert Gosling, 1710), p. 39.

28. Colley Cibber, *An Apology for the Life of Mr. Colley Cibber: Comedian, and Late Patentee of the Theatre-Royal* (London: by John Watts for the author, 1740), p. 95.

29. Anon., *A Poem to the Memory of Mrs Oldfield. Inscrib'd to the Honourable Brigadier Charles Churchill* ([Dublin]: George Faulkner, 1731), pp. 4, 6.

30. Anon., 'An Essay on the Theatres: or the Art of Acting. In Imitation of *Horace's* Art of Poetry', in *The Harleian Miscellany or, a Collection of Rare, Curious, and*

Entertaining Pamphlets and Tracts, 8 vols (London: for T. Osborne, 1744), V, pp. 543–9, p. 547.

31. Theophilus Cibber, *Romeo and Juliet, a Tragedy, Revis'd, and Alter'd From Shakespear* [*sic*] *to Which is Added, a Serio-Comic Apology, for Part of the Life of Mr. Theophilus Cibber, Comedian* (London: for C. Corbett and G. Woodfall, 1748), p. 93.

32. Gildon, *Life of Mr. Thomas Betterton,* pp. 86, 88.

33. Jean I. Marsden, *Fatal Desire: Women, Sexuality, and the English Stage, 1660–1720* (Ithaca: Cornell University Press, 2006), p. 63.

34. Thomas Laqueur, *Making Sex: Body and Gender From the Greeks to Freud* (Cambridge, MA: Harvard University Press, 1990); Londa Schiebinger, *The Mind Has No Sex?: Women in the Origins of Modern Science* (Cambridge, MA: Harvard University Press, 1989), especially 189–244; Londa Schiebinger, 'Skeletons in the Closet: The First Illustrations of the Female Skeleton in Eighteenth-Century Anatomy', in *The Making of the Modern Body: Sexuality and Society in the Nineteenth Century,* ed. by Catherine Gallagher and Thomas Laqueur (Berkeley and Los Angeles: University of California Press, 1987), pp. 42–82; Karen Harvey, *Reading Sex in the Eighteenth Century: Bodies and Gender in English Erotic Culture* (Cambridge: Cambridge University Press, 2004), p. 5.

35. For a succinct description of the one-sex body and its relationship to gender see *English Masculinities, 1660–1800,* ed. by Tim Hitchcock and Michèle Cohen (London: Longman, 1999), p. 6.

36. See Anthony Fletcher, *Gender, Sex, and Subordination in England, 1500–1800* (New Haven: Yale University Press, 1995), p. xvii.

37. Margaret R. Sommerville, *Sex and Subjection: Attitudes to Women in Early-Modern Society* (London: Arnold, 1995), p. 40.

38. Edmund Curll, *The Life of That Eminent Comedian Robert Wilks, Esq* (London: for E. Curll, 1733), p. 38.

39. Thomas Betterton, *The History of the English Stage, From the Restoration to the Present Time. Including the Lives, Characters and Amours, of the Most Eminent Actors and Actresses* (London: printed for E. Curll, 1741), p. 29.

40. Betterton, *History of the English Stage,* p. 14.

41. Betterton, *History of the English Stage,* p. 14.

42. Betterton, *History of the English Stage,* p. 16.

43. Cibber, *Apology,* p. 95.

44. William Rufus Chetwood, *A General History of the Stage, From Its Origin in Greece Down to the Present Time. With the Memoirs of Most of the Principal Performers That Have Appeared on the English and Irish Stage for These Last Fifty Years* (London: for W. Owen, 1749), p. 127.

45. Chetwood, *General History of the Stage,* p. 127.

46. William Cooke, *Memoirs of Charles Macklin: Comedian, With the Dramatic Characters, Manners, Anecdotes, &c, of the Age in Which He Lived: Forming an History of the Stage During Almost the Whole of the Last Century* (London: for James Asperne, 1806), p. 26.

47. Colley Cibber was recorded as testifying in court that he 'chiefly instructed her [and . . .] spent a good deal of time, and took great delight in it; for she was very capable of receiving instruction', Anon., *The Tryal of a Cause for*

Criminal Conversation, Between Theophilus Cibber, Gent. Plaintiff, and William Sloper, Esq; Defendant (London: T. Trott, 1739), p. 9.

48. Cibber, *Apology*, p. 176.
49. Cibber, *Apology*, p. 176.
50. Anon., *Authentick Memoirs of the Life of That Justly Celebrated Actress, Mrs. Ann Oldfield, Collected From Private Records By a Certain Eminent Peer of Great Britain* ([Dublin]: George Faulkner, 1731), p. 13.
51. Felicity Nussbaum notes Kitty Clive's claim to training a fellow actress at her own expense in *Rival Queens: Actresses, Performance, and the Eighteenth-Century British Theater* (Philadelphia: University of Pennsylvania Press, 2010), p. 37.
52. Cibber, *Apology*, p. 96.
53. Benjamin Victor reports that Mary Porter 'came very young to the Stage, and was trained upon under one of the before-mentioned great Actresses', probably meaning Mary Betterton although it could also refer to Elizabeth Barry, *The History of the Theatres of London and Dublin, From the Year 1730 to the Present Time. To Which is Added, an Annual Register of All the Plays, &c. Performed at the Theatres-Royal in London, From the Year 1712*, 2 vols (London: for T. Davies; R. Griffiths, T. Becket, et al., 1761), p. 2:57.
54. Letter to Hester Thrale, London, 21 October 1783, *The Letters of Samuel Johnson, IV, 1782–1784*, ed. by Bruce Redford, (Princeton: Princeton University Press, 1994), p. 229.
55. Undated extract in, London, Garrick Club, 'Original Letters of Dramatic Performers Collected and Arranged By C[harles] B. Smith. Collected Up to C.1850, Folio', 9 vols, I, p. 132. For a description of Molini's attempts in *The Country Girl*, and *The Spoil'd Child* see, *True Briton*, 29 November 1798; ?3 February 1811 *Mrs. Jordan and Her Family: Being the Unpublished Correspondence of Mrs. Jordan and the Duke of Clarence, Later William IV*, ed. by Arthur Aspinall, (London: Arthur Barker, 1951), p. 184.
56. Nicolas Venette, *Conjugal Love Reveal'd; in the Nightly Pleasures of the Marriage Bed, and the Advantages of That Happy State. Seventh Edition* (London: for the author, 1720?), p. 161. Although Venette still considered women more lascivious than men, it must be noted that for him the cause was women's greater heat rather than moisture (110).
57. William Oldys, *Memoirs of Mrs. Anne Oldfield* (London: [n. pub], 1741), p. 65.
58. Cibber, *Apology*, pp. 97, 101.
59. Anon., *The Life of Lavinia Beswick, Alias Fenton, Alias Polly Peachum* (London: for A. Moore, 1728), p. 17.
60. Oldys, *Memoirs of Anne Oldfield*, pp. 44–5. Oldys misquotes *The Tatler* No. 212 which describes Flavia's beauty as 'full of Attraction, but not of Allurement', see Anon [Addison, and others], *The Lucubrations of Isaac Bickerstaff Esq*, 5 vols [London: for E. Nutt, A. Bell, J. Darby, A. Bettesworth, et al., 1720], IV, p. 82; Anon., *Authentick Memoirs*, p. 16.
61. Tuana, *Woman and the History of Philosophy*, p. 39.
62. *Poem to the Memory of Mrs Oldfield*, p. 7; *James Thomson (1700–1748): Letters and Documents*, ed. by Alan Dugald McKillop (Lawrence: University of Kansas Press, 1958), pp. 7–8.
63. Richard Savage, 'An Epistle to Mrs Oldfield of the Theatre Royal', in *Miscellaneous Poems and Translations* (London: for Samuel Chapman, 1726), pp. 187–90 (p. 189).

3 Playing Men: 'Half the men in the house take me for one of their own sex'

1. William Rufus Chetwood, *A General History of the Stage, From Its Origin in Greece Down to the Present Time. With the Memoirs of Most of the Principal Performers That Have Appeared on the English and Irish Stage for These Last Fifty Years* (London: for W. Owen, 1749), p. 252.

2. Chetwood, *General History of the Stage*, p. 252. This apocryphal story is repeated across theatrical tracts and biographies in the eighteenth-century, including Anon., *The Life of Mr. James Quin, Comedian. With the History of the Stage From His Commencing Actor to His Retreat to Bath* (London: for S. Bladon, 1766), p. 68; James Quin, *Quin's Jests; or, the Facetious Man's Pocket-Companion. Containing Every Species of Wit, Humour, and Repartee* (London: for S. Bladon, 1766), p. 20; and Anon., *The Court and City Jester: Being an Original Collection of Jests, Puns, Bons Mots, Repartees, Quibbles, Bulls, &c.* (London: for B. Robinson, 1770), p. 37.

3. Woffington had first performed the role of Sir Harry Wildair earlier the same year, on 25 April 1740, in Dublin. The only plays in which she is recorded as performing after her debut in *The Recruiting Officer* and before 21 November are *The Double Gallant* and *The Country Lasses*. However the casts of *The Quaker of Fair Deal* and *The Funeral* (performed on 12 November and 14 November respectively) are not recorded. See *The London Stage, 1660–1800: a Calendar of Plays, Entertainments & Afterpieces, Together With Casts, Box-receipts and Contemporary Comment. Compiled From the Playbills, Newspapers and Theatrical Diaries of the Period, 5 Parts in 11 Volumes*, ed. by William Van Lennep et al. (Carbondale: Southern Illinois University Press, 1960–1968), Part 3 1729–1747, The Theatrical Season 1736–1747, pp. 861–6.

4. Shirley Strum Kenny, 'Farquhar, George (1676/7–1707)', *Oxford Dictionary of National Biography* (2004) http://www.oxforddnb.com/view/article/9178 [accessed 7 March 2014].

5. Thomas Laqueur, *Making Sex: Body and Gender from the Greeks to Freud* (Cambridge, MA: Harvard University Press, 1990), p. 8. Valerie R. Hotchkiss argues that the variety of responses to female transvestites in the Middle Ages indicates that there were no universal notions of gender as either biological or cultural but rather a view that male characteristics and behaviour were superior: *Clothes Make the Man: Female Cross Dressing in Medieval Europe* (New York: Garland, 1996), p. 126. See also John Tosh, 'The Old Adam and the New Man: Emerging Themes in the History of English Masculinities, 1750–1850', in *English Masculinities, 1660–1800*, ed. by Tim Hitchcock and Michèle Cohen (London: Longman, 1999), pp. 217–38 (pp. 231–3).

6. See for example Laqueur, *Making Sex*, p. 152; and Michael McKeon, 'Historicizing Patriarchy: The Emergence of Gender Difference in England, 1660–1760', *Eighteenth-Century Studies*, 28.3 (1995), 295–322, (p. 301).

7. See for example, Elizabeth Howe, *The First English Actresses: Women and Drama, 1660–1700* (Cambridge: Cambridge University Press, 1992), p. 56; and Pat Rogers who argues that 'since there was no attempt to portray anything other than a notional or stylised masculinity, the actress did not risk losing any glamour or sex-appeal – usually, quite the opposite', 'The Breeches Part', in *Sexuality in Eighteenth-Century Britain*, ed. by Paul-Gabriel Boucé

(Manchester: Manchester University Press, 1982), pp. 244–58 (p. 249). For Rogers the actress's overt femininity was central to the effect (255).

8. Rudolf M. Dekker and Lotte C. van de Pol, *The Tradition of Female Transvestism in Early Modern Europe* (Basingstoke: Macmillan – now Palgrave Macmillan, 1989), p. 90.

9. Dianne Dugaw has argued that ballad-makers regularised the female warrior as an idealised figure in the eighteenth century, turning her into 'an imaginative archetype in popular balladry a standard motif', Dianne Dugaw, *Warrior Women and Popular Balladry 1650–1850* (Chicago: University of Chicago Press, 1996).

10. *The Life and Adventures of Mrs Christian Davies, Commonly Call'd Mother Ross* (London: printed for and sold by R. Montagu, 1740); *The Female Soldier; or, the Surprising Life and Adventures of Hannah Snell* (London: printed for, and sold by R. Walker, 1750)

11. Terry Castle, 'The Culture of Travesty: Sexuality and Masquerade in Eighteenth-Century England', in *Sexual Underworlds of the Enlightenment*, ed. by G. S. Rousseau and Roy Porter (Manchester: Manchester University Press, 1987), pp. 156–80 (pp. 156–7). For discussion of cross-dressing in daily life see Randolph Trumbach, 'London's Sapphists: From Three Sexes to Four Genders in the Making of Modern Culture', in *Body Guards: The Cultural Politics of Gender Ambiguity*, ed. by Julia Epstein and Kristina Straub (London: Routledge, 1991), pp. 112–41, (pp. 121–5). Lynne Friedli argues that contemporary texts show an increasing interest in female transvestism in this period, '"Passing Women": A Study of Gender Boundaries in the Eighteenth Century', in *Sexual Underworlds of the Enlightenment*, ed. by G. S. Rousseau and Roy Porter (Manchester: Manchester University Press, 1987), pp. 234–60 (p. 234). Dekker and van de Pol highlight that the current situation, where transvestism is associated largely with men, is a reversal of the situation before 1800 where there was a tradition of cross dressing among women, but not men, *Tradition of Female Transvestism*, p. 54.

12. *Life of James Quin*, p. 67.

13. Diane Torr and Stephen Bottoms, *Sex, Drag, and Male Roles: Investigating Gender as Performance* (Ann Arbor: University of Michigan, 2010), p. 1.

14. George Farquhar, *The Constant Couple: or, a Trip to the Jubilee. A Comedy. Acted At the Theatre-Royal in Drury-lane, By His Majesty's Servants. The Seventh Edition; With a New Scene Added to the Part of Wildair; and a New Prologue* (London: for John Clarke, 1738)

15. On 17 March 1743 Woffington played Lurewell for the first time, for her benefit. She was partnered by Garrick as Sir Harry Wildair. As a side note, and evidencing the layering of roles for the public, a month later, on 23 April, Woffington played the breeches role of Sylvia in *The Recruiting Officer*, opposite Garrick as Plume.

16. George Piggford, '"Who's That Girl?": Annie Lennox, Woolf's *Orlando*, and Female Camp Androgyny', in *Camp: Queer Aesthetics and the Performing Subject: a Reader*, ed. by Fabio Cleto (Edinburgh: Edinburgh University Press, 1999), pp. 283–99, p. 284.

17. *Life of James Quin*, p. 68.

18. Piggford, 'Who's That Girl?', p. 284.

19. Richard Dyer, 'It's Being So Camp as Keeps Us Going', in *Camp: Queer Aesthetics and the Performing Subject: a Reader*, ed. by Fabio Cleto (Edinburgh: Edinburgh University Press, 1999), pp. 110–16 (p. 113).

20. Joanne Entwistle, 'Addressing the Body', in *Fashion Theory: a Reader*, ed. by Malcolm Barnard (Abingdon: Routledge, 2007), pp. 273–91 (p. 280).

21. Esther Newton, 'Role Models', in *Camp: Queer Aesthetics and the Performing Subject: a Reader*, ed. by Fabio Cleto (Edinburgh: Edinburgh University Press, 1999), pp. 96–109, (pp. 100–1).

22. Prologue, Hannah More, *Percy, a Tragedy. As it is Acted At the Theatre-Royal in Covent-Garden* (Dublin: R. Marchbank, for the Company of Booksellers, 1778).

23. Dror Wahrman, 'Percy's Prologue: From Gender Play to Gender Panic in Eighteenth-Century England', *Past and Present*, 159 (1998), 113–60 (p. 115).

24. Kristina Straub, 'The Guilty Pleasures of Female Theatrical Cross-Dressing and the Autobiography of Charlotte Charke', in *Body Guards: The Cultural Politics of Gender Ambiguity*, ed. by Julia Epstein and Kristina Straub (London: Routledge, 1991), pp. 142–66 (p. 150).

25. For discussion of the representation of cross-dressed women as having excessive sexual appetites see Jean E. Howard, 'Crossdressing, the Theatre, and Gender Struggle in Early Modern England', *Shakespeare Quarterly*, 39.4 (1988), 418–40 (pp. 424–5).

26. Marion Jones argues that 'more than one excuse served to get actresses into breeches for the delectation of a predominantly male audience [. . .] prologues and epilogues were sometimes given by favourite actress in men's clothes with no other apparent reason than to provide the same arbitrary thrill. Something akin to this was the practice by which an actress took the part of a male character just to amuse the audience', 'Actors and Repertory', in *The Revels History of Drama in English. V: 1660–1750*, ed. by John Loftis et al. (London: Methuen, 1976), pp. 119–57 (p. 148). Vern L. Bullough and Bonnie Bullough note that there is a distinct difference to men playing women who were seen as becoming 'dangerously feminine' whereas women impersonating men provided an erotic attraction, showing their legs and figures in a way unavailable to ordinary women, *Cross Dressing, Sex, and Gender* (Philadelphia: University of Pennsylvania Press, 1993), p. 85. The point about the eroticism of seeing an actress in breeches is echoed across numerous studies including, Laurence Senelick, *The Changing Room: Sex, Drag and Theatre* (London: Routledge, 2000), p. 212; Straub, 'Guilty Pleasures', p. 143; Felicity Nussbaum, *Rival Queens: Actresses, Performance, and the Eighteenth-Century British Theater* (Philadelphia: University of Pennsylvania Press, 2010), p. 195; and Howe, *First English Actresses*, p. 56. Leslie Ferris argues that Restoration breeches roles were a 'sexualised theatrical commodity' and notes that cross-dressed epilogues played off actresses' real or supposed sexual exploits, *Acting Women: Images of Women in Theatre* (New York: New York University Press, 1989), pp. 72, 149. Of course the sexualisation of women in breeches also pre-dates the arrival of the professional actress, see Ann Rosalind Jones and Peter Stallybrass who discuss the 1620 pamphlet *Hic Mulier* which accused 'he-women' of wearing men's attire to be ready for illicit sex and drew connections between mannish independence and sexual depravity, 'Fetishizing Gender: Construcing the Hermaphrodite in Renaissance Europe', in *Body Guards: The Cultural Politics of Gender Ambiguity*, ed. by Julia Epstein and Kristina Straub (London: Routledge, 1991), pp. 80–111 (pp. 100–1).

27. Elizabeth Miller Lewis, 'Hester Santlow's *Harlequine*: Dance, Dress, Status, and Gender on the London Stage, 1706–1734', in *The Clothes That Wear*

Us: Essays on Dressing and Transgressing in Eighteenth-Century Culture, ed. by Jessica Munns and Penny Richards (Cranbury, NJ: Associated University Presses, 1999), pp. 80–101 (p. 84).

28. *Epilogue to Don Quixot for Mr Bickerstaff's Benefit, spoken by Miss Santlow in Boy's Cloaths*, in Anon., *A Collection and Selection of English Prologues and Epilogues, Commencing With Shakespeare, and Concluding With Garrick*, 4 vols (London: for Fielding and Walker, 1779), IV, p. 61.

29. *English Prologues and Epilogues*, IV p. 59.

30. Randolph Trumbach argues that it was only at the end of the century that a type of woman appeared who sought to be sexually desirable to women by dressing, in part, as a man. He identifies these women as London's first sapphists. At the same time he dismisses travesty performances as being designed to appeal sexually to men rather than women, see Trumbach, 'London's Sapphists,' p. 115. I would argue however that the innuendo within prologues and epilogues prefigures the use of cross-dressing by late century sapphists.

31. On 30 June 1750, for example, the *General Advertiser* announced that the former marine Hannah Snell (aka James Gray) would perform a new ballad that evening at the New Wells in Goodman's Fields, 'at the Desire of several Ladies'.

32. Chetwood, *General History of the Stage*, p. 69. Although Chetwood gives no dates for the performance, Mrs Bellamy performed in Ireland after 1726 and was also in Dublin in the mid 1730s.

33. Trumbach, for example, notes that women were not incorporated into the new gender paradigm fully in the eighteenth century since until the late nineteenth and early twentieth centuries their legitimate feminine status was based more on sex with men than the avoidance of sex with women, Trumbach, 'London's Sapphists,' p. 113. For a discussion of the changing representation of female same-sex attraction over the eighteenth century see Sally O'Driscoll, 'A Crisis of Femininity – Re-making Gender in Popular Discourse', in *Lesbian Dames: Sapphism in the Long Eighteenth Century*, ed. by John C. Beynon and Caroline Gonda (Farnham: Ashgate, 2010), pp. 45–60.

34. In making this argument I am drawing on Emma Donoghue's argument that crossdressing in the seventeenth and eighteenth century was, 'the frame of interpretation for passion between women', providing a space for women to recognise each other, *Passions Between Women: British Lesbian Culture 1668–1801* (London: Scarlet Press, 1993), p. 108. I am also aware of the wide range of behaviours, practices, and identifications which can be encompassed under the umbrella of female homosexuality. Valerie Traub, for example, notes that she uses the term lesbian as 'an exceptionally compressed and admittedly inadequate rubric for a wide, and sometimes conflicting, range of affective and erotic desires, practices, and affiliations, which have taken different historical forms and accrued varied historical meanings', *The Renaissance of Lesbianism in Early Modern England* (Cambridge: Cambridge University Press, 2002), p. 15. Chris Mounsey and Caroline Gonda also point out that it is often difficult to find continuity between the emotional and sexual aspects of women's relationships with each other, 'Queer People: an Introduction', in *Queer People: Negotiations and Expressions of Homosexuality, 1700–1800*, ed. by Chris Mounsey and

Caroline Gonda (Cranbury, NJ: Assocated University Presses, 2007), pp. 9–37 (pp. 14–15).

35. 'To Mrs Woffington, appearing in the Part of Silvia in the *Recruiting Officer*' [*sic*] in Benjamin Victor, *The History of the Theatres of London, From the Year 1760 to the Present Time* (London: for T. Becket, 1771), pp. 4–5.

36. Anon., *The Vision. Inscribed to Mrs. Woffington. Wrote By a Lady* (Dublin: James Esdall, 1753), pp. 7–8.

37. Terry Castle argues that the 'symbolic assumption of the identity of the male libertine has had a shaping role to play [. . .] in the cultural evolution of female homosexual identity', *The Apparitional Lesbian: Female Homosexuality and Modern Culture* (New York: Columbia University Press, 1993), p. 104.

38. Terry Castle, *The Female Thermometer: Eighteenth-Century Culture and the Invention of the Uncanny* (Oxford: Oxford University Press, 1995), p. 80. Castle is referring to Aristophanes's speech in *The Symposium* in which, she notes, Plato 'acknowledges the universal desire for androgyny'.

39. Beth H. Friedman-Romell, 'Breaking the Code: Toward a Reception Theory of Theatrical Cross-Dressing in Eighteenth-Century London', *Theatre Journal*, 47.4 (December 1995), 459–79 (p. 463).

40. *World*, 7 February 1754.

41. John Hill, *The Actor: or, a Treatise on the Art of Playing* (London: for R. Griffiths, 1755), p. 202.

42. A number of scholars have read these criticisms as referring to Woffington's lack of the appropriate genitalia. Laurence Senelick argues that 'either she conjures up a flaccid image of impotence or stirs up nauseating fancies of lesbianism', *The Changing Room*, p. 215; Felicity Nussbaum concurs, pointing out that 'her weak performance arose from her failing to possess the requisite male genitalia, something that would have been especially apparent in the high cut of the waistcoat of the time' *Rival Queens*, p. 224. The idea of sexual impotence was certainly one which was familiar to audiences. A number of prologues and epilogues played with the idea of the cross-dressed actress's impotence, for example Hester Santlow's epilogue to *Valentinian* in which she declared that she was 'not altogether what I seem' and mocked male spectators on the basis that 'Were ye once try'd, [you] would prove deficient too!', *English Prologues and Epilogues*, IV, p. 59.

43. Mary Douglas, *Implicit Meanings: Selected Essays in Anthropology* (London: Routledge, 1999), p. 150.

44. Eric Weitz, *The Cambridge Introduction to Comedy* (Cambridge: Cambridge University Press, 2009), p. 65.

45. Edmund Burke, *A Philosophical Enquiry Into the Origin of Our Ideas of the Sublime and Beautiful* (London: for R. and J. Dodsley, 1757), p. 26.

46. *The London Stage* notes that it was the seventh most frequently performed tragedy between 1747 and 1776, being preceded by *Romeo and Juliet*, *Hamlet*, *King Lear*, *The Mourning Bride*, *Macbeth*, and *The Orphan*, *London Stage*, Part 4, *1747–1776*, I, p. clxii. There were few newspaper commentaries on Woffington's performance as Lothario, although the fact that she only performed it once more that season, on 22 April for the benefit of Mr Barrington and Mr Lampe, speaks to its reception. Thomas Davies moreover comments that 'she did not meet with the same approbation in the part of *Lothario* as in that of *Wildair*', *Memoirs of the Life of David Garrick, Esq. Interspersed With*

Characters and Anecdotes of His Theatrical Contemporaries, 2 vols (London: for the author, 1780), I, p. 307.

47. Nicholas Rowe, *The Fair Penitent. A Tragedy* (London: for J. and R. Tonson and S. Draper, 1754). Further references to the play are given after quotations in the text.

48. Elaine M. McGirr, *Eighteenth-Century Characters: A Guide to the Literature of the Age* (Basingstoke: Palgrave Macmillan, 2007), p. 33.

49. Anon., *Memoirs of the Celebrated Mrs. Woffington, Interspersed With Several Theatrical Anecdotes; the Amours of Many Persons of the First Rank; and Some Interesting Characters Drawn From Real Life* ([London]: [J. Swan], 1760), p. 31.

50. *Memoirs of Mrs. Woffington*, p. 31.

51. 'The Dramatic Register, No. 16' in *Evening Advertiser*, 26–9 March 1757.

52. George Farquhar, *The Recruiting Officer. A Comedy. As it is Acted At the Theatre-Royal in Drury-Lane* (London: for Bernard Lintot, 1736); David Garrick, *The Country Girl, a Comedy, (altered From Wycherley) as it is Acted At the Theatre-Royal in Drury-Lane* (Dublin: for W. and W. Smith, J. Hoey, Sen. J Murphy, et al., 1766).

53. Francis Gentleman, *The Dramatic Censor: or, Critical Companion*, 2 vols (London: J. Bell, 1770), I, p. 77.

54. Gentleman, *Dramatic Censor*, I, p. 77.

55. William Cooke, *Memoirs of Charles Macklin: Comedian, With the Dramatic Characters, Manners, Anecdotes, &c, of the Age in Which He Lived: Forming an History of the Stage During Almost the Whole of the Last Century* (London: for James Asperne, 1806), p. 126.

56. Randolph Trumbach, 'London's Sodomites: Homosexual Behavior and Western Culture in the 18th Century', *Journal of Social History*, 11.1 (1977), 1–33 (p. 16).

57. Judith Butler, *Bodies That Matter: On the Discursive Limits of 'Sex'* (London: Routledge, 1993), p. 126.

58. Thomas Shadwell, *The Humours of the Army. A Comedy. As it is Acted At the Theatre-Royal in Drury-Lane* (London: for James Knapton, 1713).

59. John Philip Kemble, *The Female Officer, or the Humours of the Army, a Comedy. Altered From Shadwell* (Dublin: by James Hoey, 1763). Both spellings (Charlot and Charlotte) are used within the play and I have replicated their use here.

60. Howard, 'Crossdressing,' p. 439.

61. As Kristina Straub argues the cross-dressed actress (by which she means travesty rather than breeches) points to a feminine desire in excess of the role of woman as man's commensurate and oppositional other, threatening 'the apparent naturalness and stability of what was becoming dominant gender ideology', Straub, 'Guilty Pleasures', p. 150.

62. *The Court and City Magazine; or, a Fund of Entertainment for the Man of Quality, the Citizen, the Scholar, the Country Gentleman, and the Man of Gallantry; as Well as for the Fair of Every Denomination*, 2 vols (London: for Joseph Smith, 1770–1771), II, p. 353.

63. *Court and City Magazine*, II, p. 352.

64. Leigh Hunt, *Critical Essays on the Performers of the London Theatres Including General Observations on the Practise and Genius of the Stage* (London: John Hunt, 1807), p. 167.

65. Londa Schiebinger, 'Skeletons in the Closet: The First Illustrations of the Female Skeleton in Eighteenth-Century Anatomy', in *The Making of the Modern Body: Sexuality and Society in the Nineteenth Century*, ed. by Catherine Gallagher and Thomas Laqueur (Berkeley and Los Angeles: University of California Press, 1987), pp. 42–82 (p. 46).

66. 'Theatrical Journal', in *The European Magazine, and London Review*, 13 (May 1788), pp. 371–4 (p. 372).

67. Examining over 900 eighteenth-century plays Wahrman finds that in most decades until 1780 more than half of all prologues and epilogues interested in gender explored its playful instability, with only a small percent insisting on its fixity. In the last two decades of the century however, he notes a radical change in the pattern, with prologues and epilogues allowing for instability of gender virtually vanishing, 'Percy's Prologue,' pp. 149–50, also 123–4.

68. Eve Kosofsky Sedgwick, *Epistemology of the Closet* (Berkeley and Los Angeles: University of California Press, 2008), p. 156.

69. Cooke, *Memoirs of Charles Macklin*, p. 126.

70. Dror Wahrman, *The Making of the Modern Self: Identity and Culture in Eighteenth-Century England* (New Haven: Yale University Press, 2006), p. 53.

71. Prologue to Frederick Reynolds, *Cheap Living: a Comedy in Five Acts. As it is Performed At the Theatre-Royal, Drury Lane*, 3rd edn (London: for G. G and J. Robinson, 1797).

72. On 23 October 1797 the *Morning Chronicle* described the play as contented to 'excite a moment's merriment by the display of some ridiculous caricatura, or extort a laugh by some whimsical situation', whilst noting that although 'the powers of Mrs Jordan were exerted in the best manner to support the character the Author has drawn [. . .] the character is completely unnatural'; *Lloyd's Evening Post*, 23 October 1797.

73. *London Packet or New Lloyd's Evening Post*, 20 October 1797.

74. *Lloyd's Evening Post*, 23 October 1797.

75. *True Briton*, 23 October 1797.

76. James Boaden, *The Life of Mrs. Jordan, Including Original Private Correspondence, and Numerous Anecdotes of Her Contemporaries*, 2 vols (London: Edward Bull, 1831), I, p. 46.

77. Boaden, *Life of Mrs Jordan*, I, p. 127.

78. Boaden, *Life of Mrs Jordan*, I, p. 127.

79. William Clark Russell, *Representative Actors: A Collection of Criticisms, Anecdotes, Personal Descriptions, Etc, Etc Referring to Many Celebrated British Actors From the Sixteenth to the Present Century With Notes, Memoirs and a Short Account of English Acting* (London: Frederick Warne and Co, [n.d.]), pp. 383–4.

4 Playing Herself: 'It was not as an actress but as herself, that she charmed every one'

1. Rather than being the Beaumont and Fletcher version, the *Philaster* which was revived was the one adapted and first staged on 8 October 1762 by George Colman whilst he was acting manager at Drury Lane during David Garrick's Grand Tour.

2. *Morning Post and Daily Advertiser*, 6 October 1785.
3. The play was advertised as, 'not acted these 12 years' but the London Stage notes was last acted just under 12 years earlier, on 16 December 1774, *The London Stage, 1660–1800: a Calendar of Plays, Entertainments & Afterpieces, Together With Casts, Box-Receipts and Contemporary Comment. Compiled From the Playbills, Newspapers and Theatrical Diaries of the Period, 5 Parts in 11 Volumes*, ed. by William Van Lennep et al. (Carbondale: Southern Illinois University Press, 1960–1968), Part 5, 1776–1800, II, The Theatrical Season 1783–1792, p. 836.
4. *Morning Post and Daily Advertiser*, 8 October 1785.
5. Whilst there are too many 'Mrs Browns' to determine definitively which one this was, it is likely that this was Mrs J. Brown née Mills who had a similar acting style to Jordan and who, with her husband, was performing in Bath between 1782 and 1784, and who subsequently toured to York, Hull and back to Norwich by 1785–6, see *A Biographical Dictionary of Actors, Actresses, Musicians, Dancers, Managers & Other Stage Personnel in London, 1660–1800*, 16 vols, ed. by Philip H. Highfill, Kalman A. Burnim and Edward A. Langhans (Carbondale: Southern Illinois University Press, 1973), II, p. 364.
6. Barbara Maria Stafford, *Body Criticism: Imaging the Unseen in Enlightenment Art and Medicine* (Cambridge, MA: MIT Press, 1993), p. 26.
7. James Boaden, *Memoirs of Mrs. Siddons: Interspersed With Anecdotes of Authors and Actors*, 2 vols (London: Henry Colburn, 1827), II, p. 182; James Boaden, *The Life of Mrs. Jordan, Including Original Private Correspondence, and Numerous Anecdotes of Her Contemporaries*, 2 vols (London: Edward Bull, 1831), I, p. 72.
8. W. Fraser Rae, *Sheridan: a Biography*, 2 vols (London: Richard Bentley and Son, 1896), II, p. 13.
9. Examining Jordan's portraits, Gill Perry has highlighted how Jordan's loose curls signified her performance of self and her rejection of the mediating effects of theatrical performance 'Staging Gender and "Hairy Signs": Representing Dorothy Jordan's Curls', *Eighteenth-Century Studies*, 38.1 (2004), 145–63, p. 148.
10. Jacob Golomb, *In Search of Authenticity: Existentialism From Kierkegaard to Camus* (Abingdon: Routledge, 1995), p. 12. Lionel Trilling offers a similar definition, noting that 'sincerity is the avoidance of being false to any man through being true to one's own self', *Sincerity and Authenticity* (London: Oxford University Press, 1972), p. 5.
11. Felicity Nussbaum identifies what she describes as the 'interiority effect', an illusion of interiority which, 'blended the actress's putative personality with the assigned character's emotions and thoughts', and argues that this was cultivated by mid-century performers including Peg Woffington, see *Rival Queens: Actresses, Performance, and the Eighteenth-Century British Theater* (Philadelphia: University of Pennsylvania Press, 2010), pp. 20–2. Whilst I agree that earlier actresses drew on aspects of their allegedly 'real' personalities in creating public personas, the distinction at the end of the century, I argue in these final two chapters was that there was an increasing attempt to establish a direct relationship between actresses' 'selves' and their theatrical performances of character: an attempt which responded specifically to the Romantic notion of self and which was evident not just in their presentation of self in the print media, or through sartorial choices, but in their performance techniques.

12. Felicity Nussbaum, 'Heteroclites: The Gender of Character in the Scandalous Memoirs', in *The New Eighteenth Century: Theory, Politics, English Literature*, ed. by Felicity Nussbaum and Laura Brown (London: Methuen, 1987), pp. 144–67 (p. 145); Charles Guignon, *On Being Authentic* (London: Routledge, 2004), p. 6.
13. Cited in E. J. Hundert, 'The European Enlightenment and the History of the Self', in *Rewriting the Self: Histories From the Middle Ages to the Present*, ed. by Roy Porter (London: Routledge, 1997), pp. 72–3 (p. 82). As Dror Wahrman argues in an excellent summary of the late-century reversals of understandings of identity, at the end of the century it 'became much harder for people to imagine identities as mutable, assumable, divisible, or actively malleable', with personal identity being increasingly seen as, 'an innate, fixed, determined core: that "essentiality of man"', *The Making of the Modern Self: Identity and Culture in Eighteenth-Century England* (New Haven: Yale University Press, 2006), p. 275.
14. See Guignon, *On Being Authentic*, p. 12. Guignon notes that although the 'scaffolding of ideas that made the ideal of authenticity possible' can be seen in the cultural revolution which took place between the sixteenth and eighteenth centuries, it was not until the late eighteenth century that the idea of being true to yourself became considered an end in itself, rather than being a means to something else (27).
15. William Godwin, *Enquiry Concerning Political Justice, and Its Influence on Morals and Happiness*, 2 vols (London: G. G. and J. Robinson, 1798), I, p. 333.
16. For an exploration of Godwin's philosophy see, Andrea K. Henderson, *Romantic Identities: Varieties of Subjectivity, 1774–830* (Cambridge: Cambridge University Press, 1996), pp. 60–1.
17. Samuel Stanhope Smith, *An Essay on the Causes of the Variety of Complexion and Figure in the Human Species* (Edinburgh: for C. Elliot and T. Kay, 1788), p. 126.
18. Newspaper clipping dated 1783, London, British Library, *A Collection of Cuttings From Newspapers, and Magazines Relating to Celebrated Actors, Dramatists, Composers, Etc.* 2 vols ([unpub.], 1730?–1855?). Interestingly, as another clipping reveals, the lecture Mrs Curtis gave detailed the, 'relative and reciprocal duties, which are incumbent on BOTH sexes, to advance their particular, as well as mutual happiness' and included 'a few words reprehending the present, indecent, and unnatural phrenzy of the British Stage of turning Men into Women, and Women into Men' [n.d].
19. *Memoirs, Journal, and Correspondence of Thomas Moore*, V, ed. by John Russell, (London: Longman, Brown, Green, and Longmans, 1854), p. 297.
20. Boaden, *Life of Mrs Jordan*, I, p. 220.
21. Boaden, *Life of Mrs Jordan*, I, p. 20.
22. Colley Cibber, *An Apology for the Life of Mr. Colley Cibber: Comedian, and Late Patentee of the Theatre-Royal* (London: by John Watts for the author, 1740), p. 98.
23. John Hill, *The Actor: or, a Treatise on the Art of Playing* (London: for R. Griffiths, 1755), pp. 60–1.
24. Anon., 'An Essay on the Theatres: or the Art of Acting. In Imitation of *Horace's* Art of Poetry', in *The Harleian Miscellany or, a Collection of Rare, Curious, and Entertaining Pamphlets and Tracts*, 8 vols (London: for T. Osborne, 1744), V, pp. 543–9, p. 548.

25. Aaron Hill, *The Works of the Late Aaron Hill, Esq; in Four Volumes. Consisting of Letters on Various Subjects, and of Original Poems, Moral and Facetious. With an Essay on the Art of Acting*, 2nd edn (London: for the benefit of the family, 1754), IV, p. 343. For a discussion of the notion of selfhood as self-loss or release see Guignon, *On Being Authentic*, pp. 7–8. The difference between this mid-century mode of acting and the earlier model of rhetorical acting was in the techniques used rather than in their ends. From emphasising control and restraint, with the performer being counselled 'never to be so extravagantly immoderate as to transport the Speaker out of himself', in the mid-century, acting theory began to demand that the performer be taken over by the role, and 'transported beyond himself', see Charles Gildon, *The Life of Mr. Thomas Betterton, the Late Eminent Tragedian. Wherein the Action and Utterance of the Stage, Bar, and Pulpit, Are Distinctly Consider'd* (London: for Robert Gosling, 1710), p. 86; and, Letter from David Garrick to Helfrich Peter Sturz, Hampton, 3 January 1769, *The Letters of David Garrick*, 3 vols, ed. by David M. Little and George M. Kahrl (Cambridge, MA: Belknap Press of Harvard University Press, 1963) II, p. 635.

26. William Hazlitt, *A View of the English Stage, or a Series of Dramatic Criticisms* (London: John Warren, 1821), p. 169.

27. Patricia Howell Michaelson, *Speaking Volumes: Women, Reading, and Speech in the Age of Austen* (Stanford: Stanford University Press, 2002), p. 105.

28. *Discours Sur Les Sciences Et Les Arts: Lettre à D'Alembert*, ed. by Jean Varloot, (Paris: Gallimard, 1987), p. 239, cited in Erika Fischer-Lichte, *History of European Drama and Theatre* (London: Routledge, 2002), pp. 1–2.

29. Trilling, *Sincerity and Authenticity*, p. 64.

30. John Bennett, *Letters to a Young Lady, on a Variety of Useful and Interesting Subjects, Calculated to Improve the Heart, to Form the Manners, and Enlighten the Understanding*, 2 vols (London: for T. Cadell, Junior, and W. Davies, 1795), II, p. 80.

31. Hannah More, *Strictures on the Modern System of Female Education. With a View of the Principles and Conduct Prevalent Among Women of Rank and Fortune*, 2 vols (London: for T. Cadell Jun. and W. Davies, 1799), I, p. 105.

32. For a discussion about the anxiety over theatricality in the novel see Joseph Litvak, *Caught in the Act: Theatricality in the Nineteenth-Century English Novel* (Berkeley and Los Angeles: University of California Press, 1992). Trilling notes the antitheatrical prejudice evident in *Mansfield Park*, arguing that the novel has the same objection to histrionic art as Rousseau: that impersonation leads to the negation of self and therefore weakens the social fabric, see *Sincerity and Authenticity*, pp. 75, fn.2.

33. Boaden, *Life of Mrs Jordan*, I, pp. 219–20.

34. Joseph Haslewood, *The Secret History of the Green-Room: Containing Authentic and Entertaining Memoirs of the Actors and Actresses in the Three Theatres Royal. A New Edition, With Improvements*, 2 vols (London: for J. Owen, 1795), II, pp. 29, 28.

35. 'On Seeing Mrs Woffington Appear in Several Tragick Characters', *London Magazine, or Gentleman's Monthly Intelligencer*, February 1749. Arguing that we need to acknowledge the existence of competing publics even from the birth of the public sphere, Geoff Eley points out that 'the public sphere makes more sense as the structured setting where cultural and ideological

contest or negotiation among a variety of publics takes place, rather than as the spontaneous and class-specific achievement of the bourgeoisie in some sufficient sense', 'Nations, Publics, and Political Cultures: Placing Habermas in the Nineteenth Century', in *Habermas and the Public Sphere*, ed. by Craig Calhoun (Cambridge, MA: MIT Press, 1992), pp. 289–339 (p. 306).

36. Salt Hill, 13 October 1794, reproduced in *Catalogue of the Collection of Autograph Letters and Historical Documents Formed Between 1865 and 1882 By Alfred Morrison*, V, ed. by A. W. Thibaudeau ([London]: printed for private circulation, 1883–1892), V, p. 303.

37. Salt Hill, 13 October 1794, reproduced in *Catalogue of the Collection*, p. 287.

38. Hill, *The Actor*, p. 54.

39. Entry dated 6 January 1833, *The Journal of Thomas Moore: IV, 1831–1835*, ed. by Wilfred S. Dowden, Barbara G. Bartholomew and Joy L. Linsley (Cranbury, NJ: Associated University Presses, 1987), p. 1517.

40. Gildon, *Life of Mr. Thomas Betterton*, pp. 62, 63. Gildon also advises actors to emulate Le Brun who, he says, would watch quarrels in the street to observe the different expressions (37); David Garrick, *An Essay on Acting: in Which Will be Consider'd the Mimical Behaviour of a Certain Fashionable Faulty Actor, and the Laudableness of Such Unmannerly, as Well as Inhumane Proceedings* (London: for W. Bickerton, 1744), pp. 9–11.

41. Aaron Hill, *The Works of the Late Aaron Hill, Esq; in Four Volumes. Consisting of Letters on Various Subjects, and of Original Poems, Moral and Facetious. With an Essay on the Art of Acting* (London: for the Benefit of the Family, 1753), IV, p. 362.

42. Paul Goring, *The Rhetoric of Sensibility in Eighteenth-Century Culture* (Cambridge: Cambridge University Press, 2005), p. 130.

43. Entry for 6 January 1833, Moore, *Journal*, p. 1517. Moore is citing Lord L. who had heard Siddons comment, when looking over the statues at Lansdowne House, 'that the first thing that suggested to her the mode of expressing intensity of feeling was the position of some of the Egyptian statues, with the arms close down by the sides & the hands clenched'.

44. Leigh Hunt, *The Autobiography of Leigh Hunt. A New Edition* (London: Smith, Elder and Co, 1870), p. 121.

45. Leigh Hunt, *Critical Essays on the Performers of the London Theatres Including General Observations on the Practise and Genius of the Stage* (London: John Hunt, 1807), p. 165.

46. Hunt, *Critical Essays*, p. 165.

47. Hunt, *Critical Essays*, pp. 165–6.

48. Charles Lamb, *The Prose Works of Charles Lamb*, 3 vols (London: Edward Moxon, 1836), II, p. 303.

49. Boaden, *Life of Mrs Jordan*, I, p. 20; Sir Jonah Barrington, *Personal Sketches of His Own Times*, 5th edn (New York: Redfield, 1854), p. 407.

50. Tate Wilkinson, *The Wandering Patentee; or, a History of the Yorkshire Theatres, From 1770 to the Present Time*, 4 vols (York: for the author, by Wilson, Spence, and Mawman, 1795), II, p. 145. Although Wilkinson's reflection reveals the training Jordan underwent, Swan did nevertheless tell Wilkinson that after only three lessons Jordan was 'so adroit at receiving my instructions' that she repeated the character as well as Mrs Cibber.

51. Fanny Burney, *Evelina or the History of a Young Lady's Entrance Into the World. A New Edition in Two Volumes* (London: for W. Lowndes, 1794), I, p. 19.

52. J. J. McGann, *The Romantic Ideology: A Critical Investigation* (Chicago: University of Chicago Press, 1985), p. 63.

53. Book 6, *Institutio Oratoria*, cited in Joseph R. Roach, *The Player's Passion: Studies in the Science of Acting* (Ann Arbor: University of Michigan Press, 1993), p. 26; Anon., *A Poem to the Memory of Mrs Oldfield. Inscrib'd to the Honourable Brigadier Charles Churchill* ([Dublin]: George Faulkner, 1731), p. 5; Thomas Wilkes, *A General View of the Stage* (London: for J. Coote, 1759), p. 91.

54. Antony Aston, *A Brief Supplement to Colley Cibber, Esq; His Lives of the Famous Actors and Actresses* ([London]: for the author, 1747?), pp. 16, 18.

55. Barrington, *Personal Sketches*, p. 414.

56. Anon., *The Great Illegitimates: Public and Private Life of That Celebrated Actress Miss Bland, Otherwise Mrs. Ford, or Mrs Jordan, Late Mistress of HRH the Duke of Clarence, Now King William IV* (London: J. Duncombe, 1832?), p. 209. Deborah Kennedy notes however that this conversation probably never happened, *Helen Maria Williams and the Age of Revolution* (Cranbury, NJ: Associated University Presses, 2002), pp. 246–7 fn. 34.

57. *The British Magazine and Review; or Universal Miscellany,* I (London: Harrison and Co., 1782), p. 62; *The Reminiscences of Sarah Kemble Siddons, 1773–1785,* ed. by William Van Lennep (Cambridge: Widener Library, 1942), p. 20.

58. Edmond Waller, 'Anecdotes of Illustrious Females' in, *La Belle Assemblée: or Court and Fashionable Magazine,* Oct 1817, p. 151.

59. Golomb, *In Search of Authenticity*, pp. 12, 19.

60. Jonah Barrington, 'Sir Jonah Barrington's Sketches (4th Notice: – Conclusion)', in *The Literary Gazette; and Journal of Belles Lettres, Arts, Sciences, &c. for the Year 1827,* (London: by James Moyes for the Proprietors at the Literary Gazette Office, 1827), pp. 358–9 (p. 358).

61. Boaden, *Life of Mrs Jordan*, I, p. 220.

62. Fischer-Lichte citing Ekhof, *History of European Drama*, p. 168.

63. David Garrick, *The Country Girl, a Comedy (altered From Wycherley) as it is Acted At the Theatre-Royal in Drury-Lane* (Dublin: for W. and W. Smith, J. Hoey, Sen. J Murphy, et al., 1766).

64. Matthew H. Wikander, *Fangs of Malice: Hypocrisy, Sincerity, and Acting* (Iowa City: University of Iowa Press, 2002), p. xvii.

65. David Marshall, 'Rousseau and the State of Theater', in *Jean-Jacques Rousseau: Politics, Art, and Autobiography*, ed. by John T. Scott (Abingdon: Routledge, 2006), pp. 139–70 (p. 140).

66. Christine Roulston, *Virtue, Gender, and the Authentic Self in Eighteenth-Century Fiction: Richardson, Rousseau, and Laclos* (Gainesville: University Press of Florida, 1998), p. xix.

67. Barrington, *Personal Sketches*, p. 414.

68. Garrick attempted to prohibit spectators from sitting on the stage shortly after he became manager of Drury Lane. However he took nearly fifteen years to succeed in banning the audience from the stage and it was only when the newly enlarged auditorium was opened that he was able to end the practice outright in 1762. Prior to this spectators had often interrupted the performances, as one amusing example from a performance of *Philaster* in December 1711 reveals: 'A very lusty Fellow' in the audience the Spectator reported 'who getting into one of the Side-Boxes on the Stage,

before the Curtain drew, was disposed to shew the whole Audience his Activity by leaping over the Spikes; he passed from thence to one of the entering doors, where he took Snuff with a tolerable good grace, displayed his fine Cloaths, made two or three feint Passes at the Curtain with his cane, then faced about and appeared at the other Door: Here he affected to survey the whole House, bowed and smiled at Random, and then shew'd his Teeth [. . .] After this he retired behind the Curtain, and obliged us with several views of his Person from every Opening', Spectator No. 240 in Joseph Addison and Richard Steele, *The Spectator. Volume the Third* (Edinburgh: [n.pub], 1776), p. 312.

69. Trilling, *Sincerity and Authenticity*, p. 97.
70. Guignon, *On Being Authentic*, p. 76.
71. Golomb, *In Search of Authenticity*, p. 12.
72. In developing the idea of an authentic theatrical signature I am drawing on Michael Davies's discussion of William Cowper's 'authentic literary signature' and its variations across his work, 'Authentic Narratives: Cowper and Conversion', in *Literature and Authenticity, 1780–1900: Essays in Honour of Vincent Newey*, ed. by Ashley Chantler, Michael Davies and Philip Shaw (Farnham: Ashgate, 2011), pp. 9–24 (pp. 9–10).
73. Hazlitt, *View of the English Stage*, p. 169.
74. Boaden, *Memoirs of Mrs Siddons*, II, p. 122.
75. Jeremiah Jones, *A New and Full Method of Settling the Canonical Authority of the New Testament*, 3 vols (Oxford: Clarendon Press, 1798), I, p. 75.
76. Anon., *The Laureat: or, the Right Side of Colley Cibber, Esq; Containing Explanations, Amendments and Observations, on a Book Intituled [sic], an Apology for the Life, and Writings of Mr. Colley Cibber* (London: for J. Roberts, 1740), p. 56.
77. Hunt, *Critical Essays*, p. 162.
78. Hunt, *Critical Essays*, p. 162.
79. Boaden, *Life of Mrs Jordan*, I, p. 221.
80. Boaden, *Life of Mrs Jordan*, I, p. 329.
81. Boaden, *Life of Mrs Jordan*, I, p. 80.
82. Letter of Anna Seward (xxxiv) to Miss Weston Lichfield, 20 July 1786, *Letters of Anna Seward: Written Between the Years 1784 and 1807*, 6 vols (Edinburgh: for Archibald Constable and Company, 1811), I, p. 165. It should be noted that a notebook in the British Library records Siddons's performance of Rosalind for her benefit on 30 April 1785 as proving, 'to a numerous & astonish'd audience, that her vast Empire of Genius, brok'd no limitation – she acquitted herself throughout with wonderful ease, considering its being a first appearance & in her Delivery of the Text, observ'd a most critical articulation, which she enliven'd with a very peculiar Elegance of Humour'. British Library MSS. f.12 AD 78705.
83. *Life and Letters of Sir Gilbert Elliot, First Earl of Minto, From 1751 to 1806*, 3 vols, ed. by Emma Eleanor Elizabeth (Hislop) Elliot-Murray-Kynynmound Minto (London: Longmans, Green & Co., 1874), p. 154.
84. [Edward Mangin], *Piozziana; or, Recollections of the Late Mrs Piozzi With Remarks, By a Friend* (London: Edward Moxon, 1833), p. 86.
85. Anne Jackson, *A Continuation of the Memoirs of Charles Mathews, Comedian*, 2 vols (Philadelphia: Lea & Blanchard, 1839), I, p. 120.
86. 26 April 1814, Royal Archives, GEO/ADD40/234.

87. April 1814, RA, GEO/ADD40/235.
88. Boaden, *Life of Mrs Jordan*, I, p. 329; *Morning Post*, 10 February 1814.
89. RA, GEO/ADD40/230.
90. Entry for 12 April 1787, Minto, *Life and Letters*, I, p. 152.
91. *The Court Journals and Letters of Frances Burney*, II, *1787*, ed. by Stewart Cooke, (Oxford: Clarendon Press, 2011), p. 229, fn. 648.
92. Siddons, *Reminiscences*, pp. 16, 17.
93. Horace Walpole to the Countess of Upper Ossory, Berkeley Square, Christmas Night, 1782, *The Letters of Horace Walpole, Fourth Earl of Orford*, *XII, 1781–1783* (Oxford: Clarendon Press, 1905), p. 386.
94. Siddons, *Reminiscences*, pp. 16–17.
95. London, Garrick Club, 'Original Letters of Dramatic Performers Collected and Arranged By C[harles] B. Smith. Collected Up to C.1850, Folio', 9 Vols, pp. 85–91; *Great Illegitimates*, p. 26.
96. To William, Duke of Clarence, RA, GEO/ADD40/99.
97. Margate [11? September 1802], *Mrs. Jordan and Her Family: Being the Unpublished Correspondence of Mrs. Jordan and the Duke of Clarence, Later William IV*, ed. by Arthur Aspinall, (London: Arthur Barker, 1951), p. 51.
98. To William, Duke of Clarence: Bushy [October 1808], RA, GEO/ADD40/131; see also, Bath [16 April] and [30 April 1809] in, San Marino, CA, Huntington Library, Dorothy Jordan Papers, DJ 220 and 232.
99. Guignon, *On Being Authentic*, p. 76. This argument is also made by Trilling, using Rousseau, *Sincerity and Authenticity*, p. 93.
100. Michaelson, *Speaking Volumes*, p. 105.
101. Ruth W. Grant, *Hypocrisy and Integrity: Machiavelli, Rousseau, and the Ethics of Politics* (Chicago: University of Chicago Press, 1997), p. 15.
102. Judith Pascoe, *Romantic Theatricality: Gender, Poetry, and Spectatorship* (Ithaca: Cornell University Press, 1997), p. 13.
103. Emily Hodgson Anderson, *Eighteenth-Century Authorship and the Play of Fiction: Novels and the Theater, Haywood to Austen* (Abingdon: Routledge, 2009), p. 7.

5 Playing Mothers: 'Stand forth ye elves, and plead your mother's cause'

1. Hampton, 31 July 1775, *The Letters of David Garrick*, 3 vols, ed. by David M. Little and George M. Kahrl (Cambridge, MA: Belknap Press of Harvard University Press, 1963), III, p. 1021.
2. August 1775, British Library, MS 25383.
3. BL, MS 25383.
4. Hampton, 15 August 1775, Garrick, *Letters*, III, p. 1027.
5. Linda Colley, *Britons: Forging the Nation 1707–1837* (New Haven, CT: Yale University Press, 1992), p. 240.
6. See Cindy McCreery on the increasing production of sentimental images of mothers, *The Satirical Gaze: Prints of Women in Late Eighteenth-century England* (Oxford: Oxford University Press, 2004), pp. 207, also 190; Barbara Gelpi on the eroticised breasts of the mother, and in particular, the nursing mother, across British magazine illustrations, 'Significant Exposure: The

Turn-of-the-Century Breast', *Nineteenth-Century Contexts*, 20.2 (1997), 125–45; and Toni Bowers on changing practices of breastfeeding, *The Politics of Motherhood: British Writing and Culture, 1680–1760* (Cambridge: Cambridge University Press, 1996), pp. 161–2.

7. Siddons's first attempt at the Drury Lane stage, in the 1775–1776 season, had ended in failure and when Garrick had retired at the end of the season her contract had not been renewed. In the intervening years, prior to her return to Drury Lane in 1782, Siddons worked on the provincial circuit which included the theatres in Liverpool, Birmingham, York, Bristol and Bath.

8. David Garrick, *Isabella; or, the Fatal Marriage. A Tragedy, Altered From Southern By D. Garrick, Esq. Marked With the Variations in the Manager's Book, At the Theatre-Royal, in Drury-Lane* (London: for C. Bathurst, T and W. Lowndes, T. Longman, T. Caslon, W. Nicoll, S. Bladon, and T. Wheildon, 1783). Further references to the play are given after quotations in the text.

9. Robyn Asleson, '"She Was Tragedy Personified"': Crafting the Siddons Legend in Art and Life', in *A Passion for Performance: Sarah Siddons and Her Portraitists*, ed. by Shelley M. Bennett et al. (Los Angeles: The J. Paul Getty Museum, 1999), pp. 41–95 (p. 52).

10. *Morning Post and Daily Advertiser*, 10 October 1782.

11. Anon., *The Theatrical Portrait, a Poem on the Celebrated Mrs Siddons in the Characters of Calista, Jane Shore, Belvidera, and Isabella* (London: T. Wilkins, 1783), p. 15.

12. In Asleson, 'She Was Tragedy Personified' p. 53. Asleson points out that many of the images produced following Siddons's performance focused either on her cradling her son's hands in her own or on the private interview between the mourning mother and child.

13. James Boaden, *Memoirs of Mrs. Siddons: Interspersed With Anecdotes of Authors and Actors*, 2 vols (London: Henry Colburn, 1827), I, p. 290.

14. *Whitehall Evening Post*, 10–12 October 1782.

15. Anon., *The Beauties of Mrs Siddons: or, a Review of Her Performances of the Characters of Belvidera, Zara, Isabella, Margaret of Anjou, Jane Shore and Lady Randolph* (London: John Strahan, 1786), pp. 25–6.

16. Boaden, *Memoirs of Mrs Siddons*, p. 1:295.

17. Boaden, *Memoirs of Mrs Siddons*, p. 1:292.

18. In discussing Siddons's performance of maternity Jan McDonald suggests that Siddons was 'a skilled exponent of what Stanislavsky over a century later was to call the technique of "emotion memory", that is the use of the recollection of one's own deeply felt experiences in the creation of a theatrical persona', '"Acting and the Austere Joys of Motherhood": Sarah Siddons Performs Maternity', in *Extraordinary Actors: Essays on Popular Performers: Studies in Honour of Peter Thomson*, ed. by Jane Milling and Martin Banham (Exeter: University of Exeter Press, 2004), pp. 57–70 (p. 60). Similarly Shearer West argues that Siddons went 'a step further than Garrick in attempting to exemplify real emotion, and her private correspondence reveals that she at times entered the emotional life of her characters – especially when their situations had parallels with her own', 'The Public and Private Roles of Sarah Siddons', in *A Passion for Performance: Sarah Siddons and Her Portraitists*, ed. by Robyn Asleson et al. (Los Angeles: J. Paul Getty Museum, 1999), pp. 1–39 (p. 16).

19. *The Times*, 19 May 1788. Siddons's official farewell was on 29 June 1812, although she did continue by offering private readings and recitals at home following her retirement.

20. Letter from Sarah Siddons to Viscountess Perceval, 24 November 1795, cited in Roger Manvell, *Sarah Siddons* (London: Heinemann, 1970), p. 363.

21. Letter from Sarah Siddons to Mrs FitzHugh, Westbourne Farm, 7 April 1815, cited in Manvell, *Sarah Siddons*, p. 306.. Henry Siddons died from tuberculosis in 1815 at the age of forty.

22. Letter from Oxford, 4 August 1793, London, British Library, Barrington Papers. vols. cxci–cxcii. 'Letters From Sarah Siddons, Mostly Addressed to Elizabeth Barrington (née Adair), Wife of George Barrington, 5th Viscount, Concerning Health, Family, the Theatre, etc.; Before 1788–1824', Add MSS 73736–73737.

23. Cited in Clement Parsons, *The Incomparable Siddons* (London: Methuen & Co, 1909), p. 197.

24. Manvell, *Sarah Siddons*, p. 221.

25. Entry of 6 June 1828, *Memoirs, Journal, and Correspondence of Thomas Moore*, V, ed. by John Russell (London: Longman, Brown, Green, and Longmans, 1854), p. 297.

26. *The Intimate Letters of Hester Piozzi and Penelope Pennington, 1788–1821*, ed. by Oswald G. Knapp (London: John Lane, 1914), p. 302.

27. Letter to Penelope Sophia Pennington Brynbella, [6] September 1801 in *The Piozzi Letters: Correspondence of Hester Lynch Piozzi, 1784–1821 (formerly Mrs. Thrale) III, 1799–1804*, ed. by Edward A. Bloom and Lillian D. Bloom (Newark: University of Delaware Press, 1993), p. 315.

28. Letter to Penelope Sophia Pennington Brynbella [6] September 1801, in Piozzi, *Letters*, p. 315.

29. [6] September 1801 in Piozzi, *Letters,* p. 315.

30. By the late eighteenth-century motherhood, as scholars including Cindy McCreery, Linda Colley, and Felicity Nussbaum have demonstrated, had become integrally tied up with issues of nation. See McCreery, *Satirical Gaze*, pp. 185, 211; Colley, *Britons*, p. 240; and Felicity A. Nussbaum, '"Savage" Mothers: Narratives of Maternity in the Mid-Eighteenth Century', *Cultural Critique*, 20 (1991–1992), 123–51 (pp. 127, 129).

31. Christian Augustus Struve, *A Familiar View of the Domestic Education of Children, During the Early Period of Their Lives. Being a Compendium Addressed to All Mothers, Who Are Seriously Concerned for the Welfare of Their Offspring* (London: for Murray and Highley, 1802), p. 165.

32. Thomas Bull, *Hints to Mothers, for the Management of Health During the Period of Pregnancy* (London: Longman, Orme, Brown, Green & Longhams, 1837), pp. 103, also 22; Struve, *Familiar View*, p. 164.

33. Martha Mears, *The Pupil of Nature; or Candid Advice to the Fair Sex, on the Subjects of Pregnancy; Childbirth; the Diseases Incident to Both; the Fatal Effects of Ignorance and Quackery; and the Most Approved Means of Promoting the Health, Strength, and Beauty of Their Offspring* (London: for the authoress, 1797), p. 46.

34. Priscilla Wakefield, *Reflections on the Present Condition of the Female Sex; With Suggestions for Its Improvment* (London: for J. Johnson; and Darton and Harvey, 1798), pp. 15–16.

35. Struve, *Familiar View*, p. 161; Bull, *Hints to Mothers*, p. 104.
36. Mears, *Pupil of Nature*, p. 31; for discussions on the dangers of fear, terror, and grief, see Struve, *Familiar View*, p. 161.
37. Struve, *Familiar View*, p. 161.
38. *Morning Chronicle and London Advertiser*, 30 September 1773.
39. Entry of 3 April 1794, *Thraliana: The Diary of Mrs Hester Lynch Thrale (later Mrs Piozzi) 1776–1809*, 2 vols, ed. by Katharine C. Balderston (Oxford: Clarendon Press, 1942), II, pp. 876–7.
40. Bowers, *Politics of Motherhood*, p. 159; Struve, *Familiar View*, p. 211.
41. For a discussion of the ways in which actresses may have balanced the demands of breastfeeding with working in the theatre see, Helen E. M. Brooks, '"The Divided Heart of the Actress": Late Eighteenth-Century Actresses and the "cult of Maternity"', in *Women, Work and the Theater, 1660–1830: Stage Mothers* (Lewisburg: Bucknell University Press, 2014).
42. Ann Catherine Holbrook, *The Dramatist; or, Memoirs of the Stage. With the Life of the Authoress, Prefixed, and Interspersed With, a Variety of Anecdotes, Humourous and Pathetic* (Birmingham: Martin & Hunter, 1809), p. 60.
43. Observer No. 123 in Richard Cumberland, *The Observer. Being a Collection of Moral, Literary and Familiar Essays*, 4 vols (Dublin: for P. Byrne, R. Marchbank, J. Moore, and W. Jones, 1791), IV p. 20.
44. It is a question which echoes through Cumberland's writing: as he asked a woman who had been composing verses, 'if such are to be your studies and occupations, what is to become of all the comforts of a husband? How are you to fulfil the duties of a mother, or manage the concerns of a family?' Observer No. 6, Cumberland, *Observer*, I, p. 38.
45. Letter to Elizabeth Barrington, Dublin, 5 January 1794 in BL, Add MSS 73736–73737.
46. Royal Archives [W.m 1801] GEO/ADD40/91; Fortunes Hotel, Edinburgh, 17 June 1810, *Mrs. Jordan and Her Family: Being the Unpublished Correspondence of Mrs. Jordan and the Duke of Clarence, Later William IV*, ed. by Arthur Aspinall (London: Arthur Barker, 1951), p. 141.
47. Letter from Dora Jordan to William, Duke of Clarence, 12 December 1810, Jordan, *Mrs Jordan and Her Family*, p. 175.
48. Letters from Dora Jordan to William, Duke of Clarence [September 1802] RA, GEO/ADD40/98; RA, GEO/ADD40/99.
49. Letter from Dora Jordan to William, Duke of Clarence, Dublin, 11 June 1809, San Marino, CA, Huntington Library, Dorothy Jordan Papers, DJ 243.
50. 11 April 1794 in BL, Add MSS 73736–73737.
51. Letter from Dora Jordan to William, Duke of Clarence, Canterbury [1 September 1801] *Mrs Jordan and Her Family*, p. 47.
52. Claire Tomalin and Ian A. C. Dejardin, *Mrs Jordan: The Duchess of Drury Lane* (London: English Heritage, 1995), p. 61.
53. *Sophie in London, 1786: Being the Diary of Sophie V. La Roche*, trans. by Clare Williams (London: Jonathan Cape, 1933), p. 267.
54. La Roche, *Sophie in London*, p. 267. This image of Siddons being discovered breastfeeding echoes the scenes of mothers caring for their children which Kate Retford argues were proliferating in novels and conduct books and which served to present precepts in optical form, providing a viewpoint which encouraged feelings of elation and tenderness in the reader. In these

scenes the mother was usually absorbed in her maternal duties, often suck-
ling her offspring, and unaware of the presence of the spectator and thereby
exempt from accusations of insincerity or immodesty, *The Art of Domestic
Life: Family Portraiture in Eighteenth-Century England* (New Haven: for the
Paul Mellon Centre for Studies in British Art by Yale University Press, 2006),
p. 87. The only notable difference with Sophie von La Roche's description is
Siddons's juggling of work with her maternal duties.

55. See E. Ann. Kaplan, *Motherhood and Representation: The Mother in Popular Culture
and Melodrama* (London: Routledge, 1992), pp. 9–10; Susan C. Greenfield,
'Introduction', in *Inventing Maternity: Politics, Science, and Literature, 1650–1865*,
ed. by Susan C. Greenfield and Carol Barash (Lexington: University Press of
Kentucky, 1999), pp. 1, 8; and Rebecca S. Davies, 'The Maternal Contradiction:
Representing the Fictional Mother in Richardson's Pamela Ii (1741)', *Journal
for Eighteenth-Century Studies*, 33.3 (2010), 381–97 (p. 382).

56. Entry for 'Bannister (Mrs)' Cooke, *The Thespian Dictionary; or, Dramatic
Biography of the Eighteenth Century; Containing Sketches of the Lives, Productions,
& C. of All the Principal Mangers, Dramatists, Composers, Commentators, Actors,
and Actresses, of the United Kingdom* (London: for T. Hurst, 1802)

57. 'Memoirs of Mrs Davenport' in London, Garrick Club, 'Original Letters
of Dramatic Performers Collected and Arranged By C[harles] B. Smith.
Collected Up to C.1850, Folio', 9 vols, p. 3:40.

58. Petronius Arbiter, *Memoirs of the Present Countess of Derby (late Miss Farren)*
(London: Symonds, 1797?), p. 11; entry for 'Pritchard (Mrs)' in Cooke,
Thespian Dictionary.

59. Susan Kingsley Kent, *Gender and Power in Britain, 1640–1990* (London:
Routledge, 2013), p. 70.

60. Kent, *Gender and Power*, p. 70.

61. Catherine Belsey, 'Reading Cultural History', in *Reading the Past: Literature
and History*, ed. by Tamsin Spargo (Basingstoke: Palgrave – now Palgrave
Macmillan, 2000), pp. 103–17 (p. 109).

62. *The Reminiscences of Sarah Kemble Siddons, 1773–1785*, ed. by William Van
Lennep (Cambridge: Widener Library, 1942), p. 16.

63. Nancy Armstrong, *Desire and Domestic Fiction: A Political History of the Novel*
(Oxford: Oxford University Press, 1989), pp. 59, 61.

64. Bowers expresses some doubts over whether *Emile* was the seminal point his-
torians often locate it as, arguing that England is a separate case from France
and that many developments in maternal behaviours and the gendered divi-
sion of childcare appears before mid-century in England. She argues instead
that Rousseau's formulations functioned to accelerate trends and ways of
thinking and behaving that were already underway in England, *Politics of
Motherhood*, p. 15. Julie Kipp however suggests that *Emile* transformed atti-
tudes towards children and played a key role in childcare debates, whilst
noting that a widespread interrogation of mothering practices had been
underway long before it was published, *Romanticism, Maternity, and the Body
Politic* (Cambridge: Cambridge University Press, 2003), pp. 21–2.

65. Jean-Jacques Rousseau, 'Emile ou de L'éducation' in *Œuvres Complètes* (Paris:
Gallimard, Bibliothèque de la Pléiade, 1969) IV: 768, cited in Mary Seidman
Trouille, *Sexual Politics in the Enlightenment: Women Writers Read Rousseau*
(Albany: State University of New York Press, 1997), p. 139.

66. Anon., *The Life of Lavinia Beswick, Alias Fenton, Alias Polly Peachum* (London: for A. Moore, 1728), pp. 7, 8.
67. Boaden, *Memoirs of Mrs Siddons*, I, pp. 1–3.
68. Boaden, *Memoirs of Mrs Siddons*, I, p. 5.
69. Ambrose Philips, *The Distrest Mother, a Tragedy. Translated By Ambrose Philips, From the Andromaque of Racine* (Dublin: for William Jones, 1792), p. 142. Further references to the play are given after quotations in the text.
70. Paul E. Parnell, 'The Distrest Mother: Ambrose Philips' Morality Play', *Comparative Literature*, 11.2 (1959), 111–23 (pp. 117, 121).
71. Philips, *The Distrest Mother*, p. ix.
72. Jean I. Marsden, *Fatal Desire: Women, Sexuality, and the English Stage, 1660–1720* (Ithaca: Cornell University Press, 2006), p. 145.
73. As Toni Bowers argues, whilst the ideal of the tender, noble, self-sacrificial, and ever-nurturing mother was codified in the early part of the century, it was only put to political use in the second half of the century, *Politics of Motherhood*, p. 15.
74. Rebecca Davies discusses Pamela's response to the play, noting that the character was disturbed by flippant epilogue and its effacement of the virtuous sentiments raised by the play, 'Maternal Contradiction,' p. 388.
75. Joseph Haslewood, *The Secret History of the Green Room: Containing Authentic and Entertaining Memoirs of the Actors and Actresses in the Three Theatres Royal, the Second Edition*, 2 vols (London: for H. D. Symmonds, 1792), I, p. 8. Further references to this text are given after quotes in the text.
76. Charles Frederick Partington, *The British Cyclopedia of Biography: Containing the Lives of Distinguished Men of All Ages and Countries, With Portraits, Residences, Autographs, and Monuments*, II (London: WM. S. Orr and Co, 1838), p. 952.
77. 'Memoirs of Mrs Siddons with a Striking Likeness of that Celebrated Actress' in London, British Library, *A Collection of Cuttings From Newspapers, and Magazines Relating to Celebrated Actors, Dramatists, Composers, etc.* 2 vols ([unpub.], 1730?–1855?)
78. Celestine Woo, *Romantic Actors and Bardolatry: Performing Shakespeare From Garrick to Kean* (New York: Peter Lang, 2008), p. 89; McDonald, 'Austere Joys of Motherhood,' p. 58. For professional ambition as a pervasion of normative sexuality see Kristina Straub, *Sexual Suspects: Eighteenth-Century Players and Sexual Ideology* (Princeton: Princeton University Press, 1992), p. 98.
79. Elizabeth Helme, *Clara and Emmeline; or, the Maternal Benediction, a Novel in Two Volumes* (London: for G. Kearsley, 1788), I, p. iv. I am indebted to Jennie Batchelor for bringing this reference to my attention.
80. Laetitia Matilda Hawkins, *Anecdotes, Biographical Sketches and Memoirs, Collected By Laetitia Matilda Hawkins*, I (London: F. C. and J. Rivington, 1822), p. 218.
81. Anon., *The Great Illegitimates: Public and Private Life of That Celebrated Actress Miss Bland, Otherwise Mrs. Ford, or Mrs Jordan, Late Mistress of HRH the Duke of Clarence, Now King William IV* (London: J. Duncombe, 1832?), p. 7; Cooke, *The Thespian Dictionary; or, Dramatic Biography of the Eighteenth Century*, 2nd edn (London: James Cundee, 1805), [n.pg].
82. Partington, *British Cyclopedia*, p. 952.
83. Boaden, *Memoirs of Mrs Siddons*, p. 336.

84. Letter to Elizabeth Barrington, 12 September 1794 in BL Add MSS 73736–73737.
85. Letter to Elizabeth Barrington, 12 November 1794 in BL, Add MSS 73736–73737.
86. *Intimate Letters,* p. 98.
87. 5 January 1794 in BL, Add MSS 73736–73737.
88. Dublin [9 June 1810], Huntington, DJ 241.
89. Samuel Rogers, *Recollections of the Table-Talk of Samuel Rogers to Which is Added Porsoniana* (New York: D. Appleton and Company, 1856), p. 186.

Bibliography

Manuscripts

London, British Library (BL), *A Collection of Cuttings From Newspapers, and Magazines Relating to Celebrated Actors, Dramatists, Composers, etc.*, 2 vols ([unpub.], 1730?–1855?)

BL, Barrington Papers. vols cxci–cxcii. 'Letters From Sarah Siddons, Mostly Addressed to Elizabeth Barrington (née Adair), Wife of George Barrington, 5th Viscount, Concerning Health, Family, the Theatre, etc.; Before 1788–1824', Add MSS 73736–73737

BL, Letter from the Reverend Harry Bate to David Garrick, August 1775, MS 25383

BL, MSS f.12 AD 78705

Garrick, 'Original Letters of Dramatic Performers Collected and Arranged By C[harles] B. Smith. Collected Up to C.1850, Folio', 9 vols

London, Garrick Club, *Dramatic Annals: Critiques on Plays and Performers*, I, 1741–1785. Collected By John Nixon

San Marino, CA, Huntington Library, Dorothy Jordan Papers

Kew, The National Archives (TNA), 'Agreement Between John Vanbrugh Esq and Mrs Ann Oldfield for Acting in Her Majesties [*sic*] Company of Comedians in the Hay Market, August 15 1706', LC 7/2, Folio 3

TNA, 'Articles of Agreement Indented, Made, Concluded, and Agreed Upon This 21st Day of April 1709 By and Between Owen Swiney of the Parish of St James Gent of the One Part, and Anne Oldfield of the Parish of St Pauls Covent Garden, Spinster, of the Other Part', LC 7/3, Folio 111

TNA, 'Articles of Agreement on 24 May 1709 Between Owen Swiney and Mary Porter of St Paul's Covent Garden, Spinster', LC 7/3, Folio 117

TNA, 'From Anne Arne Complaint to the Right Honourable Philip Lord Hardwick Baron of Hardwick Lord High', C11

TNA, LC 5/157, f.284

TNA, 'Mrs Oldfield Complains, 4 March 1708/9', LC 7/3, Folio 101

Windsor, Royal Archives, Dorothy Jordan Collection

Published works

Addison, Joseph and Richard Steele, *The Spectator. Volume the Third* (Edinburgh: [n.pub], 1776)

[Addison, Steele, and others], *The Lucubrations of Isaac Bickerstaff Esq*, 5 vols (London: for E. Nutt, A. Bell, J. Darby, A. Bettesworth, et al., 1720)

Allestree, Richard, *The Ladies* [*sic*] *Calling in Two Parts* (Oxford: Printed at the Theater, 1673)

Anon., *Authentick Memoirs of the Life of That Justly Celebrated Actress, Mrs. Ann Oldfield, Collected From Private Records By a Certain Eminent Peer of Great Britain* ([Dublin]: George Faulkner, 1731)

——, *The Beauties of Mrs Siddons: or, a Review of Her Performances of the Characters of Belvidera, Zara, Isabella, Margaret of Anjou, Jane Shore and Lady Randolph* (London: John Strahan, 1786)

——, *The British Magazine and Review; or Universal Miscellany*, I (London: Harrison and Co., 1782)

——, *A Collection and Selection of English Prologues and Epilogues, Commencing With Shakespeare, and Concluding With Garrick*, 4 vols (London: for Fielding and Walker, 1779)

——, *The Court and City Jester: Being an Original Collection of Jests, Puns, Bons Mots, Repartees, Quibbles, Bulls, &c.* (London: for B. Robinson, 1770)

——, *The Court and City Magazine; or, a Fund of Entertainment for the Man of Quality, the Citizen, the Scholar, the Country Gentleman, and the Man of Gallantry; as Well as for the Fair of Every Denomination*, 2 vols (London: for Joseph Smith, 1770–1771)

——, 'An Essay on the Theatres: or the Art of Acting. in Imitation of *Horace's* Art of Poetry', in *The Harleian Miscellany or, a Collection of Rare, Curious, and Entertaining Pamphlets and Tracts*, 8 vols, (London: for T. Osborne, 1744), V pp. 543–9

——, *The Female Soldier; or, the Surprising Life and Adventures of Hannah Snell* (London: printed for, and sold by R. Walker, 1750)

——, *The Great Illegitimates: Public and Private Life of That Celebrated Actress Miss Bland, Otherwise Mrs. Ford, or Mrs Jordan, Late Mistress of HRH the Duke of Clarence, Now King William IV* (London: J. Duncombe, 1832?)

——, *The Green-Room Mirror, Chiefly Delineating Our Present Theatrical Performers* (London: for the author, 1786)

——, *The History of the Stage in which is Included, the Theatrical Characters of the Most Celebrated Actors Who Have Adorn'd the Theatre* (London: for J. Miller, 1742)

——, *An Impartial Examen of the Present Contests Between the Town and the Manager of the Theatre* (London: M. Cooper, 1744)

——, *The Laureat: or, the Right Side of Colley Cibber, Esq; Containing, Explanations, Amendments and Observations, on a Book Intituled [sic], an Apology for the Life, and Writings of Mr. Colley Cibber* (London: for J. Roberts, 1740)

——, *The Life and Adventures of Mrs Christian Davies, Commonly Call'd Mother Ross* (London: printed for and sold by R. Montagu, 1740)

——, *The Life of Lavinia Beswick, Alias Fenton, Alias Polly Peachum* (London: for A. Moore, 1728)

——, *The Life of Mr. James Quin, Comedian. With the History of the Stage From His Commencing Actor to His Retreat to Bath* (London: for S. Bladon, 1766)

——, *Memoirs of the Celebrated Mrs. Woffington, Interspersed With Several Theatrical Anecdotes; the Amours of Many Persons of the First Rank; and Some Interesting Characters Drawn From Real Life* ([London]: [J. Swan], 1760)

——, *A Poem to the Memory of Mrs Oldfield. Inscrib'd to the Honourable Brigadier Charles Churchill* ([Dublin]: George Faulkner, 1731)

——, *The Theatrical Portrait, a Poem on the Celebrated Mrs Siddons in the Characters of Calista, Jane Shore, Belvidera, and Isabella* (London: T. Wilkins, 1783)

——, *The Tryal of a Cause for Criminal Conversation, Between Theophilus Cibber, Gent. Plaintiff, and William Sloper, Esq; Defendant* (London: T. Trott, 1739)

——, *The Vision. Inscribed to Mrs. Woffington. Wrote By a Lady.* (Dublin: James Esdall, 1753)

Appadurai, Arjun, 'Introduction: Commodities and the Politics of Value', in *The Social Life of Things: Commodities in Cultural Perspective*, ed. Arjun Appadurai (Cambridge: Cambridge University Press, 1988), pp. 3–63

Arbiter, Petronius, *Memoirs of the Present Countess of Derby, (late Miss Farren)* (London: Symonds, 1797?)

Arikha, Noga, *Passions and Tempers: A History of the Humours* (New York: HarperCollins, 2007)

Armstrong, Nancy, *Desire and Domestic Fiction: A Political History of the Novel* (Oxford: Oxford University Press, 1989)

Asleson, Robyn, '"She Was Tragedy Personified": Crafting the Siddons Legend in Art and Life', in *A Passion for Performance: Sarah Siddons and Her Portraitists*, ed. Shelley M. Bennett, Robyn Asleson, Mark Leonard and Shearer West (Los Angeles: The J. Paul Getty Museum, 1999), pp. 41–95

Aspinall, Arthur, ed., *Mrs. Jordan and Her Family: Being the Unpublished Correspondence of Mrs. Jordan and the Duke of Clarence, Later William IV* (London: Arthur Barker, 1951)

Aston, Antony, *A Brief Supplement to Colley Cibber, Esq; His Lives of the Famous Actors and Actresses* ([London]: for the author, 1747?)

Baker, David Erskine, *Biographia Dramatica, or, a Companion to the Playhouse: Containing Historical and Critical Memoirs, and Original Anecdotes, of British and Irish Dramatic Writers*, 2 vols (London: for Mess. Rivington, T. Payne and son, L. Davis, et al., 1782)

Balderston, Katharine C., ed., *Thraliana: The Diary of Mrs Hester Lynch Thrale (later Mrs Piozzi) 1776–1809*, 2 vols (Oxford: Clarendon Press, 1942)

Barker-Benfield, G. J., *The Culture of Sensibility: Sex and Society in Eighteenth-Century Britain* (Chicago: University of Chicago Press, 1992)

Barker, Hannah and Karen Harvey, 'Women Entrepreneurs and Urban Expansion: Manchester 1760–1820', in *Women and Urban Life in Eighteenth-Century England: On The Town*, ed. Rosemary Sweet and Penelope Lane (Aldershot: Ashgate, 2003), pp. 111–29

Barrington, Jonah, 'Sir Jonah Barrington's Sketches (4th Notice: – Conclusion)', in *The Literary Gazette; and Journal of Belles Lettres, Arts, Sciences, &c. for the Year 1827*, (London: by James Moyes for the Proprietors at the Literary Gazette Office, 1827), pp. 358–9

Barrington, Sir Jonah, *Personal Sketches of His Own Times*, 5th edn (New York: Redfield, 1854)

Beauvoir, Simone de, *The Second Sex* (London: Vintage, 1997)

Bellamy, George Anne, *An Apology for the Life of George Anne Bellamy, Late of Covent Garden Theatre, Written By Herself*, 5 vols (London: for the author, 1785)

Belsey, Catherine, 'Reading Cultural History', in *Reading the Past: Literature and History*, ed. Tamsin Spargo (Basingstoke: Palgrave – now Palgrave Macmillan, 2000), pp. 103–17

Bennett, John, *Letters to a Young Lady, on a Variety of Useful and Interesting Subjects, Calculated to Improve the Heart, to Form the Manners, and Enlighten the Understanding*, 2 vols (London: for T. Cadell, Junior, and W. Davies, 1795)

Betterton, Thomas, *The History of the English Stage, From the Restoration to the Present Time. Including the Lives, Characters and Amours, of the Most Eminent Actors and Actresses* (London: printed for E. Curll, 1741)

Bloom, Edward A. and Lillian D. Bloom, eds, *The Piozzi Letters: Correspondence of Hester Lynch Piozzi, 1784–1821 (formerly Mrs. Thrale) III, 1799–1804* (Newark: University of Delaware Press, 1993)

Boaden, James, *Memoirs of Mrs. Siddons: Interspersed With Anecdotes of Authors and Actors,* 2 vols (London: Henry Colburn, 1827)

——, *The Life of Mrs. Jordan, Including Original Private Correspondence, and Numerous Anecdotes of Her Contemporaries,* 2 vols (London: Edward Bull, 1831)

Bowers, Toni, *The Politics of Motherhood: British Writing and Culture, 1680–1760* (Cambridge: Cambridge University Press, 1996)

Brooks, Helen E. M., 'Women and Theatre Management in the Eighteenth Century', in *The Public's Open to Us All: Essays on Women and Performance in Eighteenth-century England,* ed. Laura Engel (Newcastle-upon-Tyne: Cambridge Scholars Press, 2009), pp. 73–95

——, 'Negotiating Marriage and Professional Autonomy in the Careers of Eighteenth-Century Actresses', *Eighteenth-Century Life,* 35.2 (2011), 39–75

——, '"The Divided Heart of the Actress": Late Eighteenth-Century Actresses and the "Cult of Maternity"', in *Women, Work and the Theater, 1660–1830: Stage Mothers* (Lewisburg: Bucknell University Press, 2014),

Bull, Thomas, *Hints to Mothers, for the Management of Health During the Period of Pregnancy* (London: Longman, Orme, Brown, Green & Longhams, 1837)

Bullough, Vern L. and Bonnie Bullough, *Cross Dressing, Sex, and Gender* (Philadelphia: University of Pennsylvania Press, 1993)

Burke, Edmund, *A Philosophical Enquiry Into the Origin of Our Ideas of the Sublime and Beautiful* (London: for R. and J. Dodsley, 1757)

Burney, Fanny, *Evelina or the History of a Young Lady's Entrance Into the World. A New Edition in Two Volumes* (London: for W. Lowndes, 1794)

Bush-Bailey, Gilli, *Treading the Bawds: Actresses and Playwrights on the Late-Stuart Stage* (Manchester: Manchester University Press, 2006)

Butler, Judith, *Bodies That Matter: On the Discursive Limits of 'Sex'* (London: Routledge, 1993)

——, *Gender Trouble: Feminism and the Subversion of Identity* (New York: Routledge, 2006)

Castle, Terry, 'The Culture of Travesty: Sexuality and Masquerade in Eighteenth-century England', in *Sexual Underworlds of the Enlightenment,* ed. G. S. Rousseau and Roy Porter (Manchester: Manchester University Press, 1987), pp. 156–80

——, *The Apparitional Lesbian: Female Homosexuality and Modern Culture* (New York: Columbia University Press, 1993)

——, *The Female Thermometer: Eighteenth-Century Culture and the Invention of the Uncanny* (Oxford: Oxford University Press, 1995)

Cave, Richard Allen, 'Woffington, Margaret [Peg] (1720?–1760)', *Oxford Dictionary of National Biography,* (2004) http://www.oxforddnb.com/view/article/29820 [accessed 7 March 2014]

Chandler, Joan, *Women Without Husbands: An Exploration of the Margins of Marriage* (London: Macmillan, 1991)

Chetwood, William Rufus, *A General History of the Stage, From Its Origin in Greece Down to the Present Time. With the Memoirs of Most of the Principal Performers That Have Appeared on the English and Irish Stage for These Last Fifty Years* (London: for W. Owen, 1749)

Cheyne, George, *The Natural Method of Cureing the Diseases of the Body, and the Disorders of the Mind Depending on the Body* (London: for Geo. Strahan, and John and Paul Knapton, 1742)

Cibber, Colley, *An Apology for the Life of Mr. Colley Cibber: Comedian, and Late Patentee of the Theatre-Royal* (London: by John Watts for the author, 1740)

Cibber, Theophilus, *Romeo and Juliet, a Tragedy, Revis'd, and Alter'd From Shakespear* [sic] *to Which is Added, a Serio-Comic Apology, for Part of the Life of Mr. Theophilus Cibber, Comedian* (London: for C. Corbett and G. Woodfall, 1748)

Cleto, Fabio, 'Introduction: Queering the Camp', in *Camp: Queer Aesthetics and the Performing Subject: a Reader*, ed. Fabio Cleto (Edinburgh: Edinburgh University Press, 1999), pp. 1–42

Clive, Catherine, *The Rehearsal: or, Bays in Petticoats. A Comedy in Two Acts. As it is Performed At the Theatre Royal in Drury-Lane* (Dublin: J. Exshaw and M. Williamson, 1753)

Colley, Linda, *Britons: Forging the Nation 1707–1837* (New Haven, CT: Yale University Press, 1992)

Cooke, *The Thespian Dictionary; or, Dramatic Biography of the Eighteenth Century; Containing Sketches of the Lives, Productions, & C. of All the Principal Mangers, Dramatists, Composers, Commentators, Actors, and Actresses, of the United Kingdom* (London: for T. Hurst, 1802)

Cooke, *The Thespian Dictionary; or, Dramatic Biography of the Eighteenth Century,* 2nd end (London: James Cundee, 1805)

Cooke, Stewart, ed., *The Court Journals and Letters of Frances Burney, II, 1787* (Oxford: Clarendon Press, 2011)

Cooke, William, *Memoirs of Charles Macklin, Comedian With the Dramatic Characters, Manners, Anecdotes, &c, of the Age in Which He Lived: Forming an History of the Stage During Almost the Whole of the Last Century* (London: for James Asperne, 1806)

Coulangeon, Philippe, Hyacinthe Ravet and Ionela Roharik, 'Gender Differentiated Effect of Time in Performing Arts Professions: Musicians, Actors and Dancers in Contemporary France', *Poetics*, 33.5–6 (2005), 369–87

Crouch, Kimberly, 'The Public Life of Actresses: Prostitutes or Ladies?', in *Gender in Eighteenth-Century England: Roles, Representations, and Responsibilities*, ed. Hannah Barker and Elaine Chalus (London: Longman, 1997), pp. 58–78

Cumberland, Richard, *The Observer. Being a Collection of Moral, Literary and Familiar Essays, 4 Vols* (Dublin: for P Byrne, R. Marchbank, J. Moore, and W. Jones, 1791)

Curll, Edmund, *The Life of That Eminent Comedian Robert Wilks, Esq* (London: for E. Curll, 1733)

Davidoff, Leonore and Catherine Hall, *Family Fortunes: Men and Women of the English Middle Class 1780–1850* (London: Hutchinson, 1987)

Davies, Michael, 'Authentic Narratives: Cowper and Conversion', in *Literature and Authenticity, 1780–1900: Essays in Honour of Vincent Newey*, ed. Ashley Chantler, Michael Davies and Philip Shaw (Farnham: Ashgate, 2011), pp. 9–24

Davies, Rebecca S., 'The Maternal Contradiction: Representing the Fictional Mother in Richardson's Pamela II (1741)', *Journal for Eighteenth-Century Studies*, 33.3 (2010), 381–97

Davies, Thomas, *Memoirs of the Life of David Garrick, Esq. Interspersed With Characters and Anecdotes of His Theatrical Contemporaries*, 2 vols (London: for the author, 1780)

Dekker, Rudolf M. and Lotte C. van de Pol, *The Tradition of Female Transvestism in Early Modern Europe* (Basingstoke: Macmillan – now Palgrave Macmillan, 1989)

Dickson, P. G. M., *The Financial Revolution in England: A Study in the Development of Public Credit, 1688–1756* (London: Macmillan, 1967)

Donkin, Ellen, 'Mrs Siddons Looks Back in Anger: Feminist Historiography for Eighteenth-Century British Theatre', in *Critical Theory and Performance*, ed. Janelle G. Reinelt and Joseph R. Roach (Ann Arbor: University of Michigan Press, 1992), pp. 276–90

Donoghue, Emma, *Passions Between Women: British Lesbian Culture 1668–1801* (London: Scarlet Press, 1993)

Douglas, Mary, *Implicit Meanings: Selected Essays in Anthropology* (London: Routledge, 1999)

Dowden, Wilfred S., Barbara G. Bartholomew and Joy L. Linsley, eds, *The Journal of Thomas Moore: IV, 1831–1835* (Cranbury, NJ: Associated University Presses, 1987)

Dugaw, Dianne, *Warrior Women and Popular Balladry* (Chicago: University of Chicago Press, 1996)

Dyer, Richard, 'It's Being So Camp as Keeps Us Going', in *Camp: Queer Aesthetics and the Performing Subject: a Reader*, ed. Fabio Cleto (Edinburgh: Edinburgh University Press, 1999), pp. 110–16

Earle, Peter, 'The Female Labour Market in London in the Late Seventeenth and Early Eighteenth Centuries', *The Economic History Review*, 42.3 (1989), 328–53

Egerton, William and [Edmund Curll], *Faithful Memoirs of the Life, Amours and Performances, of That Justly Celebrated, and Most Eminent Actress of Her Time, Mrs. Anne Oldfield* (London: [n. pub], 1731)

Eley, Geoff, 'Nations, Publics, and Political Cultures: Placing Habermas in the Nineteenth Century', in *Habermas and the Public Sphere*, ed. Craig Calhoun (Cambridge, MA: MIT Press, 1992), pp. 289–339

Emsley, Clive, Tim Hitchcock and Robert Shoemaker, 'London History – Currency, Coinage & the Cost of Living', *Old Bailey Proceedings Online*, www.oldbaileyonline.org, version 7.0 [accessed 4 June 2013]

Engel, Laura, *Fashioning Celebrity: Eighteenth-Century British Actresses and Strategies for Image Making* (Columbus: Ohio State University Press, 2011)

Entwistle, Joanne, 'Addressing the Body', in *Fashion Theory: a Reader*, ed. Malcolm Barnard (Abingdon: Routledge, 2007), pp. 273–91

Farquhar, George, *The Recruiting Officer. A Comedy. As it is Acted At the Theatre-Royal in Drury-Lane* (London: for Bernard Lintot, 1736)

——, *The Constant Couple: or, a Trip to the Jubilee. A Comedy. Acted At the Theatre-Royal in Drury-lane, By His Majesty's Servants. The Seventh Edition; With a New Scene Added to the Part of Wildair; and a New Prologue* (London: for John Clarke, 1738)

Ferris, Lesley, *Acting Women: Images of Women in Theatre* (New York: New York University Press, 1989)

Fischer-Lichte, Erika, *History of European Drama and Theatre* (London: Routledge, 2002)

Fletcher, Anthony, *Gender, Sex, and Subordination in England, 1500–1800* (New Haven: Yale University Press, 1995)

Forse, James H., *Art Imitates Business: Commercial and Political Influences in Elizabethan Theatre* (Bowling Green, OH: Bowling Green State University Popular Press, 1993)

Fothergill, Brian, *Mrs. Jordan: Portrait of an Actress* (London: Faber and Faber, 1965)

Freeman, Lisa A., *Character's Theater: Genre and Identity on the Eighteenth-Century English Stage* (Philadelphia: University of Pennsylvania Press, 2002)

Friedli, Lynne, '"Passing Women": a Study of Gender Boundaries in the Eighteenth Century', in *Sexual Underworlds of the Enlightenment*, ed. G. S. Rousseau and Roy Porter (Manchester: Manchester University Press, 1987), pp. 234–60

Friedman-Romell, Beth H., 'Breaking the Code: Toward a Reception Theory of Theatrical Cross-dressing in Eighteenth-Century London', *Theatre Journal*, 47.4 (December 1995), 459–79

Gaillet, Lynée Lewis and Elizabeth Tasker, 'Recovering, Revisioning, and Regendering the History of 18th- and 19th-Century Rhetorical Theory and Practice', in *The Sage Handbook of Rhetorical Studies*, ed. Andrea A. Lunsford (Thousand Oaks, CA: Sage, 2009), pp. 67–84

Garrick, David, *An Essay on Acting: in Which Will be Consider'd the Mimical Behaviour of a Certain Fashionable Faulty Actor, and the Laudableness of Such Unmannerly, as Well as Inhumane Proceedings* (London: for W. Bickerton, 1744)

——, *The Country Girl, a Comedy, (altered From Wycherley) as it is Acted At the Theatre-Royal in Drury-Lane* (Dublin: for W. and W. Smith, J. Hoey, Sen. J Murphy, et al., 1766)

——, *Isabella; or, the Fatal Marriage. A Tragedy, Altered From Southern By D. Garrick, Esq. Marked With the Variations in the Manager's Book, At the Theatre-Royal, in Drury-Lane* (London: for C. Bathurst, T. and W. Lowndes, T. Longman, T. Caslon, W. Nicoll, S. Bladon, and T. Wheildon, 1783)

——, *The Poetical Works of David Garrick, Esq*, 2 vols (London: for George Kearsley, 1785)

——, *The Private Correspondence of David Garrick, With the Most Celebrated Persons of His Time, Second Edition*, 2 vols (London: for H. Colburn by R. Bentley, 1835)

Gelpi, Barbara, 'Significant Exposure: The Turn-of-the-Century Breast', *Nineteenth-Century Contexts*, 20.2 (1997), 125–45

Gentleman, Francis, *The Dramatic Censor: or, Critical Companion*, 2 vols (London: J. Bell, 1770)

Gildon, Charles, *The Life of Mr. Thomas Betterton, the Late Eminent Tragedian. Wherein the Action and Utterance of the Stage, Bar, and Pulpit, Are Distinctly Consider'd* (London: for Robert Gosling, 1710)

Godwin, William, *Enquiry Concerning Political Justice, and Its Influence on Morals and Happiness*, 2 vols (London: G. G. and J. Robinson, 1798)

Golomb, Jacob, *In Search of Authenticity: Existentialism From Kierkegaard to Camus* (Abingdon: Routledge, 1995)

Goring, Paul, *The Rhetoric of Sensibility in Eighteenth-Century Culture* (Cambridge: Cambridge University Press, 2005)

Gracián, Baltasar, *The Art of Prudence: or, a Companion for a Man of Sense* (London: for Daniel Brown, J. Walthoe, T. Benskin, and Tho. Brown, 1705)

Grant, Ruth W., *Hypocrisy and Integrity: Machiavelli, Rousseau, and the Ethics of Politics* (Chicago: University of Chicago Press, 1997)

Greenfield, Susan C., 'Introduction', in *Inventing Maternity: Politics, Science, and Literature, 1650–1865*, ed. Susan C. Greenfield and Carol Barash (Lexington: University Press of Kentucky, 1999)

Guignon, Charles, *On Being Authentic* (London: Routledge, 2004)

Harvey, Karen, 'The Century of Sex? Gender, Bodies, and Sexuality in the Long Eighteenth Century', *The Historical Journal*, 45.4 (2002), 899–916

——, *Reading Sex in the Eighteenth Century: Bodies and Gender in English Erotic Culture* (Cambridge: Cambridge University Press, 2004)

Haslewood, Joseph, *The Secret History of the Green Room: Containing Authentic and Entertaining Memoirs of the Actors and Actresses in the Three Theatres Royal, the Second Edition*, 2 vols (London: for H. D. Symmonds, 1792)

——, *The Secret History of the Green-Room: Containing Authentic and Entertaining Memoirs of the Actors and Actresses in the Three Theatres Royal. A New Edition, With Improvements*, 2 vols (London: for J. Owen, 1795)

Hawkins, Laetitia Matilda, *Anecdotes, Biographical Sketches and Memoirs, Collected By Laetitia Matilda Hawkins*, I (London: F. C. and J. Rivington, 1822)

Hay, Douglas and Nicholas Rogers, *Eighteenth-Century English Society: Shuttles and Swords* (Oxford: Oxford University Press, 1997)

Hazlitt, William, *A View of the English Stage, or a Series of Dramatic Criticisms* (London: John Warren, 1821)

Hecht, J. Jean, *The Domestic Servant Class in Eighteenth-Century England* (London: Routledge & Kegan Paul, 1956)

Helme, Elizabeth, *Clara and Emmeline; or, the Maternal Benediction, a Novel in Two Volumes* (London: for G. Kearsley, 1788)

Henderson, Andrea K., *Romantic Identities: Varieties of Subjectivity, 1774–1830* (Cambridge: Cambridge University Press, 1996)

Highfill, Philip H., Kalman A. Burnim and Edward A. Langhans, eds., *A Biographical Dictionary of Actors, Actresses, Musicians, Dancers, Managers & Other Stage Personnel in London, 1660–1800*, 16 vols (Carbondale: Southern Illinois University Press, 1973)

Hill, Aaron, *The Works of the Late Aaron Hill, Esq; in Four Volumes. Consisting of Letters on Various Subjects, and of Original Poems, Moral and Facetious. With an Essay on the Art of Acting* (London: for the Benefit of the Family, 1753)

——, *The Works of the Late Aaron Hill, Esq; in Four Volumes. Consisting of Letters on Various Subjects, and of Original Poems, Moral and Facetious. With an Essay on the Art of Acting*, 2nd edn (London: for the benefit of the family, 1754)

Hill, John, *The Actor: or, a Treatise on the Art of Playing* (London: for R. Griffiths, 1755)

Hitchcock, Tim, *English Sexualities, 1700–1800* (Basingstoke: Macmillan – now Palgrave Macmillan, 1997)

Hitchcock, Tim and Michèle Cohen, eds., *English Masculinities, 1660–1800* (London: Longman, 1999)

Hodgson Anderson, Emily, *Eighteenth-Century Authorship and the Play of Fiction: Novels and the Theater, Haywood to Austen* (Abingdon: Routledge, 2009)

Holbrook, Ann Catherine, *The Dramatist; or, Memoirs of the Stage. With the Life of the Authoress, Prefixed, and Interspersed With, a Variety of Anecdotes, Humourous and Pathetic* (Birmingham: Martin & Hunter, 1809)

Hotchkiss, Valerie R., *Clothes Make the Man: Female Cross Dressing in Medieval Europe* (New York: Garland, 1996)

Howard, Jean E., 'Crossdressing, the Theatre, and Gender Struggle in Early Modern England', *Shakespeare Quarterly*, 39.4 (1988), 418–40

Howe, Elizabeth, *The First English Actresses: Women and Drama, 1660–1700* (Cambridge: Cambridge University Press, 1992)

Hughes, Alan, 'Art and Eighteenth-Century Acting Style. Part I: Aesthetics', *Theatre Notebook*, 41.1 (1987), 24–31

——, 'Art and Eighteenth-Century Acting Style. Part II: Attitudes', *Theatre Notebook*, 41.2 (1987), 79–89

——, 'Art and Eighteenth-Century Acting Style. Part III: Passions', *Theatre Notebook*, 41.3 (1987), 128–39

Hume, David, 'Of Commerce', in *Political Discourses*, (Edinburgh: R. Fleming, 1752)

Hume, Robert D., *Reconstructing Contexts: The Aims and Principles of Archaeo-Historicism* (Oxford: Oxford University Press, 1999)

Hundert, E. J., 'The European Enlightenment and the History of the Self', in *Rewriting the Self: Histories From the Middle Ages to the Present*, ed. Roy Porter (London: Routledge, 1997), pp. 72–83

Hunt, Leigh, *Critical Essays on the Performers of the London Theatres Including General Observations on the Practise and Genius of the Stage* (London: John Hunt, 1807)

——, *The Autobiography of Leigh Hunt. A New Edition* (London: Smith, Elder and Co, 1870)

Jackson, Anne, *A Continuation of the Memoirs of Charles Mathews, Comedian,* 2 vols (Philadelphia: Lea & Blanchard, 1839)

James, Susan, *Passion and Action: the Emotions in Seventeenth-Century Philosophy* (Oxford: Oxford University Press, 1999)

Jones, Anne Rosalind and Peter Stallybrass, 'Fetishizing Gender: Constructing the Hermaphrodite in Renaissance Europe', in *Body Guards: The Cultural Politics of Gender Ambiguity*, ed. Julia Epstein and Kristina Straub (London: Routledge, 1991), pp. 80–111

Jones, Jeremiah, *A New and Full Method of Settling the Canonical Authority of the New Testament*, 3 vols (Oxford: Clarendon Press, 1798)

Jones, Marion, 'Actors and Repertory', in *The Revels History of Drama in English. V: 1660–1750*, ed. John Loftis, Richard Southern, Marion Jones and A. H. Scouten (London: Methuen, 1976), pp. 119–57

Kaplan, E. Ann., *Motherhood and Representation: The Mother in Popular Culture and Melodrama* (London: Routledge, 1992)

Kelly, Linda, *The Kemble Era: John Philip Kemble, Sarah Siddons and the London Stage* (New York: Random House, 1980)

Kemble, John Philip, *The Female Officer, or the Humours of the Army, a Comedy. Altered From Shadwell* (Dublin: by James Hoey, 1763)

Kennedy, Deborah, *Helen Maria Williams and the Age of Revolution* (Cranbury, NJ: Associated University Presses, 2002)

Kenny, Shirley Strum, 'Farquhar, George (1676/7–1707)', *Oxford Dictionary of National Biography*, (2004) http://www.oxforddnb.com/view/article/9178 [accessed 7 March 2014]

Kent, Susan Kingsley, *Gender and Power in Britain, 1640–1990* (London: Routledge, 2013)

Kipp, Julie, *Romanticism, Maternity, and the Body Politic* (Cambridge: Cambridge University Press, 2003)

Klein, Lawrence E., 'Gender and the Public/Private Distinction in the Eighteenth Century: Some Questions About Evidence and Analytic Procedure', *Eighteenth-Century Studies*, 29.1 (1995), 97–109

——, 'Property and Politeness in the Early Eighteenth-Century Whig Moralists. the Case of the *Spectator*', in *Early Modern Conceptions of Property*, ed. John Brewer and Susan Staves (London: Routledge, 1995), pp. 221–33

Knapp, Oswald G., ed., *The Intimate Letters of Hester Piozzi and Penelope Pennington, 1788–1821* (London: John Lane, 1914)

La Chambre, Marin Cureau de, *A Discourse Upon the Passions in Two Parts* (London: by Tho. Newcomb for Hen. Herringman, 1661)

——, *The Art How to Know Men Originally Written By the Sieur De La Chambre. rendered Into English By John Davies* (London: by T. R for Thomas Dring, 1665)

Lafler, Joanne, *The Celebrated Mrs. Oldfield: The Life and Art of an Augustan Actress* (Carbondale: Southern Illinois University Press, 1989)

Lamb, Charles, *The Prose Works of Charles Lamb*, 3 vols (London: Edward Moxon, 1836)

Langhans, Edward A., 'Tough Actresses to Follow', in *Curtain Calls: British and American Women and the Theater, 1660–1820*, ed. Mary Anne Schofield and Cecilia Macheski (Athens: Ohio University Press, 1991), pp. 3–17

Laqueur, Thomas, *Making Sex: Body and Gender from the Greeks to Freud* (Cambridge, MA: Harvard University Press, 1990)

Lehmann, Gilly, 'The Birth of a New Profession: The Housekeeper and her Status in the Seventeenth and Eighteenth Centuries', in *The Invisible Woman: Aspects of Women's Work in Eighteenth-Century Britain*, ed. Isabelle Baudino, Jacques Carré and Marie-Cécile Révauger (Aldershot: Ashgate, 2005), pp. 9–25

Lewis, Elizabeth Miller, 'Hester Santlow's *Harlequine*: Dance, Dress, Status, and Gender on the London Stage, 1706–1734', in *The Clothes That Wear Us: Essays on Dressing and Transgressing in Eighteenth-Century Culture*, ed. Jessica Munns and Penny Richards (Cranbury, NJ: Associated University Presses, 1999), pp. 80–101

Little, David M. and George M. Kahrl, eds., *The Letters of David Garrick*, 3 vols (Cambridge, MA: Belknap Press of Harvard University Press, 1963)

Litvak, Joseph, *Caught in the Act: Theatricality in the Nineteenth-Century English Novel* (Berkeley and Los Angeles: University of California Press, 1992)

Lobman, Carrie and Barbara E. O'Neill, 'Introduction: Play, Performance, Learning, and Development: Exploring the Relationship', in *Play and Performance*, ed. Carrie Lobman, and Barbara E. O'Neill (Lanham, MD: University Press of America, 2011), pp. vii–xvii

Loussouarn, Sophie, 'Governesses of the Royal Family and the Nobility, 1750–1815', in *The Invisible Woman: Aspects of Women's Work in Eighteenth-Century Britain*, ed. Isabelle Baudino, Jacques Carré and Cécile Révauger (Aldershot: Ashgate, 2005), pp. 47–55

Lowenthal, Cynthia, *Performing Identities on the Restoration Stage* (Carbondale: Southern Illinois University Press, 2003)

Lucey, Janet Camden, *Lovely Peggy: The Life and Times of Margaret Woffington* (London: Hurst and Blackett, 1952)

Mandeville, Bernard, *The Fable of the Bees: or, Private Vices, Publick Benefits* (London: J. Roberts, 1714)

[Mangin, Edward], *Piozziana; or, Recollections of the Late Mrs Piozzi With Remarks, By a Friend* (London: Edward Moxon, 1833)

Manvell, Roger, *Sarah Siddons* (London: Heinemann, 1970)

Marsden, Jean I., *Fatal Desire: Women, Sexuality, and the English Stage, 1660–1720* (Ithaca: Cornell University Press, 2006)

Marshall, David, 'Rousseau and the State of Theater', in *Jean-Jacques Rousseau: Politics, Art, and Autobiography*, ed. John T. Scott (Abingdon: Routledge, 2006), pp. 139–70

Maus, Katherine Eisaman, 'Playhouse Flesh and Blood: Sexual Ideology and the Restoration Actress', *English Literary History*, 46.4 (1979), 595–617

McCreery, Cindy, *The Satirical Gaze: Prints of Women in Late Eighteenth-Century England* (Oxford: Oxford University Press, 2004)

McDonald, Jan, '"Acting and the Austere Joys of Motherhood": Sarah Siddons Performs Maternity', in *Extraordinary Actors: Essays on Popular Performers: Studies in Honour of Peter Thomson*, ed. Jane Milling and Martin Banham (Exeter: University of Exeter Press, 2004), pp. 57–70

McDonald, Russ, *Look to the Lady: Sarah Siddons, Ellen Terry, and Judi Dench on the Shakespearean Stage* (Athens: University of Georgia Press, 2005)

McGann, J. J., *The Romantic Ideology: A Critical Investigation* (Chicago: University of Chicago Press, 1985)

McGirr, Elaine M., *Eighteenth-Century Characters: A Guide to the Literature of the Age* (Basingstoke: Palgrave Macmillan, 2007)

McKeon, Michael, 'Historicizing Patriarchy: The Emergence of Gender Difference in England, 1660–1760', *Eighteenth-Century Studies*, 28.3 (1995), 295–322

McKillop, Alan Dugald, ed., *James Thomson (1700–1748): Letters and Documents* (Lawrence: University of Kansas Press, 1958)

Mears, Martha, *The Pupil of Nature; or Candid Advice to the Fair Sex, on the Subjects of Pregnancy; Childbirth; the Diseases Incident to Both; the Fatal Effects of Ignorance and Quackery; and the Most Approved Means of Promoting the Health, Strength, and Beauty of Their Offspring* (London: for the authoress, 1797)

Michaelson, Patricia Howell, *Speaking Volumes: Women, Reading, and Speech in the Age of Austen* (Stanford: Stanford University Press, 2002)

Milhous, Judith, 'The First Production of Rowe's *Jane Shore*', *Theatre Journal*, 38.3 (1986), 309–21

Milhous, Judith and Robert D. Hume, 'John Rich's Covent Garden Account Books for 1735–36', *Theatre Survey*, 31.2 (1990), 200–41

Millar, James, ed., *Encyclopaedia Edinensis: or a Dictionary of Arts, Sciences, and Literature* (Edinburgh: J. Anderson, 1827)

Milling, Jane, 'Porter, Mary (d.1765)', *Oxford Dictionary of National Biography*, (2004; online edn, Jan 2008) http://www.oxforddnb.com/view/article/22575 [accessed 7 March 2014]

——, 'Oldfield, Anne (1683–1730)', *Oxford Dictionary of National Biography* (2004; online edn, Jan 2008) http://www.oxforddnb.com/view/article/20677 [accessed 21 March 2014]

Minto, Emma Eleanor Elizabeth (Hislop) Elliot-Murray-Kynynmound, ed., *Life and Letters of Sir Gilbert Elliot, First Earl of Minto, From 1751 to 1806*, 3 vols (London: Longmans, Green & Co., 1874)

More, Hannah, *Percy, a Tragedy. As it is Acted At the Theatre-Royal in Covent-Garden* (Dublin: R. Marchbank, for the Company of Booksellers, 1778)

——, *Strictures on the Modern System of Female Education. With a View of the Principles and Conduct Prevalent Among Women of Rank and Fortune*, 2 vols (London: for T. Cadell Jun. and W. Davies, 1799)

Mounsey, Chris and Caroline Gonda, 'Queer People: an Introduction', in *Queer People: Negotiations and Expressions of Homosexuality, 1700–1800*, ed. Chris

Mounsey and Caroline Gonda (Cranbury, NJ: Assocated University Presses, 2007), pp. 9–37

Muri, Allison, *The Enlightenment Cyborg: A History of Communications and Control in the Human Machine, 1660–1830* (Toronto: University of Toronto Press, 2007)

Newman, Louise M., 'Critical Theory and the History of Women: What's At Stake in Deconstructing Women's History', *Journal of Women's History*, 2.3 (1991), 58–68

Newton, Esther, 'Role Models', in *Camp: Queer Aesthetics and the Performing Subject: a Reader*, ed. Fabio Cleto (Edinburgh: Edinburgh University Press, 1999), pp. 96–109

Norris, John, *A Treatise Concerning Christian Prudence: Or the Principles of Practical Wisdom* (London: for Samuel Manship, 1710)

Nussbaum, Felicity, 'Heteroclites: the Gender of Character in the Scandalous Memoirs', in *The New Eighteenth Century: Theory, Politics, English Literature*, ed. Felicity Nussbaum and Laura Brown (London: Methuen, 1987), pp. 144–67

——,'"Savage" Mothers: Narratives of Maternity in the Mid-Eighteenth Century', *Cultural Critique*, 20 (1991–1992), 123–51

——, 'Actresses and the Economics of Celebrity, 1700–1800', in *Theatre and Celebrity in Britain, 1660–2000*, ed. Mary Luckhurst and Jane Moody (Basingstoke: Palgrave Macmillan, 2005), pp. 148–168

——, *Rival Queens: Actresses, Performance, and the Eighteenth-Century British Theater* (Philadelphia: University of Pennsylvania Press, 2010)

O'Brien, John, ed., *The Wonder: A Woman Keeps a Secret* (Peterborough, Ontario: Broadview Press, 2004)

O'Driscoll, Sally, 'A Crisis of Femininity – Re-making Gender in Popular Discourse', in *Lesbian Dames: Sapphism in the Long Eighteenth Century*, ed. John C. Beynon and Caroline Gonda (Farnham: Ashgate, 2010), pp. 45–60

Oldys, William, *Memoirs of Mrs. Anne Oldfield* (London: [n. pub], 1741)

Parnell, Paul E., 'The Distrest Mother: Ambrose Philips' Morality Play', *Comparative Literature*, 11.2 (1959), 111–23

Parsons, Clement, *The Incomparable Siddons* (London: Methuen & Co, 1909)

Partington, Charles Frederick, *The British Cyclopedia of Biography: Containing the Lives of Distinguished Men of All Ages and Countries, With Portraits, Residences, Autographs, and Monuments*, II (London: WM. S. Orr and Co., 1838)

Pascoe, Judith, *Romantic Theatricality: Gender, Poetry, and Spectatorship* (Ithaca: Cornell University Press, 1997)

Perfect, David, *Briefing Paper 6: Gender Pay Gaps, 2012* (Manchester: Equality and Human Rights Commission, 2013)

Perry, Gill, 'Musing on Muses: Representing the Actress as "Artist" in British Art of the Late Eighteenth and Early Nineteenth Centuries', in *Women, Scholarship and Criticism: Gender and Knowledge c.1790–1900*, ed. Joan Bellamy, Anne Laurence and Gillian Perry (Manchester: Manchester University Press, 2000), pp. 16–41

——, 'Ambiguity and Desire: Metaphors of Sexuality in Late Eighteenth-Century Representations of the Actress', in *Notorious Muse: the Actress in British Art and Culture, 1776–1812*, ed. Robyn Asleson (New Haven: Published for the Paul Mellon Centre for Studies in British Art [and] the Yale Center for British Art [by] Yale University Press, 2003), pp. 57–80

——, 'Staging Gender and "Hairy Signs": Representing Dorothy Jordan's Curls', *Eighteenth-Century Studies*, 38.1 (2004), 145–63

Philips, Ambrose, *The Distrest Mother, a Tragedy. Translated By Ambrose Philips, From the Andromaque of Racine* (Dublin: for William Jones, 1792)

Phillips, Nicola, *Women in Business, 1700–1850* (Woodbridge: The Boydell Press, 2006)

Picard, Liza, *Dr. Johnson's London: Life in London, 1740–1770* (London: Phoenix, 2003)

Piggford, George, '"Who's That Girl?": Annie Lennox, Woolf's *Orlando*, and Female Camp Androgyny', in *Camp: Queer Aesthetics and the Performing Subject: a Reader*, ed. Fabio Cleto (Edinburgh: Edinburgh University Press, 1999), pp. 283–99

Porter, Roy, *Flesh in the Age of Reason* (London: Allen Lane, 2003)

Postlewait, Thomas, 'Writing History Today', *Theatre Survey*, 4.2 (2000), 83–106

Prynne, William, *Histrio-Mastix: The Players Scourge, or, Actors Tragaedie* (London: E[dward] A[llde, Augustine Mathewes, Thomas Cotes] and W[illiam] I[ones] for Michael Sparke, 1633)

Pullen, Kirsten, *Actresses and Whores: on Stage and in Society* (Cambridge: Cambridge University Press, 2005)

Quin, James, *Quin's Jests; or, the Facetious Man's Pocket-Companion. Containing Every Species of Wit, Humour, and Repartee* (London: for S. Bladon, 1766)

Quinn, Michael L., 'Celebrity and the Semiotics of Acting', *New Theatre Quarterly*, 6.22 (1990), 154–61

Rae, W. Fraser, *Sheridan: A Biography*, 2 vols (London: Richard Bentley and Son, 1896)

Redford, Bruce, ed., *The Letters of Samuel Johnson, IV, 1782–1784* (Princeton: Princeton University Press, 1994)

Retford, Kate, *The Art of Domestic Life: Family Portraiture in Eighteenth-Century England* (New Haven: for the Paul Mellon Centre for Studies in British Art by Yale University Press, 2006)

Reynolds, Frederick, *Cheap Living: A Comedy in Five Acts. As it is Performed At the Theatre-Royal, Drury Lane*, 3rd edn (London: for G. G and J. Robinson, 1797)

Roach, Joseph R., *The Player's Passion: Studies in the Science of Acting* (Ann Arbor: University of Michigan Press, 1993)

Rogers, Pat, 'The Breeches Part', in *Sexuality in Eighteenth-Century Britain*, ed. Paul-Gabriel Boucé (Manchester: Manchester University Press, 1982), pp. 244–58

Rogers, Samuel, *Recollections of the Table-Talk of Samuel Rogers to Which is Added Porsoniana* (New York: D. Appleton and Company, 1856)

Roulston, Christine, *Virtue, Gender, and the Authentic Self in Eighteenth-Century Fiction: Richardson, Rousseau, and Laclos* (Gainesville: University Press of Florida, 1998)

Rowe, Nicholas, *The Tragedy of Jane Shore. Written in Imitation of Shakespear's [sic] Style* (Dublin: reprinted for S. Powell, P. Cambel, and G. Grierson, 1714)

——, *The Fair Penitent. A Tragedy* (London: for J. and R. Tonson and S. Draper, 1754)

Russell, John, ed., *Memoirs, Journal, and Correspondence of Thomas Moore*, V (London: Longman, Brown, Green, and Longmans, 1854)

Russell, William Clark, *Representative Actors: A Collection of Criticisms, Anecdotes, Personal Descriptions, Etc, Etc, Referring to Many Celebrated British Actors From the Sixteenth to the Present Century With Notes, Memoirs and a Short Account of English Acting* (London: Frederick Warne and Co, [n.d.])

Savage, Richard, 'An Epistle to Mrs Oldfield of the Theatre Royal', in *Miscellaneous Poems and Translations* (London: for Samuel Chapman, 1726), pp. 187–90

Schiebinger, Londa, 'Skeletons in the Closet: The First Illustrations of the Female Skeleton in Eighteenth-century Anatomy', in *The Making of the Modern Body: Sexuality and Society in the Nineteenth Century*, ed. Catherine Gallagher and Thomas Laqueur (Berkeley and Los Angeles: University of California Press, 1987), pp. 42–82

——, *The Mind Has No Sex?: Women in the Origins of Modern Science* (Cambridge, MA: Harvard University Press, 1989)

Sedgwick, Eve Kosofsky, *Epistemology of the Closet* (Berkeley and Los Angeles: University of California Press, 2008)

Senelick, Laurence, *The Changing Room: Sex, Drag and Theatre* (London: Routledge, 2000)

Seward, Anna, *Letters of Anna Seward: Written Between the Years 1784 and 1807*, 6 vols (Edinburgh: for Archibald Constable and Company, 1811)

Shadwell, Thomas, *The Humours of the Army. A Comedy. As it is Acted At the Theatre-Royal in Drury-Lane* (London: for James Knapton, 1713)

Shilling, Chris, *The Body and Social Theory*, 3rd edn (London: Sage, 2013)

Shoemaker, Robert B., *Gender in English Society, 1650–1850: The Emergence of Separate Spheres?* (London: Longman, 1998)

Smith, Adam, *An Inquiry Into the Nature and Causes of the Wealth of Nations*, 3 Vols. (Dublin: printed for Messrs. Whitestone, Chamberlaine, W. Watson, et al., 1776)

Smith, Samuel Stanhope, *An Essay on the Causes of the Variety of Complexion and Figure in the Human Species* (Edinburgh: for C. Elliot and T. Kay, 1788)

Sommerville, Margaret R., *Sex and Subjection: Attitudes to Women in Early-Modern Society* (London: Arnold, 1995)

Stafford, Barbara Maria, *Body Criticism: Imaging the Unseen in Enlightenment Art and Medicine* (Cambridge, MA: MIT Press, 1993)

Straub, Kristina, 'The Guilty Pleasures of Female Theatrical Cross-Dressing and the Autobiography of Charlotte Charke', in *Body Guards: The Cultural Politics of Gender Ambiguity*, ed. Julia Epstein and Kristina Straub (London: Routledge, 1991), pp. 142–66

——, *Sexual Suspects: Eighteenth-Century Players and Sexual Ideology* (Princeton: Princeton University Press, 1992)

Struve, Christian Augustus, *A Familiar View of the Domestic Education of Children, During the Early Period of Their Lives. Being a Compendium Addressed to All Mothers, Who Are Seriously Concerned for the Welfare of Their Offspring* (London: for Murray and Highley, 1802)

Taylor, Diana, *The Archive and the Repertoire: Performing Cultural Memory in the Americas* (Durham, NC: Duke University Press, 2003)

The Letters of Horace Walpole, Fourth Earl of Orford, XII, 1781–1783 (Oxford: Clarendon Press, 1905)

Thibaudeau, A. W., ed., *Catalogue of the Collection of Autograph Letters and Historical Documents Formed Between 1865 and 1882 by Alfred Morrison, V* ([London]: printed for private circulation, 1883–1892)

Thompson, E. P., 'History From Below (first Published 7 April 1966, *Times Literary Supplement*)', in *The Essential E. P. Thompson*, ed. Dorothy Thompson (New York: The New Press, 2001), pp. 481–9

Tomalin, Claire, *Mrs Jordan's Profession: The Actress and the Prince* (New York: Alfred A. Knopf, 1995)

Tomalin, Claire and Ian A. C. Dejardin, *Mrs Jordan: The Duchess of Drury Lane* (London: English Heritage, 1995)

Torr, Diane and Stephen Bottoms, *Sex, Drag, and Male Roles: Investigating Gender as Performance* (Ann Arbor: University of Michigan, 2010)

Tosh, John, 'The Old Adam and the New Man: Emerging Themes in the History of English Masculinities, 1750–1850', in *English Masculinities, 1660–1800*, ed. Tim Hitchcock and Michèle Cohen (London: Longman, 1999), pp. 217–38

Traub, Valerie, *The Renaissance of Lesbianism in Early Modern England* (Cambridge: Cambridge University Press, 2002)

Trilling, Lionel, *Sincerity and Authenticity* (London: Oxford University Press, 1972)

Trouille, Mary Seidman, *Sexual Politics in the Enlightenment: Women Writers Read Rousseau* (Albany: State University of New York Press, 1997)

Trumbach, Randolph, 'London's Sodomites: Homosexual Behavior and Western Culture in the 18th Century', *Journal of Social History*, 11.1 (1977), 1–33

——, 'London's Sapphists: From Three Sexes to Four Genders in the Making of Modern Culture', in *Body Guards: The Cultural Politics of Gender Ambiguity*, ed. Julia Epstein and Kristina Straub (London: Routledge, 1991), pp. 112–41

——, 'Sex, Gender, and Sexual Identity in Modern Culture: Male Sodomy and Female Prostitution in Enlightenment London', *Journal of the History of Sexuality*, 2.2 (1991), 186–203

Tuana, Nancy, *Woman and the History of Philosophy* (New York: Paragon House Publishers, 1992)

——, *The Less Noble Sex: Scientific, Religious, and Philosophical Conceptions of Woman's Nature* (Bloomington & Indianapolis: Indiana University Press, 1993)

Van Lennep, William, ed., *The Reminiscences of Sarah Kemble Siddons, 1773–1785* (Cambridge: Widener Library, 1942)

Van Lennep, William, Emmett L. Avery, Arthur H. Scouten and others, eds., *The London Stage, 1660–1800: A Calendar of Plays, Entertainments & Afterpieces, Together With Casts, Box-Receipts and Contemporary Comment. Compiled From the Playbills, Newspapers and Theatrical Diaries of the Period*, 5 Parts in 11 Volumes (Carbondale: Southern Illinois University Press, 1960–1968)

Varloot, Jean, ed., *Discours Sur Les Sciences Et Les Arts: Lettre à D'Alembert* (Paris: Gallimard, 1987)

Venette, Nicolas, *Conjugal Love Reveal'd; in the Nightly Pleasures of the Marriage Bed, and the Advantages of That Happy State. Seventh Edition* (London: for the author, 1720?)

Victor, Benjamin, *The History of the Theatres of London and Dublin, From the Year 1730 to the Present Time. To Which is Added, an Annual Register of All the Plays, &c. Performed at the Theatres-Royal in London, From the Year 1712*, 2 vols (London: for T. Davies; R. Griffiths, T. Becket, et al., 1761)

——, *The History of the Theatres of London, From the Year 1760 to the Present Time* (London: for T. Becket, 1771)

——, *Original Letters, Dramatic Pieces, and Poems, 3 Vols.* (London: for T. Becket, 1776)

Wahl, Elizabeth Susan, *Invisible Relations: Representations of Female Intimacy in the Age of Enlightenment* (Stanford: Stanford University Press, 1999)

Wahrman, Dror, 'Percy's Prologue: From Gender Play to Gender Panic in Eighteenth-Century England', *Past and Present*, 159 (1998), 113–60

——, *The Making of the Modern Self: Identity and Culture in Eighteenth-Century England* (New Haven: Yale University Press, 2006)

Wakefield, Priscilla, *Reflections on the Present Condition of the Female Sex; With Suggestions for Its Improvment* (London: for J. Johnson; and Darton and Harvey, 1798)

Wanko, Cheryl, *Roles of Authority: Thespian Biography and Celebrity in Eighteenth-Century Britain* (Lubbock: Texas Tech University Press, 2003)

Weitz, Eric, *The Cambridge Introduction to Comedy* (Cambridge: Cambridge University Press, 2009)

Wellman, Kathleen, *La Mettrie: Medicine, Philosophy, and Enlightenment* (Durham, NC: Duke University Press, 1992)

West, Shearer, 'The Public and Private Roles of Sarah Siddons', in *A Passion for Performance: Sarah Siddons and Her Portraitists*, ed. Robyn Asleson, Shelley Bennett, Mark Leonard and Shearer West (Los Angeles: J. Paul Getty Museum, 1999), pp. 1–39

Wiesner-Hanks, Merry E., *Early Modern Europe, 1450–1789* (Cambridge: Cambridge University Press, 2013)

Wikander, Matthew H., *Fangs of Malice: Hypocrisy, Sincerity, and Acting* (Iowa City: University of Iowa Press, 2002)

Wilkes, Thomas, *A General View of the Stage* (London: for J. Coote, 1759)

Wilkin, Rebecca M., *Women, Imagination and the Search for Truth in Early Modern France* (Aldershot: Ashgate, 2008)

Wilkinson, Tate, *Memoirs of His Own Life*, 3 vols (York: Printed for the author by Wilson, Spence, and Mawman, 1790)

——, *The Wandering Patentee; or, a History of the Yorkshire Theatres, From 1770 to the Present Time*, 4 vols (York: for the author, by Wilson, Spence, and Mawman, 1795)

Williams, Clare, trans., *Sophie in London, 1786: Being the Diary of Sophie V. La Roche* (London: Jonathan Cape, 1933)

Wiskin, Christine, 'Urban Businesswomen in Eighteenth-Century England', in *Women and Urban Life in Eighteenth-Century England: On The Town*, ed. Rosemary Sweet and Penelope Lane (Aldershot: Ashgate, 2003), pp. 87–110

Woo, Celestine, *Romantic Actors and Bardolatry: Performing Shakespeare From Garrick to Kean* (New York: Peter Lang, 2008)

Wright, Thomas, *The Passions of the Minde in Generall. Corrected, Enlarged, and With Sundry New Discourses Augmented* (London: for Walter Burre [and Thomas Thorpe], 1604)

Yang, Sharon Rose, *Goddesses, Mages, and Wise Women: The Female Pastoral Guide in Sixteenth and Seventeenth-Century English Drama* (Cranbury, NJ: Associated University Presses, 2011)

Index

Printed and bound by CPI Group (UK) Ltd, Croydon, CR0 4YY